THE STUDY AND CRITICISM OF
ITALIAN SCULPTURE

THE STUDY AND CRITICISM OF ITALIAN SCULPTURE

JOHN POPE-HENNESSY

THE METROPOLITAN MUSEUM
OF ART / NEW YORK

Published in association with
PRINCETON UNIVERSITY PRESS
Princeton, New Jersey

ON THE JACKET: Antonio Rossellino, *Madonna and Child with Angels.* Marble. The Metropolitan Museum of Art, New York. Bequest of Benjamin Altman. (Photography by Walter J. F. Yee, Photograph Studio, The Metropolitan Museum of Art.)

PUBLISHED BY
The Metropolitan Museum of Art, New York
Bradford D. Kelleher, Publisher
John P. O'Neill, Editor in Chief
Emily Walter, Editor
Peter Oldenburg, Designer

LIBRARY OF CONGRESS CATALOGING IN PUBLICATION DATA

Pope-Hennessy, John Wyndham, Sir, 1913-
 The study and criticism of Italian sculpture.

 1. Sculpture, Italian. 2. Sculpture, Renaissance—
Italy. I. Title.

NB 616.P66 730'.945 80-20651
ISBN 0-87099-239-2 (MMA)
ISBN 0-691-03967-4 (Princeton)

Composition by Zimmering & Zinn, New York, New York
Printed by Meriden Gravure Company, Meriden, Connecticut
Bound by Publishers Book Bindery, Inc., Long Island City, New York

CONTENTS

PREFACE

The essays in this book deal with aspects of Italian sculpture in the fifteenth century. The first, "Connoisseurship," serves as an introduction to the articles which follow; it originated as a lecture to the Friends of the Fogg Art Museum at Harvard University in 1979. The second, "The Sixth Centenary of Ghiberti," discusses the development of Ghiberti's style and the extent to which current preconceptions of it require to be revised. It too was delivered as a lecture, in Italian, and in a somewhat different form, at the opening session of the Convegno Internazionale di Studi "Lorenzo Ghiberti nel suo tempo," in the Palazzo Vecchio in Florence in October 1978, and in its present form a year later at the Frick Collection. I am indebted to the Secretary of the British Academy for permission to reprint a lecture on Italian Renaissance plaquettes and their cultural implications, which forms a by-product of my catalogue of the plaquettes in the Kress Collection at the National Gallery of Art in Washington. "The Altman Madonna by Antonio Rossellino" was written for the Metropolitan Museum *Journal* of 1970 on the occasion of the centenary of The Metropolitan Museum of Art, New York. Six of the articles were first printed in *Apollo,* one of the few periodicals dealing with art history in which visual points can be made visually. I am indebted to my friend Denys Sutton for permission to reproduce them here. Four of them are devoted to facets of the mysterious personality of Donatello. The last, "The Forging of Italian Renaissance Sculpture," caused a flurry of thermoluminescence testing by the owners of suspect terra-cottas when it first appeared, and as a result it has been demonstrated that two works which I had looked on as forgeries, one in the Isabella Stewart Gardner Museum in Boston and the other in the Birmingham Museum and Art Gallery, indubitably date from the fifteenth century. I should add that all the essays printed here, however specialized their ostensible scope, are designed for reading by nonspecialists.

J P-H

ACKNOWLEDGMENTS

From *Apollo* Magazine. By Permission of the Editor:

"The Forging of Italian Renaissance Sculpture,"
Apollo, Vol. XCIX, No. 146 (April 1974)

"The Medici Crucifixion of Donatello,"
Apollo, Vol. CI, No. 156 (February 1975)

"The Madonna Reliefs of Donatello,"
Apollo, Vol. CIII, No. 169 (March 1976)

"Donatello and the Bronze Statuette,"
Apollo, Vol. CV, No. 179 (January 1977)

"The Evangelist Roundels in the Pazzi Chapel,"
Apollo, Vol. CVI, No. 188 (October 1977)

"Thoughts on Andrea della Robbia,"
Apollo, Vol. CIX, No. 205 (March 1979)

"The Italian Plaquette" first appeared in the *Proceedings of the British Academy*, Vol. I (1964), Oxford University Press, and is reprinted by permission of The British Academy.

EDITOR'S NOTE: Previously published articles included in this volume have been brought up-to-date to reflect current scholarship, cross-references have been added to other articles in this volume, British spellings have been changed to American usage, and the notes and captions for each article have been recast in a consistent style.

THE STUDY AND CRITICISM OF
ITALIAN SCULPTURE

CONNOISSEURSHIP

A LITTLE TIME AGO, sitting in a restaurant, I overheard a man at the next table saying to his companion, in a voice of great contempt: "He is simply a manipulator." The expression was so equivocal that I went on listening. To whom could it possibly apply? A chiropractor? An asset-stripping company director? But no, not a bit of it. The two men were mathematicians, and their subject was a colleague of whose mental processes they disapproved. I could quite imagine two art historians lunching together, and saying rather the same thing. "Of course," one would exclaim dismissively, "he is just a connoisseur." And for all one knows, one might oneself be the subject of the conversation, for my own interest in art history (and I should say this frankly at the start) lies predominantly in the murky area known as connoisseurship. It is not that I am temperamentally impatient of historical constraints; it is simply that the problems which I attack from choice are those arising out of works of art, for which the work of art itself is the main, sometimes the sole source of evidence.

In the seventeenth and eighteenth centuries it was accepted that the legitimate authorities on art were artists, and it was an artist, Jonathan Richardson the Elder, who in 1719 published the first reasoned account of the processes of connoisseurship. It was addressed primarily to collectors (Richardson himself, of course, was on both sides of the fence; he was a great collector of drawings as well as a painter), and its scope is established on the title page. It is called *The Connoisseur: an Essay on the Whole Art of Criticism as it relates to Painting showing how to judge I. of the Goodness of a Picture; II. of the Hand of the Master; and III. Whether 'tis an Original or a Copy.*[1] The theme is stated in a quotation from a letter of Nicolas Poussin to Fréart de Chambray, praising him for having opened the eyes of those who saw only through the eyes of others and had previously allowed themselves to be deceived by "une fausse opinion commune." Richardson's argument is a disturbingly sophisticated one. Collectors, says Richardson, fall into two types. One has "neither the leisure nor the inclination to become a connoisseur himself, and yet may delight in those things and desire to have them," and his actions, therefore, will be governed by "arguments in favour of the honesty and understanding of the man he relies upon; not at all relating to the intrinsick worth of the thing in question." Certificate fodder, we would call him nowadays. The second and superior class of collector is the man who judges for himself, in the conviction that "one man may be as good a judge as another if he applies himself to it." If he does, he will find, says Richardson, that the styles of the greatest

masters can be apprehended without difficulty, while their imitators are harder to distinguish, and as for "masters of the middle class...there is but one way to come to a knowledge of hands, and that is to furnish our minds with as just and compleat ideas of the masters as we can." Just as we recognize who is represented in a portrait by our antecedent knowledge of other portraits of the same sitter, so with paintings "we compare the work under consideration with the idea we have of the manner of such a master, and perceive the similitude." Copies and reproductive prints may help, but "tis on the works themselves we must chiefly and ultimately depend, as giving us ideas which no *words* possibly can, being such for which we have no name, and which cannot be communicated but by the things themselves." The basis of study is reason. "Tis as necessary to a connoisseur as to a philosopher or a Divine to be a good Logician; the same faculties are employed in the same manner, the difference is only in the subject." The connoisseur must "take care not to confound things in which there is a real difference because of the resemblance they may seem to have"; and conversely he must never "make a difference where there is none, and so attribute those works to two several masters which were both done by the same hand."

Given the vastness of the field, specialization is advisable, and even so, judgments will be liable to contain a strong subjective element, "the appearance of evidence being necessarily so various to every one of us." Divergence of view, when it occurs, "does not always happen from the obscurity of the science, but frequently from some defect in the man." Moreover, the relations between experts and collectors, Richardson admits, may well prove tense. "No man," he asserts, "is bound to deliver the truth to him who has no right to demand it." Let the connoisseur, therefore, cultivate "pensieri stretti ed un volto sciolto," let him, in other words, keep his own counsel, and if pressed by collectors "to give his opinion of something they have lately acquired, and the honeymoon is not yet over," let him recall "the words of the Savior to his disciples: 'I have many things to say to you, but you cannot bear to hear them now.'"

I think the main points stand out pretty clearly from that summary. Take nothing at second hand, apply your eyes to paintings in the same critical fashion in which you use them in daily life, promulgate systematic study of works of art in the original, depend on reason not emotion, and avoid wholly subjective judgments so far as possible. The book rests on two assumptions, the ultimate importance of which Richardson could scarcely have foreseen. First, that connoisseurship has a special significance for collectors, and is therefore indissociable from the purchase and sale of works of art. Second, that the form of judgment it implies can be exercised with reasonable success by nonprofessionals, to whom his volume was addressed. And when, more than a hundred and fifty years later, the subject of connoisseurship again attracted widespread prominence, on a much narrower front, that of Italian painting, under the stimulus of a naturalized Italian, Giovanni Morelli, the postulates remained the same, that collectors (mainly public collectors, though Morelli was also involved, pretty heavily involved, in the art market) required to know who painted the

pictures in their galleries, and that this could be established by intelligible arguments from the exercise of which perceptive, educated people ought not to be debarred.

It is hard in retrospect to feel anything but a bit ambivalent about Morelli. He was a natural polemicist, and when he reached a new result, he stated it in a form which was deliberately designed to cause the greatest possible antagonism. The eddies of the opposition he aroused extend down to today. A northerner—he was educated in Switzerland and Munich, and German was the language of his published works—he was at the same time an Italian patriot. In 1860 he became a Sardinian subject; soon after he joined the Chamber of Deputies in Turin as representative for Bergamo; and between that date and 1873, when he became a senator, he was concerned with aspects of fine art administration.

By 1874, when Morelli published his first book,[2] the historiography of Italian painting had evolved into a study not wholly unrelated to the one we know today. Insofar as credit for that was due to any single man, it was Giovanni Battista Cavalcaselle. A chance encounter in 1847 with an Englishman, J. A. Crowe, led to his involvement in a volume on *The Early Flemish Painters* (which eventually appeared in 1856), and in 1860 he and Crowe met again in Germany and began work on *A New History of Painting in Italy,*[3] which was succeeded in 1871 by a three-volume *History of Painting in North Italy,*[4] which was followed in turn by a great monograph on Titian and five years later by a no less excellent two-volume book on Raphael. Crowe was the synthesizer and historian, Cavalcaselle was the eye. "To see and judge of panels and canvases, and confirm and contest my opinions respecting them," Crowe tells us, "was Cavalcaselle's main share in the history of the Flemish painters." In the Italian volumes Cavalcaselle naturally contributed much more. One has only to look at the notes of the two scholars in the library of the Victoria and Albert Museum to find proof of that. Among them are careful annotations of a visit paid to the Beaumont (later the Allendale) Collection, where they studied the Giorgione *Nativity* which is now in the National Gallery of Art in Washington. There is a thumbnail drawing of the picture, seemingly by Crowe, and also in Crowe's handwriting an attribution to a minor master, which was brusquely struck out by Cavalcaselle and replaced with the name Giorgione. Cavalcaselle was likewise responsible for the astonishingly accurate and vivid color notes (castagno, cioccolato, caffé, and so on), but once the act of connoisseurship was accomplished, it was set in a historical frame, for Crowe saw the development of the artists he described as part of a firmly apprehended cultural scene. That view was common also to another English art historian, J. C. Robinson, who produced in 1862 a catalogue of the Italian sculpture at South Kensington, one of the cornerstones of the modern study of Italian sculpture, and in 1870 published a *Critical Account of the Drawings by Michel Angelo and Raffaello in the University Galleries* (Oxford), the first book in which an artist's drawings were critically sifted and were treated as an index to his creative intentions and artistic personality, the initial step on a long ascent that was eventually to lead to Brauer and Wittkower's great study of the drawings of Bernini.

Morelli, therefore, was concerned with rectification rather than with the groundwork of original research. His first work was written under a pseudonym, Lermolieff, and was published serially, and it is not absolutely certain that it was from the beginning intended as a book. But when the articles, on the Borghese and Doria galleries, were reprinted in a single volume, they proved unexpectedly successful, and in 1877 they were succeeded by a second volume on galleries in Germany.[5] It was directed against four targets: Wilhelm von Bode, the then young luminary of the Kaiser Friedrich Museum in Berlin; the authors of the catalogues of paintings in Dresden and in Munich (they were sitting targets, as a matter of fact); and the luckless Cavalcaselle. And it was preceded by a preface of astounding disingenuousness. "May I also express the hope," wrote Morelli, "that the famous authors of the *New History of Painting in Italy,* should these modest lucubrations meet their eyes, will not blame me for not always sharing their opinions, but will grant me the same freedom in the republic of thought which I do not grudge to them, or to any fellow workers? To bickering and strife I am a declared enemy. Life is too short and time too precious to waste on the weary polemics daily waged by art critics." But the plain fact is that the bickering and strife Morelli cultivated from the first did a good deal to discredit connoisseurship, and that its contagion has extended almost to our own times.

Obviously the credentials of any connoisseur cannot be judged, Beckmesser-fashion, by chalking up a list of his mistakes. It is, after all, extremely odd that Cavalcaselle should have accepted the great *Pietà* of Giovanni Bellini at Rimini as a work by a second-rate Romagnole painter, Zaganelli.[6] "That Messrs. Crowe and Cavalcaselle could so entirely fail to recognize Giambellino," says Morelli, relishing the full enormity of the mistake, "is what I honestly regret, both for their own sake in missing a high artistic treat, and still more for the multitude of their pupils and followers, who are thus led aside from the broad road of art science into a thicket of thorns out of which it will cost them no little time and trouble to extricate themselves." But Morelli's mistakes were pretty odd as well. Witness his ascription to Pinturicchio of the "magnificent drawing washed with Indian ink, of Aeneas Sylvio's setting to the Council of Basel, at the Uffizi Gallery, where it is still ascribed to Raphael by the careless directors of that collection." But people today would agree that the "careless directors" were right and Morelli was wrong. Or his encounter with two little *Scenes from the Life of the Virgin* by Giovanni di Paolo in the Doria Collection. A colleague, "the late Mr. Mündler," had given them to Pisanello. But Morelli, as always, knew better. "These two pictures, if I am not greatly mistaken, belong to the school of Siena and are probably by Bartolo di Maestro Fredi." To the school of Siena, yes, but the late Mr. Mündler, however aberrant his attribution, had at least recognized that from costume alone the panels must date in the 1420s or 1430s and could not possibly have been produced half a century before. Witness too that not very distinguished female portrait in the Borghese Gallery—it seems to have been painted by Licinio—of which Morelli writes:

"One day, as I stood before this mysterious portrait, entranced and questioning, the spirit of the master met mine, and the truth flashed upon me. 'Giorgione, it is thou,' I cried in my excitement; and the picture answered, 'Yes, it is I.'" Mendaciously, of course.[7]

Throughout Morelli's work judgments which are reputedly objective and judgments which can only be subjective are found side by side. As a journalist he was addicted to the time-honored technique of the imaginary conversation, and his single serious statement on method, at the beginning of the book on the Borghese Gallery, is cast in dialogue form, the "I" being an unregenerate listener, whom I shall call Lermolieff, and the expounder of the method "an elderly gentleman, apparently an Italian of the better class." The conversation starts off with a distinction between connoisseurship and art history. The only "sure and solid foundation" on which knowledge of art can rest, affirms the upper-class gentleman, is study of works of art in great detail in the original. "But, my dear sir," interjects Lermolieff, "the elaborate and tedious course of study, which you appear to think incumbent on an art historian, would end by turning him into a mere connoisseur, and would leave him no time for studying the history of art itself." And this elicits the triumphant rejoinder, "True enough, your art historian will gradually disappear (no great loss either, you will admit), and in due course of time, as the larva develops into the butterfly, the connoisseur will emerge from his chrysalis state." "Every great artist," he adds, "sees and represents forms in his own distinctive manner, but most persons, and pre-eminently art historians and art philosophers, do not see these various forms at all. It is their wont to look at a picture as if it were a mirror, in which, as a rule, they see nothing but the reflection of their own minds." Slowly Lermolieff is persuaded by the Italian "that the work of art itself is after all the only trustworthy evidence for purposes of identification." On the following day he and the gentlemanly Italian meet in the Uffizi. They look at a little painting by Botticelli which was then wrongly ascribed to Fra Filippo Lippi (noting especially the fingers, "not beautiful but always full of life," the nails, "square with black outlines," and the "short nose with dilated nostrils"), and then move on to the works of Raphael, which are accepted or dismissed on broadly the same principles. There is a muddle (or to my way of thinking a muddle) over the *Vision of Ezekiel* ("the ears of the angels, and especially their thick upper lips" convince the Italian that it is by Giulio Romano), and in front of the *Donna Velata* a row breaks out, in which the Italian routs a compatriot who considers it a Bolognese copy of a lost Raphael. The two companions part, and when years later Morelli returns to Florence, he is told that his interlocutor has been expelled because he was a dangerous anarchist.

Now two attitudes can be adopted to all this. One—the view adopted by the most recent commentator on Morelli, Richard Wollheim[8]—is that Morelli advocated a quasi-scientific technique of connoisseurship. Admittedly in Morelli's two books we do come across strange little drawings of malformations of hands by Titian (where "the base of the thumb in his

men's hands is abnormally developed, somewhat as I reproduce it here"), or ears by Botticelli and Lippi and Tura. But there is no evidence from anything he published that he actually saw salvation along those lines. Indeed Professor Wollheim seems to me to be conducting a dialogue with Morelli which is not unlike the imaginary dialogues in Morelli's own books. After all, about this time, one of Morelli's disciples, Jean Paul Richter, was busy in England, going round private collections and drawing deductions from ears and nostrils and fingernails, which could have left Morelli in no doubt at all that the method, whatever its advantages, was not infallible. Probably Max Friedländer was right in thinking that Morelli's intention was mainly dialectical. The alternative view is that Morelli's faith was pinned to something less explicit, to detailed morphological examination of works of art in the original, and that he is important because he insisted on close physical analysis of paintings, because he believed that antecedent judgments must without exception be questioned, and because he gave visual observation primacy over tradition and documentary evidence. When two generations later that great scholar Richard Offner affirmed, as he so often did: "If a document fails to agree with what I see with my own eyes, then the document is wrong," he was speaking, in a much more authoritative fashion, with Morelli's voice. The objection to Morelli's method was a simple one, that it seemed to many of his contemporaries, not just to Bode (who proclaimed in the *Quarterly Review* that his work "impeded the progress of art history") but to other scholars as well, to open the way to a form of art history from which the history was excised.

One wonders indeed how Morelli would be regarded today, had he not inspired one disciple, of conspicuously much greater intellectual command, who stabilized the whole concept of connoisseurship. Bernard Berenson read Morelli's work at Harvard; and in Venice, in the summer of 1889, he met Richter, who in turn gave him a card of introduction to Morelli.[9] In January 1890 he arrived in Milan armed with the gift of the North-brook catalogue. Morelli formed a good impression of him (he seemed to be "ein ausserordentlich lernbegieriger junge Mann"), took him round his pictures, and passed him on to Gustavo Frizzoni to test out in the Museo Poldi-Pezzoli. Was he, Morelli asked, as good as he appeared to be at analyzing paintings? In the middle of May, Berenson visited Morelli again, traveling up on the night train from Ancona where he had been immersed in Lotto. He was, as Richter said, "ein gute Lermolieffaner," and at the same time in the early 1890s, though it was not printed till 1902, he wrote an essay on the "Rudiments of Connoisseurship."[10] The essay is always discussed as though it were strictly Morellian, but it is Morellian with a material difference.

Berenson begins with documents. Whereas in history the primacy of the document is total, in art history documents are ancillary: "the document helps to establish proof, but the proof is only complete when confirmed by connoisseurship." All that remains of an event in general history is the account of it in document or tradition; but in art the work of

16

art itself is the event, and the only adequate source of information about the event. Before long we are in an area of heightened rationality, which marks a significant advance on Morelli's primitive morphological analysis. "Excellent a test of authenticity as the ear is, its application is by no means easy, nor as proof is it absolutely coercive." "Rather than ask, 'Is this Leonardo's ear or hand?' we should ask, 'Is this the ear or hand Leonardo, with his habits of visualisation and execution, would have painted?'" And at what point do these tests justify a direct attribution? If, replies Berenson, he be "a master with a distinct quality, we can scarcely be justified in identifying a picture unless we find in it practically all the characteristics of one period of his career. If the author on the other hand has no distinct quality of his own, we may be satisfied with comparatively few tests. . . . The value of those tests which come nearest to being mechanical is inversely as the greatness of the artist. The greater the artist, the more weight falls on the question of quality in the consideration of a work attributed to him." I do not want to interpolate anything contentious at this point, but debility in qualitative judgment is, of course, the reason why certain connoisseurs, operating on crypto-Berensonian lines, produce infallible results on painters whose work falls short of the first rank, but are untrustworthy on major artists.

Perhaps it is best to think of Berenson's essay not as a restatement of Morellian method, but as a redefinition of what particularized study of pictures means. Its importance lies in the results that it produced. Where the most extended of Morelli's accounts of artistic personalities covers four or five pages, Berenson, in his *Lorenzo Lotto*, achieved a whole Morellian monograph. Where Morelli gave no more than spasmodic attention to drawings (in a few scrappy notes on German print rooms), Berenson produced, in *The Drawings of the Florentine Painters*, the masterpiece of graphic connoisseurship, a survey of the hinterland style. Where Morelli supplied no more than embryonic lists of the works known to him by certain artists, Berenson, in the publications which later became the *Italian Pictures of the Renaissance*, defined, as he saw it, the character and the activity of every major Italian painter from the fourteenth century down to the sixteenth. He carried much greater intellectual ballast than Morelli—the cast of his mind was philosophical (there are passages in the *Lotto* which recall William James), and his concern was with the abstract value judgments from which specific qualitative judgments must in the last resort depend.

The technique of which Berenson disposed is illustrated in the three volumes of *The Study and Criticism of Italian Art*.[11] I can still remember, when I received them as a prize at school, the sense of intellectual excitement they communicated. There was that splendid article on the Amico di Sandro; it is discounted nowadays simply because the painter proved by and large to be no more than an early phase of Filippino Lippi (and because his catalogue unaccountably included one or two genuine works by Botticelli as well), but it seemed, and still seems, a brilliant analysis. There was the famous article on the exhibition of Venetian art at the New Gallery in 1895, where Berenson performed for pictures in English collec-

tions the same task that Morelli undertook in the Berlin and Munich and Dresden galleries. Particularly striking was what one would now think of as the anti-Morellian account of the *Shepherd Boy* by or after Giorgione at Hampton Court: "What then is the fatal flaw in this picture? Alas, it is the hand holding the flute, which as it happens, is not at all unlike Giorgione's hand—*he,* by the way, has a number of characteristic hands—but which is unfortunately, in the opinion of some critics, more like Palma's hand, and in the opinion of others more like Pordenone's. Therefore, despite the diametrical opposition in every other morphological detail, and, above all, in spirit, between this head and every other authenticated work by either Palma or Pordenone, the fatal hand condemns it to be the work of one or the other of these inferior painters."

In the second volume the section on the Raphael cartoon in the British Museum seemed rather wayward (Berenson gives it to a Sienese painter, Brescianino), but it was compensated by a really admirable article on Masolino. There was the article on the Caen *Sposalizio* of Perugino:[12] "When I went to Caen I had not a shadow of a doubt that I was going to see, not only one of Perugino's best pictures, but certainly a picture painted by him between the month of November 1500 and the year 1504, in the course of which Raphael painted his admirable so-called imitation. Imagine my astonishment when, at the first glance, the Caen picture presented me with a combination of vivid colours, the like of which I could not possibly recall in a single other work by Perugino." So far so good; nobody today would claim that the picture was actually painted by Perugino. But instead of leaving well alone, Berenson goes on to claim it as a later adaptation by Lo Spagna, of the Raphael *Sposalizio* in Milan. The balloon burst after a few months, when it was shown from documents that the altarpiece really was commissioned from Perugino and that the dating previously proposed for it was perfectly correct. If Berenson, after he had been to Caen, had spent a week in the archive at Perugia, the confusion would never have occurred. This was a valid observation pressed just a shade beyond the limits of historicity.

As for the third volume, it was dominated by Venice; it contained the beautiful study of the Carità triptychs of Giovanni Bellini, two articles on Antonello da Messina, and most instructive of all, the essay explaining that the *Santa Giustina* in the Bagatti-Valsecchi Collection was by Giovanni Bellini, not, as Morelli had supposed, Alvise Vivarini. It was written in 1912, and it presents connoisseurship as a process of self-education. The old attribution, says Berenson, was taken over "from my revered master Morelli. Then a long time passed without my seeing it again, at least with active and not merely passive eyes. But finally, a few years ago, I looked once more, and saw that it was by Giovanni Bellini. Morelli's error was excusable, for in his day artistic personalities had outlines that seem very nebulous when compared with the definiteness we have been able to give them since, and much then seemed to be probable that we now know to be impossible." What was contagious in the three volumes was the conjunction of ocular analysis and sheer cleverness;

18

yet all the articles were honest-minded in the sense that the catena of argument presented in them was invariably that through which the conclusion had been reached. And that impression was fortified a year or two later by one of the very best of Berenson's books, *Venetian Painting in America,* which is remarkable not simply because it presents a comprehensive view of the connoisseurship of Venetian painting, but because, more than any previous book about Italian art, it defines degrees of doubt.

In art history "honest-mindedness," in the sense in which I use it here, is not a universal attribute. In 1913 a young Italian of exceptional gifts translated four of Berenson's essays. The translations were never published—Berenson said that they misrepresented his thought—and from that inauspicious start there grew forty years of misunderstanding and antipathy between him and the greatest Italian connoisseur of the generation following his own, Roberto Longhi. If I were speaking simply about art history, I should be bound to say that Longhi's *Piero della Francesca* (which appeared in a poor English version in 1930) was one of the subtlest and most brilliant monographs to have been written about any Renaissance artist. Part of its fascination was, and is, its claim as literature. Steeped in Laforgue and Mallarmé, Longhi possessed the gift of transposing paintings into superlatively well-judged writing, of creating works of art from works of art. But as a connoisseur his position is less secure. He regrouped and reattributed a vast number of paintings, often with abnormal perspicacity. But where Berenson represented art history as reason, Longhi adopted the role of a prestidigitator, or magician. Common sense assured one that his results could only have been reached by the prosaic process of confrontation and comparison that other connoisseurs employed, but when the result was published it was presented as an act of intuition, a sort of visual water divining. That did not, of course, invalidate the results. A very high proportion of them were correct and, like all right findings, spoke for themselves. But the consequences, for students who took his work at its face value, were disastrous. If Longhi, with his computerized memory, his wide range, his overopen open-mindedness, could achieve results in this way, so could his followers; but what was imitated was the form in which his conclusions were presented, not the covert method by which they had actually been reached. To put the matter at its crudest, attribution is or should be a slow process (the attributions in Longhi's *Fatti di Masolino e di Masaccio* were years in gestation), and Longhi fallaciously made it appear an instantaneous one. There was a second difficulty too. It would be absurd to claim that Longhi was impercipient of quality, but his qualitative judgments were made ad hoc. One of the only things of which an art historian can be absolutely confident is that whatever he may say of any work of art, the work of art remains the same. But for Longhi works of art were mutable. Inflated or deflated, their whole nature was presumed to undergo a change when they found themselves afloat on the surface of his prose. This, too, proved an insidious myth that led inevitably to the principle of the *ballon d'essai*—the attribution of which the proponent is

not himself convinced and which he cannot prove, but which seems to be worth floating on the chance that it may have the luck to be included in the footnotes of other people's books and to be taken, here or there, a trifle more seriously than it deserves.

Longhi would have accepted the Berensonian thesis that the results of connoisseurship were, in large part, provisional. But one feels a natural impatience with provisional results, and before the Second World War there was one scholar who believed that in the field of connoisseurship the truth (real truth, not relative truth) could be attained. That was Richard Offner, who in 1927 appended to a volume of essays on trecento painting "An Outline of a Theory of Method."[13] The first prerequisite was specialization. "Following a period of pioneering," he writes, "in which the student extended himself over the various schools in all the length of their evolution, comes the present, wherein the field is beginning to contract both chronologically and territorially." "The older generation of critics" (this must have meant Berenson) worked "with a large field before them," and as a result "the pictures bearing the stamp of a known style were by common habit labelled with a name best known of those who painted in it." By contrast with this "genteel transcendentalism" (not, I think, a very complimentary term), "the ideal, more detached, specialised modern historian of art is scrupulously bent on according every painter his proper character and proper place...leaving appraisal to another occasion." What is remarkable about this ungainly article is its fundamentalism and its unmitigated seriousness. Certainly no scholar I have ever known engaged as intensely as he with individual works of art. As a connoisseur, his eye was superior to any other I have known, especially when he was differentiating between works of art (Emilian cinquecento paintings or bronze statuettes) which would normally be thought outside his competence, and though he did with superhuman concentration clarify a great part of Florentine trecento painting, one wonders whether his influence might not have been more fertile and far-reaching had he acknowledged frankly that the results that he secured were less than absolute, and had he focused less exclusively on one comparatively narrow front.

Only at one point in Offner's essay would I demur. "I seriously believe," he writes, "that the art historian has this in common with the better part of thinking humanity, that he knows by a sort of Kantian intuition when he is right, or at least when the general tendency of his conclusion is." I cannot speak for thinking humanity, but it is manifestly possible for efficient specialists honestly to think that they are right and to be wrong. When cases are argued more urgently and in much greater detail than they deserve, one can sometimes infer the action of inner doubt. If a mistake has once been made, one looks to see why it occurred. I did that when I realized that the miniatures in the Yates-Thompson Dante Codex in the British Library after all were not by the Sienese painter Vecchietta[14] (though they are indeed much closer to Vecchietta than to the artist to whom they have since been

reattributed),[15] and I imagine that that much more substantial art historian Millard Meiss, after he had mistakenly ascribed some book illuminations to Mantegna,[16] must have done precisely the same thing. Human beings have a vast capacity for self-deception, and I doubt whether, in this comparatively narrow focus, an appeal to Kantian intuition is much use.

But why does attribution matter quite so much? For the very good reason that unless an artistic personality is rightly reconstructed, the paintings he produced cannot be properly interpreted or understood. It is, of course, the greatest artists who present the greatest problems, and the responsibility of adding to or of subtracting from the list of works ascribed to them is very grave. Inevitably it will affect our view of the intentions of the artist, of his capacity, of his historical importance, and of his development. May I take just one obvious example? When I first started working on Italian painting, forty-five or more years ago, Masaccio was a different painter from the painter we know today. In the monographs on him on which one was brought up, the first plate showed a fresco at Montemarciano of the Virgin and Child with two saints (fig. 1). It had got into the Masaccio catalogue by the back door, in a guidebook as a matter of fact,[17] and it was then accepted successively by August Schmarsow (who was blind anyway; any Masolino was a Masaccio to him), and following Schmarsow by all the canonical writers on Florentine painting. It was supposed to date from the very start of Masaccio's career, about 1422. And though a few people did say, under their breaths, that it was a rather disappointing work, much weaker than Masaccio's paintings of two or three years later would lead one to expect, their views at first cut no ice at all. But gradually skepticism grew, and books on Masaccio started to appear which relegated this wretched work to an appendix or even left it out. How right they were, for when, in 1961, a real early painting by Masaccio was discovered, an altarpiece at Cascia, not signed but dated 1422, the correctness of the attribution was self-evident.[18] In its tactility and, more important, in its structure, the new painting linked up directly with the earliest authentic work planned by Masaccio that was then known, the *Virgin and Child with Saint Anne* in the Uffizi (fig. 2). There were a few skeptics, naturally, but the painting has won through.

In the last thirty years, our knowledge of Masaccio has changed in other ways as well. The *Virgin and Child with Saint Anne* was itself cleaned, and it became abundantly apparent (as Roberto Longhi indeed had guessed)[19] that though Masaccio designed it, it was executed in part by Masolino, and that the parts ascribable to the two artists could be quite clearly differentiated. The head of the Virgin, for example, was painted by Masaccio and the angel to the left was painted by Masolino. And yet another discovery occurred: the two wings of the Colonna altarpiece from Santa Maria Maggiore in Rome, which are now in the National Gallery in London. They, too, were executed by Masaccio and Masolino working

side by side, and they enabled the late style of Masaccio (the style that he developed in the ten or twelve months he spent in Rome before his death in 1428) to be pinpointed for the first time.

The fresco at Montemarciano is not the only work which is omitted from most Masaccio catalogues. Another is the *Madonna of Humility* in the National Gallery of Art in Washington (fig. 3). It appeared, not exactly from nowhere but from nowhere of consequence, in 1929, and though it was much damaged and heavily repainted, it seemed to Berenson, who published it in *Dedalo*,[20] to be a work by Masaccio of the mid-1420s. There was no argument; the article assumed what it should properly have proved. "It is not," says Berenson, "worth the trouble of demonstrating what is self-evident." The picture went into orbit, and it remained in orbit for twenty years, till writers on Masaccio, in the familiar fashion, started to omit it from their monographs.[21] When you asked students of Early Renaissance painting what they thought about it, they would just shake their heads. Till the other day, I would have done so too. The only convincing thing about it was its gross unorthodoxy. But suddenly I came upon some photographs of it made in 1930 when it was being cleaned (fig. 4). They showed parts of it in its stripped state, after the first repainting was removed and before the second was applied. One of them shows the left-hand angel (fig. 5), and I think that no one who examines this and the right-hand angel (fig. 6) freed of repaint will have any doubt at all that these tough, resolute little figures were executed by the artist who painted the parts of the *Virgin and Child with Saint Anne* which are now universally given to Masaccio. Still more convincing are the heads of the Virgin and Child (fig. 7). They look rather depressing in their repainted state, of course, but they prove to have been built up in areas of light and shade in a way of which only Masaccio at that time was capable. They are indeed directly comparable to the Virgin in the Uffizi painting. The predatory dove flies and does not float. In the more problematical lower part, the protruding knees and the strong diagonals of the lower legs recall the angels in the foreground of the Pisa *Madonna* in London. They confirm that this *Madonna of Humility* was in its time, that is about 1425, an innovation of great consequence, and is the source of what would otherwise be an inexplicable work, the *Madonna of Humility* in Siena, painted five years after Masaccio's death, in 1433, by Domenico di Bartolo, who had himself worked for the Carmine in Florence.

In the field of attribution, rejection and acceptance are two sides of the same coin. There is a tendency for art historians, especially in youth, to construct from authenticated works an ideal image of an artist, and to free it of all those works which seem not to conform. Philosophically there may be something to be said for distilling the essence of an artistic personality. But the validity of the whole process is debatable. And it is this (and not self-interest or venality) that leads so many art historians to retreat from a position that is exclusive and narrow to one that represents a kind of qualified expansionism. The classic

22

1. FRANCESCO DI ANTONIO.
*Madonna and Child with Saints John
and Michael.* Fresco. Madonna delle
Grazie, Montemarciano

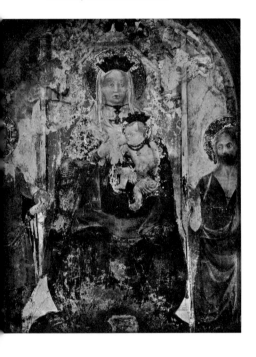

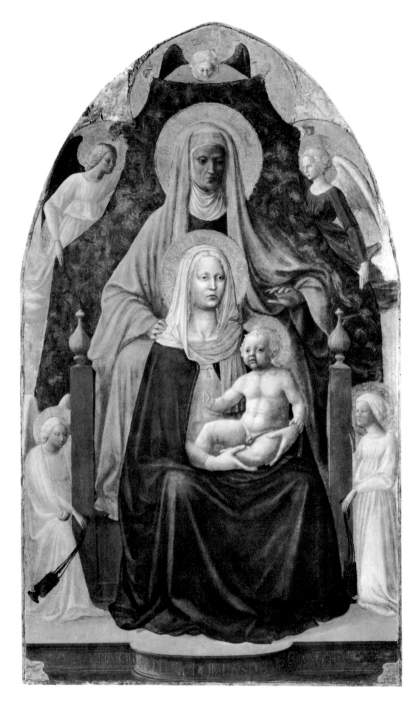

2. MASACCIO AND MASOLINO.
Virgin and Child with Saint Anne.
c. 1424. Tempera on panel, 175 x
103 cm. Uffizi Gallery, Florence

3.
MASACCIO.
Madonna of Humility.
c. 1425. Tempera on panel,
102 x 52 cm.
National Gallery of Art,
Washington, D.C.
Andrew W. Mellon Collection

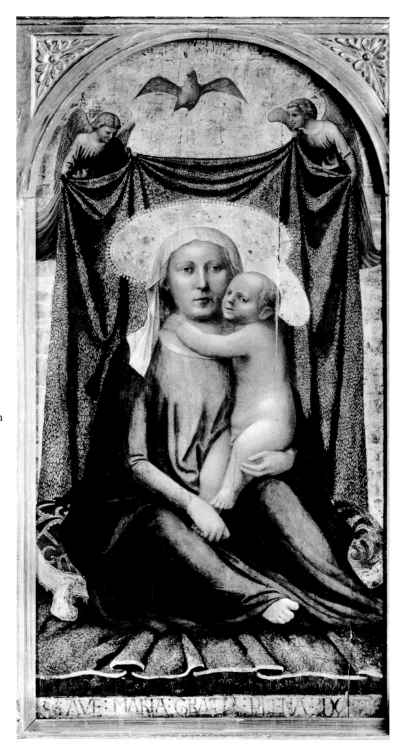

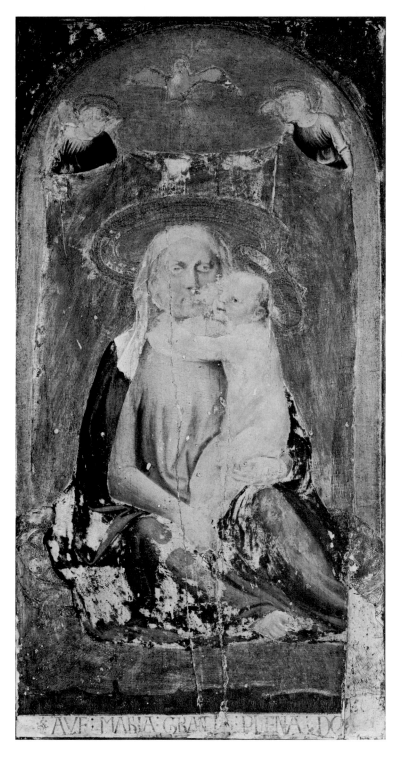

4.
MASACCIO.
Madonna of Humility,
cleaned state

5.
MASACCIO. Angel on left side of Virgin and Child, detail of fig. 4

OPPOSITE PAGE:

6.
MASACCIO. Angel on right side of Virgin and Child, detail of fig. 4

7.
MASACCIO.
Heads of Virgin and Child, detail of fig. 4

case is that of Berenson, whose initial lists were comparatively short—there was historical necessity at the time that they were published for them to be so—and were revised in 1932, and 1936, and after 1957 as long inclusive lists in which the criteria were or appeared to be less exigent. When I myself wrote on Fra Angelico,[22] I believed there was, above all, an obligation to eliminate—how otherwise could the artist's stature be properly defined?—and some of the work I did has been corroborated. For example, I drastically reduced the number of cell frescoes at San Marco for which Angelico was personally responsible. The frescoes have now been cleaned, and only last summer I was gratified to see that the division I established between autograph frescoes and frescoes by pupils was incontrovertibly correct and that the differences between them were much more marked than they had been before. But I also excluded, as I think now, a number of absolutely genuine works. Luckily there was an opportunity to make amends.[23] When art historians do not do this for themselves, posterity is liable to do it for them. One may prefer to believe that the "only complete work actually painted by Orcagna himself" is the Strozzi altarpiece,[24] but the fact is that the Orcagna we know now, credited with a number of not absolutely first-rate paintings, is historically the more convincing figure of the two. It is salutary to imagine what a well-trained connoisseur of Italian painting would make of Renoir if there were no signed paintings and no documents. One can envisage it quite well, a little nucleus of masterpieces, plus a penumbra of shop paintings, plus a whole series of minor painters—Fucecchio Masters, I mean—responsible for facets of the total work.

Let us make no mistake about it, the balance is extremely delicate. Very few paintings—certainly very few Renaissance paintings—stand alone, and almost always the act of acceptance or rejection applies not simply to the picture before one's eyes but to a number of other related paintings, which will stand or fall by one's judgment on this single work. Shakespeare says that "sorrows come not single spies, but in battalions," and misattributions, whether positive or negative, do precisely the same thing.

Paradoxically, the significance of connoisseurship transpires most clearly from areas to which it was applied belatedly or was not applied at all. One of them is the study of Renaissance sculpture. In 1907, when Maud Cruttwell's volume on the Pollaiuoli appeared, Bode attacked it in the *Burlington Magazine*[25] for its Morellian or Berensonian tendencies, adding, with what reads as a sigh of relief, "the Morelli school ignored plastic art." And so it did, for the early study of Italian sculpture was prosecuted principally in Berlin by Bode and his disciples. He was anything but a negligible art historian, but he had a positive aversion to rational analysis. In the 1902 German edition of his celebrated *Italian Sculptors of the Renaissance* there is a section devoted to the Madonna reliefs by Donatello; it reproduced twenty-three reliefs, and they are by eleven different hands.[26] When one comes to think of it, this is a very peculiar phenomenon. A large number of documented Donatellos, after all, were known, but never did Bode take the elementary step of checking the Madonna

reliefs ascribed to Donatello against the works for which Donatello could be shown to be responsible.

It must be said at once that the connoisseurship of Italian sculpture presents far greater difficulties than the connoisseurship of Italian painting. Most of them arise simply from the fact that sculpture has a third dimension. It presents the problem of actual, not notional tactility. From the 1880s on, valid results could be obtained with paintings by comparing one flat photographic image with another. But if sculptures are looked at as though they were in two dimensions, the results will almost inescapably be wrong. Not only is a knowledge of their physical properties essential, but it is vital to understand the creative act through which they were produced. The early students of Italian painting, whatever their shortcomings, would never have misdated pictures by a whole century. Yet with sculpture that frequently occurred. In the Bargello, beside the bronze *David* of Donatello, stand two other sculptures ascribed to him, a marble Baptist (the Martelli Baptist), carved about 1460 by Desiderio, and a second marble Baptist, carved shortly before 1530 by Francesco da Sangallo; both, as I say, are given to Donatello. And the putative works of Michelangelo have included a Hellenistic statue, and statues by much later sculptors, like Domenico Pieratti, and a seventeenth-century Roman group, the Palestrina Pietà. Even today, if you go to the Casa Buonarotti in Florence, you will find that Michelangelo's name has been attached to a female figure by Vincenzo Danti, and a so-called Slave by heaven knows whom.[27] You might infer from this that sculptures are especially deceiving, and that in my experience would be correct. They must be apprehended slowly (always in the original, since photographs are almost invariably misleading), and there are no shortcuts. Without an understanding of the artist's mind, as it is revealed in the totality of his surviving works, and of his working procedure and technique—the way in which he made his models and approached the marble block—useful attributions cannot be made. And the difficulty of the study is reflected in the fact that, whereas the connoisseurship of Italian painting was developed in the last quarter of the nineteenth century and reached maturity in 1914, the very first occasion when the principles of style analysis were applied to Italian sculpture was in 1935. The instrument of change was a Hungarian, Jenö Lányi. Inevitably, Lányi made mistakes—he was active as a scholar only for six or seven years—but his hits were more important than his misses, and as Morelli had done sixty-five years before, he opened up the study by proving how vulnerable to rational analysis many of its sacrosanct assumptions were. His significance cannot be measured in terms of his results. He returned to the Morellian principle that every attribution must be questioned and each artistic personality defined.

A good deal of progress has been made since then, but many problems which seem prima facie to be soluble are still unsolved. Problems like that presented by the bronze *Baptist* ascribed to Donatello, formerly in Berlin, which disappeared after the Second World War

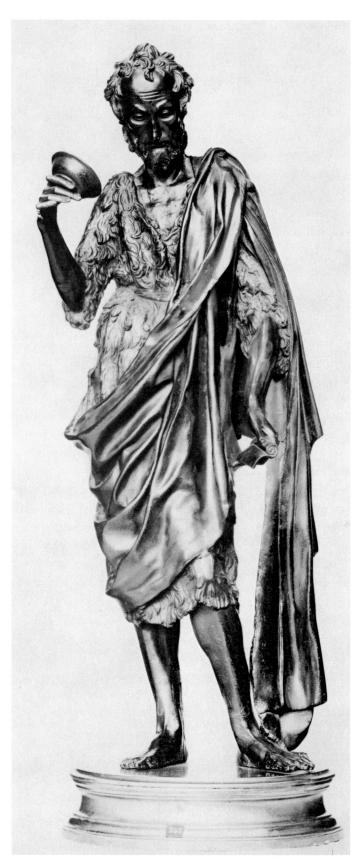

8.
ANTONIO DEL POLLAIUOLO (?).
Saint John the Baptist.
Bronze, height 84 cm.
Formerly Kaiser Friedrich Museum,
Berlin

9.
ANDREA DEL VERROCCHIO (?).
Francesco Sassetti, 1464–65. Marble.
Museo Nazionale del Bargello,
Florence

10.
ANDREA DEL VERROCCHIO (?).
Francesco Sassetti,
side view of fig. 9

(fig. 8). It was quite large (eighty-four centimeters high) and was a work of extraordinary individuality and power. Bode, obsessed like so many historically minded people with literary evidence, reached for the nearest document, linking it to a commission to Donatello of 1423 for a gilt-bronze Baptist for Orvieto, and as late as 1935 this explanation of it was still entertained as a serious possibility. But in the latest Donatello monograph, it was very properly denied to Donatello and given a considerably later date.[28] I never studied it in the original, but some reasonably accurate modern bronze casts were made from it, one on the font at Barga in the Garfagnana, and another in Florence, in the Ognissanti.[29] They tell one nothing, naturally, about the facture of the bronze original, but when I last looked at them it seemed to me, from the way in which the lost bronze was constructed (it has three supports, the two feet and the cloak resting on the ground behind), that the original must have been by Antonio Pollaiuolo, who habitually constructed his small bronzes in this rather eccentric way. I believe that the attribution can be confirmed from the modeling of the arms and the attenuated, rather mannered forefingers, which have parallels in the reliefs of *Theology* and *Dialectic* on the Sixtus IV tomb; from the treatment of the temples, which are shown as indented planes receding sharply from the forehead in a way that recalls the treatment of the shoulders and shoulder blades of the *Hercules* in the Bargello; and from the heavy drapery which falls free of the spare, ascetic limbs in a way that cannot but remind us of the cloak of Hercules in the *Hercules and Antaeus* bronze. Pollaiuolo's authorship of this beautiful and moving work could, I believe, be demonstrated without difficulty, if the original survived.

I will take one more example, a work which is very widely known, the marble bust of *Francesco Sassetti* in the Bargello (figs. 9, 10).[30] The authenticity of the Sassetti bust had

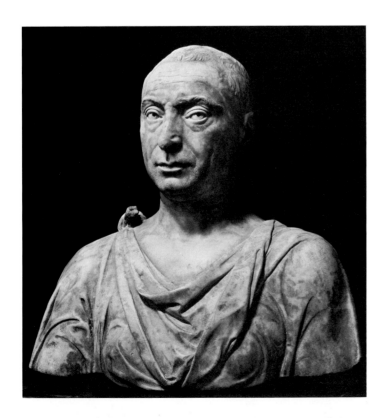

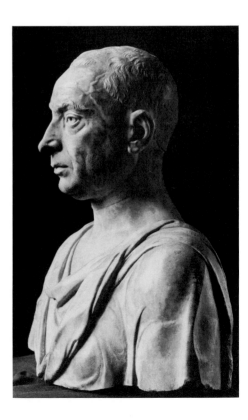

been unquestioned until, in 1972, a graduate student in a dissertation which, surprisingly, was printed as a work of exceptional merit,[31] listed the bust in an appendix of "Possible Fakes." Her reasons for doing so were that the bust "does not have the smooth, almost silky polish which is so characteristic of Rossellino," that the pupils of the eyes "are indicated by deep holes," and that the figure "seems to have female breasts protruding from under his toga, as if the artist derived the torso from a draped classical portrait of a woman." "The work," this strange analysis concluded, "is a pastiche of several artists' styles. The work should be tested." So indeed it should, though there is in practice no physical test that can be applied to marble busts.

Not only do we know who is represented in this bust, but we know when it was made. Inside it is an inscription in characteristic humanist epigraphy: FRANC. SAXETTVS. FLORENT. CIVIS ANN. XLIII. The bust was therefore carved in Sassetti's forty-fourth year, and since he was born on March 9, 1421 (old style 1420), it must have been carved between March 1464 and March 1465, precisely at the moment when, with the accession of Piero de' Medici, Sassetti became the most powerful financier in Florence.[32] Even without the inscription we might guess that Sassetti was portrayed, since the features correspond closely with those of the painted profile portrait by Ghirlandaio in the Sassetti Chapel in Santa Trinita, which is dated 1485. The inscription tells us more than the plain fact of when the bust was made. It tells us where it belongs in the remarkable twenty-year period which witnessed the development of the Florentine portrait bust. The sequence is bounded at one end by Mino da Fiesole's bust of Piero de' Medici of 1453 and at the other by Benedetto da Maiano's bust of Pietro Mellini in 1474. Historically the Sassetti portrait forms a middle term between two great busts by Antonio Rossellino, the portrait of Giovanni Chellini of 1456 in London (fig. 11) and the portrait of Matteo Palmieri of 1468 in the Bargello. But we have only to compare it with the Rossellino busts to see that though it was at one time labeled as a work of Rossellino, a different mind is palpably at work. The objective, to provide a meticulously accurate representation of the features in their full singularity, is the same, but the means by which the objective is attained are altogether different. If we compare it with the Chellini bust, we find that the transitions in the planes of the face are more abrupt, the mouth is fleshier and more physical, the recession from the eyebrow to the eyelid and the eye is treated more emphatically, the eyebrows are carved with bold cursive strokes, of a type that is never found in the work of Rossellino, and the pupils of the eyes (like the pupils in the eyes of Mino's busts) are drilled. The chin and upper lip are covered with realistic stubble, indicated with tiny chisel strokes that remind one how ill-shaved men of the fifteenth century habitually were.

The bodies in Antonio Rossellino's busts are invariably centralized—the collar, in other words, falls over the center of the base—and traces of this practice appear in the Sassetti bust, where the center of the base is marked by a decisive fold. But the neck is exposed, as

32

11. Antonio Rossellino. *Giovanni Chellini*. 1456. Marble, height 51.1 cm.
Victoria and Albert Museum, London

it is in Roman busts, and is not concealed by the close-fitting collar of the tunics that are
worn by Chellini and Palmieri, while the cloak, tied with a knot on the right shoulder, is
classical and does not correspond with any form of dress worn in the fifteenth century.
What is remarkable about the drapery is first of all its weight—clearly the heavy folds of
the cloak across the chest are the work of a sculptor with an obsessive, almost abstract
interest in drapery forms—and second, the overpowering sense of a body underneath. It is
not that the figure is shown with "female breasts," but that the powerful shoulders and
heavy chest impress themselves upon us decisively as a rendering of the physical impression
made by Sassetti at this time. "If Sassetti had been an athlete," says the writer of the thesis,

12. Andrea del Verrocchio and Assistants. *Death of Francesca Tornabuoni*, detail. 1478–79. Marble. Museo Nazionale del Bargello, Florence

"then there would be some logical explanation for those over-developed chest muscles, but he is known to have been a banker." Banker or not, the sculptor assures us that this is how Sassetti looked. Perhaps he took up jogging when he was in France.

How then is the style of this remarkable bust to be explained? There is one work with which it has obvious affinities, and which is indeed shown in the same room in the Bargello. This is the relief of the *Death of Francesca Tornabuoni*. The relief is later than the bust; it records Francesca Tornabuoni's death in childbirth on September 23, 1477, and is likely therefore to date from 1478.[33] It derives, as Schottmüller demonstrated,[34] from a Roman relief of the Death of Alcestis, and was commissioned as part of a projected monument. The relief is based on a model by Verrocchio, and is by two hands, one that of an assistant, responsible for the left half, and the other that of Verrocchio (fig. 12). As soon as we look at the figure of a distraught woman on the extreme right, we come, in the carving of the drapery round the breasts and across the stomach, on a close parallel for the drapery forms across the chest of the Sassetti bust. Neither Sassetti nor Giovanni Torna-buoni was a humanist in the true sense, but it seems that the Sassetti bust represents the first stage in an experiment in the rendering of life *sub specie antiquitatis* that continues in the *Death of Francesca Tornabuoni* and reaches a climax in Giuliano da Sangallo's frieze on the Sassetti monument. Are we concerned here with analogy or with identity of authorship?

34

We know extremely little about Verrocchio's origins, and study of them has been bedeviled by the emphasis of Müntz "sur la lenteur du développement de Verrocchio, sur la difficulté avec laquelle ce maître s'émancipa."[35] Seen in the broad context of quattrocento style, Verrocchio's mind seems so original and his personality so powerful that we necessarily have some difficulty in believing that he got off to quite so slow a start as Müntz supposed. There is no earlier work that is obviously by the same hand as the Sassetti bust, and we must therefore infer that we are dealing with a young sculptor who held personal convictions both about style and portraiture that led him to break with the formula employed by Rossellino in the Chellini bust. If there are no earlier, then what later works did he produce? Let us start with the drapery forms. The heavy fold of the hood in the center of the bust must remind us of the winding sheet of Christ in the Careggi *Resurrection* of Verrocchio, where the same form is again employed. The turbulent, conflicting currents of the drapery recall Verrocchio as well, this time the *Madonna* from Santa Maria Nuova in the Bargello. Both these works are considerably later than the bust, but we know one figure by Verrocchio that seems to have been commissioned about 1465, and that is the bronze *Christ* on Or San Michele, where the treatment of the torso, with its strong shoulders and firmly modeled breasts, is astonishingly similar. Once more the drapery forms seem to proceed from the same mind as those in the Sassetti bust. There is, moreover, one marble bust that is universally accepted as Verrocchio's, the *Lady with the Primroses* in the Bargello, which is not exactly datable, but was probably carved about 1475, a decade after the bust of *Francesco Sassetti*. Here the dress, of transparent lawn not heavy cambric, is drawn round the breasts in rather the same fashion, and the folds on the sleeves are pulled towards the body in rather the same way. In Verrocchio's only earlier female bust, the *Portrait of a Lady* in the Frick Collection, on loan to the Princeton Art Museum, the reference to an antique model and the careful naturalistic carving of the eyebrows once more offer suggestive parallels for the Sassetti bust. Finally the eyes of the Sassetti portrait, with their heavily drilled irises and lightly incised pupils, are fully characteristic of Verrocchio. They recur in bronze in the *David*, and the *Putto with a Fish*, and the *Christ* on Or San Michele, and are used to vivid effect at the end of Verrocchio's career in the penetrating glance of *Bartolommeo Colleoni*. So the a priori case for regarding the Sassetti bust as an early work by Verrocchio is very strong. Verrocchio, after all, was already a Medicean artist, and Sassetti's affiliations were unambiguously with the Medici.

I rehearse these details not to prove that the findings are correct—to do that it would be necessary to present them at much greater length—but to demonstrate that, over a great part of this field, connoisseurship is not a poor substitute for knowledge, but provides the only means by which our limited stock of documented knowledge can be broadened and brought into conformity with what actually occurred. In the great monographs on Renaissance sculptors printed in the last twenty years, its potential has been all but ignored.

There comes a point where strict adherence to historicity, in the form of documented works, is in fact unhistorical. One is reminded of a passage in Morelli's preface, where it is explained that "in Germany and Paris art historians do not acknowledge art connoisseurs and vice versa." Morelli's view was a great deal more extreme than mine. "Art connoisseurs," he declares, "say of art historians that they write about what they do not understand." I believe simply that art history is a looser, more speculative science than some of its practitioners suppose, and that the technique of connoisseurship must be inculcated and encouraged if it is significantly to advance. There are dangers in doing that, of course. Those innocent imitators of Panofsky who mistook mousetraps for winepresses might be succeeded by a generation which commands nothing but the semantic basis of connoisseurship. Teachers everywhere tend very naturally to concentrate on topics that can readily be taught—the interpretation of documents, the transmission of images, the elucidation of literary meaning, the projection of space—areas which can be successfully attacked by intelligent students gifted with industry and common sense. What as a whole they do not do, though there are some notable exceptions, is to cultivate the gift of sight. But the main task is, after all, to break down the inhibitions that discourage neophytes from looking, to assist them to transcend received opinion and study a wide range of works of art in the original intensively, as though nobody had looked at them before. There can be no really sound, really constructive historiography of art which does not proceed from the concept of similitude—how simple the term sounds, and how complex the process is; from the apprehension of artistic personalities as once living organisms whose responses and intentions are still reconstructible; and from conscientious application of the style-analytical techniques that are grouped together under the ugly, maligned, rather inappropriate word, connoisseurship.

NOTES

1. Reprinted in *The Works of Mr. Jonathan Richardson, edited by his son Mr. Jonathan Richardson* (London, 1773). A modern facsimile published in Hildesheim in 1969 is also available.

2. "Die Galerien Romas. Ein kritischer Versuch von Iwan Lermolieff," in *Zeitschrift für bildende Kunst*, ix (1874), pp. 1–11, 73–81, 171–78, 249–53; x (1875), pp. 97–106, 207–11, 264–73, 329–34; xi (1876), pp. 132–37, 168–73. The second section of the book, on the Doria-Pamphili Gallery, was not published serially.

3. J. A. Crowe and G. B. Cavalcaselle, *A New History of Painting in Italy*, 3 vols. (London, 1864–66).

4. J. A. Crowe and G. B. Cavalcaselle, *A History of Painting in North Italy*, 2 vols. (London, 1871).

5. *Die Werke italienischer Meister in der Galerien von München, Dresden und Berlin. Ein kritischer Versuch von Iwan Lermolieff aus dem russischen übersetzt von Dr. Johannes Schwarze* (Leipzig, 1880).

6. Crowe and Cavalcaselle, op. cit., i, p. 601: "same subject with four angels, assigned to Giovanni Bellini, recalls Rondinello and Coda, but is probably by Zaganelli."

7. For the critical history of this painting, see P. della Pergola, *Galleria Borghese: i Dipinti*, i (Rome, 1955), no. 204, pp. 114–15, as Seguace di Giorgione.

8. R. Wollheim, "Giovanni Morelli and the Origins of Scientific Connoisseurship," in *On Art and the Mind* (London, 1973), pp. 177–200.

9. *Italienische Malerei der Renaissance in Briefwechsel von Giovanni Morelli und Jean Paul Richter, 1876-1891* (Baden-Baden, 1960), pp. 565–67, 569.

10. The essay is printed in *The Study and Criticism of Italian Art*, 2nd series (London, 1902), pp. 111–48. It is explained in a prefatory note (p. vi) that: "The 'Rudiments of Connoisseurship' has never appeared before. It was written more than eight years ago, as the first section of a book on the Methods of Constructive Art Criticism."

11. B. Berenson, *The Study and Criticism of Italian Art* (London, 1901); 2nd series (London, 1902); 3rd series (London, 1916).

12. "Le 'Sposalizio' du Musée de Caen" was first printed in the *Gazette des Beaux-Arts*, xv (1896), pp. 273–80, where it was presented, in an editorial note, as a study in method. It was so treated in an in large part conclusive rejoinder by L. Manzoni, "I quadri dello Sposalizio della Beata Vergine dipinti da Pietro Perugino e da Raffaello," in *Bollettino della regia Deputazione di Storia Patria per l'Umbria*, iv (1898), pp. 511–34, who concludes his article with the words: "Il critico americano...dovra onestamente dichiarare che esso è caduto in errore. Non posso a meno, nel chiudere queste osservazioni, di non muovere una lamentanza di vedere ciò trattare la critica con sorprese fondate solo sopra congetture e sopra ipotesi, come farebbe un giuocatore di bussolotti."

13. R. Offner, "An Outline of a Theory of Method," in *Studies in Florentine Painting* (New York, 1927), pp. 127–36.

14. J. Pope-Hennessy, *A Sienese Codex of the Divine Comedy* (London, 1947).

15. M. Meiss, in P. Brieger, M. Meiss, and C. S. Singleton, *Illuminated Manuscripts of the Divine Comedy*, i (Princeton, 1969), pp. 70–80 ascribes the illuminations to Priamo della Quercia. Against this attribution it must be noted first that there is no explicit connection between the style of the illuminations and works by or ascribed to Priamo, and second that the panel paintings of Priamo are strikingly lacking in the precision and the delicacy usually to be found in the work of painters who also practiced as illuminators.

16. M. Meiss, *Andrea Mantegna as Illuminator* (New York, 1957).

17. G. Magherini-Graziani, *Masaccio: ricordo delle onoranze rese in San Giovanni Valdarno* (Florence, 1904), pp. 107–13.

18. L. Berti, "Masaccio 1422," in *Commentari*, xii (1961), pp. 84–107.

19. R. Longhi, "Fatti di Masolino e di Masaccio," in *La Critica d'Arte*, xviii–xix (1940), pp. 152–55.

20. B. Berenson, "Un nuovo Masaccio," in *Dedalo*, x (1929), pp. 331–36, reprinted in translation as "A New Masaccio," in *Art in America*, xviii (1930), pp. 45–53.

21. The most circumspect of the later comments on this work is that of Longhi, op. cit., p. 181: "Incline ad accettare l'ascrizione proposta dal Beren-

son e communemente accolta, mi sono astenuto dal parlarne perchè lo stato dell'opera non permette una classificazione precisa nello svolgimento del maestro." The photographs here published form part of the archive of the restorer Picchetto in The Metropolitan Museum of Art.

22. J. Pope-Hennessy, *Fra Angelico* (London, 1952).

23. J. Pope-Hennessy, *Fra Angelico,* 2nd. ed. (London, 1974).

24. This view, entertained initially by Berenson, is endorsed by Offner, op. cit., p. 107. Berenson's list later became less exclusive, and by 1962, when his *Corpus* volume appeared, Offner's catalogue had also been marginally revised. A number of conjectural attributions to Orcagna have since been made.

25. W. von Bode, in *Burlington Magazine,* xi (1907), pp. 181–82.

26. W. von Bode, "Die Madonnenreliefs Donatellos in ihren Originalen und in Nachbildungen seiner Mitarbeiter und Nachahmer," in *Florentiner Bildhauer der Renaissance* (Berlin, 1902), pp. 96–125.

27. C. de Tolnay, *Alcune recenti scoperte e risultati negli studi Michelangeioleschi,* Accademia Nazionale dei Lincei, Quaderno N. 153 (Rome, 1971).

28. H. W. Janson, *The Sculpture of Donatello,* ii (Princeton, 1957), pp. 246–47: "Although the authenticity of the statuette as a work of Donatello has never been questioned so far, it seems to me impossible to fit into the master's oeuvre." Janson proposes a very reasonable dating c. 1470.

29. A blunt plaster cast exists in the Bargello (Alinari 4784).

30. *Catalogo del R. Museo Nazionale di Firenze* (Rome, 1898), no. 147, p. 408.

31. J. Schuyler, *Studies of Florentine Quattrocento Portrait Busts,* Ph.D. diss., Columbia University, 1972 (published Ann Arbor, 1975), pp. 239–40.

32. For Sassetti see R. A. de Roover, "Francesco Sassetti," in *Bulletin of the Business Historical Society,* xviii (1943), pp. 65–80, and idem, *The Rise and Decline of the Medici Bank* (Cambridge, Mass., 1963), pp. 68, 72, 85–86, 362–64.

33. The date of the death of Francesca Tornabuoni is established by a well-known letter written by Giovanni Tornabuoni from Rome to Lorenzo il Magnifico on September 24, 1477, reporting his wife's death on the preceding evening (Archivio Mediceo avanti il Principato, filza 34, published by Reumont, "Il Monumento Tornabuoni del Verrocchio," in *Giornale de Erudizione artistica,* ii [1873], pp. 167–68). It is demonstrated by H. Egger, *Francesca Tornabuoni und ihre Grabstätte in S. Maria sopra Minerva,* Römische Forschungen des Kunsthistorischen Institutes Graz (Vienna, 1934), that the tomb of Francesca Tornabuoni in Santa Maria sopra Minerva was almost certainly executed by Mino da Fiesole, and that the relief in the Bargello and the related figures of Virtues in the Musée Jacquemart-André must therefore have formed part of a rejected project for the tomb and were retained in Florence, where the relief appears for the first time as a work of Donatello in a Medici inventory of 1666. Verrocchio's authorship of the relief is attested by Vasari.

34. F. Schottmüller, "Zwei Grabmäler der Renaissance und ihre antiken Vorbilder," in *Repertorium für Kunstwissenschaft,* xxv (1902), pp. 401–8.

35. E. Müntz, "Andrea Verrocchio et le tombeau de Francesca Tornabuoni," in *Gazette des Beaux-Arts,* 3e. pér., vi (1891), p. 283.

THE SIXTH CENTENARY
OF GHIBERTI

T HIS IS THE CENTENARY of a mythmaker. If indeed it is a centenary at all. Ghiberti almost certainly was illegitimate, and for most of his life he gave his birth date as 1381. He was in his twenties when his father married his mother and became, ostensibly, his stepfather, and only after he was sixty and a candidate for public office did he push back his birth date by three years, in an attempt—seemingly it was successful—to prove he was his mother's husband's son.[1] However, the centenary of his birth was celebrated in Florence in October 1978, and whether it is a real or fictitious one, it provides an occasion to look again at Ghiberti and his work.

So far as I know the fifth centenary of Ghiberti's birth was not commemorated in the nineteenth century, and if it had been it would have celebrated a rather different artist. We are all of us familiar (art historians in a rather special sense) with the sad phenomenon of cataract. What happened with Ghiberti is that the scales were removed not from the eyes of the beholders but from the works themselves. Generations of scholars had studied the bronze doors of the Florence Baptistery, but what they saw were generalized images, from which no valid picture of Ghiberti's artistic personality could be deduced. In 1948, however, we looked for the first time at the Baptistery doors in their cleaned state, as Ghiberti had intended we should, in full awareness of their decorative splendor and of their expressive subtlety.[2] Their appearance has deteriorated since that time, and it would be very welcome if the noncentenary persuaded the authorities in Florence to restore them to the state in which they were thirty years ago.

Over and above the cleaning of the doors, this century has seen two other substantial changes in the study of Ghiberti. The first dates from 1912, when there appeared an exemplary edition by that great scholar Schlosser of Ghiberti's written works.[3] The *Commentaries*—they were written about 1447, seven or eight years before Ghiberti's death—were preserved, like so many *memoriali,* by the sculptor's descendants, and were known to Vasari, whose approach to them was rather cavalier.[4] "He admits," says Vasari, "that the book was written by others; but later on, like someone who is more accustomed to drawing, sculpturing and casting in bronze than to spinning stories, speaking of himself, he uses the first person singular: I did, I said, I used to do, I used to say." He accepted at their face value those parts of the first and second Commentaries which were historical, and

he rejected the third Commentary as the scrapbook we now know it to be. Nonetheless, since the *Commentaries* were analyzed by Schlosser, the Ghiberti literature has taken a rather different turn from that of any other Early Renaissance artist. We know, or seem to know, more about his intellectual processes, more about the preconceptions on which they rested, more about his attitude to the immediate and the distant past, more about his reading and the lumber crammed into his mind. As we look at his self-portrait, not only can we reconstruct his benevolent, sagacious character from the traces which it leaves upon his face, but we can guess also at the kind of thinking that was going on in his domed intellectual head. The result is that modern studies of Ghiberti have been concerned with reconciling what we see with what we know, with interpreting Ghiberti as a visual artist in the light of the ideas that he committed to the written page. The second change dates from 1956, when that challenge was taken up by Richard Krautheimer, in one of the most thorough books ever devoted to an Italian artist.[5] The formation of Ghiberti's style, the social setting in which it grew, the influences to which he was exposed, his response to the antique, the almost embarrassingly rich documentation of his work—all these are examined with unfailing exactness and profundity. I shall recognize the onset of old age only when I am no longer able to pick up that mammoth book.

Autobiographies by artists are almost invariably elusive, and Ghiberti's is no exception.

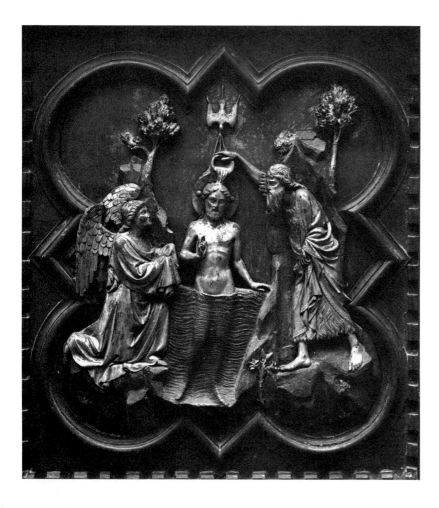

1.
Andrea Pisano.
Baptism of Christ, on the South Doors, Baptistery, Florence. 1330–33. Bronze, parcel-gilt, 49.7 x 43.2 cm.

His second Commentary describes some of his major works, but never does it give us the least hint as to the creative process through which he arrived at his results. We assume, because the reliefs of the bronze doors of the Baptistery are so familiar, that they could not have been other than they were. But logic tells us that their form was not predestined. Each of them must have been preceded by rejected options, and only by force of constant and tenacious self-criticism could it have assumed its final form. The goldsmith's habit was to make careful working drawings, and if this was Ghiberti's practice with works in precious metal, it was almost certainly his practice with bronze reliefs as well. There is only one drawing, of the *Flagellation* in Vienna,[6] that can be associated with the first bronze door, but it must be representative of an incalculable number of preliminary sketches in which Ghiberti in two dimensions refined and elaborated his designs. The initial contract for the first bronze door provided for the completion of three reliefs each year. As the designs were finalized in Ghiberti's shop, they would necessarily have been compared with the reliefs on the door of Andrea Pisano. Only one scene, the *Baptism of Christ,* is common to both doors. Andrea's relief (fig. 1) makes no concession to the quatrefoil surround. The composition indeed reads as though it were removed from a rectangle and inserted in an inappropriate decorative frame. For Ghiberti, on the other hand, the quatrefoil surround is the determinant of the design (fig. 2). One of the upper quadrilobes contains a burgeoning tree, the

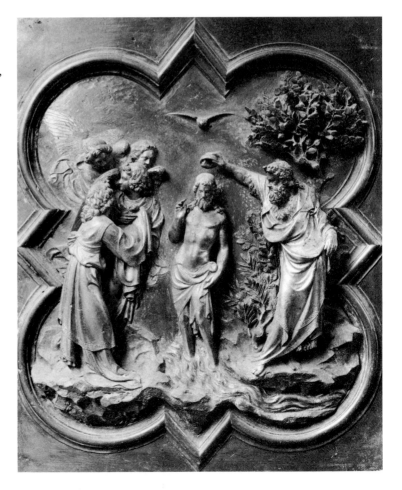

2.
LORENZO GHIBERTI.
Baptism of Christ, on the North Doors, Baptistery, Florence. Bronze, parcel-gilt, 39 x 39 cm.

3.

LORENZO GHIBERTI.
Christ Teaching in the Temple, on
the North Doors, Baptistery,
Florence.
Bronze, parcel-gilt,
39 x 39 cm.

other is filled by angels descending on the scene, and each of the four angles between the quadrilobes is put to narrative use. There is an omnipresent sense of depth and space. More important still, the psychological character of the event has been thought out afresh. The Baptist shrinks back from the divine figure in the center as he performs his allotted task, and the ruminative head of Christ establishes the significance of the event.

The sequence of work on the reliefs has been established, in a very convincing fashion, by Professor Krautheimer, and we can as a result trace Ghiberti's development from a small group of early reliefs, such as the *Annunciation* and *Nativity,* to the more ambitious scenes modeled about 1417, such as the *Flagellation* and *Christ Carrying the Cross.* But though the style evolves, the constant factor in the scenes is narrative consistency, and it is as a narrative sequence that the panels are supreme. In the *Christ Teaching in the Temple* (fig. 3), to take one example only, when we recover from our delight at the beautiful device whereby the soft robes of the seated figures cover the hard line of the platform, what most impresses us is the consummate repertory of expression in the proud figure of the Virgin, the respectful features of Saint Joseph, and the worried heads of the doctors at the front. One of the things Ghiberti effected on the first bronze door was a quiet revolution in narrative technique.

Ghiberti's *Commentaries* contain only one clue to his attitude to subject matter. It is the well-known passage describing a classical intaglio of Apollo and Marsyas. "The figures," he says, "were an old man seated on a rock on which was a lion skin, and bound with his hands behind him to a dead tree. At his feet was a child kneeling on one foot and looking at a youth who held a paper in his right hand and in his left a cithara. It seemed that the child was seeking instruction from the youth." Ghiberti, in other words, read the intaglio as narrative, not as iconography. He mistook the lyre for a cithara and the plectrum for a scroll, and he deduced the content of the relief solely from the deportment and expressions of the figures it contained. He would, one suspects, have been surprised to learn that people would in the future read his own reliefs in any other way.

Once the designing stage was past, there remained the problem of transposing the formal scheme into appropriate plastic terms. If we isolate the single figures at the bottom of the door, we shall find that their relief style is of incredible variety. In the *Saint Augustine* (fig. 4) the seat is foreshortened, and the saint's cloak, pulled across his knees, falls on the right in a fantastic pattern of small folds. In the *Saint Jerome* the reading desk is visualized from one corner, and the upper part of the saint's body is slightly turned. *Saint John* is shown leaning diagonally across the relief, while in the *Saint Luke* (fig. 5), the most elaborately posed of the eight figures, the knee protrudes and the right lower leg recedes

4. LORENZO GHIBERTI. *Saint Augustine*,
 on the North Doors, Baptistery, Florence.
 Bronze, parcel-gilt, 39 x 39 cm.

5. LORENZO GHIBERTI. *Saint Luke*,
 on the North Doors, Baptistery, Florence.
 Bronze, parcel-gilt, 39 x 39 cm.

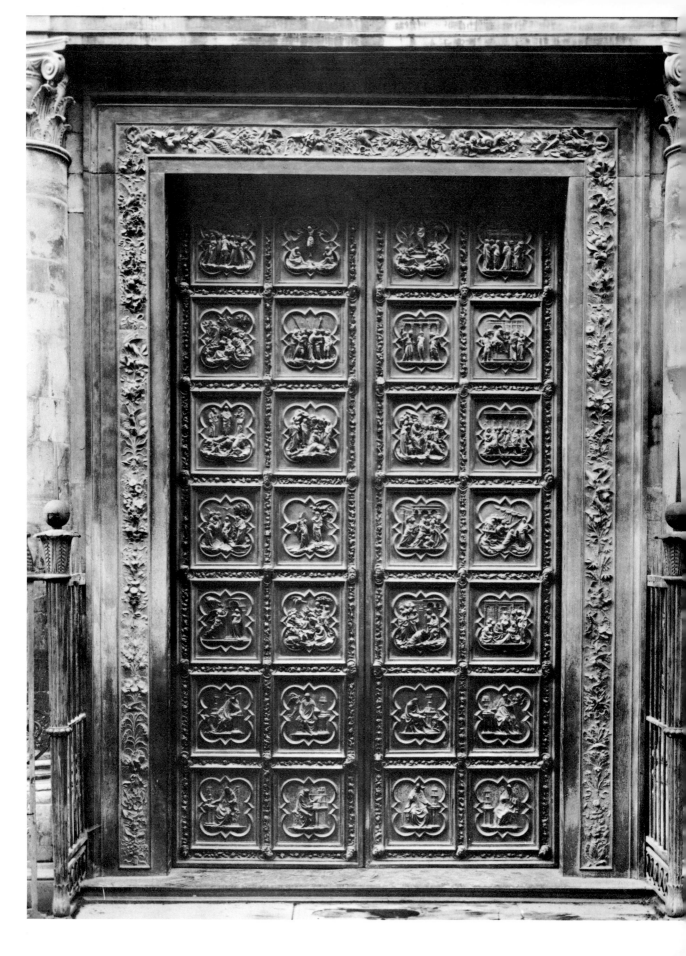

into the picture space. Nowhere does Ghiberti accept the dominance of a single relief plane. In the upper panels, even when, as in the *Flagellation,* the figures are distributed on a narrow horizontal platform against a building set flat across the back, their surface is treated irregularly, sometimes with small, sometimes with bold variations in the depth of the relief. Not only was that a radical departure from the practice of Andrea Pisano's uniform, flattened reliefs, but it invested the individual scenes with magical animation and diversity.

That affected the totality of the door (fig. 6). In the early fifteenth century Andrea's door, despite the praise dutifully ladled out upon it by Ghiberti, must have looked a little dull. Its flat reliefs constricted by their frames, its rows of gilded studs along the framing, its unemphatic lion heads, how unexciting they would have seemed. From the outset Ghiberti's aim was more adventurous. It was to devise a relief surface the whole of which would be invested with a sense of movement, not simply through the flickering planes of the quadrilobes themselves, but also through the structure in which they were set. So the gilded studs in the interstices of Andrea Pisano's door were replaced in Ghiberti's by strips of foliated ornament, not static ornament but living plants with insects clambering through them, and Andrea Pisano's uniform lion masks were replaced with heads of Prophets protruding irregularly from the door.

Scholarly attention has been focused on the narrative scenes, but the door jambs and architrave were also innovations of great consequence. If Luca della Robbia as a youth worked with Ghiberti, it was surely on the chasing of this part of the door, on these closely observed, minutely rendered natural forms, these bunches of roses, these pea pods and fruit, these birds modeled in the act of taking flight. We must suppose that the naturalistic motifs which Ghiberti employed in three dimensions in the surround of the first door were simply a cross section of an infinitely richer graphic record of plants and foliage, birds and animals made summer after summer in the countryside. In 1425, when the sculptor Goro di ser Neroccio died—he was one of the secondary local sculptors employed on the Sienese Baptismal Font—Ghiberti requested the return of some drawings of birds ("charte degli uccelli"), which he had let him have on loan.[7] All the motifs of the architrave on the first door, or almost all of them, became common currency later in the century. Scholars tell us Ghiberti was inspired by Roman carvings, and so he must have been, but if we juxtapose the architrave of the bronze door with even the finest Trajanic reliefs, the effect it makes is altogether different. One is reminded of that tag of Landor, "Nature I loved, and next to nature art," for those were Ghiberti's priorities. Nowhere is that more evident than in the reliefs on the back of the first door facing into the interior of the Baptistery (fig. 7). They have never been adequately studied, I doubt if they are even adequately photographed. But

6. LORENZO GHIBERTI. North Doors. 1403–24. Bronze, parcel-gilt. Baptistery, Florence

these snarling lion heads were drawn and modeled only a year or two after the *Marzocco* of Donatello, and we must imagine Ghiberti, like Donatello, patiently studying the living lions which were caged in the Gabbia dei Leoni near the Palazzo Vecchio, and extrapolating them into their wild state.

Ghiberti at the age of twenty-one or twenty-two was active as a painter. Because of the plague he left Florence "with an excellent painter whom the Lord Malatesta of Pesaro had summoned. He had us do a room which was painted by us with the utmost diligence." "My mind," he adds, "was largely directed towards painting." And this work ended only when Ghiberti was recalled by his stepfather to take part in the competition for the bronze door of the Baptistery. It has been argued that the "egregio pittore" with whom Ghiberti worked was Mariotto di Nardo,[8] and an attempt has been made, a less convincing one, to reascribe a number of paintings by Mariotto di Nardo to Ghiberti. But the fact is that we know a good deal more about Ghiberti as a painter between 1405 and 1415 than books about Ghiberti are ready to admit. "I designed on the façade of Santa Maria del Fiore in the circular window in the center the Assumption of the Virgin and I designed the others which are beside it." No payment to Ghiberti for the window of the *Assumption* is recorded, but the second Commentary is a confidence-inspiring testament, and I was disconcerted the other day to see a detail of the window illustrated in a recent book with the name of Mariotto di Nardo printed underneath.[9] The window (fig. 8) is a work of absolute originality. Its decorative border is depicted on a more distant plane than the scene that it surrounds, and is broken at the top by an apparition of Christ supported by two angels holding a foreshortened crown. The Virgin is a serious, aged figure, seated against a mandorla partly hidden by a shower of golden rays. Her veil is treated realistically (more realistically, that is, than in trecento paintings of the theme), and so are the elaborate folds of cloak over her knees, where the deformation of the surface pattern is rigorously calcu-

7. Detail from the reverse of the North Doors. Bronze. Baptistery, Florence

8.
LORENZO GHIBERTI.
Assumption of the Virgin.
Stained glass. Façade,
Cathedral, Florence

lated. Under her feet is a supporting line of cloud, and beneath are two seraphim, whose red wings are protracted towards the frame with splendid decorative effect. The angels, two at each side supporting the mandorla and three making music, rotate in space and establish a sense of depth far greater than any to be found in panel paintings of the time. It is indeed with this truly astonishing design that any history of Florentine Renaissance painting ought properly to begin. For Lorenzo Monaco its message seems to have been very clear, and can be seen in the transition from the timid polyptych of 1406 in the Palazzo Davanzati to the celestial space of the *Coronation of the Virgin* of 1414.

The roundels of Saints Lawrence and Stephen at the sides are of less consequence, but they too testify to Ghiberti's highly sophisticated grasp of large-scale, two-dimensional design. Across each roundel stretches a platform, which protrudes beyond the frame and is compensated at the top by the geometrical device of a concave tabernacle, which ties the figures into the circular surround. The two lateral windows were commissioned in 1412, though the cartoons may have been made a little earlier.

47

The fact is that Ghiberti was a hybrid artist. Nowadays painting and sculpture are looked on as two separate arts, each with a creative procedure and with an aesthetic of its own. This is a comparatively modern view, but we take it so much for granted that we project it back into the past. It is indeed the postulate on which modern study of Early Renaissance art is based. But in relation to the fifteenth century it is unhistorical. In the first Commentary Ghiberti refers to painting and sculpture in the singular. "Sculpture and painting," he writes, "are a science ornamented with many disciplines and diverse instruction, which, of all the other arts, is the highest invention," and a little later he speaks of *"disegno* which is the origin and basis of the art of sculpture and painting." Obviously the noun *disegno* in that passage signifies drawing, not design. To artists of an earlier generation, such as Agnolo Gaddi (who habitually made drawings for carved sculpture), the contention would have seemed a commonplace.

What then is Ghiberti's significance in the history of painting in the first two decades of the fifteenth century? If we suppose that influence is a matter of the transposition of motifs, he appears a strangely isolated figure. But if influence is assessed in terms of compositional procedures, not motifs, Ghiberti's relevance to contemporary painting becomes very plain. One of his primary concerns was with the geometrical division of the

9.
LORENZO GHIBERTI.
Adoration of the Magi, on the North Doors, Baptistery, Florence. Bronze, parcel-gilt, 39 x 39 cm.

10.
LORENZO MONACO.
Adoration of the Magi, from the predella of *Coronation of the Virgin.* 1414. Tempera on panel. Uffizi Gallery, Florence

relief field. In the *Saint John the Evangelist* on the North Door, for instance, the back of the seat on the left is set on a line running down the exact center of the relief, and the back of the seat on the right is set on a line running down the center of the right-hand quadrilobe. As representation the result may be eccentric, but as design it does command great strength. This technique is also, of course, applied to narrative, and in the *Adoration of the Magi* (fig. 9), the central support of the loggia once more runs down the exact center of the relief, a second support to the right links the inner angles of the quadrilobe, and a third support, on the extreme right, is set against the outer angles. The supports are naturally put to spatial use, but their prime function is metrical.

Passing to the *Adoration of the Magi* in the predella of Lorenzo Monaco's *Coronation of the Virgin* of 1414 in the Uffizi (fig. 10), we find it is constructed essentially in the same way. Down the left quadrilobe, a little to the left of center, runs the end of the containing wall, and down the center of the right-hand quadrilobe runs the farther edge of the wall behind the Virgin, and it is within this framework of geometry that the figures are articulated. The narrative panels Lorenzo Monaco painted in the 1390s, such as the *Arrest of Christ* under the *Agony in the Garden* in the Accademia in Florence, are constructed differently, and the first works which adhere to a firm basis of geometry date from after 1405, when the

49

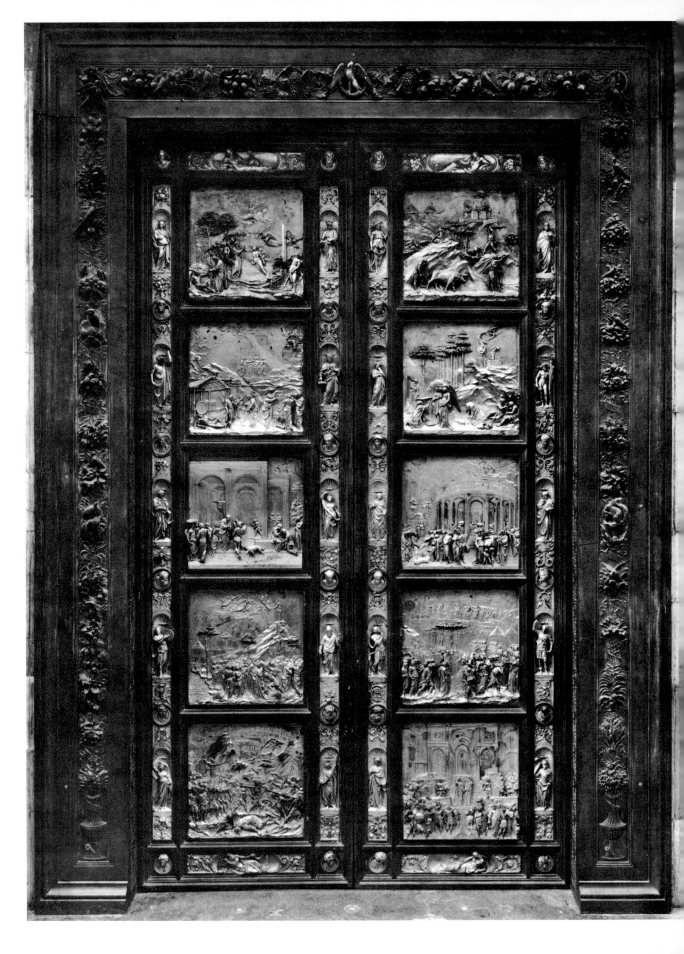

earliest reliefs on Ghiberti's door were already an accomplished fact. By what is surely more than a coincidence, the panels of Lorenzo Monaco also bear the impress of Ghiberti's narrative technique. But as a narrator Ghiberti was by far the greater artist, and charming as is Lorenzo Monaco's little *Adoration of the Magi,* the *Adoration of the Magi* of Ghiberti is on an altogether different level of psychological and visual complexity. When Gentile da Fabriano arrived in Florence in 1420 or 1421, his dominant impression must have been not of contemporary painters but of Ghiberti. Perhaps the later reliefs on the bronze door played some part in the remarkable stylistic change from the loosely composed predella of the Strozzi *Adoration of the Magi* to the more subtle, more concentrated narratives of the Quaratesi altarpiece.

The second bronze door by Ghiberti, the Porta del Paradiso (fig. 11), was commissioned in 1425, less than a year after the first door was set in place, and its ten narrative reliefs seem to have been cast, not singly but together, in 1437, and were completed over the next ten years. Plans for the door must have been made some years before it was formally commissioned (this was an invariable practice with major contracts for the Duomo and the Baptistery), and they provided for a counterpart to the first door, with twenty-eight narrative panels and figure reliefs. But for some time, probably from 1416, Ghiberti had concerned himself with the designing of two rectangular reliefs for the Siena Font, and it would have been hard, perhaps impossible, to revert from this new type of relief to small narrative reliefs in ornamental borders of the type he had produced before. Hence the decision, of which he almost certainly was the proponent, to replace the small scenes with ten large rectangular reliefs. There could be no reduction in the number of scenes to be portrayed, and Ghiberti therefore was committed to representing a number of separate incidents in each relief. If the expository function of the door were to be properly discharged, the prime consideration would be clarity. To be fully intelligible from the ground, the scenes in the reliefs had to be clearly differentiated.

Modern writers on perspective often speak of it as though it were an abstract discipline, directed to the creation of a space structure and nothing more. But Ghiberti's attitude towards it was pragmatic; it was a response to narrative necessity. This is abundantly apparent if we turn for a moment to the *Story of Isaac* (fig. 12), where the perspective construction is most orthodox. Into its unitary scheme are compressed no less than seven single scenes. In the upper right corner the Lord appears to Rebecca with the prediction, "Two nations are in thy womb." Across to the left in the middle distance is the birth scene, and a little farther forward in the center we see the quarrel between Jacob and Esau. At this point we switch to the foreground, where Esau, accompanied by his dogs, is instructed by Isaac to take his weapons and go out into the fields to hunt. Halfway up on the right we see

Esau departing on his mission. Underneath and slightly to the left Rebecca instructs Jacob to impersonate his brother. And in the foreground on the right is the culminating scene of Jacob, dressed in Esau's clothes, receiving Isaac's blessing in the presence of Rebecca. In the most prominent position of all, on the left, are three women whose presence is unexplained; they may represent Rachel and Leah and a serving maid. All these incidents are unified in an orthodox Albertian perspective scheme. But the purpose of the scheme is not the creation of a space illusion for the sake of space; it is the creation of a space illusion for purposes of narrative lucidity.

With its open setting the *Story of Cain and Abel* (fig. 13) is constructed in the same way. Perhaps it is worthwhile to turn back once more to the second Commentary. "In the second relief is shown how Adam and Eve have begotten two small children, Cain and Abel." This is the scene at the top on the left. "There is shown how they make sacrifices, and Cain so sacrificed the meanest and vilest things he had. Abel sacrificed the best and most noble. His sacrifice was very acceptable to God, and that of Cain was quite the opposite." On a hill on the right we see this scene, the willing and the unwilling sacrifice. "In that relief Abel was shown watching his flock and Cain tilled the soil." These two incidents are in the foreground and middle distance on the left. "There was shown how Cain slays Abel out of envy." This scene is in the middle on the right. "There was also shown how God appears to Cain, inquiring about his brother whom he has killed." This is the scene in the extreme right foreground.

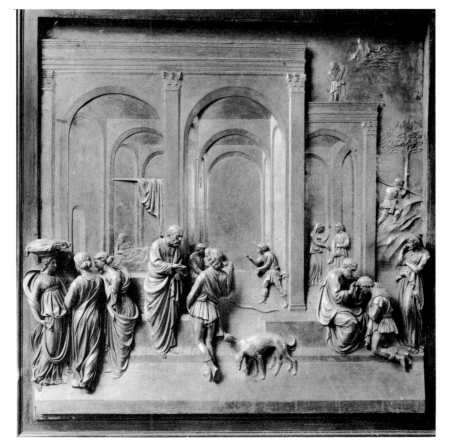

12.
LORENZO GHIBERTI.
Story of Isaac, on the
Gates of Paradise,
Baptistery, Florence.
Gilt bronze, 79.5 x 79.5 cm.

Krautheimer believes (and has reasserted in the introduction to the second edition of his book) that the only system of space construction used in the reliefs is Albertian perspective, and that it is employed only where we might expect, in depictions of architecture or of other regular structures to which it was applicable, such as the altars at which Cain and Abel sacrifice. I suspect (and I think that I am not alone in doing so) that the depiction of landscape in this and in the two following scenes and the diminution of the figures in the landscape were also arrived at logically, albeit on a system which can be deduced only from the reliefs. We know other sculptures (the relief by Donatello of *Saint John on Patmos* in the Sagrestia Vecchia of San Lorenzo, for example) where that was unquestionably done, and we know paintings in which it was done too.

Ghiberti's proneness was to experiment, and the nature of the experiment was determined by the nature of the subject he had in hand. He could divide the relief horizontally, as he does in the *Story of Noah,* with the ark in the upper half and the Sacrifice and Drunkenness of Noah underneath. He could divide it vertically, as he does in the *Story of Abraham,* where we see the Sacrifice of Isaac on the right and Abraham and the Three Angels on the opposite side. He could construct the composition on a diagonal, as he does in the most rhetorical of the reliefs, the *Story of Moses,* where we see, in Ghiberti's words, "how Moses received the tablets on top of the mountain and how Joshua remained halfway up the mountain and how the people marvel at the earthquakes, lightnings and thunders, and how the people stare at the foot of the mountain all stunned."

13.
LORENZO GHIBERTI.
Story of Cain and Abel, on the
Gates of Paradise, Baptistery,
Florence. Gilt bronze,
79.5 x 79.5 cm.

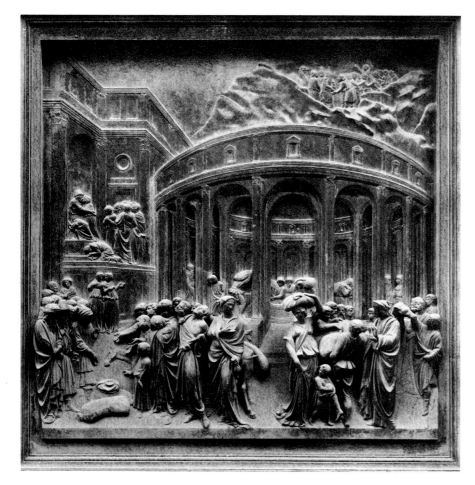

14.
LORENZO GHIBERTI.
Story of Joseph, on the
Gates of Paradise,
Baptistery, Florence.
Gilt bronze, 79.5 x 79.5 cm.

But the lower down the door we move the less sophisticated is the narrative technique. We know from the *Commentaries* what Ghiberti wished us to see in the *Story of Joseph* (fig. 14), but it is very hard in practice to isolate the individual scenes. The episode of Joseph cast into the well and his sale to the Ishmaelites is tucked away in the upper right corner of the scene; at the front on the left is the discovery of the cup, to the right is the distribution of grain, and in the middle distance is the gathering of the grain and Joseph revealing himself. The scene is difficult to read today, and must have been still harder to read in the fifteenth century. Similarly in the *Story of David* (fig. 15) the various episodes are segregated in Ghiberti's text more clearly than they are in the relief. "In the ninth panel," says Ghiberti, "is shown how David slays Goliath, and how they, the people of the Lord, defeat the Philistines, and how he returns with the head of Goliath in his hands, and how the people come to meet him, making music and singing and saying: Saul percussit mille et David decem milia." But what we see in the relief is the battle and the death of Goliath, and only with strong spectacles can we detect the tiny figure of David greeted by the

54

15.
LORENZO GHIBERTI.
Story of David, on the
Gates of Paradise,
Baptistery, Florence.
Gilt bronze, 79.5 x
79.5 cm.

populace at the back. The *Story of Joshua* reads in the same rather awkward fashion from back to front, and in the final relief, the *Meeting of Solomon and the Queen of Sheba,* only one scene is shown.

How is all this to be explained? The chasing of the lower scenes is generally conceded to be inferior to that of the reliefs above, and on that account they are supposed to represent the late style, the "ultima maniera" of Ghiberti. But what is at issue is the design, not just the finish of the reliefs. We know that they were modeled in a period of about seven years and were cast in 1436 or 1437. If Ghiberti was capable about 1430 of planning the upper reliefs, why should he revert, about 1435, to the less skillful, less organic designs below?

This problem deserves more attention than it has received; it is indeed central to any understanding of Ghiberti as an artist, and the only means by which a solution of it can be reached is to restudy the two independent reliefs Ghiberti executed while the Porta del Paradiso was in progress and before it was begun. The earlier of them is the scene of *Saint John the Baptist Brought Before Herod* on the Siena Baptismal Font; it was designed probably

in 1417 or very shortly thereafter, and it has long been recognized that its design depends from the *Christ Before Pilate* on the first bronze door. There are differences in the construction of the two reliefs, of course; the figures at Siena are larger and more fully modeled than those on the door, and the architecture is extended at the back by the employment, on the ceiling of the loggia, of a rudimentary system of orthogonals. The later of the Siena Font reliefs is the *Baptism of Christ* (figs. 16, 17). When the drawings for it were prepared we do not know, but it seems to have been modeled sometime before 1424, and it was chased and gilded by 1427. If we juxtapose the Siena *Baptism* with the much earlier *Baptism* on the bronze door (fig. 2), the differences are self-evident. The major innovation is in Ghiberti's attitude to space. It is defined by the horizontal lines of figures in the sky, the angels, dove, and cherubim, which diminish in size in proportion to their assumed distance from the eye. One would expect this type of empirical space representation to recur on the Porta del Paradiso, and so it does, but it appears on what are generally conceived to be the later of the reliefs on the bronze door. If, for example, we pass to the relief of the *Story of Joshua,* we find that space is again represented by the diminution of the figures. We move in the same way from a relatively fully modeled foreground to a middle distance in lower relief and a far distance in extremely low relief. Comparing the two angels on the left of the Siena *Baptism* with the two women beside the river to left of center in the *Joshua* scene, we might be tempted to infer that the two reliefs were planned in close proximity. Can it then be that the supposedly late reliefs on the Porta del Paradiso were modeled before those which supposedly are earlier?

I think that really must have been the case, and the corroboratory evidence comes from an independent work, the Shrine of Saint Zenobius in the cathedral. The facts about it are quite simple. It was commissioned in 1432, and the two end reliefs are now generally dated between 1432 and 1434. But the large relief on the back (fig. 18) was not cast till after 1439, and it has been argued for this reason that it was modeled in the mid-1430s.[10] Its subject is exactly described by Ghiberti as "how the saint revives the child whom the mother had left in his care till she returned from her pilgrimage." We know (and Ghiberti naturally knew too) that the mother was a Frenchwoman on her way to Rome, that Saint Zenobius when he performed the miracle was going in procession to San Pier Maggiore, and that the miracle occurred in a specific place, in the Borgo degli Albizzi outside the Palazzo Altoviti. In order to represent all this Ghiberti divides the panel lengthwise into three equal parts. The center is organized as a legitimate construction, in the Albertian sense, with a view of San Pier Maggiore at the back, and the two sections at the sides are organized empirically, with, on the right, a view of the walls of the city of Florence (at the time of the miracle San Pier Maggiore was outside the city wall), and, on the left, an open landscape and a building which may be intended to depict the Palazzo Altoviti. The members of the procession following the saint are disposed on two sides of a visual pyramid, and in the center, isolated in a triangle of space, are two separate scenes, the

mother discovering her dead child and the saint raising him from the dead. The effect is not a very happy one; it is like a double exposure on one negative. Now the really surprising thing about the scheme is this, that when Fra Angelico painted an oblong panel roughly of the same proportions for Santa Maria degli Angeli in 1431 or 1432 (fig. 19), he organized it essentially in the same way.[11] In the center the open graves are rendered perspectively, and to right and left the disposition is empirical. Who was the inventor of this ambivalent device? There is no precedent for it in Angelico and one suspects it originated with Ghiberti, but in that case the relief would have been designed considerably earlier than has been supposed. It would represent not his late style but his style about 1430, at the time he started work on the narrative reliefs of the Gates of Paradise.

There is one relief on the door in which the compositional method is effectively the same. It is the *Solomon and the Queen of Sheba* (fig. 20), which is commonly thought of as the latest of the reliefs. In the center of the background there is a legitimate construction, which is extended at the sides by other buildings; the main figures are once more shown in silhouette, isolated in the center of the scene; in the foreground to left and right are rows of figures modeled in depth; and at the back, behind the balustrade, are smaller figures whose

16. LORENZO GHIBERTI. *Baptism of Christ*, on the Baptismal Font, Baptistery, Siena. Bronze, 63.5 x 61 cm.

17. Saint John the Baptist, detail of fig. 16.

18. LORENZO GHIBERTI. *Miracle of Saint Zenobius*, on the Shrine of Saint Zenobius, Cathedral, Florence. Bronze, 41 x 160 cm.

19. FRA ANGELICO. *Last Judgment*. c. 1431. Tempera on panel, 105 x 210 cm.
 Museo di San Marco, Florence

distance from the eye is established by a reduction in their scale and by a diminution in the depth of the modeling.

Putting all this evidence together—and I am speaking, I must remind you, only of the models for the narrative scenes; the scenes were cast together in 1436 or 1437—we reach a conclusion which is the exact opposite of that now entertained. That Ghiberti started work on the Porta del Paradiso precisely as he had on the first bronze door, with the reliefs at the

58

bottom, not with the reliefs at the top. And that the great scenes in the upper reaches of the door—the *Story of Abraham,* the *Story of Noah,* the *Story of Isaac*—are more mature in style than the less organic scenes beneath. The transition from one group to the other is marked by the *Story of Moses,* where Ghiberti was compelled to portray Mount Sinai at the back, and discovered for the first time the implications that calculated differences of level might have for the narratives with which he had to deal. But in the first relief to which the lesson was applied, the *Story of Joseph,* the results were not entirely fortunate. Two scenes relegated to the top right corner of the relief read almost as an insertion, not as a coherent part of a fully cogitated scheme. From this point on linear perspective becomes a dominant factor in the reliefs. It does so, in a modified form, in the first of the Genesis scenes. In front is the Creation of Adam in very deep relief; in the center a little farther back and merging with it is the Creation of Eve; on the same level on the left, in much lower relief, and therefore in a more distant plane, is the Fall; and in the foreground on the right the wretched couple (once more in very deep relief) are driven through the Gate of Paradise. The *Story of Isaac* is an orthodox Albertian construction, and no one who troubles to contrast the *Story of Moses* with the *Story of Noah* could, I think, doubt that in the *Story of Moses* the structure is empirical, whereas in the *Story of Noah* it is systematic: a technique of projection is employed not simply to create the illusion of vast distance but to establish a logical diminution in the scale of the human and the natural forms.

How are we to express all this in terms of a hypothetical chronology? The Porta del Paradiso was commissioned in 1425 in a form that differed radically from the form that we know now. As Brockhaus correctly deduced, it was to contain twenty-four upright panels, twelve in each wing. When the back of the door was cast, in 1428 or 1429, it reflected the intended form of the front face. It has been argued that Ghiberti was too busy in these years to give serious thought to the narrative reliefs, but to my way of thinking it is almost inconceivable that an artist so committed did not, when the commission was an accomplished fact, give thought to the form and content of at least some of the narrative scenes. The change from the twenty-four-panel to the ten-panel scheme that was finally adopted probably took place, as Krautheimer infers, in 1429. We have one and only one narrative relief the design of which is attributable to this time. This is the back relief on the Shrine of Saint Zenobius (fig. 18), which must have existed at least in graphic form when the plan of the shrine was approved early in 1432. At about the same moment, about 1430 that is, Ghiberti started drawing out and modeling the lower reliefs on the door. His problem was self-imposed; it was after all Ghiberti, by his own account, who was responsible for the change in the shape and the number of the reliefs, and therefore for portraying what are in effect a succession of crowd scenes. But the compositional technique at his disposal was, by the standards of Brunelleschi, and Masaccio, and the Donatello of the *stiacciato* reliefs, rather an archaic one. In the earliest of the panels, the *Solomon and the Queen of Sheba* (fig. 20), the

foreground figures are inhibited and comparatively little tactile—the standard of comparison is the foreground figures of the rather later *Joshua* panel and of the *Joseph* scene above—and the main figures, Solomon and the Queen of Sheba isolated in the center, read as flat silhouettes; they are sliced off at the back in rather the same way as the Baptist in the later of the Siena Font reliefs. These first reliefs for the Porta del Paradiso must have been known to Filarete when he started work on the door of Saint Peter's in Rome in 1433; they provided a taking-off point for the much cruder reliefs of the deaths of Saints Peter and Paul in the bottom register of the Saint Peter's door. But suddenly the situation changed. About

20. LORENZO GHIBERTI. *Meeting of Solomon and the Queen of Sheba*, on the Gates of Paradise, Baptistery, Florence. Gilt bronze, 79.5 x 79.5 cm.

1433 or 1434 the clouds began to clear, and Ghiberti learned—was it from Alberti, was it from some other source?—the intellectual discipline that enabled him to clarify the upper scenes. The time intervals with which we are dealing are all comparatively short. The ten reliefs were cast at latest in 1437. There can be no reasonable doubt that the upper panels of the Porta del Paradiso were preceded by a process of graphic preparation far more elaborate than that implied by the reliefs of the first bronze door. In a scene like the *Story of Noah* (fig. 21) each figure or group of figures must have been studied and restudied in graphic form before they were transcribed into relief, and countless relief models of the individual

21. Lorenzo Ghiberti. *Story of Noah*, on the Gates of Paradise, Baptistery, Florence. Gilt bronze, 79.5 x 79.5 cm.

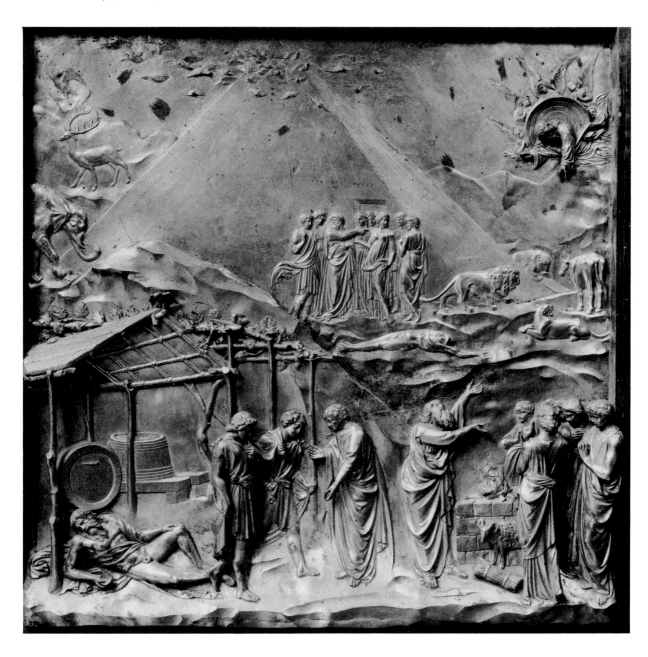

22.
LORENZO GHIBERTI.
Presentation in the Temple.
Stained glass, diameter 473 cm.
Cathedral, Florence

components must have been prepared before the panel assumed its final form. We can imagine the careful preparatory drawings for the group of Noah and his family outside the ark, the meticulous studies for God the Father on the right, the Pisanello-like drawings for the animals leaving the ark, the detailed sketches for Noah and his family before the altar at the front, the studies for the linear figure of the drunken Noah on the left and for the stance and psychologically truthful gestures of his sons. So perfect, so definitive is the result that one can scarcely suppose the design of the relief to have resulted from less than many months of work. Nothing in it is loose, nothing is extemporized, nothing is provisional. Having regard to all that, and to the pressure Ghiberti must have been under to make progress with the door, we need not wonder that there was no time to revise or to replan the earlier reliefs. Nor need we wonder that after 1437, when the process of chasing began, Ghiberti concentrated on the later and finer reliefs and relegated the earlier ones in the main to members of his shop.

There is one other source from which corroborative evidence can be obtained. In the year in which the reliefs of the Porta del Paradiso were cast, Ghiberti resumed his work as a designer of stained glass with the windows of the tribune chapels of the cathedral, where the lower figures, paired saints shown in an arcaded loggia, recall the work of Masolino. In 1435 he made a cartoon of the *Coronation of the Virgin* for a more important site, the central window beneath the cupola. It was rejected in favor of a cartoon by Donatello, and looking

23.
LORENZO GHIBERTI.
Agony in the Garden.
Stained glass, diameter 480 cm.
Cathedral, Florence

at the window which was executed—it registers from the whole length of the nave—one cannot blame the Operai for their choice. The only blame attaches to modern art historians who neglect this window just as they neglect Ghiberti's. Eight years later, in 1443, Ghiberti designed three more windows, the *Presentation in the Temple*, the *Resurrection*, and the *Agony in the Garden*. And unmistakably great works two of them are.

There is a famous passage in the *Commentaries* in which Ghiberti praises Ambrogio Lorenzetti. One superlative chases another through his text—"famosissimo," "singolarissimo," "nobilissimo componitore," "perfettissimo maestro," and so on. In the first of the windows beneath the cupola (fig. 22) this enthusiasm is expressed in visual form, in a scheme derived from the great *Presentation in the Temple* of Ambrogio Lorenzetti. A good deal is changed, of course—the classic drapery forms are those of the Porta del Paradiso— but the pryamidal composition and the spacing of the figures are retained, and so is the backward movement of the Child's head. One detail of enchanting intimacy is introduced, the Child's arm reaching towards the Virgin and the Virgin's hand extended to the Child. They are isolated in a rectangle in the center of the scene. It is surely more probable that this beautiful design emerges from the logical structure of the *Story of Isaac* than that it proceeds from the confused reliefs at the base of the door.

And of the *Agony in the Garden* (fig. 23) precisely the same thing, it seems to me, is true. The figurative elements go back to Lorenzo Monaco, to the great altarpiece of 1395 in the

Accademia, where the landscape is conceived on the scale of the small kneeling figure on the left, and the gigantic figures of the sleeping Apostles in the foreground and of the kneeling Christ above them are inserted in an arbitrary fashion across the scene. In Ghiberti's window the design is opened out with a distant view of Jerusalem at the back. And the means whereby the eye is led from the coherent, mellifluous group of Apostles in the right foreground to Christ kneeling in the middle distance and thence diagonally to the city of Jerusalem are precisely the same means that are used to articulate the *Story of Abraham* on the Gates of Paradise.

Ghiberti is the only Early Renaissance sculptor who claims that he realized some of his ideas through other artists. The passage occurs at the very end of his autobiography: "Also for many painters, sculptors and stone carvers I provided the greatest honors in their works, for I have made very many models in wax and clay, and for the painters I have designed very many things. Moreover, for him who had to make large figures 'fuori della naturale forma' [there is a certain ambiguity about that phrase] I have given the rules for making them in perfect scale." The passage has been attributed to a kind of senile boastfulness, but Ghiberti, when he penned it, was unaware that it would be printed and would be the subject of endless comment, and my inclination is to think that he was speaking nothing but the literal truth. Each time I walk along the south face of Or San Michele and look at the little relief beneath the statue of Saint James, the decapitated figure of the saint reminds me of Mary Magdalen falling at the feet of Christ in the *Raising of Lazarus* on the first bronze door.[12] So, for that matter, do the rocks at the base projecting across the frame and the three cliffs at the back. This is not a very distinguished relief—whether it is by Niccolò di Pietro Lamberti or Piero di Niccolò is anybody's guess—and if we did not know that Ghiberti made wax models for other sculptors we might dismiss it as a pastiche. But given that passage in the *Commentaries* the possibility that it was based on a Ghiberti model has to be taken into very serious account.

Nowadays Ghiberti is allowed only a very small oeuvre catalogue. It consists of works which are documented or which he himself describes, and it comprises two bronze doors, three life-size statues, two reliquary chests, a couple of reliefs for the Siena Font, and a tabernacle door. But he looked upon himself as a prolific artist. Are these really all the "moltissime opere per me prodotte"? By and large Florentine workshops in the second quarter of the fifteenth century were geared to a high level of productivity, and sculptors in particular seemed to have depended for their livelihood in part on the sale and manufacture of reproductive reliefs. Donatello certainly did so from the 1430s on; Luca della Robbia produced modeled reliefs while working on the Cantoria; and Michelozzo and Buggiano made them too. It is highly improbable that Ghiberti forewent this source of income, and I suspect that he was even the inventor of this class of relief. The evidence for that comes from two molded reliefs—no modeled original of them survives—which enjoyed an enor-

mous vogue.[13] The only fact we know about them is that one relief was current before 1427, when the Child on it, with his protruding elbow and startled face, was copied on a Venetian wellhead. Manifestly the whole design results from aesthetic calculation of a highly experienced kind. The Child's arm is thrust back against the Virgin's neck, and his right leg is threaded through his left, with the sole turned outwards above the Virgin's hand. The factor of aesthetic calculation is still more apparent in a second relief, also extremely popular, where the Child is shrouded in the Virgin's cloak, his left leg thrust diagonally downwards and his right knee raised. There are two more reliefs—less frequently met with, and therefore presumably less popular—for which the same sculptor manifestly was responsible. Was the sculptor Ghiberti? After many years of doubt, I feel pretty certain that he was. The case rests not only on the presence in some of the reliefs of a cast from the figure of Eve on the Gates of Paradise, but also on the style of the reliefs themselves. Looking at the way in which Ghiberti disposes the legs of the drunken Noah on the Gates of Paradise, it seems to me quite possible that he planned the cartoons of the Child in these placid and beautiful reliefs. More specific is the connection with the *Saint Stephen* on which he was working at the time the reliefs must have been made. Not the statue of *Saint Stephen,* where the forms are monumental and simplified, but the preliminary drawing in the Louvre, where the folds work in rather the same way. The case is not susceptible of proof, but I should stress here that it rests on observation, and not, as has been claimed, on the desire of museum officials in the nineteenth century to add works by Ghiberti to the collections of which they were in charge.

At that time, of course, quite a large number of works were given to Ghiberti for which he cannot possibly have been responsible. But the claims of certain of the sculptures ought not to be dismissed. One exists in a single version only and is at Rochester (fig. 24). What connects it with Ghiberti are the fluid drapery forms and the type of the Virgin; the head of the Child, indeed, recalls the Christ in the *Christ Among the Doctors* on the first bronze door. The trick of pulling the heads of the two figures forward from the relief plane is one that we find constantly in Ghiberti's early bronze reliefs. This is not at first sight a very appealing sculpture—it is really a raised painting from which the color has been removed—and it is very difficult to judge if it was modeled by Ghiberti or was designed by Ghiberti about 1415 and modeled by one of the assistants on the first bronze door. There is one other relief—it comes from the Silten Collection and is now in London (fig. 25)—which also proceeds from the first bronze door; its point of affinity is with the Virgin and Child in the *Adoration of the Magi.* It is weakly modeled—an attribution to Ghiberti could not, for that reason, be given serious credence—and whether or not it was designed by Ghiberti, it must be the work of some hanger-on in his densely populated shop. This relief, too, would have looked a great deal more appealing when it still wore a decent painted dress.

The finest of these modeled reliefs is a marvelous terra-cotta Madonna at Detroit (fig.

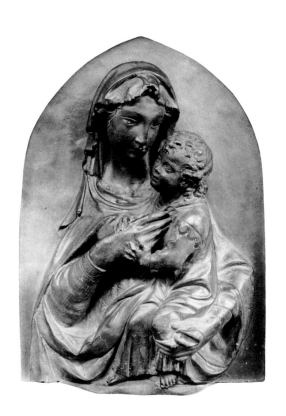

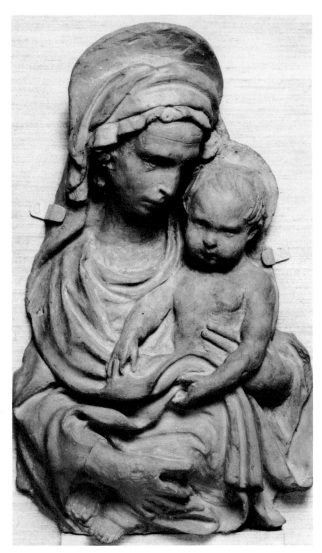

24. LORENZO GHIBERTI. *Virgin and Child*. Terra-cotta, 55.9 x 36.9 cm.
Memorial Art Gallery, Rochester, New York

25. WORKSHOP OF LORENZO GHIBERTI. *Madonna and Child*. Terra-cotta, 35 x 21 cm.
Victoria and Albert Museum, London. Lent by H. Ingham

26. LORENZO GHIBERTI. *Madonna and Child*. Pigmented terra-cotta, 69.9 x 43.2 cm.
Detroit Institute of Arts. Bequest of Eleanor Clay Ford

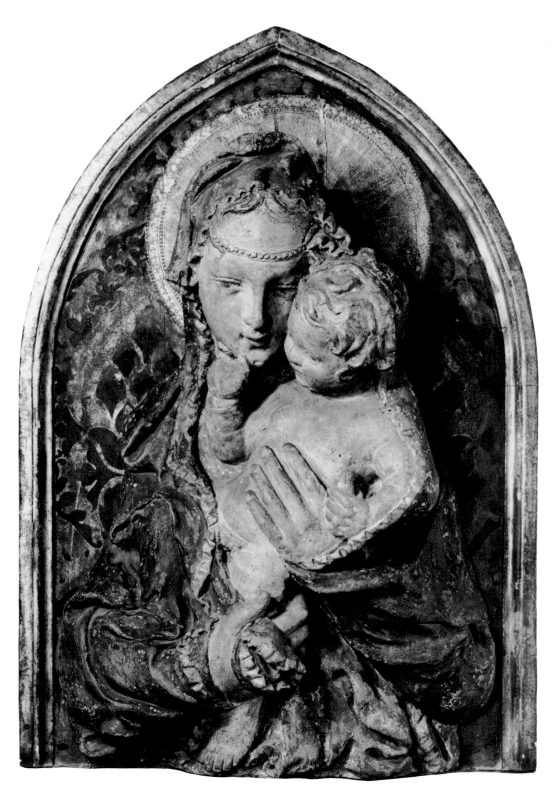

26), where the wriggling Child touches his mother's chin, and the cloak which encloses the two figures is broken up in folds of fantastic animation and variety. Quite a lot of the original paint surface is preserved, and the hair is gilt. The style recalls the little relief of Puarphera on the Gates of Paradise, and it is one of the few works of its class for which a direct ascription to Ghiberti and a dating to the mid-1430s can be seriously sustained.

As Ghiberti's son Vittorio reached maturity—he joined the studio in 1437—the production of modeled terra-cotta reliefs seems to have been stepped up. Experiments were made with the manufacture of cassoni inlaid with terra-cotta reliefs. One cassone, with *God the Father Rebuking Adam and Eve,* the *Expulsion,* and the *Labors of Adam and Eve,* survives in London, and part of a second, with the *Creation of Eve,* is in storage in Florence.[14] There is no way of telling whether they originated with Vittorio or were modeled by him after his father's designs. Plainly by the same hand as the cassoni is a Madonna relief covered with white slip as a base for gilding (the cassoni reliefs were also glazed and gilded); and in this case the possibility of a Ghiberti model can be dismissed.[15] The head of the Child corresponds very closely with the head of the child carried by Adam on the surround of Andrea Pisano's door on the Baptistery, and the relief was therefore almost certainly made *ab initio* by Vittorio Ghiberti. We know, moreover, one other work made by this same sculptor, a seated statuette in London.[16] When I catalogued it fifteen years ago, I was a little influenced by the old myth that the great collections of Italian sculpture were filled with forgeries, and I implied in the entry that this group might just conceivably be wrong. The group has lost almost all its paint, but it is an imposing thing, and I believe that if the Child is compared with the child on the shoulder of Vittorio Ghiberti's Adam, the identity of handling will be plain.

So I think Ghiberti's claim that he was a prolific artist who made models which were employed by other sculptors was perfectly correct. But the sentence in the *Commentaries* contains a second clause: "and for the painters I have designed very many things." One document refers obliquely to a work of painting, the commission in 1432 for the tabernacle which contains the great Linaiuoli triptych of Fra Angelico. The triptych is very large, and if it were permissible to translate Ghiberti's phrase "fuori della naturale forma" as "above their original scale" and not "above the scale they had in life," one could conceive that here cartoons by Angelico were enlarged under Ghiberti's guidance to what, for Angelico, was the exceptional scale of the painting. The outsides of the triptych wings, with their majestic figures of Saints Peter and Mark, may have been wholly designed by Ghiberti; their relation to the *Saint Stephen* on Or San Michele is very close. I wonder indeed if the connection ends there. One of the features of the tabernacle we take for granted is the frame of small music-making angels round the Virgin and Child. There is no precedent in Angelico for their twisted poses and cursive forms, and I have on more than one occasion asked myself whether these curiously tactile little figures could not have been Ghiberti-

planned. Ghiberti's influence on Angelico during the 1430s has been discussed more generally in a brilliant article by Ulrich Middeldorf.[17] There is also quite a high degree of probability that models were made by Ghiberti for some of the figures in Uccello's early Genesis frescoes in the Chiostro Verde.[18]

There is one other area where Ghiberti probably intervened in painting, though there are no documents to prove it, and that is in the cathedral. We know that he designed the windows for the tribune chapels, which showed, generally in the upper section, the titular saint. But lest the dedication of the chapel be in any doubt provision was also made for a fresco of the titular saint on the altar wall. It was really a single operation; Ghiberti's designs for most of the windows date from about 1439, and in the years 1439 and 1440 the frescoes beneath them were produced. They were entrusted to a secondary artist, Bicci di Lorenzo, and are difficult to judge today since they are almost totally repainted. Some of them were destroyed by restoration in 1840, and some had to wait till 1906. But it is surely unlikely that when the windows above were planned by Ghiberti with such close care, the uniform scheme for the frescoes was not also his.

There are, lastly, certain things of which Ghiberti could not have been conscious when the *Commentaries* were written. He could not have predicted that about 1452 the structure of the *Story of Isaac* would be taken over by Fra Filippo Lippi and inserted in the background of the tondo that is now in the Palazzo Pitti. He could not have told that also in the 1450s and also by Filippo Lippi the modest scheme of the *Story of Abraham* would in the choir of Prato cathedral be expanded to a colossal scale. He could not have told that the romantic view of nature which he impressed on the bronze door would give rise, in the hands of Lippi, to the mysterious vision of the Annalena altarpiece. He could not have told that Benedetto da Maiano, when he designed the marble pulpit for Pietro Mellini in Santa Croce, would set his sights on the bronze reliefs on the Gates of Paradise. He could not have predicted that in the sixteenth century Cellini's last major aspiration would be to make a counterpart to his bronze door, and that for Sansovino in Venice, a hundred years after it had been completed, the door would still serve as a paradigm of style. In a sense Vasari, writing at a time when the sculptor's reputation was at its peak, on the basis of quite close familiarity with his descendants, was perfectly correct in regarding the *Commentaries* as an accretion to his achievement. There is a passage in Nietzsche which says: "To experience a thing as beautiful is to experience it necessarily wrongly." It is no use to approach Ghiberti in that way, for the qualities for which we prize him now are the same qualities for which he was prized in the fifteenth and sixteenth centuries, the mellifluousness and lyricism of his style, the delicacy and the conscientiousness of his technique, the power and individuality of his imagination, and the sense (which he was the first European sculptor to define and to transmit) that the fit subject of art is the whole God-created natural world.

NOTES

1. R. Krautheimer, in collaboration with T. Krautheimer-Hess, *Lorenzo Ghiberti,* 2nd ed., i (Princeton, 1970), p. 3.

2. G. Poggi, "La ripulitura delle porte del Battistero fiorentino," in *Bollettino d'Arte,* xxxiii (1948), pp. 244–57.

3. J. von Schlosser, ed., *Lorenzo Ghibertis Denkwürdigkeiten* (Berlin, 1912).

4. G. Vasari, *Vite,* ed. G. Milanesi, ii (Florence, 1906), p. 247. There is no reference to Ghiberti's written work in the first edition of the *Lives.*

5. Krautheimer, op. cit., 1st ed. (Princeton, 1956).

6. For an exemplary analysis of this drawing and of the problem of Ghiberti's drawing style, see B. Degenhart and A. Schmitt, *Corpus der italienischen Zeichnungen, 1300–1450,* 1, ii (Berlin, 1968), pp. 289–93.

7. Ibid., p. 290.

8. M. Salmi, "Lorenzo Ghiberti e la pittura," in *Scritti di storia dell'arte in onore di Lionello Venturi* (Rome, 1956), pp. 223–37.

9. M. Boskovits, *Pittura Fiorentina alla vigilia del Rinascimento, 1370–1400* (Florence, 1975), fig. 452.

10. Krautheimer, op. cit. (1956), p. 154: "The large front relief of Saint Zenobius resurrecting a boy of the Strozzi family was probably designed prior to 1437 and cast after 1439." The subject of the scene is described correctly by Ghiberti and incorrectly by Krautheimer.

11. For the panel of the *Last Judgment* see S. Orlandi, *Beato Angelico* (Florence, 1964), pp. 28–29, and J. Pope-Hennessy, *Fra Angelico,* 2nd ed. (London, 1974), p. 192.

12. The attribution of the design to Ghiberti is due to L. Planiscig, *Lorenzo Ghiberti* (Florence, 1949), p. 96: "Forse da un disegno del Ghiberti, eseguito da un ignoto scarpellino."

13. For a detailed analysis of this problem see J. Pope-Hennessy and R. Lightbown, *Catalogue of Italian Sculpture in the Victoria and Albert Museum,* i (London, 1964), pp. 59–61.

14. Ibid., pp. 57–59.

15. W. von Bode, "Ghibertis Versuche, seine Tonbildwerke zu glasieren," in *Jahrbuch der preussischen Kunstsammlungen,* xlii (1921), pp. 53–54.

16. Pope-Hennessy and Lightbown, op. cit., i, pp. 61–63.

17. U. Middeldorf, "L'Angelico e la scultura," in *Rinascimento,* vi (1955), pp. 179–94.

18. J. Pope-Hennessy, *Paolo Uccello,* 2nd ed. (London, 1969), p. 5.

THE MADONNA RELIEFS
OF DONATELLO

SOME READERS may demur at the plural. It is now widely believed that Donatello made only two Madonna reliefs, and a few benighted purists think he made only one. The reason for that is that early in this century the whole subject was queered by hopeless hopefulness. It was first discussed in articles by Bode in 1884 and 1886,[1] which are filled, like so much of his work, with brilliant observations, but which were based on faulty terms of reference; they deal with the work of Donatello's followers and collaborators as well as with that of Donatello. The consequence of this approach is evident in Schubring's *Klassiker der Kunst* volume of 1907, in which it is assumed that anything, absolutely anything, may be by Donatello (fig. 1). There are no documents—with reliefs of the Virgin and Child there seldom are—so Donatello students decided, timidly, to reduce the risk of error by ignoring the Madonna reliefs. It was a strange decision. If other sculptors gave careful thought to reliefs of the Virgin and Child, why should not Donatello have done so too? Certainly in the sixteenth century it was believed he had; quite a number of Florentine

1. Plate from Paul Schubring's *Donatello (Klassiker der Kunst)*, Stuttgart-Leipzig, 1907. Of the four reliefs attributed to Donatello, one (upper right) is a stucco replica of a relief of 1854 in Santa Croce by Odoardo Fantacchiotti (1809–1877); another (lower left) is by a fifteenth-century imitator of Donatello; the third is by a provincial Aretine sculptor; and the fourth (upper left) is after Donatello.

71

palaces boasted reliefs for which he was considered to have been responsible.[2] The Madonnas ascribed to him, moreover, include some of the greatest works produced in the whole fifteenth century. This is one of those cases—they are not uncommon in art history—where the application of rigid historical method has led to an unhistorical result.

The single relief which has never been doubted is the Pazzi Madonna in Berlin (fig. 2).[3] Its provenance has been questioned (wrongly I suspect),[4] but not its attribution. Looked at afresh, it is an astonishing invention. Where other sculptured Madonnas are planned in relation to real space, the space of the room in which they stood or hung, Donatello's is self-contained; it is enclosed in a kind of perspective cage. The figures are compressed between a perfect square behind and a frontal frame which reads as a square, though it is in fact a little higher than it is wide. Across the rectangle from the corners of the ceiling run two diagonals which meet in the center of the base. Analogies for this scheme are found in painting, in Masaccio's Pisa polyptych of 1426, where the construction of the Brunelleschan throne is on a higher level of accomplishment, and in the mid-1430s in the Carnesecchi Madonna by Domenico Veneziano, where the wings of the throne fulfill the same function as the diagonals of the Pazzi Madonna. How then does Donatello's Madonna relate to these two paintings?

The conventional answer is that it comes first. From the time it reached Berlin—it did so comparatively late, in 1886—it was dated about 1420, and a dating about 1422 is still

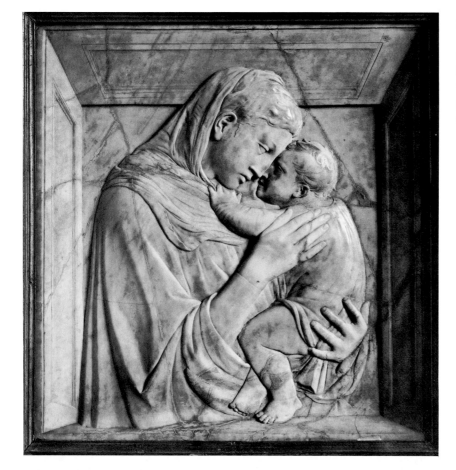

2.
DONATELLO. Pazzi Madonna. c. 1430. Marble, 74.5 x 69.5 cm. Staatliche Museen, Berlin. The viewing point adopted in this photograph is in the center of the relief.

favored in most Donatello catalogues.[5] The date rests on two separate arguments. The first is its connection with a datable work of 1422, the *Sibyl* on the Porta della Mandorla of the cathedral. At first sight the two profiles look very similar, but when the reliefs are read more carefully it transpires, from the rippling hair of the Virgin and from the carving of her right hand which presses on the Child's shoulder with the little finger slightly turned, that the Madonna is more advanced and must be a later work. The second argument derives from the perspective scheme. The Pazzi Madonna is claimed to have three vanishing points,[6] and therefore to precede the relief of the *Feast of Herod* on the Siena Font, which is constructed more scientifically. There is a fundamental misconception in that case. It presupposes that in the Pazzi Madonna Donatello was endeavoring to produce a systematic, unified perspective scheme. The evidence from the relief itself, however, is that he was attempting nothing of the kind. The relevance of the diagonals established by the corners of the ceiling is to the relief as pattern not to the relief as space, and the rendering of the receding surfaces, at the sides and on the top, cannot be regarded as other than empirical. There is, moreover, an essential difference between the way in which we see the carving in photographs and the way in which Donatello intended that it should be seen. The viewing point postulated in photographs is in the center of the relief, but the true viewing point is, as we might expect, where the guiding diagonals coincide in the center of the base (fig. 3). When it is inspected from a lower level, the geometry of the whole scheme looks less

3.
DONATELLO. Pazzi Madonna. See fig. 2. This photograph is made from the correct viewing point in the center of the base.

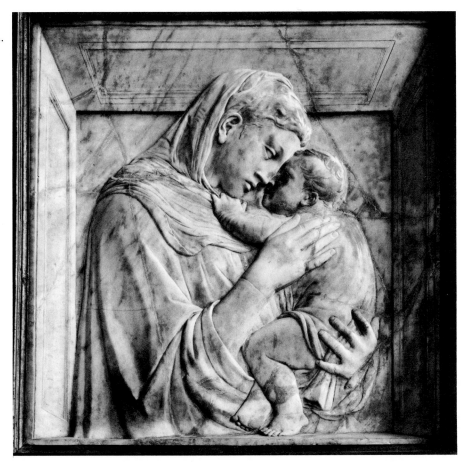

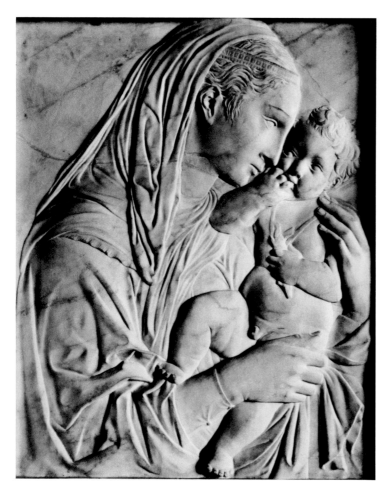

4.
Orlandini Madonna, by an unidentified imitator of Donatello.
Marble, 80 x 69 cm.
Staatliche Museen, Berlin

5.
Virgin and Child, after Donatello.
1430–35. Bronze, 11.6 x 9.4 cm.
Victoria and Albert Museum,
London

6.
Virgin and Child, after Donatello.
Mid-1430s. Stucco, 12.1 x 9.5 cm.
(relief only). Painted frame
by Paolo di Stefano.
Victoria and Albert Museum,
London

confusing, and there is nothing in it that would be inconsistent with a dating about 1430.

That dating is supported by the figure style. In the Child the foreshortened left arm depicted from beneath and the turned up sole of the right foot recall the Prato pulpit of the early 1430s, while the bold modeling of the Virgin's cloak and the soft transverse lines of the veil across her shoulder resemble the *Ascension with Christ Giving the Keys to Saint Peter* in London, and no earlier relief. A curious device in the Pazzi Madonna, whereby part of the Child's head is concealed behind the head of the Virgin, recalls the superimposed profiles of the *Ascension,* and it would be reasonable to assume that the relief proceeds from the same experience of Masaccio and of the antique from which the *Ascension* itself springs.

One other Madonna relief by Donatello, in Siena, is planned with a fixed viewing point. It was carved more than twenty-five years later for a monumental complex in which its position was (or was wrongly supposed to be) immutable, and it may well be that the Pazzi Madonna, with its highly unorthodox shape, its elaborate construction and its exceptional scale, was also destined for some larger whole. In independent reliefs, which were liable to

be moved, a fixed viewing point would have been something of a liability, and in the stucco squeezes which were made from the Pazzi Madonna the casement is simplified or left out, and what is disseminated is the figure group. Through stuccos it became an immensely influential composition. The sculptor of the Orlandini Madonna (fig. 4) in Berlin reproduces the head and veil of the Virgin, but changes the position of her hands and the posture of the Child,[7] while the author of a weak stucco relief in London modifies both heads, but reproduces the shoulder of the Virgin and her right arm.[8] For Donatello the Pazzi Madonna is a key work. It reveals him as a mimetic artist concerned with translating into marble aspects of ocular experience that would normally be thought of as unsuited to sculpture, and it is the first pictorial Madonna relief. Its interpretative level is, however, more exalted than that of any contemporary painting, and where Donatello, in the cameo profile of the Virgin, refers to the antique, he anticipates the ambiguous emotional language of High Renaissance art.

In the first half of the 1430s this composition was developed in a bronze plaquette

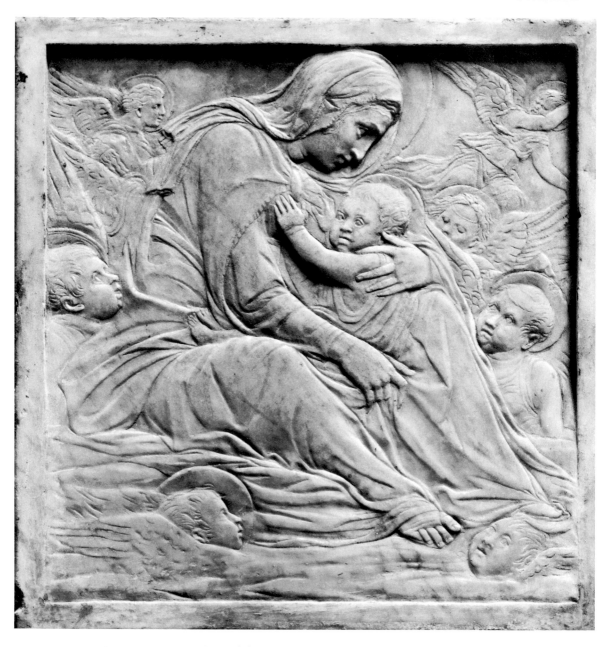

7. DONATELLO. *Madonna of the Clouds*. Mid-1430s. Marble, 33.5 x 32.2 cm.
Museum of Fine Arts, Boston

(fig. 5), one of the only two small bronze plaquettes of the Virgin and Child ascribed to
Donatello in which the figure style is fully consistent with his authorship.[9] The diagonal
posture of the Virgin, with head in profile, is the same, but the Child no longer presses his
face against hers. Instead, swathed in her cloak, he looks out to the right. This is the first
intimation of a new relationship between the figures that reaches its climax a decade later
in a painted terra-cotta Madonna in the Louvre. The autograph original of this small relief

has not survived. It was, however, molded, and from the mold pigmented stucco copies were made. With the sculptor's approval, one presumes, for an example in London (fig. 6) has a painted frame by a known artist, Paolo di Stefano, which can be dated to the middle of the 1430s, when Donatello was still at work in Florence.[10] So we may infer that not only was the style of Donatello's Madonnas consciously pictorial, but that he was prepared to acquiesce in, even to encourage, their transmutation into painting.

One other Madonna relief can be ascribed to the mid-1430s, the small relief in Boston known as the *Madonna of the Clouds* (fig. 7).[11] It has been identified as a work which was once in the *guardaroba* of Cosimo I de' Medici, in a wooden frame with miniature scenes by Fra Bartolommeo, and which in the late fifteenth century was owned by Piero del Pugliese.[12] This pedigree is not absolutely certain, but the arguments in its favor are substantial, the more so that the relief, with its unsightly, flat surround, must from the first have been intended to have a wooden frame with a receding molding that would heighten the illusionism of the central scene. The *Madonna of the Clouds* is generally dated about 1428, on the strength of its relationship to a work that is exactly datable, the *Assumption of the Virgin* on the Brancacci monument (fig. 8).[13] In practice this connection is of a rather superficial kind. There is a world of difference between the Masaccio-inspired Virgin in the *Assumption* and the post-Masacciesque Virgin in the *Madonna of the Clouds*; between the classicizing angels in the earlier and the rotund cherub heads in the later relief;

8. DONATELLO. *Assumption of the Virgin*. c. 1428. Marble, 53.5 x 78 cm.
 Relief on the Brancacci Monument, Sant' Angelo a Nilo, Naples

and between the narrative techniques of the two scenes. In the *Assumption* the head of the Virgin is disengaged from the top frame, and the whole of each angel, save that in the lower right corner, is shown. But in the *Madonna of the Clouds* the frame presses down heavily on the Virgin's head, trepans the angel on the left, and cuts off the wings of the distant angel above and the hands of the angel opposite. The spatial concept is also rather different. In the *Assumption* depth is intimated by the receding surface of the Virgin's seat; in the *Madonna* it is indicated more subtly through the foreshortening of the right leg of the Virgin, which seems to protrude from the plane of the relief. In the *Madonna*, moreover, despite its tiny scale, two of the putto heads seem to have been carved by an assistant, who was also employed by Donatello in the middle of the 1430s on the pulpit at Prato. The Boston Madonna, therefore, is likely to date from the 1430s too.[14] Implicit in the arbitrary severing of the composition on three sides was a threat of formlessness, which is averted by two simple geometrical expedients, first that the Child's extended legs rest on a horizontal drawn through the exact center of the slab, and second that the right forearm of the Virgin establishes, with decisive strength, a diagonal from the upper left to the lower right corner of the relief.

If it be accepted that the Pazzi Madonna and the *Madonna of the Clouds* have in common the geometrical planning of a rectangle, we are bound to entertain the possibility of Donatello's authorship of works where the geometrical expedients are the same but the surface is circular. This is the case with a little gilt-bronze Madonna in Vienna (fig. 9), of which Donatello's authorship is now almost universally denied.[15] My reason for returning

9.
DONATELLO.
Virgin and Child with Two Angels. c. 1440.
Gilt bronze,
diameter 27 cm.
Kunsthistorisches Museum,
Vienna

to it here is not just that the main figure, a Madonna of Humility seated as she should be on the ground not in the sky, is wholly in the spirit of the works we have been looking at, but that its structure plainly proceeds from the same mind. Once more a strong diagonal runs across the composition, established on this occasion by the left leg of the Virgin and the two arms of the Child, and reinforced, as it is in the *Madonna of the Clouds*, by the Virgin's right leg, and once more the surface is divided horizontally. The *Scenes from the Life of Saint John the Evangelist* in the Sagrestia Vecchia of San Lorenzo in Florence are subdivided horizontally in rather the same way. No less decisive are the putti at the sides. Their function is spatial—the one on the left stands forward of the central group, half concealing the line of the Virgin's back, and the one on the right stands behind—and the tension they create as they stretch out their heavy garland, each pulling away from the center of the scene, closely recalls the paired figures of shrinking saints on the doors of the Sagrestia Vecchia. This little relief has been claimed as the work of a follower of Donatello, but the truth is that he had no followers capable of inventions of this kind. If we compare the drapery folds, in the Virgin's veil or cloak or dress, with the robe of the Evangelist in *Saint John the Evangelist on Patmos* in the Sagrestia Vecchia (fig. 10), we can only conclude that the Vienna relief is a minor work produced at the same time.

The Madonna owned by Piero del Pugliese was supplied with wings by Fra Bartolommeo, and with the Vienna roundel something of the same sort occurred. About 1470, it was provided with a marble frame carved, no doubt at some expense, by a follower of Desiderio. More than that, stuccos from it were made (fig. 1), and though they are less

10.
DONATELLO.
Saint John the Evangelist on Patmos. 1434–43. Pigmented stucco, diameter 215 cm. (without molding). Old Sacristy, San Lorenzo, Florence

79

crisp than the original, they successfully transmit the essence of Donatello's design. The *Madonna of the Clouds* was never reproduced in stucco.[16] It is more pictorial than the Pazzi Madonna or either of the small bronze reliefs, and we could well imagine it translated into paint with gilded angels in a pale blue sky. In fact the only copies of it that we know, a coarse version in marble in London and a drawing in Florence, date from quite late in the sixteenth century.

In 1443, Donatello moved his studio from Florence to Padua, to work on the *Gattamelata* and on the crucifix and high altar for the Santo, and there is one substantial relief, the so-called Verona Madonna (fig. 11), which was almost certainly executed while he was there.[17] The reason for saying that is that the best-known version of it, in the Via della Fogge at Verona, is accompanied by casts from two of the angels on the Padua high altar. So the Madonna may date from about the same time as the reliefs of angels, from about 1450 that is. One takes the Padua angels for granted, but they are in fact rather unorthodox works. They are set in space (each of them is backed by a shallow rectangular niche), but the space is so contrived that it appears to be much greater than it is. What is involved is not perspective, but a kind of optical trick, whereby the shallow niches are made to look deeper than they are, and the figures in half-relief register as being almost in the round. The Verona Madonna is treated in precisely the same way. Once more there is physical depth, in the ledge or balustrade across which the Child's foot projects, and the figures above are once more in half-relief, though they leave, like the angels on the altar, a strong impression of recessiveness. To judge from the versions that survive, this was Donatello's most popular relief. A number of the surviving versions certainly date from the fifteenth century, but none of them is so remarkable that it can be looked upon as the original. There is indeed no certainty as to the medium in which the original was made—bronze or terra-cotta, we simply do not know—but it seems that the best versions were made from a single mold, probably with the authority, perhaps under the supervision of Donatello. The emotions that can be read into the Pazzi Virgin become more explicit here. There is a letter from Sant' Antonino to Diodata degli Adimari which describes how Christ, through his divine nature, even as a child enjoyed prevision and foresaw the bitter suffering of his future passion, and in Donatello's relief the prophetic intuition that leaves its mark on the Virgin of the Pazzi Madonna has its corollary in the human fear experienced by the Child.

Before the last war there existed in the Kaiser Friedrich Museum in Berlin a colored terra-cotta relief (fig. 12), which had a Florentine provenance but may also have been made in Padua.[18] The Virgin was shown in prayer, with the Child propped up in her left arm against her side. The relief was covered with gesso and fully pigmented, and was (and would have been considered in the fifteenth century) not a sculpture but a recessive painting. The Virgin's hair was parted in the center, as it is in the Madonna of the high altar; her hands were modeled like those of the Santa Giustina on the high altar, with long

12. DONATELLO. *Virgin and Child.*
 Pigmented terra-cotta, 102 x 72 cm.
 Formerly Kaiser Friedrich Museum, Berlin

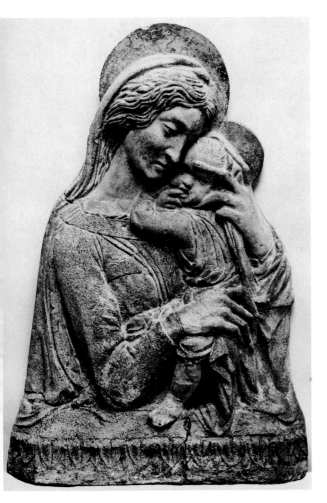

11. Verona Madonna, after Donatello. c. 1450. Stucco,
 height 95.3 cm. Victoria and Albert Museum, London

RIGHT:

13. DONATELLO. *Virgin and Child.* Present state of relief
 shown in fig. 12. Bode Museum, East Berlin

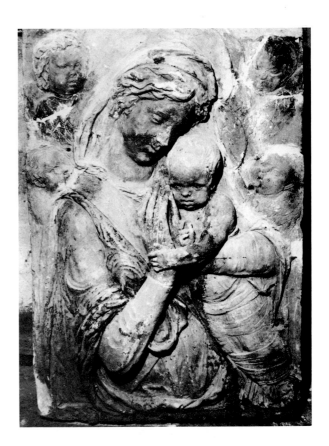

fingers and protracted nails; across her left arm there flowed a veil like that held by Saint Daniel; and the type of the Child corresponded with that of the Child on the high altar, with its strongly defined chin and protruding lower lip.

The past tense must be used for the sad reason that in 1945 this relief was virtually destroyed. The surface was burned, so that the paint and gesso preparation came away, and the terra-cotta beneath was fragmented. The pieces that survived were swept up and taken to Russia, where they were reintegrated. The result (fig. 13) is now shown in the Bode Museum in East Berlin. As a work of art the relief has been destroyed. It was one of the most beautiful Madonnas of the quattrocento, but nobody would guess that now. Nonetheless the pieces of it that are genuine still have some interest, simply because they prove that the relief was autograph. And none more so than the almost intact head of the Child.

The relief is unique. It was modeled by Donatello, and since he was a painter, it was presumably pigmented by him too. Its influence (or more strictly the influence of the type of relief it represents) was felt long after he left Padua. About 1460 it established the type of Mantegna's Madonna in the Metropolitan Museum, and about 1480 it was developed by Mantegna into the *Madonna and Child with Cherubim* in Milan. One other unique relief of the same kind survives. This is the Madonna in the Louvre (fig. 14), where the whole of Donatello's paint surface is still preserved.[19] It is a good deal more schematic than the Berlin Madonna—the Virgin's left arm reasserts the horizontal of the base, and her neck and the Child's legs are parallel with a diagonal from the top left to the bottom right corner of the relief—and on that account it could be argued either that it was one of the last works Donatello produced in Florence or one of the first works he made in Padua. The modeling of the veil and dress recall two immediately pre-Paduan stucco reliefs, the *Saints Stephen and Lawrence* and *Cosmas and Damian* in the Sagrestia Vecchia. As in the Pazzi Madonna, the two figures are compressed in a comparatively shallow area, established in front by the arms of the seat and at the back by a suspended curtain covering the rear wall. This time, however, the Child's body is turned above the waist, and he looks out in the same direction as the Virgin, to the left, with one hand raised in a tentative gesture of benediction and the other clenched. This superb relief exercised no influence on painting, but it is one of the sources of the Altman Madonna by Antonio Rossellino in the Metropolitan Museum (see pages 135 to 154). These Madonnas must have been made comparatively rapidly. They were modeled in clay, baked, and painted, and the directness of the handling is one source of their appeal. Though very few of them survive, they suggest that Donatello was a productive artist. This was the view of older Donatello scholars, and it has been discredited simply because so many of the works they gave to Donatello are in fact by other hands.

14. DONATELLO. *Virgin and Child*. 1440–45. Pigmented terra-cotta, 102 x 74 cm.
 Musée National du Louvre, Paris

82

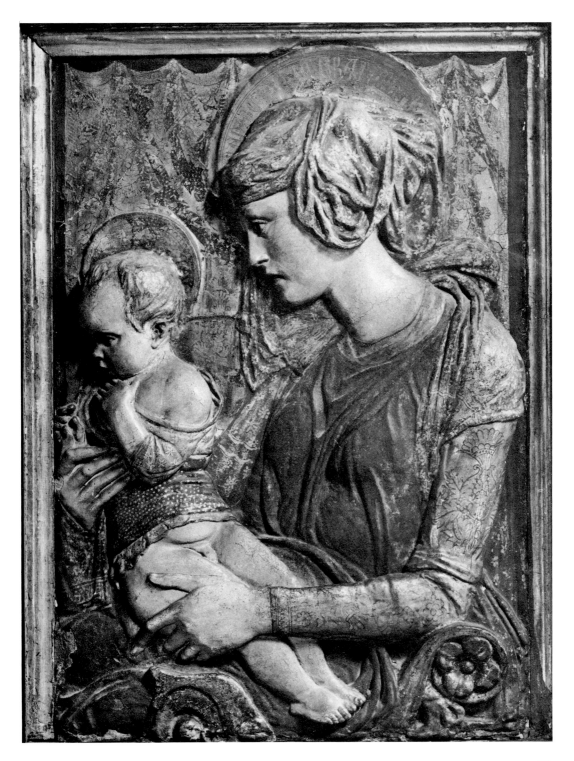

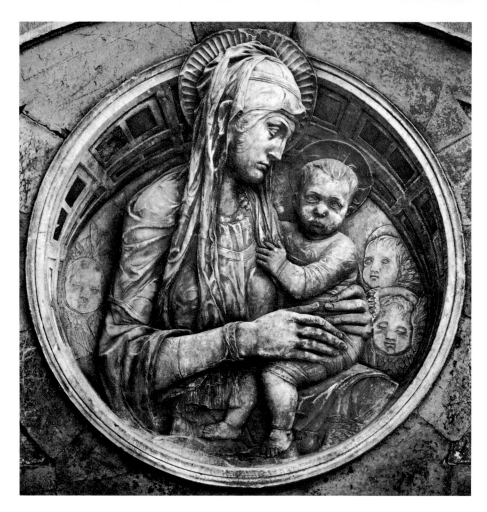

15.
DONATELLO AND
ASSISTANTS. *Virgin and
Child with Two Angels*.
1457–58. Marble.
Cathedral, Siena

Donatello returned to Florence in 1453, stayed there for four years, and then in 1457 moved to Siena, where he seems to have intended—he was aged over seventy—to pass the remainder of his life working for the cathedral. By and large these were unhappy and frustrating years. The great bronze Baptist in Siena was cast in Florence before he left, was damaged or flawed during its journey, and remained in storage under the cathedral till after Donatello's death. The project for bronze doors for the cathedral was abandoned, and almost the only work to be completed was in the Chapel of Saint Calixtus.[20] It took the form of an altar with an empty niche (presumably for a figure of the saint). Above it was a circular relief of the *Virgin and Child with Two Angels* (fig. 15), and above that again was a half-length figure of Christ. From inventories it appears that the work was completed by 1458.[21] At a much later date, in the seventeenth century, the *Virgin and Child* was moved to the Chapel of the Madonna delle Grazie or the Cappella del Voto, and in 1677 it was built into the side of the cathedral over the Porta del Perdono.[22] Though the position in which we see it now must be a little higher than that for which it was intended, it is, like the Pazzi Madonna, a work designed with a fixed viewing point. The effect is more summary

84

simply because the interstices of the surround radiate from the center of the roundel, and the diminution of the panels between them is optical. The speed with which the altar was finished is reflected in the execution of the relief. To judge from the carvings on the Prato pulpit, Donatello's practice was to make clay models which were carved in marble in his studio and which he then retouched, and something of the sort unquestionably happened here, though the Virgin's severe, reflective head, her transparent veil, and the carving of her sleeve are likely to be in part autograph.

Though it was executed against time, the Siena Madonna resulted from long thought. The thinking of which it is the outcome began in Padua, where, in the background of the *Miracle of the Newborn Child*, Donatello inserted above a door a round Madonna (fig. 16) which is important not for its diminutive figure content but for its design; it is framed in a wreath which diminishes at the base. When he returned to Florence he continued to ponder the implications of this frame. The proof of that is contained in a newly discovered autograph relief.

Its story is so strange that I shall tell it in the first person singular. About twelve years ago, when I was cataloguing the Italian sculpture in London, I reached an impasse with the entry for Antonio Rossellino's bust of Giovanni Chellini (fig. 17). There was no doubt who carved it or when—Rossellino's name and the date 1456 were underneath—and there was no doubt whom it represented—Chellini's name was underneath as well. The trouble was that we know almost nothing about Giovanni Chellini save that he was for a time lecturer in medicine at the University of Florence and was buried at San Miniato al Tedesco. So I arranged for Ronald Lightbown, who was working with me on the catalogue, to go to

16. DONATELLO. *Miracle of the Newborn Child*, detail. 1446–50. Bronze. Sant' Antonio, Padua

17. ANTONIO ROSSELLINO. *Giovanni Chellini*. 1456. Marble, height 51.1 cm. Victoria and Albert Museum, London

Florence to investigate Chellini. He succeeded in turning up in the Archivio di Stato a seventeenth-century copy of a history of Chellini's family by Scipione Ammirato, who had access to the text of a *Memoriale*, a little autobiography, prepared by Chellini himself for the information of his descendants. From that something rather startling transpired, that Chellini was a friend and doctor of Donatello, and that when Donatello returned from Padua he suffered an illness from which he eventually recovered thanks to Chellini's skill. In 1456 Chellini was presented by Donatello with a bronze relief. It showed the Virgin and Child with angels, it was the size of a *tagliere* (I shall return to that point), and on the back it was recessed in such a way that when a cast was made the resulting image was identical with that on the front face.[23] A little later another, superior transcript of this document was traced by Professor Janson.[24] Unwisely, he applied the hatchet of reason to the information it contained. No relief of the kind, he declared, was known, and Chellini, or the "old gentleman," as he pityingly called him, must in his ignorance have supposed that the

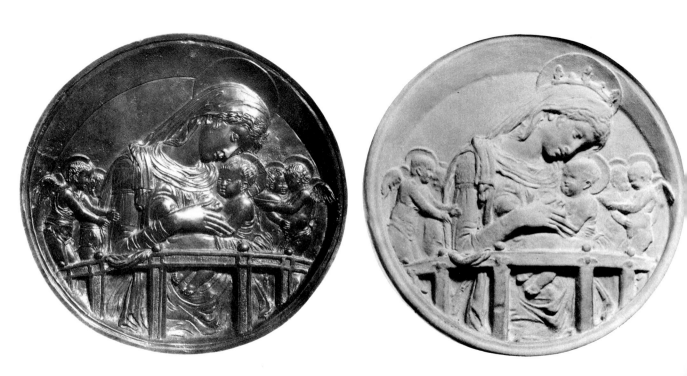

repoussé back of some conventional relief was intended as a mold. I too might have dismissed the whole thing as fiction, but for the fact that I have a tremendous suspicion of logic; give me controlled intuition any day of the week. Anyway when one turns up new evidence, one's job is to explain it, not to explain it away. I looked at the bust, and Chellini's did not seem to me a stupid face. He had, moreover, a collection of silver vessels which he occasionally lent to his friends, and he must therefore have known something about metalwork techniques. More important, the description was so specific, that even if no other fifteenth-century incuse (recessed) relief existed, I thought it could hardly be wrong.

There were quite a number of problems nonetheless. First of all what was the size of the relief? Professor Janson had no doubt of that. *Tagliere*, he said, meant "trencher," a large platter for carving up or serving meat, and from that he deduced that the relief had a diameter of sixty to ninety centimeters, and was intended for the wall of Chellini's funerary chapel at San Miniato al Tedesco. Psychologically at least it seemed a little odd that a near nonagenarian doctor should be presented by the patient he had rescued from the brink of death with a large bronze relief for his own funerary chapel. The trouble lay with the word *tagliere*. It has quite a number of senses, but its conventional use is simply "plate." With the change from trencher to plate, the problem had to be redefined. Instead of looking for something big, one was looking for something small. There was as a matter of fact one other quite trivial mistranslation of which Professor Janson was guilty. He said that the relief showed the Virgin Mary with the Child at her neck and two angels at the sides, a Virgin and Child with two angels in other words. I read the words *da lato* to mean that there were two angels on each side, so that it was a Virgin and Child with four angels. On that account when I was cataloguing the Kress bronzes in the National Gallery of Art in Washington, I looked with renewed interest at one of the reliefs (fig. 18). Obviously it was

18. *Virgin and Child with Four Angels*,
 after Donatello.
 Bronze, diameter 22.2 cm.
 National Gallery of Art, Washington, D.C.
 Samuel H. Kress Collection

19. *Virgin and Child with Four Angels*, after Donatello.
 18th century. Plaster. Sir John Soane's Museum,
 London

20. J. K. SHERWIN. *Virgin and Child with Four Angels*.
 1770s. Etching. British Museum, London

not by Donatello, for one thing the surface working was too weak, but it showed the right number of figures and could quite well depend from a lost Donatello design.[25] Taking it out of its case I put it flat on a table in the hope that Chellini's term *tagliere* might be explained. And so it was, for when the relief was flat, it did look like the middle of a majolica plate. If it had had a flat rim, the description would have been entirely apt.

It transpired that there had, at one time, been another version of the design. The main respect in which it differed from the Washington relief was that the Virgin had a crown. Proof of its existence was contained in two fifteenth-century gesso squeezes, both badly damaged, one near Florence at Vicchio di Rimaggio and the other at Verona, in the Museo del Castelvecchio. In Sir John Soane's Museum in London, moreover, there was a late eighteenth-century plaster of the composition (fig. 19); it was given to Soane by the painter Henry Howard and it reproduced the whole design. It seemed likely that, when it was made, the relief was in English hands. There was confirmation that this was so, for in the

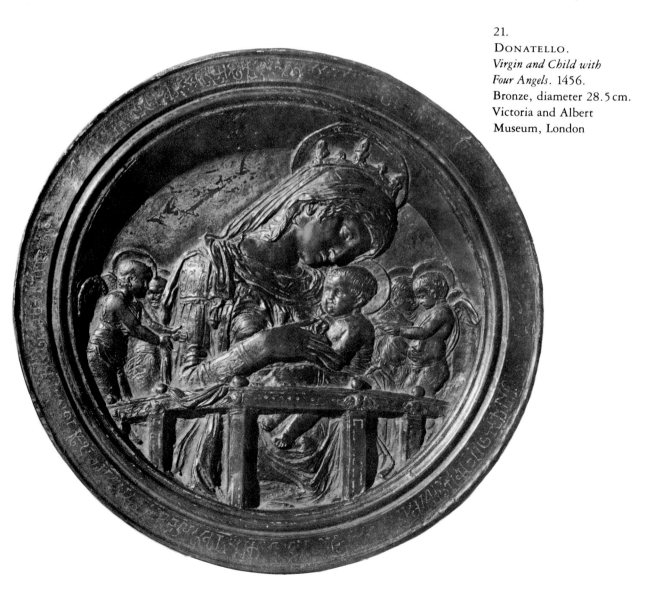

21.
DONATELLO.
Virgin and Child with Four Angels. 1456.
Bronze, diameter 28.5 cm.
Victoria and Albert Museum, London

1770s it was engraved by Sherwin (fig. 20), and the engraving showed round the edge the flat rim that was missing from the relief in Washington.[26] It was then the property of the second Marquess of Rockingham. Before his succession, as Lord Malton, Rockingham had spent the winter of 1748–49 in Florence.[27] One of his occupations there was the purchase of statues, tables, and other furnishings for Wentworth Woodhouse, which was in course of rebuilding by Flitcroft. In March 1750 he was summarily ordered by his father, the first marquess, to desist from further purchases, so he was likely to have secured the Donatello between 1748 and 1750. If one assumed, as it was reasonable to do, that the relief was preserved by Chellini's descendants along with the bust by Rossellino of the man for whom it was made, its sale would have taken place at almost exactly the same moment at which, through the marriage of the daughter of its putative owner, Senator Ascanio Samminiati, to Gian Cosimo Pazzi, the Rossellino bust passed to the Pazzi family.[28]

This was, therefore, likely to be the missing relief. The only thing that would prove it to

22.

Virgin and Child with Four Angels. Plate shows mold on reverse of bronze relief illustrated in fig. 21.

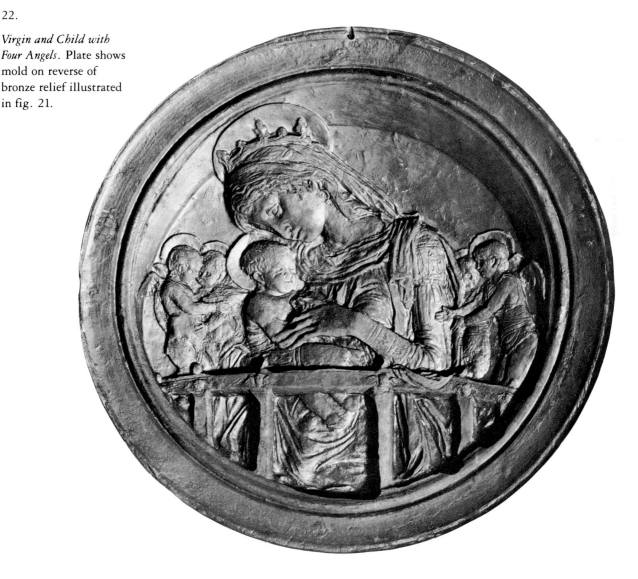

be so, however, would be the relief itself. If it had a recessed mold on the back, and only if it had a mold, could it be the relief made for Chellini by Donatello. Often the quickest way of finding things is not to look for them, and I did not look for this. A little time went by, and then, in the most casual fashion, the relief turned up. Late one evening, leaving a dinner party at the American embassy, I ran into David Carritt, who told me he had come across a circular bronze relief of the Virgin and Child in use as an ashtray. Was it double-sided? I asked him. Yes, he replied, he thought it was. Next day it was brought to my office, and sure enough the front face (fig. 21) corresponded with the engraving and the cast. But what mattered was the back, and when I hesitantly turned it over, I found the mold (fig. 22). So this was a new, fully documented, exactly datable Donatello relief.[29]

In one sense the relief was no surprise; its design corresponded exactly with that of the replicas. One feature only could not have been predicted, the presence of local gilding on the surface of the bronze. The inscription recorded by Sherwin proved to be applied, not incised or damascened, and the molding round the figurated area was also enriched with gilded ornament, in the form of small diagonal strokes which are shown in the Sherwin etching as strapwork. There were traces of gilding on the balustrade, round the edge of the Virgin's halo and on her crown, on her right shoulder and right cuff, and round the rim of the bowl held by the angel on the right. The flat background proved also to have been gilt. But while its form was predictable enough, neither the stucco and gesso copies nor the bronze copy in Washington gave the least impression of its artistic quality. Where the modeling throughout the Washington relief was smooth and superficial—witness the rendering of the Virgin's cheek and neck, her right hand, the hard folds of the veil across her throat, and the chest and left shoulder of the Child—and the degree of finish was of deadly uniformity, in the new bronze the modeling was infallibly precise and the degree of finish had the diversity of all of Donatello's autograph reliefs. To take one instance only, the two angels on the right were more highly worked up than the two angels on the left, where the top of one head was left almost in the rough and the exposed leg showed evidence of hammering (fig. 24). In the hands of a great artist bronze is a mysterious medium, and one would be hard put to it to name a single small relief in which its expressive possibilities are so fully explored as they are here and the emotional content is so direct. Whereas Donatello's other authenticated bronze reliefs were intended for public inspection on altars or pulpits or statues or fonts, this is quintessentially a private work, and no one who has had the good fortune to hold it in his hands could for a moment doubt that it is in this way alone that the relief was intended to be read.

Perhaps I should begin with the only aspect of the relief which was not reproducible. This is the inscription in gold letters round the rim. It takes us into the world of Kufic and cursive inscriptions on paintings. When the relief reappeared, I sent a photograph of the inscription to the Warburg Institute, in the hope that, in association with some Islamicist,

they could make out what it said. Their verdict was disappointing; they said that it meant nothing at all. My own view, nonetheless, is that having regard to the circumstances in which the relief was made, this is improbable.[30] The sense may be roughly in the only respect in which the two transcriptions of the *Memoriale* differ from one another. One ascribes Donatello's recovery simply to the medical treatment Chellini gave him, whereas the other says that the efficacy of Chellini's treatment was due to "divine aid" ("having through divine aid cured him of his ailments," is the exact translation). It would be credible if the relief, like so many other works of art in the fifteenth century, were structured, on Donatello's side, and perhaps on Chellini's too, on a hard core of personal belief.

Before I go on to discuss the style of the relief, I should also say a word about the mold. It has a certain significance since it shows that the relief was not simply self-reproducing (and that in itself is an odd phenomenon; the earliest incuse plaquettes date from the sixteenth century), but was designed to be diffused. In the middle of the century it was a common practice in the studios of Desiderio da Settignano and Antonio Rossellino to take molds from marble reliefs, from which gesso squeezes were made. They were colored, and in the case of those after Desiderio, were painted and sold by Neri di Bicci. From time to time we must all of us have caught ourselves wishing that quite so many replicas of works like the Turin Madonna of Desiderio and the Morgan Madonna of Rossellino (see fig. 8 on page 144) were not known. Our distaste springs from a modern prejudice that works of art ought to be unique. Yet here we find Donatello overtly subscribing to a view of the relief as a kind of multiple. Why did he do that? The answer must go something like this. By and large Florentine fifteenth-century paintings exist only in single versions. In a few studios they were reproduced in semimechanical fashion—in the shop of the Pseudo-Pier Francesco Fiorentino, for example—and in others, Botticelli's for instance, workshop copies were made from autograph originals. Nowadays we disregard them because of their impoverished artistic quality, but they fulfilled a valid function in their time; they admitted people who could not command the personal services of a great painter to the spiritual world that he explored. First and foremost they were objects of devotion, and only incidentally works of art. Sculptures could, of course, be reproduced more easily, but the copies were open to the same objection as facsimiles of paintings, that they were inferior in quality. To contemporaries it must have been abundantly apparent that the devotional efficacy of a copy was less great than that of an original. It was to this point that Donatello in the new Madonna deliberately turned his mind. As we know from all the sources, he was uninterested in money, and it is unlikely that he felt the least concern with the public-lending-right aspect of his reliefs. But he wished his images to be diffused, and diffused in a form that was demonstrably unimpaired. Proof of that is found in the nature of the mold behind the new relief. As soon as it turned up, a latex cast was made from the back (fig.

23), and it was a simulacrum of the front relief. The technique is the same that was used for the making of incuse reliefs in the sixteenth century, that the reverse was cast from a positive and the obverse from a negative of a single wax relief. As we should expect, the obverse was worked on after the cast was made; the mold shows a pattern of incisions on the Virgin's shoulder which was erased in the front relief, and the lower part of the angel on the left (figs. 24, 25), the hand of the Virgin, and the shoulder and chest of the Child were worked up manually on the front relief after it was cast. There is no evidence that this positive-negative technique was used by Donatello in any earlier work, and its employment corroborates what I have suggested earlier, that he spared no pains to disseminate the ethically inspiring images that he produced.

Of what were the replicas to have been made? According to Chellini himself, the mold was designed "per potervi gittare suso vetro strutto." This phrase is translated by Janson, "so that molten glass can be cast in it."[31] The making of a glass cast from a bronze mold is, however, a difficult operation, and the word "strutto" does not normally mean molten. Moreover, one of the contributory arguments advanced by Janson in favor of this interpretation, that "there are no replicas of the panel in cheaper materials," is incorrect. Two replicas exist in a medium which is commonly described as stucco. No thorough examination has been made of the exact constitution of stucco reliefs in the fifteenth century, but

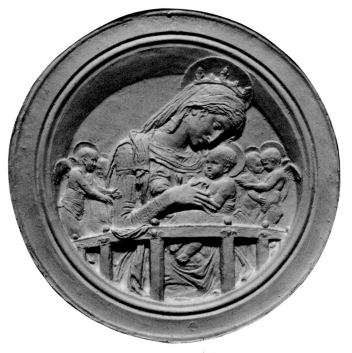

23. *Virgin and Child with Four Angels*, after Donatello. Modern latex cast made from mold shown in fig. 22.

24. Detail of fig. 22. The angel on the left side of the relief seen in reverse on the mold at the back.

25. Detail of fig. 21. The angel on the left side of the relief showing the hammering and surface working undertaken by Donatello after the bronze cast was made. Incisions which appear on the Virgin's shoulder in the mold (fig. 24) have been eliminated.

even superficial study proves that the material used for casting was susceptible of many variations; it included powdered marble and could, for all we know, have included powdered glass. In these circumstances it may be prudent to translate "vetro strutto" as "glass paste," not "molten glass," and to leave the matter in abeyance till fifteenth-century casting techniques are properly investigated.

The new relief affects our knowledge not only of the human personality of Donatello, but of his style, and we are bound to ask ourselves what light it throws on other Madonnas ascribed to Donatello and on other works by Donatello in bronze. Let us take first the matter of Donatello's independent bronze reliefs. This is an area to which my attitude was at one time negative, but in which I have become increasingly expansionist. I believe that the Medici Crucifixion in the Bargello really is by Donatello (see pages 119 to 128), and that the Camondo Crucifixion in the Louvre is also by Donatello, but of a much earlier date. The new relief does not affect our attitude towards the Bargello Crucifixion (save insofar as the gilding on the Virgin's halo and on the railing at the front anticipates the damascening in the larger relief), but it must, in a tangential fashion, affect our view of the Crucifixion in the Louvre. If we compare the vertical striations in the veil of the Virgin in the Camondo Crucifixion with the form of the veil behind the Virgin's neck in the Chellini roundel, we are bound to concede the probability that the two were modeled by a single hand. To a

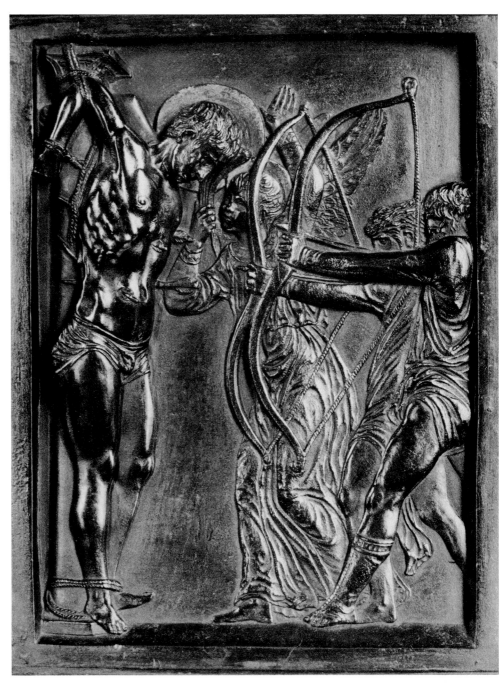

26. DONATELLO. *Martyrdom of Saint Sebastian*. Bronze, 26 x 24 cm.
Musée Jacquemart-André, Paris

third relief, the marvelous *Martyrdom of Saint Sebastian* in the Musée Jacquemart-André in Paris (fig. 26),[32] the relevance of the roundel is immediate and direct. It is a brutal scene, but it is relieved by one extraordinary touch, the antithesis between the saint's bowed head and the left hand of the angel pointing heavenwards. The source is a classical Flaying of Marsyas, and the composition has a striking resemblance to a fragmentary relief built in the seventeenth century into an outside wall of the Villa Borghese (fig. 27),[33] from which the figures of the saint and angel may have been derived. It is quite inconceivable that the Jacquemart-André relief and the new roundel are by two separate artists.

Let us then pass to the second point, the light which this roundel throws on other Madonnas ascribed to Donatello. The first thing to note about the bronze made for Chellini is the modeling of the Virgin's face (fig. 28), not just the firm curve of the eyebrow, but the curious cavity above the eye. The form of the veil behind the neck is highly individual, and so is the twist of drapery over the balustrade. If the relief is compared in these respects with a little-studied terra-cotta Madonna in the Louvre (fig. 29), it is evident that the two

27. *Flaying of Marsyas*, drawing after a classical sarcophagus relief formerly in the Villa Borghese, Rome

works, despite their different scales, absolutely must be by one hand.[34] Even what might be thought of as the weakest aspect of the Louvre relief, the Child, with its rather immobile head and its wide-open eyes, corresponds very closely with the Child in the small bronze relief. It could be argued that the relief in Paris was made from Donatello's model by a member of his shop, but looking at the foreshortening of the Virgin's face, tipped slightly backwards, and the strange little amphorae with which some of the holes in the background are filled, this surely is most improbable. The drapery forms especially are rendered with an obsessive intensity which argues strongly that they must be autograph. The relief was restored in 1959, when the frame (which was exceptionally fine) was removed, the missing glass mosaic was made up in plexiglas, and the few stucco heads and amphorae that survived were completed with modern reproductions. Old photographs (fig. 30) show how it used to look. During this process of willful mutilation, traces of gilding came to light—it was applied without priming—and the whole surface seems at one time to have been gilt. Possibly this is the relief Vasari saw in the Palazzo Gondi, in which Donatello "scherzasse nell'acconciatura del capo e nella leggiadria dell'habito, ch'ella ha indosso."[35] Of the surviving Madonnas it is the only one that this description might fit. It must have been well known, since stucco versions of it were made. In these the head of the Virgin is turned slightly towards the spectator, the Child is draped, and the position of his right arm is modified. One is in the Acton Collection in Florence (fig. 31),[36] and another is in the

28.
Virgin and Child with Four Angels,
detail of fig. 21

29.
DONATELLO. *Virgin and Child.*
Terra-cotta, diameter 71 cm.
Musée National du Louvre, Paris

30.
DONATELLO. *Virgin and Child.*
The relief shown in fig. 29 before
it was restored and made up in
1959.

31.
Virgin and Child, after Donatello.
c. 1460. Pigmented stucco.
Studio variant of the relief
illustrated in figs. 29 and 30.
Collection Sir Harold Acton,
Florence

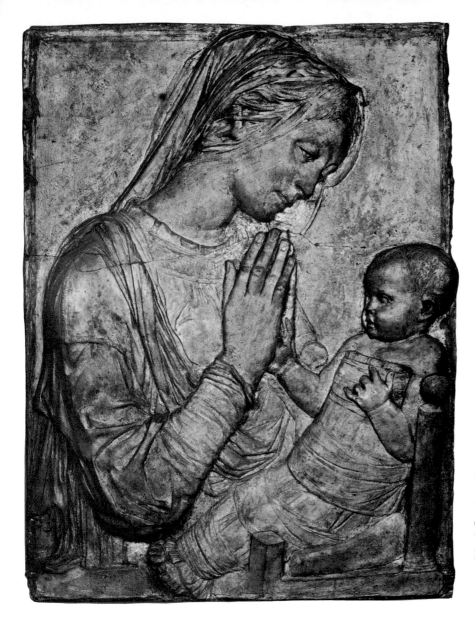

32.
DONATELLO.
Virgin and Child. c. 1458–60.
Gilt terra-cotta, 74.3 x 55.9 cm.
Victoria and Albert Museum,
London

Morgan Library. The Acton relief is in its original frame, and the spandrel paintings, which are by an unidentified hand, seem to date from about 1460.

In the *Memoriale* of Chellini, Donatello is described in 1456 as "the singular and outstanding master of bronze, wood and clay figures." That description has been contested by modern scholars. Chellini, Professor Janson tells us in a variant of the old gentleman syndrome, did not know what he was saying, since terra-cotta "after all was the material least favored by Donatello."[37] What Chellini is asserting is, however, something rather different, that Donatello in the last decade of his life was concerned with wood carving and modeled sculpture. With bronze, obviously. Then why not with baked clay or terra-cotta? After all the only proof that Donatello did not favor terra-cotta is the fact that nowadays all

the terra-cottas are omitted from the Donatello catalogues. And that is a reflection on the catalogues, not on the works that they leave out.

Like the Pazzi Madonna, the new relief exists in its own space. In the center is the seated figure of the Virgin, and at the sides are four small standing angels, roughly half the size of the Child. The space illusion they create is irrational and ambiguous, and all the more so because the figures are fenced in. The balustrade is depicted as though bulging forward from the surface, and reiterates or reinforces the circular shape of the relief. It rests on five supports, four of which are fully visible, and on the upper surface, at the top of each support, is a circular knob. The two central supports are rectangular—probably they were intended to be square—and one of them, on the right, is rendered frontally. Its receding edge can be seen on the left side. The support to the left of center is depicted in a slightly different way. Its front surface is twisted, so that it is at an angle to the relief plane, and more of the inner edge is visible. Bearing that inconsistency in mind, let us turn to another relief, the large terra-cotta Madonna in London (fig. 32).[38] It is a rather disconcerting work, mainly because of its condition. It was originally gilt, and quite extensive traces of old gilding remain in the recesses round the face and the right arm. The gilding is once more applied directly on the surface of the terra-cotta. Elsewhere it has been cleaned or rubbed down, so that the effect it makes today is quite different from that which it originally produced. The Child is propped up in a kind of seat which appears to project from the relief. The rear support is circular, and the effect of forward thrust is due to the fact that the upper surface of the cylinder is shown. The forward support is square, and seems to stick much farther out (this effect is again due to the angle of the upper face), and its front plane is not aligned on the square base of the cylinder on the right. I must admit quite frankly that I have in the past been puzzled by that fact. One knew, of course, from the San Lorenzo pulpit reliefs that Donatello at this time was prone to play with space, and play with it irrationally, but I had nonetheless in the back of my mind a residual doubt whether he would treat it quite like this. Given the balustrade in the new bronze relief that doubt can be resolved. So far from being incompatible with Donatello's style, the seat or cradle constitutes a proof of Donatello's authorship. And once that has been established we can admire this great relief once more for what it is. It is as though Donatello in old age returned to the theme of the Pazzi Madonna of thirty years before, and reinterpreted it with a new warmth and tenderness. If indeed one had to choose a single example of the transfigured realism which distinguishes his style, one might feel tempted to select the center of this relief where the clasped hands of the Virgin form a protective tabernacle over the right hand of the Child.

This image of the praying Virgin became extremely popular. It was diffused in a painted stucco relief, for which Donatello can hardly have been responsible; a poor version is in the Museo Bardini in Florence, and a better one is in the Bode Museum in Berlin (fig. 33). In this composition the structure of the seat is rectified, and the whole image becomes sweeter

33. *Virgin and Child*, after Donatello. Workshop variant of relief illustrated in fig 32. Pigmented stucco, 59 x 39 cm. Bode Museum, East Berlin

34. *Virgin and Child with Two Angels*, after Donatello. Pigmented stucco, 66 x 48 cm. (without frame). Kunsthistorisches Museum, Vienna

35. DONATELLO. *Martyrdom of Saint Lawrence*, detail from frieze above relief. Bronze. San Lorenzo, Florence

and more anodyne. It was also adapted by Urbano da Cortona for a stucco relief of the Holy Family, in which the heads of Saint Joseph and the ox and ass are inserted at the sides, and the Virgin looks down at a pigmy Child. In another stucco relief, also by Urbano da Cortona, the image is reversed and modified, this time with the ox and ass on the left and Saint Joseph on the right. Urbano moved to Siena in 1451 to undertake reliefs for the

100

Chapel of the Madonna delle Grazie in the cathedral. He was still in Siena when Donatello arrived there in 1457, and the stucco reliefs result from the contact between them that was renewed at that time.[39]

Finally, the new roundel compels us to reconsider what is in some respects the strangest of all Donatellesque reliefs (fig. 34). It was much praised by Bode. "Wohl keine zweite unter den zahlreichen Madonnendarstellungen Donatellos zeigt seine dramatische Auffassung, ergreifende Tragik, Grösse der Formengebung und Meisterschaft der Raumfüllung so ausgesprochen, so mächtig," he wrote of an incomplete version in Berlin.[40] And it was illustrated by him with a line drawing from a version owned by Bardini in which two music-making angels were shown to right and left of the group. The best version of the composition in this form is in the Kunsthistorisches Museum in Vienna. Here we are in the world of the pulpits in San Lorenzo. The angels stand outside the space of the relief, like the figures which flank the *Crucifixion* and *Entombment* on the pulpits, and they wear short tunics terminating in a frill at the level of the thighs, which we find again throughout the friezes of the pulpit reliefs. Even their weaknesses, of which the most awkward is the lolling head of the angel on the right, find a point of reference among the putti above the *Martyrdom of Saint Lawrence* (fig. 35). A concomitant of movement introduced into the main figures also has a parallel in the last of the pulpit reliefs. The convex balustrade is developed from that of the Chellini roundel, and the Virgin's elaborate veil looks back to that of the terra-cotta *Virgin and Child* in the Louvre. Despite the coarseness of the execution, the main group is an invention of the highest imaginative quality, and it can be explained only as an unworthy record of an extremely late Donatello Madonna relief.

The single artist in the fifteenth century who accepted Donatello's Madonna reliefs as the austere, uncompromising masterpieces that they are, was Mantegna, who shared the

classical experience from which they grew. Only with the onset of the High Renaissance did sculptors come to take an equally enlightened view. The change occurs when the young Michelangelo studied the *Madonna of the Clouds* in the Palazzo Medici, and through an organic development of Donatello's style and imagery evolved the *Madonna of the Steps*. Perhaps he also looked at the gilded terra-cotta Madonna in the Louvre, and remembered its lost profile and elaborately dressed head when he started work on the Taddei tondo, in London. Vasari tells us that in Florence about 1506 Leonardo, who had seen some early drawings by Bandinelli, "lo confortò a seguitare ed a prendere a lavorare di rilievo; e gli lodò grandemente l'opere di Donato, dicendogli che egli facesse qualche cosa di marmo, come o teste o di bassorilievo."[41] Bandinelli seems to have paid no heed to this advice, but it was accepted in a more serious spirit by a disciple of Leonardo, Rustici, whose great bronze Madonna in the Louvre is once more planned in a style that is consciously evolved from Donatello's. As late as 1544 the memory of the reliefs, of their interpretative content as well as their design, fortified Francesco da Sangallo when he produced his terra-cotta Madonna in Berlin. To disregard them is therefore indefensible from a historical as well as from a qualitative point of view. They are some of the most personal works of art of the fifteenth century, they were in the long term some of the most influential, and they are central to an understanding of the creative psychology of the greatest Early Renaissance sculptor.

NOTES

1. W. von Bode, "Die Madonnenreliefs Donatellos in ihren Originalen und in Nachbildungen seiner Mitarbeiter und Nachahmer," in *Jahrbuch der königlich preussischen Kunstsammlungen,* v (1884), pp. 27 ff., vii (1886), pp. 203 ff.; reprinted in *Florentiner Bildhauer der Renaissance* (Berlin, 1902), pp. 96–125.

2. The reliefs ascribed to Donatello listed by G. Vasari, *Vite,* ed. G. Milanesi, ii (Florence, 1906), pp. 417–18, were in the possession of the heirs of Jacopo Capponi ("un quadro di Nostra Donna di mezzo rilievo nel marmo, che è tenuta cosa rarissima"), the son of Antonio de' Nobili ("un quadro di marmo di mano di Donato, nel quale è di bassorilievo una mezza Nostra Donna tanto bella, che detto messer Antonio la stimava quanto tutto l'aver suo"), Bar-tolomeo Gondi ("una Nostra Donna di mezzo rilievo fatta da Donato con tanto amore e diligenza, che non è possibile veder meglio, ne immaginarsi come Donato scherzasse nell'acconciatura del capo, e nella leggiadria dell'abito ch' ell'ha indosso"), and Lelio Torelli ("un quadro di Nostra Donna di marmo di mano dello stesso Donatello"). P. Foster, "Donatello Notices in Medici Letters," in *Art Bulletin,* lxii (1980), pp. 148–49, publishes a reference to two Madonnas by Donatello made for Giovanni di Cosimo de' Medici in 1455.

3. For a summary of the literature see H. W. Janson, *The Sculpture of Donatello* (Princeton, 1963), pp. 44–45.

4. A Madonna by Donatello in the Casa di

Francesco Pazzi is described by F. Bocchi, *Le Bellezze della Citta di Firenze*, ed. G. Cinelli (Florence, 1677), pp. 369–70: "una bellissima Vergine di Basso rilievo in marmo di mano di Donatello: e il bambino Giesu a sedere sopra un Guanciale, e con la destra la Vergine il sostiene mentr'egli con la sinistra alzata regge i lembi del velo che dal capo della Madonna pendono; E vaga in ogni sua parte, ed i paneggiamenti sono bellissimi, esprime la Vergine l'affetto verso il figliuolo, con grand arte, ed e tale, che nelle divise seguite tra Pazzino, la prese Alessandro Padre di Francesco per sc. 500. secondo la stima che ne fu fatta.") The attempt of J. Cavallucci, *Vita e opere del Donatello* (Milan, 1888), p. 32, to identify the Berlin Madonna with this work is less implausible than Janson, loc. cit., suggests. In the Berlin Madonna the Virgin supports the Child Christ with her right hand (as she is stated to have done in the Madonna in the Palazzo Pazzi), and the Child's left hand is raised and holds the Virgin's veil. The only significant discrepancy arises from the statement of Bocchi-Cinelli that the Child was seated on a pillow. This may be due to a misreading of the folds of cloak under the Virgin's left hand.

5. The proposed datings range from 1415 (A. Colasanti, *Donatello* [Rome, 1927], p. 84) to 1430 (H. von Tschudi, in *Rivista storica italiana*, iv, fasc. 2 [1887], p. 33). L. Planiscig at first espoused the later dating (*Donatello* [Vienna, 1939], p. 37) and subsequently reverted to a dating c.1422 (*Donatello* [Vienna, 1947], p. 40). Janson, loc. cit., adopts this second dating.

6. Janson, loc. cit.: "The linear foreshortening of the frame in the Pazzi Madonna with the orthogonals converging upon at least three vanishing points, is no closer to the mathematical perspective of Brunelleschi than is the foreshortening in the base relief of the St. George Tabernacle."

7. Bode, op. cit. (1902), pp. 99–100, regarded the Orlandini Madonna as "wohl in der Werkstatt ausgeführt" and dated it "um 1425 oder ein wenig später." Janson, loc. cit., classifies it as "a much inferior marble variant dating from the middle years of the Quattrocento." The relief does not originate in Donatello's workshop and seems to date from the late 1430s.

8. J. Pope-Hennessy and R. Lightbown, *Catalogue of Italian Sculpture in the Victoria and Albert Museum*, i (London, 1964), no. 76, pp. 96–97.

9. Versions of the plaquette exist in the Victoria and Albert Museum (bronze), Berlin (lead), Cologne (gilded copper), and elsewhere. The attribution to Donatello was advanced in 1886 by Bode (see n. 1 above) and E. Molinier, *Les Plaquettes*, i (Paris, 1886), no. 65, pp. 34–35.

10. Pope-Hennessy and Lightbown, op. cit., i, no. 68, pp. 83–84.

11. The literature of the relief is summarized by Janson, op. cit., pp. 86–88.

12. For this see H. Kauffmann, *Donatello* (Berlin, 1935), pp. 69, 218 f., and G. Swarzenski, in *Bulletin of the Museum of Fine Arts, Boston*, xl (1942), pp.64 f.

13. Kauffmann, loc. cit., dates it immediately after the Brancacci *Assumption*, and Janson, loc. cit., believes it to have been produced "between about 1425 and 1428."

14. J. Pope-Hennessy, "Some Donatello Problems," in *Studies in the History of Art Dedicated to William E. Suida on his Eightieth Birthday* (New York, 1959), reprinted in *Essays on Italian Sculpture* (New York, 1968), pp. 54–55.

15. Bode, op. cit. (1902), p. 116, assumed that a stucco version in Berlin depended from a lost marble relief by Donatello. The bronze relief is ascribed to Donatello by L. Planiscig, *Die Estensische Kunstsammlung*, i (Vienna, 1919), no. 91, pp. 50–51, who later omitted the relief from his Donatello monograph. Janson, op. cit., p. 244, suggests that it was made "not long after Donatello's death, in the 1460s or 1470s." The attribution to Donatello is correctly endorsed by Kauffmann, op. cit., pp. 157, 241, who first pointed out that a late sixteenth-century drawing in the Uffizi (Santarelli no. 9124) reproduces both the *Madonna of the Clouds* and the Vienna relief. It is, as Kauffmann notes, to be inferred from this either that the *Madonna of the Clouds* and the Vienna relief were at that time in a single collection (perhaps the Medici *guardaroba*) or that the *Madonna of the Clouds* was then associated with a stucco replica of the roundel.

16. The "stucco replica," which is alleged by Kauffmann, loc. cit., and Janson, op. cit., p. 86, to have appeared in a Lempertz sale at Cologne in 1907, is in fact a sixteenth-century marble copy sold as no. 1148 at the Hommel sale in Zürich in 1909 (catalogue issued by Lempertz, Cologne), now in the Victoria and Albert Museum (Pope-Hennessy and Lightbown, op. cit., i, no. 70, pp. 85–86).

17. For the bibliography of the Verona Madonna see Pope-Hennessy and Lightbown, op. cit., i, no. 69, pp. 84–85.

18. No. 54. Stated by C. von Fabriczy, in *L'Arte*, ix (1906), p. 262, to have come from Santa Maria Maddalena de' Pazzi, Florence. The relief, which was purchased for Berlin in 1888, is listed by W. Paatz, *Die Kirchen von Florenz*, iv (Frankfurt am Main, 1941), p. 103, in the choir of the church. It is dated by Kauffmann, op. cit., p. 223, "um 1435, gewiss nicht später."

19. No. 704. The relief was purchased in Florence by L. Courajod (1880), and is stated to have come from the villa of Marchesa Vettori at San Lorenzo a Tignano. According to W. von Bode, op. cit. (1902), p. 106, this "Wunderwerk... fand aber in Paris wenig Anerkennung und gilt dort auch heute nur als ein Werk der Schule Donatellos." It was later ascribed to Donatello.

20. Earlier analyses of the works executed by Donatello in Siena are superseded by a new and more thorough survey of the documents by V. Herzner, "Donatello in Siena," in *Mitteilungen des Kunsthistorischen Institutes in Florenz*, xv (1971), pp. 161–86.

21. Ibid., doc. 28, p. 184.

22. For this operation see E. Carli, "Urbano da Cortona e Donatello a Siena," in *Donatello e il suo tempo* (Florence, 1966), pp. 159–60.

23. R. Lightbown, "Giovanni Chellini, Donatello, and Antonio Rossellino," in *Burlington Magazine*, civ (1962), pp. 102–4. The relevant section of the transcript reads: "Ebbe amicizia col famosissimo Scultor Donatello, il qle auendo egli delle sue infermità mediante il Divino aiuto guarito, gli donò (userò le sue proprie parole) un Tondo grande quanto un Tagliere, nel quale era scolpita la Vergine Maria col Bambino in collo, e 2 Angeli da Lato tutti di Bronzo, e dal lato di fuori cauato per poterui gettar suso vetro strutto, e farebbe qlle medesime figure d^e. dall'altro lato, il che fu l'anno 1456."

24. H. W. Janson, "Giovanni Chellini's 'Libro' and Donatello," in *Studien zur toskanischen Kunst: Festschrift für Ludwig Heinrich Heydenreich* (Munich, 1964), pp. 131–38. The relevant passage is cited from the *Libro debitori creditori e ricordanze* of Giovanni Chellini, now in the Università Bocconi in Milan, from which it was excerpted by Aldo de Maddalena, "Les Archives Saminiati," in *Annales: Economies, So-*

ciétés, Civilisations, xiv (1955), pp. 738–44, in the following form: "Ricordo che a di 27 d'Agosto 1456 medicando io Donato chiamato Donatello, singulare et precipuo maestro di fare figure di bronzo e di legno e di terra e poi cuocerle, e avendo fatto quello huomo grande che e sullo alto di una cappella sopra la porta di Santa Reparata che va a Servi e cosi che avendone principiato un altro alto braccia nove, egli per sua cortesia e per merito della medicatura che avevo fatta e facevo del suo male mi dono un tondo grande quant uno tagliere nel quale era scolpita la Vergine Maria col bambino in collo e due Angeli da lato, tutto di bronzo e dal lato in fuori cavato per potervi gittare suso vetro strutto e farebbe quelle medesime figure dette dall'altro lato."

25. J. Pope-Hennessy, *Renaissance Bronzes from the Samuel H. Kress Collection* (London, 1965), no. 56, p. 20. The relief has been variously ascribed to the school of Donatello (Molinier), to Donatello (Ricci), and to Bertoldo (Bode). While recognizing its weaknesses, I concluded that "the form and character of the relief are explicable only if it was designed by Donatello and finished in his workshop about 1455."

26. J. Soane's *Description of the House and Museum* (London, 1835), p. 53, mentions "two plaster casts of Basso-rilievos, presented to me by H. Howard, R.A.; the one from a bronze found at Dodona, the other from a work of Donatello." In the Kress catalogue I wrongly stated that this relief was acquired by Howard in Florence. Sherwin's etching (of which two impressions are in the British Museum, X8–88, 89) is inscribed *Edwd; Rumsey Delt:* and *J. K. Sherwin Sculpt. in aqua forti,* and, below, *Ex Archetypo Aereo penes Nobiliss: Virum Marchionem de Rockingham.* The draftsman Edward Rumsey is not recorded, and the plate was not made as part of any larger series of reproductions of works of art in Rockingham's collection. A *terminus ante quem* for its execution is supplied by Rockingham's death in 1782. Sherwin, who exhibited drawings at the Royal Academy between 1774 and 1784 and died in 1790, studied under Bartolozzi and was best known for engravings after Reynolds and Gainsborough. The versions of the Donatello relief at Vicchio di Rimaggio and Verona are reproduced in J. Pope-Hennessy, op. cit., (1968), figs. 30, 31.

27. G. H. Gutteridge, *The Early Career of Lord Rockingham* (Berkeley, 1952), pp. 5–7.

28. Pope-Hennessy and Lightbown, loc. cit.

29. After the death of the second Marquess of Rockingham, Wentworth Woodhouse and its contents passed to William 4th Earl Fitzwilliam, the eldest son of the eldest sister of the marquess. The relief was later at Milton. In 1954 it was given by the present Lord Fitzwilliam to his stepdaughter, then Lady Naylor-Leyland.

30. Some imaginative observations on this problem are contained in an article by H. W. Janson on the Evangelist roundels in the Pazzi Chapel ("The Pazzi Evangelists," in *Intuition und Kunstwissenschaft: Festschrift für Hanns Swarzenski* [Berlin, 1973], pp. 439–48).

31. Janson, op. cit. (1964), p. 131.

32. An excellent account of the relief is given by F. de la Moureyre-Gavoty, *Sculpture Italienne: Musée Jacquemart-André* (Paris, 1975), no. 23.

33. K. Robert, *Die Antiken Sarkophag-reliefs*, iii–2 (Berlin, 1904), Plate lxiv, fig. 199, p. 249.

34. No. 710. Coll: Piot (1890). Now ascribed to "Ateliers Florentins, XVe. siècle."

35. Vasari, op. cit., ii, pp. 417–18. The Gondi relief is the only relief by Donatello listed by Vasari which is not specifically stated to have been in marble.

36. I am indebted to Sir Harold Acton for a photograph of this relief.

37. Janson, op. cit., pp. 132–34.

38. Pope-Hennessy and Lightbown, op. cit., i, no. 64, pp. 77–78.

39. Pope-Hennessy, op. cit. (1968), pp. 60–64.

40. From the Benda Collection. Bode, op. cit., p. 114.

41. Vasari, op. cit., p. 136.

THE EVANGELIST
ROUNDELS IN
THE PAZZI CHAPEL

SOMETIMES IN DEALING with works of art one has to plunge in at the deep end, and begin by discussing not date, or attribution, or technique, but quality. A case in point is that of the four Evangelist roundels in the pendentives of the Pazzi Chapel (fig. 1). Professor Janson, the author of the latest article devoted to them, regards them as works of small artistic consequence.[1] To me, on the other hand, they seem some of the most imposing and original relief sculptures of the fifteenth century, and it is incumbent to explain why this is so. Whereas Luca della Robbia's Apostles on the wall surfaces beneath are contained within the architecture of the chapel, in the sense that the blue concentric circles behind four of them and the undifferentiated backgrounds behind the rest establish a continuous pattern in the architectural space, the Evangelists defy the architecture. Each roundel is treated as though it were an aperture through which an area of sky is visible. What makes the effect doubly disconcerting is the nature of the expanse. This is not the sky as it would look if the roundels were real holes and the sky were the real sky one can see outside. It is a carefully graduated, seemingly limitless space which is not entirely unlike the view from the window of an airplane.

No less surprising is the sheer size of the figures in the roundels.[2] All four of them are seated with legs extended, as though on the ground. The diameter of the circles is very large, and the scale is not far short of the maximum permissible if the extended legs are to establish a continuous horizontal through the circular field. If what confronted us were large figures seated against the sky, that would be remarkable enough. But each Evangelist is in fact accompanied by his symbol, and there is a carefully planned space relationship between the two. The bull kneels a little way behind Saint Luke (fig. 2); the eagle proffers Saint John an open book which recedes into the picture space (fig. 3); the lion of Saint Mark is likewise set at an angle to the main figure and reaches forward (fig. 4); and the angel floats towards Saint Matthew from behind (fig. 5). Argan declares correctly that in the roundels "la figura umana è la personificazione dell'idea di spazio."[3]

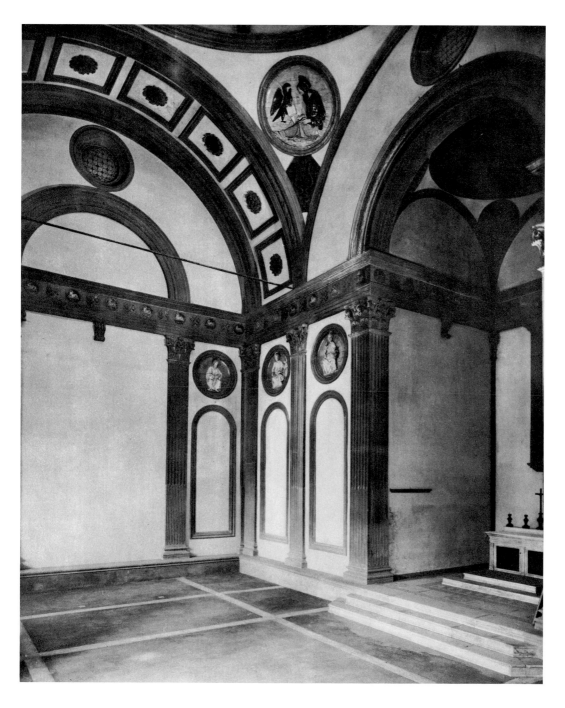

1. Filippo Brunelleschi. Pazzi Chapel, Santa Croce, Florence

Let it be said at once that the roundels, imposing as they are, are not, to the modern taste, ingratiating works. The yellow in the halos, in the interior of the cloak worn by Saint John, and on the cloak of the angel and the collar and cuff of the dress of Saint Luke is the same rather strident yellow that is used again in the cupola of the portico of the chapel, where the purple of the cloak of Saint Luke, and the dense light blue of the cloak of Saint John and the dresses of two other Evangelists, and the rather sharp green of the dress of Saint John and the cloak of Saint Mark also recur. If colors can be said to set the teeth on edge, these colors, used naturalistically, not decoratively, over large areas and abruptly juxtaposed, will, on most spectators, have precisely that effect. But it would be altogether wrong if we were to allow a sense of disquiet at the pigmentation to blind us to the care with which it is employed and to its technical accomplishment. In the *Saint Mark* the green cloak has a purple lining, which is also visible over the foot. The dress is a creamy white, and the belt and neck and cuff are blue. The yellow halo is unbroken, unlike those of Saint John the Evangelist and Saint Matthew which are striated so that they take on a per-spectival, spatial character. Optically the most sophisticated roundel is the *Saint Matthew*, where the cloak of the Evangelist and the sleeves and receding wing of the angel are

2. DONATELLO. *Saint Luke.*
 Enameled terra-cotta, diameter 170 cm.
 Pazzi Chapel, Santa Croce, Florence

3. DONATELLO. *Saint John the Evangelist.*
 Enameled terra-cotta, diameter 170 cm.
 Pazzi Chapel, Santa Croce, Florence

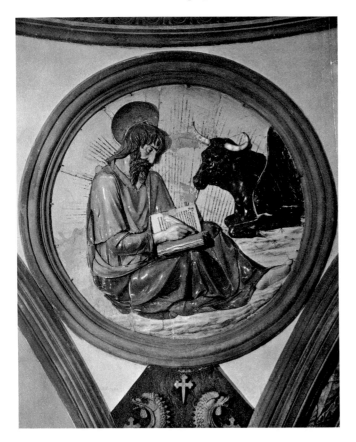

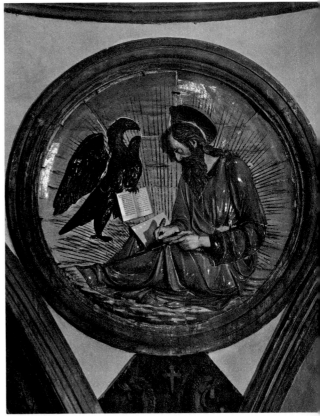

the same creamy white as the dress of Saint Mark, but allowance is made for the light striking the surfaces in such a way as to suggest that the tones are differentiated. Again the lining of the cloaks, green in that of the Evangelist and yellow in that of the angel, are used to enhance the drapery forms and enrich the compositional character of the design. In the *Saint Matthew* there is some damage at the top edge of the open book and between the halos, and in the *Saint Luke* there is a further area of damage behind the seated figure (where the surface could be interpreted as a beige cushion but is really a beige smudge). The volume of the Gospel is once more depicted, with scrupulous attention to tone as well as drawing, as an object in space, and the horns of the ox are decorated with regular pale blue stripes, while the muzzle is differentiated from the hairy surface of the head. The cloak this time is purple, and its green lining is visible not only round the free arm but intermittently along the base. In the *Saint John the Evangelist* the recession of the eagle is established by color variation as well as by the pose, and the yellow lining of the blue cloak establishes a decisive diagonal through the circular field. Nowadays we take for granted the naturalistic coloring of the heads and hair and hands—the only relative failure is with the *Saint Mark*, where the face and hands, as a result of some miscalculation, are pinker than in

4. DONATELLO. *Saint Mark.*
 Enameled terra-cotta, diameter 170 cm.
 Pazzi Chapel, Santa Croce, Florence

5. DONATELLO. *Saint Matthew.*
 Enameled terra-cotta, diameter 170 cm.
 Pazzi Chapel, Santa Croce, Florence

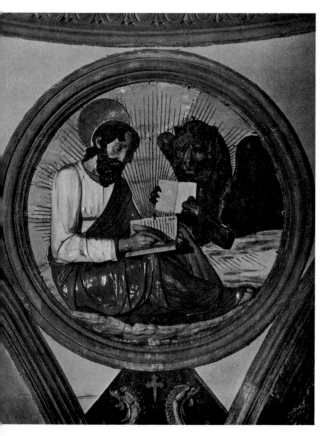

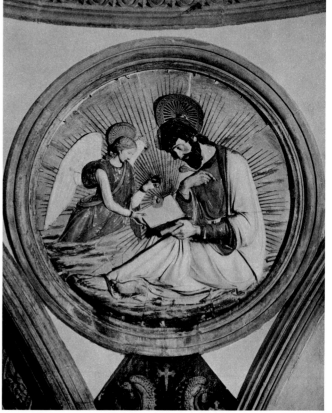

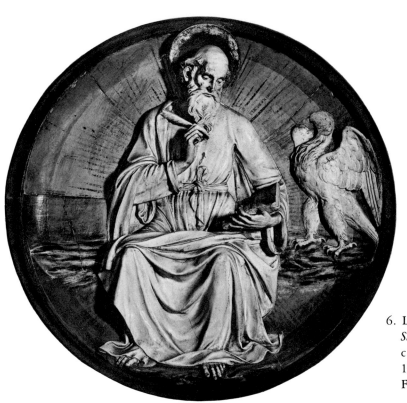

6. Luca della Robbia.
Saint John the Evangelist. Commissioned
c. 1442. Enameled terra-cotta, diameter
134 cm. Pazzi Chapel, Santa Croce,
Florence

the other roundels—but we know that this result was not easy to achieve. There is indeed no other work glazed in the Della Robbia studio before the extreme end of the fifteenth century in which it is successfully arrived at, and so difficult was the problem it presented that in works like Andrea della Robbia's *Meeting of Saint Francis and Saint Dominic,* in the Loggia di San Paolo (see fig. 18 on page 179), the flesh parts were painted and not glazed. Naturalistic glazing becomes common only in the first two decades of the sixteenth century.[4]

These are not, it must be stressed, reliefs which were modeled and then, in a casual fashion, glazed; they are reliefs which were conceived in color from the start. It may be useful, however, for a moment, to imagine them in monochrome. In each case the upper part of the body is shown in recession, with the farther shoulder drawn sharply back, while the forward arm and the extended leg are set, or appear to be set, on the relief plane. The reason for this qualification is that the lower leg of Saint John the Evangelist is shown in slight recession and the lower leg of Saint Luke is slightly advanced, but in neither case is the deviation such as to impair the horizontality of the effect. In the *Saint Luke* the right leg is placed under the left knee, and the sole of the left foot is exposed. In the *Saint John* the left leg is extended—the foot indeed touches the edge of the roundel—and the right leg is drawn up. In the *Saint Mark* the right leg is extended—the toes of the foot protrude on the right—and the left knee drawn up, and in the *Saint Matthew* the right leg is crossed under

110

the left, and both feet are visible, one represented from on top and the other from underneath. Given this broad uniformity of posture, the drapery forms are masterly in their variety. If one thing is certain, it is that the mind which conceived the roundels and the hands which modeled them were those of a great sculptor. In *Italian Renaissance Sculpture* I retained the roundels under the then conventional name of Brunelleschi, but described them as Donatellesque.[5] This point has been taken up by Janson. There is, as he rightly observes, a precedent for the celestial vision depicted in the roundels in Donatello's small *Madonna of the Clouds* at Boston (see fig.7 on page 76)."Perhaps," Professor Janson writes,[6] "this is what Pope-Hennessy had in mind." But it was not what I had in mind, or rather was only a small part of it. My conviction was, and has long been, that the thought processes elaborated in the roundels were, and could only be, those of Donatello. Only the difficulty of reconciling this with the date commonly postulated for them prevented my advancing a direct ascription to Donatello.

So much has been written in recent years on the building history of the Pazzi Chapel that I need touch on it no more than briefly here.[7] The skeleton of fact is this. As has long been recognized, the commission for the chapel dates from 1429 or 1430. Work on it was in progress in 1433, when part of the ambulatory of the convent of Santa Croce was pulled down to make way for it, but adequate funding did not become available till 1442, and work on the interior was prosecuted from that year till Brunelleschi's death. Sums for the completion of the building were bequeathed in 1445 by Andrea de' Pazzi and in 1451 by his eldest son. Provision is made for continuance of the building in the Pazzi Portata al Catasto of 1457, but it is not mentioned in that of 1469, when it may have been complete. The drum of the cupola is inscribed with the date 1459, and the cupola of the portico bears a second date, 1461. It has been demonstrated with a fair measure of certainty that the portico did not form part of Brunelleschi's scheme.[8] From all this it can be deduced that the sculptures in the chapel fall into two clearly defined groups. The first consists of the twelve roundels on the walls (fig. 6), which must have formed part of Brunelleschi's original scheme for the interior. In the absence of documents we may assume them to have been commissioned about 1442, though their production could have been phased over as much as ten years.[9] There is no evidence as to the date at which they were installed. The date 1459 refers to the construction of the cupola, not of the pendentives on which it rests, and though the roundels of the Evangelists can hardly have been installed before the cupola was complete, they may well have been commissioned in anticipation of its completion. The enameled terra-cotta decoration of the cupola in the portico must date from after the completion of the cupola in 1461, and the roundel of Saint Andrew over the door of the chapel is likely to date from the same time. The presence in the chapel of two differentiable groups of sculptures can be corroborated visually. The first and earlier group is bichromatic, while the second is polychromatic, making use not simply of white and blue

relieved with gilding, but in addition of green, aubergine, brown, and yellow. The palette of the Evangelist roundels corresponds exactly with that of the portico cupola, and the figure in the roundel above the entrance, though once again predominantly white and blue, holds a green cross. This change represents more than an increase in technical resource; it marks a revision of the aesthetic principles governing the decoration of the chapel. Since Saints Matthew and John the Evangelist appear in the Apostle roundels, it cannot indeed be assumed that Brunelleschi's original intention was to commission Evangelists for the pendentives, nor even that he necessarily intended the pendentives to be filled with sculptures.[10]

If then the Evangelist roundels date, give or take a little, from the late 1450s, their significance and authorship have to be thought out afresh. They cannot go back to models by Brunelleschi, because their whole style, as distinct from the style of the figures alone, is anti-Brunelleschan. They cannot have been modeled by Luca della Robbia, because we know, from works that are exactly datable, like the roundels on the ceiling of the Chapel of the Cardinal of Portugal,[11] that his style was developing concurrently on altogether differ-

7. LUCA DELLA ROBBIA. Ceiling, Chapel of the Cardinal of Portugal. 1460–61. Enameled terra-cotta. San Miniato al Monte, Florence

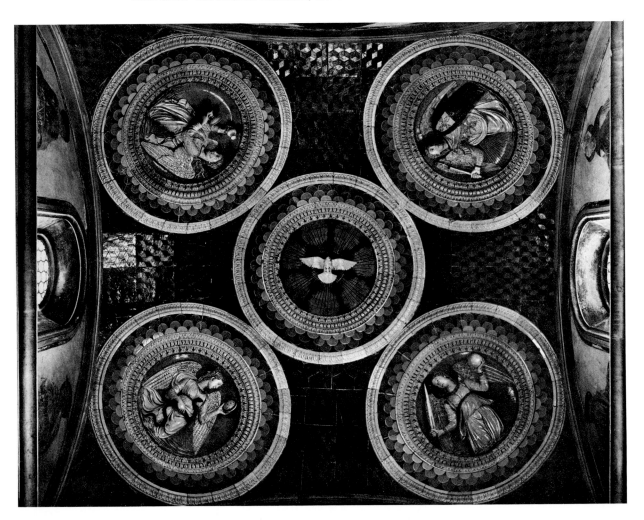

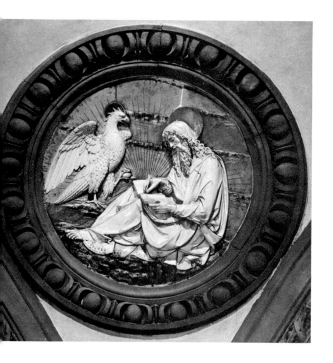

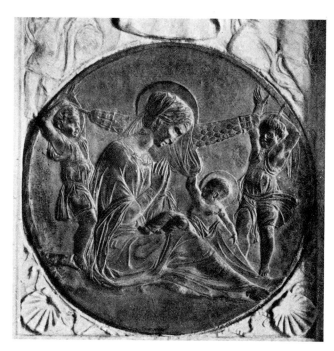

8. ANDREA DELLA ROBBIA. *Saint John the Evangelist*. Completed 1491. Enameled terra-cotta. Santa Maria delle Carceri, Prato

9. DONATELLO. *Virgin and Child with Two Angels*. c. 1440. Gilt bronze, diameter 27 cm. Kunsthistorisches Museum, Vienna

ent lines (fig. 7). They cannot be by Andrea della Robbia, because we know other Evangelist roundels by Andrea, like those in Santa Maria delle Carceri at Prato (fig. 8), with which their imagery is incompatible.[12] They can hardly have been modeled by an unknown master in Luca's studio, by whom no other work survives.[13] There is indeed no practical alternative to supposing that works as deeply imbued with Donatello's imagination and character and mind were made by Donatello.

The building history of the Pazzi Chapel is not the only area in which knowledge has advanced in recent years. We now know more than in the past about the chronology, development, and motivation of Donatello's Madonna reliefs (see pages 71 to 105). In the Pazzi Madonna in Berlin (see fig. 3 on page 73), the structure has a spatial connotation, but also establishes a complicated series of diagonals, verticals, and horizontals on the surface of the relief. This practice was pursued consistently through Donatello's Madonna reliefs. It is followed in the *Madonna of the Clouds* at Boston (see fig. 7 on page 76), where the main figure is conceived at once as a seated Virgin in the sky and as a geometrical unit in a rectangular field, and it is carried through into the circular relief of the *Virgin and Child with Two Angels* in Vienna (fig. 9), which is planned essentially in the same way. In the Evangelist roundels

113

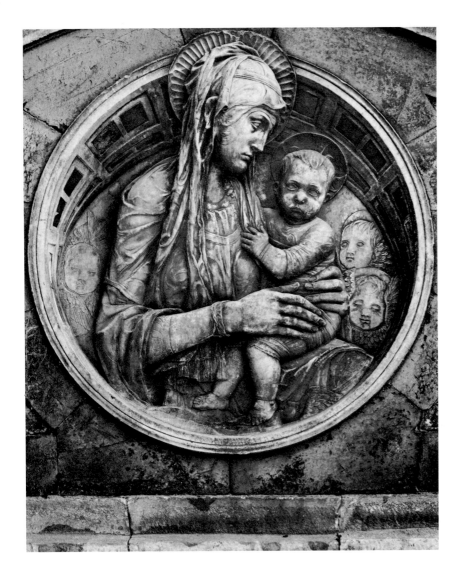

10.
DONATELLO AND ASSISTANTS.
Virgin and Child with Two Angels.
1457–58. Marble.
Cathedral, Siena

these same thought processes recur. A horizontal is established along the base (rather as it is in the narrative reliefs in the Old Sacristy), with slight variations which seem to have been introduced to avoid undue rigidity, and in the *Saint Mark* and *Saint Luke* a complementary axis is established by the firm vertical of the upper arm. In each of the reliefs (as we might expect from Donatello's other works) there are compensating diagonals which are either coloristic, as in the *Saint John,* or compositional, as in the *Saint Luke,* where the left leg and left shoulder read as a continuous line, or compositional and coloristic, as in the *Saint Matthew,* where a compositional diagonal is established by the left leg and a coloristic diagonal by the angel's right arm. Morphological comparison is prejudiced by the simple fact that these are Donatello's only works in enameled terra-cotta. They are governed by the technical consideration that the surface was to receive glaze, and this naturally ruled out highly particularized modeling like that of Donatello's bronze sculptures. Nonetheless, if we look at the sleeves of the marble *Virgin and Child* at Siena (fig. 10) and the gilt terra-

114

cotta *Virgin and Child* in London (fig. 11) we shall find more than a casual relationship between them and the three exposed sleeves of the Evangelists, as there is between the deep lozenge-shaped recess in the cloak over the thigh of Saint Matthew and the similar recession over the left thigh of the *Judith* in the Piazza della Signoria in Florence. If, moreover, we compare the corkscrew hair of Holofernes with the hair and beard of Saint John, we may well conclude that both were brought to different stages of completion by one hand. One of the minor features that distinguished Donatello's work throughout his whole career is his interest in the human foot. It is evident in the Pazzi Madonna and on the Cantoria and the Prato pulpit, in all of which there are feet twisted to reveal the soles. The last generally accepted work in which this practice recurs is one of the reliefs beneath the *Judith,* where a reclining figure on the right is similarly posed. It is, then, of some significance that with two of the Evangelists, Saint Luke and Saint Matthew, the left foot is turned essentially in the same way. By themselves these analogies might not be conclusive, but in practice they leave little room for doubt that the roundels were modeled, and not simply designed, by

11. Donatello. *Virgin and Child.*
 c. 1458–60. Gilt terra-cotta,
 74.3 x 55.9 cm.
 Victoria and Albert Museum,
 London

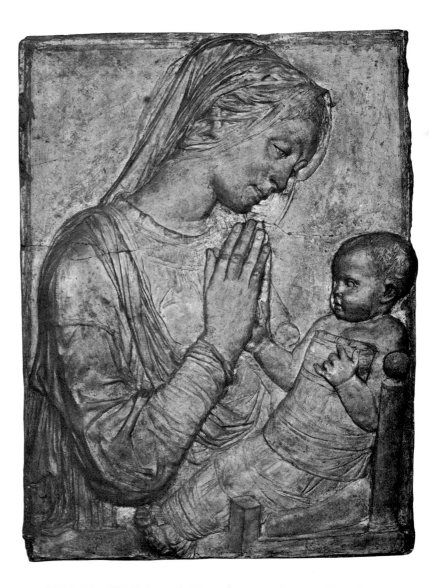

Donatello. Whether or not they were pigmented by Donatello (and since he was a painter as well as sculptor this is far from impossible), they were fired in the Della Robbia workshop, perhaps under the supervision of Andrea della Robbia who is known to have venerated Donatello (Vasari as a young man heard Andrea in old age speak of his pride at having been a pallbearer at Donatello's funeral),[14] and who, on one occasion, about 1465, in a half-length *Virgin and Child* in San Gaetano, experimented with a sky modeled and colored like that of the Evangelist roundels.[15]

The final argument is from tradition. I do not mean by this that Giovanni Chellini, in his invaluable *Memoriale*, refers to Donatello as a maker of terra-cotta sculptures.[16] That Donatello did make terra-cotta sculptures at this time is now generally recognized. Point would nonetheless be lent to Chellini's description if the terra-cotta sculptures Donatello made enjoyed great prominence and notoriety. The tradition stems from 1510, when Albertini made what is to all appearances a careful note on the church of Santa Croce and the Pazzi Chapel.[17] As every student of the Florentine Renaissance will remember, it reads like this: "La chiesa di sca. Croce antiqua & molto grade & lunga bracc. 200 nella facciata dināzi marmorea e sco Lodovico epo di bronzo a mano di Donato ilquale co Luca de rubea & Desiderio feciono assai cose nel Capitulo bellissimo de Pazi." The writer of a volume on Desiderio da Settignano published in 1962 calls this a "frase sibillina,"[18] but there is nothing sibylline about it. It names three artists, establishing the order of prominence commanded by their work, and art historians have only themselves to blame if they have disregarded it. Already Cinelli felt obliged to search for proof of Donatello's presence in the frieze of putto heads that runs along the portico,[19] and though the unity of the frieze, as a work carved by Desiderio and members of his shop, is now generally conceded, certain recent scholars have followed him. The remainder have concluded that Albertini was misinformed, and that Donatello did not work in the Pazzi Chapel. What he provided, however, was an accurate record of a living tradition, and never would he or any other Renaissance connoisseur have envisaged a time when specialists on Donatello would visit the Pazzi Chapel and inspect the roundels without the glimmering of an idea of what it was that they were looking at.

NOTES

1. H. W. Janson, "The Pazzi Evangelists," in *Intuition und Kunstwissenschaft: Festschrift für Hanns Swarzenski* (Berlin, 1973), pp. 439–48.

2. The circular *pietra serena* frames in the pendentives measure 170 cm. in diameter, as against a diameter of 134 cm. for the frames on the walls. As Janson points out, the surface area of the pendentive roundels is thus half again as big as that of the roundels beneath. The average height of the seated frontal figures on the walls is 130 cm. In the Evangelist tondi the length of the extended leg (which varies slightly from figure to figure) is about 128 cm. and the height of the body above the hips is about 85 cm.

3. G. C. Argan, *Brunelleschi* (Milan, 1955), pp. 35 ff.; Janson, op. cit., p. 443.

4. The first significant document for the use of naturalistic pigmentation by Andrea della Robbia is the flat lunette of *Saint Zenobius Between Two Angels* made for the doorway of the Compagnia di San Zenobi in 1496 (for this see G. Brunetti, in *Il Museo dell'Opera del Duomo a Firenze*, ii [Milan, 1970], p. 284). It is again employed in the roundels of saints on the Loggia di San Paolo, but not in the two portrait reliefs there or in the lunette over the doorway; a payment relating to some or all of these works (for this see A. Marquand, *Andrea della Robbia*, i [Princeton, 1922], pp. 129–39) dates from 1498. Differentiated flesh tones which stop short of fully naturalistic glazing are found in the late La Verna *Lamentation over the Dead Christ* in the *Adoration of the Magi* in the Victoria and Albert Museum (seemingly dating from the first decade of the sixteenth century), and in the *Nativity* at Massa Carrara. It is found once more in the work of Giovanni della Robbia in, e.g., the lunette of *Saint Martha Between Two Angels* in the Bargello, and in the signed and dated *Visit by the Maries to the Sepulchre* of 1521.

5. J. Pope-Hennessy, *Italian Renaissance Sculpture* (London, 1958), p. 267; 2nd ed. (London, 1971), p. 245. The attribution to Brunelleschi was first advanced by E. von Liphart, as quoted in J. Burckhardt, *Der Cicerone*, ii (Leipzig, 1884), p. 350, and is accepted by A. Venturi, *Storia dell'arte italiana*, viii (Milan, 1923), pp. 132–33, followed by P. Sanpaolesi, *Brunellesco e Donatello nella Sacristia Vecchia di San Lorenzo* (Pisa, n.d.), p. 19: "nei punti analoghi della cappella de' Pazzi, Brunellesco ha posto, modellandole forse di sua mano, quattro grandi figure di Evangelisti"), Argan, and others.

6. Janson, loc. cit., discusses the adaptation of this prototype in the Pazzi Chapel roundels as "a formal and iconographical innovation of considerable daring."

7. H. Saalman, "Filippo Brunelleschi: Capital Studies," in *Art Bulletin*, xl (1958), pp. 127–35; G. Laschi, P. Roselli, P. A. Rossi, "Indagini sulla Cappella dei Pazzi," in *Commentari*, xiii (1962), pp. 24–41; J. Bialostocki, *Spätmittelalter und Beginnende Neuzeit* (Berlin, 1972), pp. 390–91.

8. Laschi, Roselli, and Rossi, op. cit., pp. 28 ff.

9. One of the Apostle roundels, the *Saint Peter*, is more archaic in style than the rest, and it is not beyond the bounds of possibility that this figure is due to Brunelleschi. The latest of the roundels is indubitably the *Saint Andrew* over the chapel door. This figure, with its cross and book, is so posed as to fill the width of the relief more fully than, e.g., the *Saint James the Great*, *James the Less*, *Philip*, *Matthias* or *Bartholomew*. It was presumably of these reliefs that Bode was thinking, when he (to my mind mistakenly) assumed the intervention of Andrea della Robbia in the series. The classical drapery style employed throughout the roundels is more closely related to that of the Duomo *Resurrection* (commissioned 1442) than to that of the later relief of the *Ascension* (commissioned 1446).

10. It is suggested by A. Marquand, "On some recently discovered works by Luca della Robbia," in *American Journal of Archaeology*, xvi (1912), pp. 169–72; *Luca della Robbia* (London, 1914), pp. 163–67, that two reliefs of *Faith* and *Prudence* formerly with Heilbrunner, Paris, "may have been originally intended for the Pazzi Chapel of S. Croce, and that, either the series was never completed, or never put in place. The medallions are apparently of the proper size for the spandrels, and would harmonize with Luca's Apostles on the walls of the chapel better than the four garish Evangelists which now complete its decoration." A third relief, of *Temperance*, is in the Musée de Cluny, and is credited with an uncorroborated Pazzi provenance.

11. For the roundels and their documentation see

117

F. Hartt, G. Corti, C. Kennedy, *The Chapel of the Cardinal of Portugal, 1434–1459, at San Miniato in Florence* (Philadelphia, 1964), pp. 73–78.

12. It is known from documents (A. Marquand, op. cit. [1922], i, pp. 109–13) that these were completed by June 1491. The disparity is the more striking in that the poses of the Prato *Evangelists* were evidently influenced by the Pazzi Chapel reliefs.

13. It is pointed out by Janson, loc. cit., that the Evangelist roundels on the ceiling of the Martini Chapel in San Giobbe, Venice, derive certain motifs from the Evangelist roundels in the Pazzi Chapel. These weak reliefs, which seem to date from after the death of Doge Cristoforo Moro in 1471, appear to have been glazed in the Della Robbia shop, but were modeled by a hand distinct from that of either Luca or Andrea della Robbia. As noted by A. Venturi, *Storia dell'arte italiana,* ix-l (Milan, 1925), pp. 481 f., a painted roundel of *Saint John on Patmos* in the Szépmüvészeti Muzeum, Budapest, also derives from the Pazzi Chapel roundels. For this panel, which is by a follower of Domenico Ghirlandaio, see C. von Holst, *Francesco Granacci* (Munich, 1975), no. 132, pp. 183–84.

14. G. Vasari, *Vite,* ed. G. Milanesi, ii (Florence, 1906), p. 181: "ed io essendo ancor fanciullo, parlando con esso, gli udii dire, anzi gloriarsi, d'essersi trovato a portar Donato alla sepoltura; e mi ricordo

15. The earliest Madonna relief by Andrea della Robbia that is exactly datable is the *Madonna of the Architects* in the Bargello, for which payment was made in March 1475. In this work, the Child already reveals the influence of Verrocchio. The San Gaetano relief, on the other hand, derives a number of motifs (the arm of the chair, the type of the Child, and the diagonal accent of the Virgin's left forearm) from works by Antonio Rossellino (e.g., the *Madonna* in the Pierpont Morgan Library), and is likely to have been made in the half decade 1465–70.

16. H. W. Janson, "Giovanni Chellini's 'Libro' and Donatello," in *Studien zur Toskanischen Kunst: Festschrift für Ludwig Heinrich Heydenreich* (Munich, 1964), pp. 131–38.

17. F. Albertini, *Memoriale di molte statue et picture sono nella inclyta Citta di Florentia* (Florence, 1510).

18. I. Cardellini, *Desiderio da Settignano* (Milan, 1962), p. 125.

19. F. Bocchi, *Le Bellezze della Citta di Firenze,* ed. G. Cinelli (Florence, 1677).

THE MEDICI CRUCIFIXION
OF DONATELLO

I N A W E L L - K N O W N P A S S A G E in his life of Donatello, Vasari mentions three works in bronze in the Medici *guardaroba,* a crucifix, a *Crucifixion,* and a relief of the Passion of Christ. The passage reads as follows:

> Di bronzo ha il detto signor duca, di mano di Donato, un bellissimo, anzi miracoloso Crocifisso nello suo studio: dove sono infinite anticaglie rare a medaglie bellissime. Nella medesima guardaroba e, in quadro di bronzo di bassorilievo, la Passione di Nostro Signore, con gran numero di figure; ed in un altro quadro pur di metallo un' altra Crocefissione.[1]

The same three works are referred to in the *Riposo* of Borghini:

> Nella guardaroba del serenissimo Gran Duca Francesco si veggono di sua mano ...un quadro di bronzo di basso rilievo entrovi la Passione del nostro Signore con molte figure, e un altro quadro pure di metallo, in cui si vede Christo in Croce con altre figure appartenenti all'historia: e nello scrittoio di S. A. Serenissima e un Crocifisso di bronzo pure di mano di Donatello, non solo bellissimo, ma miracoloso.[2]

The only significant difference between these accounts relates to the work which Vasari calls "another Crucifixion" and Borghini describes as "Christ on the Cross with other figures belonging to this narrative." If this relief portrayed an orthodox Crucifixion scene, like that on the San Lorenzo pulpit, Borghini's words would be inexplicable. There is, however, one surviving work to which they might apply. This is the small *Crucifixion* in the Camondo Collection in the Louvre (fig. 1),[3] which is something of an anomaly in representations of this scene. It shows Christ on the cross flanked by the lance and sponge with, at the sides, the Virgin and Saint John and, at the back, three soldiers. The disposition of the main figures, with Saint John shielding his eyes while the Virgin's head is turned towards Christ, recalls the small *Crucifixion* by Fra Angelico at the base of the San Marco altarpiece, and the *Crucifixion* relief by Luca della Robbia at Impruneta. It is likely that all three illustrate the words "Mulier ecce filius tuus," in the gloss provided by Sant' Antonino, who describes how the Virgin "stava aspettare d'udire qualche parola gli dicessi il suo figliuolo a suo conforto inanzi che morisse."[4]

The relief is a characteristic work by Donatello of about 1440. The verticals of the lance and of the pole holding the sponge and the diagonals of the spear and ladder look forward to

119

the roundel of the *Attempted Martyrdom of Saint John the Evangelist* in the Old Sacristy, and the highly chased figure of Saint John stands midway between the Saint John on the right of the *Entombment* on the Saint Peter's tabernacle and the rougher, more animated saints on the bronze doors. The inclusion in the scene of distant soldiers is unique, and justifies the assumption that this is indeed the relief to which Borghini refers. If this be so, the relief in the Museo Nazionale, Florence, known as the Medici Crucifixion (fig. 2), which comes from the Medici Collection and is generally identified with one or other of the bronze reliefs in the *guardaroba,* must, by a process of exclusion, be the "Passion of Our Lord with a great number of figures," a description that fits it very adequately.[5]

No work by Donatello has suffered stranger critical vicissitudes than this. Though accepted by a succession of scholars as an autograph work,[6] it has been repeatedly dismissed, from the time of Semrau on,[7] as a pastiche. Lányi, in a note cited by Professor Janson,[8] dismissed it as Donatellesque, and Janson himself regards it as "certainly an ambitious and, in some ways, impressive work, replete with Donatellian features."[9] His objections rest on the tree forms and the angels in the clouds, which allegedly depend from the London *Presentation of the Keys*; on faulty scale and spatial discrepancies; on the presence of apparently unmotivated figures with the character of quotations (though from sources

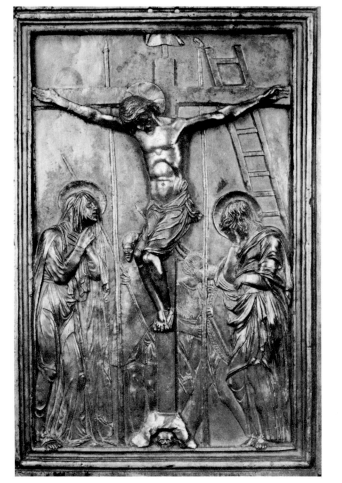

1. DONATELLO. *Crucifixion*. c. 1440.
 Bronze, 46 x 28.8 cm.
 Musée National du Louvre, Paris.
 Camondo Collection

OPPOSITE PAGE:

2. DONATELLO. *Crucifixion*.
 Formerly Medici Collection. Probably 1453–56.
 Bronze, 93 x 70 cm.
 Museo Nazionale del Bargello, Florence

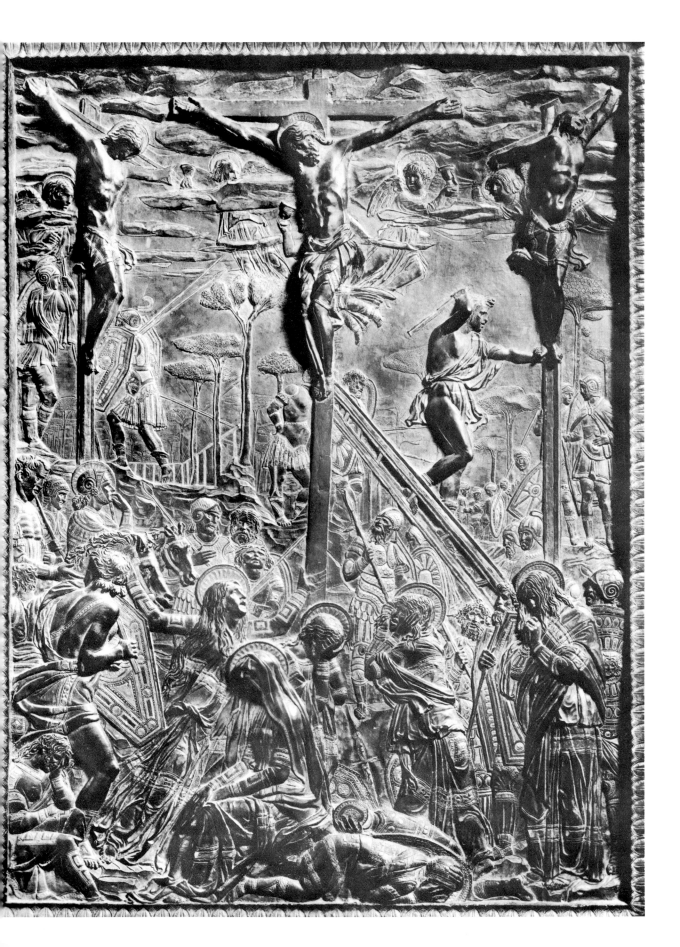

3. DONATELLO. *Miracle of the Wrathful Son*. 1446–50. Bronze, 57.1 x 123.2 cm.
Relief on the high altar, Sant' Antonio, Padua

which are unidentified); on "overemphasis on surface decoration"; and on the leaf molding in the border which Donatello "is most unlikely to have used for framing a separate pictorial relief such as ours."

All this would be plausible enough, but for the fact that the relief, in the original, reads like a masterpiece. If, indeed, the male figure hurrying forward on the left, which incurs Janson's suspicion, and the seated Virgin, which he believes to be "borrowed from the S. Lorenzo *Lamentation*," and the exquisitely delicate horses' heads above the Magdalen's right arm, which he connects with a motif in Ghiberti, are not by Donatello, they oblige us to presume the existence of an unknown sculptor, working on the same imaginative level and endowed with a manual dexterity that is indistinguishable from Donatello's.

The difficulty with the *Crucifixion* is that it is a transitional work. Its emotional language is that of the San Lorenzo pulpit reliefs, but its scale is smaller and its relief style is less recessive. It looks forward to the pulpits and at the same time back to the reliefs at Padua. If it was, as seems likely, a Medici commission, it must date from after Donatello's return from Padua and before the commencement of work on the reliefs which were incorporated in the pulpits, between about 1453 and 1456.

The connection with the Padua reliefs is very clear. The elaborate perspective of the distant fence proceeds naturally from that of the stadium in the *Miracle of the Wrathful Son* (fig. 3), as does the ladder which extends diagonally backwards from the cross, while the fully modeled male figure advancing from the left and the soldier in profile breaking the legs of the bad thief can be no more than a few years later than the comparable figure

122

standing on a block in the left foreground of the *Miracle of the Newborn Child*. At the top of this relief indeed there occurs the leaf molding which has been cited as proof that the *Crucifixion* is not by Donatello. The angels in the sky—and how wonderfully inventive they are—resemble not the angels in the *Presentation of the Keys* in London, but those that tend the dead Christ in the bronze relief at Padua, and the trees are not copied from the marble relief in London (which may by this time have formed part of the Medici Collection), but are evolved from those in the *Saint John on Patmos* in the Old Sacristy.

The probability that the relief was made soon after 1453 is confirmed by its technique. In the reliefs at Padua use is made of surface gilding, and there are references in documents to silvering, of which traces survive.[10] In the *Crucifixion* these experiments continue, but with the difference that silvering and gilding are replaced by damascening in silver and gilt metal.[11] The insertions are extremely thin, and inevitably many of them have come away. Thus the farther horse's head had a gilt bridle which has disappeared, as has the whole of the gilt halo of the angel behind the good thief and part of the gilt halo of the angel to the left of the thief opposite.

In two respects only are these losses significant. The first is in the crosses of the two thieves. That of the good thief retains a vertical silver strip on the main shaft, but lacks the silver inlay that originally ran across the arms, while the cross of the bad thief retains its original golden inlay on the arms but lacks the strip of gold that originally ran down the shaft. The second is that of the ground and sky. In the ground there are a number of irregular, lozenge-shaped recesses which were originally filled with silver (a few of these insertions survive), and in the sky there are similar recesses which leave no doubt that the underside of the clouds were filled with silver and that their upper surfaces were gold; a few pieces of silver inlay and quite a number of gilt insertions are preserved.

The more closely one looks at the relief the more evident it becomes that the intention behind the inlay was not confined to surface decoration. Those parts of the clouds which are conceived to be in shadow are damascened in silver, and those parts which are lit are gold. Similarly the front face of the cross of the good thief, which is damascened in silver, is seen against the light, while the cross of the bad thief, with its gold damascening, is fully lit. The crosses establish that the relief is lit from the left. This is confirmed by the distant trees, each of which has a narrow strip of gold on the left side of its trunk. If, as is likely, the source of light is the setting sun, it may well be that a hole just above the cross of the bad thief marks the point at which a silver moon was originally fixed. There is no bronze relief by Donatello in which the intention is so frankly coloristic and so overtly pictorial. Even the *Miracle of the Wrathful Son* at Padua, illuminated though it be by a gold sun a little to the left of the center of the scene, attempts no more than a generalized light illusion. In the *Crucifixion* Donatello is concerned with the portrayal of directed light.

With an artist of Donatello's eminence it is all too easy to assume that the styles he

practiced were autonomous. For sculptures that are fully three-dimensional, or that have a preponderant third-dimensional element, this assumption is almost certainly correct, but with low reliefs, in which the third dimension is notional or adventitious, the case is somewhat different, and here the balance of evidence is that his style, almost from the first, was conditioned by contemporary painting. Never does he transpose pictorial compositions into sculpture, but he consistently makes use of devices that appear in the first instance in painting.

In the absence of firm datings for the paintings and sculptures this cannot be proved conclusively, but in every instance in which the problem presents itself the painting seems to anticipate the sculpture.[12] It is, for example, more likely that Masaccio's *Tribute Money* precedes the *Presentation of the Keys* in London than that the *Presentation* precedes the *Tribute Money*. It is more likely that Domenico Veneziano's *Adoration of the Magi* in Berlin precedes the tondo of *Saint John on Patmos* (where the system of projection is identical) than that the tondo precedes the painting. It is more likely that the *desco* wrongly ascribed to Masaccio in Berlin precedes the *Raising of the Drusiana* than that it follows it. We may even look skeptically at the contention that the Jacopo Bellini sketchbooks in London and Paris must date from after 1455 since they reveal the influence of the reliefs on the high altar at Padua.[13] It would also, from what we know of the pattern of Donatello's relief style, be admissible to claim the opposite—that architectural structures like those in Jacopo Bellini's drawings were rationalized and consolidated in the Padua reliefs. Even in the Bargello *Crucifixion* the background, with its skeletal fence, its receding trees, and its attenuated figures, speaks the language of Jacopo Bellini more strongly than that of any contemporary painter.

In modern art-historical thinking Masaccio and Domenico Veneziano are firmly equated with progress while the art of the Venetian proto-Renaissance connotes intellectual inertia. So it is difficult for us to accept the obvious inference—that for Donatello as late as the

4. GENTILE DA FABRIANO. *Nativity*, from the predella of *Adoration of the Magi* (Strozzi altarpiece). Completed 1423. Panel, 25 x 62 cm. Uffizi Gallery, Florence

5.
Gentile da Fabriano.
Young Magus, detail of *Adoration of the Magi* (Strozzi altarpiece). Completed 1423. Panel. Uffizi Gallery, Florence

sixth decade of the century, despite his antecedent experience of the rationalism of Brunelleschi and Masaccio, International Gothic painting and its aftermath still exercised a powerful appeal.

This point must be borne in mind when we pass on from the fact of damascening in the *Crucifixion* relief to the reasons for its use. Nowhere does its employment seem more perverse than in the trees, with their gold damascening on the left-hand side. There is, however, a well-known analogy for these trees in painting, in the predella of the *Adoration of the Magi* of Gentile da Fabriano. In the *Nativity* (fig. 4) the tree under which Saint Joseph sleeps is lit, like Donatello's trees, with a thin band of light on the left side of the trunk, and in the adjacent *Flight into Egypt* trees illuminated from the left with a thin band of gold running down the trunk punctuate the entire scene.

Is it then possible that Gentile's altarpiece has the same relation to the *Crucifixion* that the *Tribute Money* has to the *Presentation of the Keys* and the Berlin tondo of Domenico Veneziano has to the roundel in the Old Sacristy? The answer appears to be affirmative. One of the puzzling features of the *Adoration of the Magi* is the use, especially in the central

group, of gilt gesso ornament, which represents a two-dimensional intrusion in the otherwise continuous tactile surface of the figures. In the young Magus standing in the center of the scene (fig. 5) the crown and halo, the collar, the area above the waist, a strip of sleeve above the elbow, and a band round the thighs are treated in this way. No doubt in the Strozzi Chapel in Santa Trinita these passages looked less flat than they do in the raking light of the Uffizi. Whatever reserve we feel about them, there can be no question that in the figures of the *Crucifixion* the gold damascening is put to the same use. The horizontal gold insertions in the dresses of the seated Virgin in the foreground and of the Magdalen beneath the cross likewise interrupt the continuum of modeling in the figures, and we may infer that the *Crucifixion*, like the *Adoration*, was designed for light conditions very different from those that it enjoys in the Museo Nazionale.

There are, moreover, two small points which serve to corroborate the connection. The first is the presence, to the left immediately beneath the cross, of a soldier with head upturned. Nowhere in Donatello, not in the roundels in the Old Sacristy, not in the four scenes at Padua, do we find a head treated in this way. But among the horsemen to the right of the *Adoration of the Magi* there is a head depicted in this fashion, which may even be the model by which the head of Donatello's soldier was inspired. The second point is that in the *Adoration*, behind and to the right of the young Magus, there stands a bearded man wearing a kind of turban. The headdress is constructed partly of paint and partly of gilt gesso, which is recessed in irregular strips excavated in the paint surface. This passage may have been the source of the horizontal gold insertions in the clouds of Donatello's relief. One of the consequences of the damascening is that the *Crucifixion* is more difficult to read than is any other bronze relief by Donatello. The gold insertions tend to throw into relief the fierce grimaces and the lurid gesticulation of the figures, and it is this which has led some students to look on it as a work from the extreme end of Donatello's life.

Despite all that has been written on Donatello's bronze reliefs, we cannot speak with confidence of the way in which they were produced. With marble reliefs such as those of the Prato pulpit, we may assume that the models were by Donatello, that the marble was roughed out in his studio, and that the figures were completed sometimes by assistants and sometimes by the master's hand. The judgments we pass upon the bronze reliefs are more subjective and less precise. No more than with the Padua reliefs is it necessary to suppose that in the *Crucifixion* all the chasing is by Donatello. There are some heads, that of a bearded man in full face beneath the ladder, for example, and certain figures in the background of which that is unlikely to be true, and in these the rather dry handling seems to argue the intervention of some Paduan assistant.[14] But the foreground figures and the whole of the upper part of the relief are likely to be fully autograph, and passage after passage has an immediacy far greater than any Donatello had achieved in bronze before. One of the most remarkable is the figure of the unrepentant thief (fig. 6), where the

126

tortured body is twisted against the cross and the head and protruding arm are left in the rough, in an inspired anticipation of the figure of Saint Lawrence in the pulpit relief in San Lorenzo (fig. 7).

To recapitulate, the *Crucifixion* was presumably a Medici commission, since it was later in the *guardaroba,* and was planned and executed soon after Donatello's return to Florence in 1453. It was intended to be seen from a low viewing point, roughly at the height at which it is now shown in the Bargello—one reason for supposing this is that the bad thief must have been well above eye level—and to be lit solely or mainly by artificial light, and for reasons we can no longer reconstruct it was influenced by Gentile da Fabriano's altarpiece in Santa Trinita, from which its decorative character and a number of the illusionistic expedients it embodies were derived. As a document it is of cardinal importance not only

6. Unrepentant Thief, detail of fig. 2

7. DONATELLO. Saint Lawrence, detail of *Martyrdom of Saint Lawrence*. Bronze. Relief on the Epistle pulpit, San Lorenzo, Florence

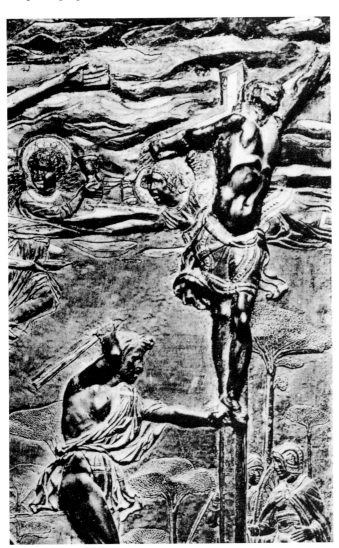

for what it tells us about Donatello's style and aspirations, but as the most radical attempt to bring bronze sculpture into conformity with painting that was made in the whole fifteenth century.

NOTES

1. Vasari, *Vite*, ed. G. Milanesi, ii (Florence, 1906), p. 417.

2. R. Borghini, *Il Riposo* (Florence, 1584), p. 321.

3. Colls.: Robinson, Camondo. Musée National du Louvre: *Catalogue de la collection Isaac de Camondo* (Paris, 1911), no. 21. The relief was shown in 1961–62 in London, Amsterdam, and Florence under the unduly conservative designation "style of Donatello" (*Meesters van het bronz der Italiaanse Renaissance* [Amsterdam, 1961], no. 5).

4. *Lettere di Sant'Antonino* (Florence, 1859), pp. 43–44.

5. The identification of the relief with one or other of the reliefs in the *guardaroba* described by Vasari is presumed by U. Rossi, "Il Museo Nazionale di Firenze nel Triennio 1889–1891," in *Archivio storico dell'arte*, vi (1893), p. 18, and by almost all writers on Donatello. It does not appear in the 1456 or 1465 inventories of the possessions of Piero de' Medici, or in the 1492 inventory of the collection of Lorenzo il Magnifico.

6. The most notable analyses are those of H. Kauffmann, *Donatello* (Berlin, 1935), p. 188, and J. White, *The Birth and Rebirth of Pictorial Space* (London, 1957), p. 165. Throughout the Donatello literature a distinction is commonly drawn between the ideation of the relief and the chasing. Thus Rossi, loc. cit., observes that "dopo la fusione fu rinettato troppo radicalmente." The working surface has been variously ascribed to Bertoldo (Schmarsow) and a Donatello pupil who is not Bertoldo (Tschudi, Planiscig).

7. M. Semrau, *Donatellos Kanzeln in S. Lorenzo* (Breslau, 1891), p. 79: "Am ehesten würde dem eklektischen Charakter dieser Tafel und den Mischung von eigenem Können mit beschrönkter Nachahmung die Vermutung entsprechen, älterer dass ein Schuler Donatellos, der ihn nach Padua begleitete, dies Werk gefertigt habe, vielleicht unter Benutzung eines ersten Entwurfs oder einzelner Studien von der Hand des Meisters."

8. H. W. Janson, *The Sculpture of Donatello* (Princeton, 1963), p. 243.

9. Ibid.

10. On Donatello's use of gilding and silvering see particularly J. White, loc. cit.; idem, "Developments in Renaissance Perspective," in *Journal of the Warburg and Courtauld Institutes*, xiv (1951), pp. 56–57, 60–61.

11. Though mid-fifteenth-century examples of its use are rare, it should be noted that at this time damascening was an accepted technique, and that upwards of thirty pieces of damascened metalwork are listed in 1456 in the inventory of Piero de' Medici (E. Müntz, *Les Collections des Medicis au XVe. siècle* [Paris, 1888], p. 25). The contract of February 28, 1445, for the bronze door of the north sacristy of the Duomo specifies that the framing should be decorated with "fregi piani lavorati alla damaschina doro et dariento solo come parra adetti operai," and that the panels of the door should contain "ciaschuno quadro uno tabernacolo di mezzo rilievo lavorato alla damaschina come idetti fregi" (A. Marquand, *Luca della Robbia* [London, 1914], p. 187).

12. For a summary of this case see J. Pope-Hennessy, "The Interaction of Painting and Sculpture in Florence in the Fifteenth Century," in *Journal of the Royal Society of Arts*, cxvii (1969), pp. 406–24.

13. M. Röthlisberger, "Notes on the Drawing Books of Jacopo Bellini," in *Burlington Magazine*, xcviii (1956), pp. 358–64.

14. There is no justification for connecting the chasing of the relief with either Bertoldo or Bellano. The gilding and silvering of the Padua reliefs seem to have been entrusted to three goldsmiths and silversmiths, and the damascening of the *Crucifixion* may likewise have been subcontracted to a specialist metalworker.

DONATELLO AND THE BRONZE STATUETTE

BOOKS ON BRONZE STATUETTES (and for the matter of that books on Donatello) proceed from a common assumption, that the revival of the small bronze should be ascribable to Donatello, but was in fact due to younger sculptors who reached maturity in the third quarter of the fifteenth century. On the basis of the evidence so far adduced, this thesis can be looked upon as valid, but it is, on broader grounds, so contrary to common sense that it may be worth while to examine it afresh.

The first objection is a simple one, and has been made often enough, that Donatello, in the 1420s and 1430s, makes repeated use of small bronze figures, which, if seen in isolation, would be regarded as independent statuettes. The key instances occur in the 1420s on the crozier of the *Saint Louis of Toulouse* and on the Siena Font. On the crozier we see three small winged figures divorced by their postures from the niches against which they stand, and on the font there are two fully freestanding figures (fig. 1), which Janson, at the end of his admirable review of the problems presented by the sculptures on the tabernacle, rightly describes as "the earliest harbingers of the *figura serpentinata*" in the quattrocento.[1] The principles implicit in them are still more evident in a third Donatello angel in Berlin, which was prized off the font, and their influence is reflected in a bronze putto in the Bargello,[2] which is now generally dismissed as Sienese, and in the work of Antonio di Chellino and Maso di Bartolommeo on the grill of the Cappella della Cintola at Prato.[3] Moreover, we know one large work in bronze by Donatello, the *David* in the Bargello, which in everything but scale anticipates the bronze statuettes of the third quarter of the century and is of particular importance for the small bronzes of Antonio Pollaiuolo, and another bronze of intermediate size, the *Amor-Atys*, where the creative process prefigures that of the small bronzes that were later produced in Mantua. It would be surprising if Donatello had stopped short at this point and did not himself experiment with the making of bronze statuettes.

The second objection arises from an observation of Middeldorf that in the background of Uccello's *Flood* there appears a figure which corresponds exactly with a known bronze model seen from behind.[4] The bronze model is the statuette of *Marsyas* which was described in the Medici Collection as the *"gnudo della paura."* One example of it appears in 1492 in the inventory of Lorenzo il Magnifico and several other examples are recorded.[5] What is in

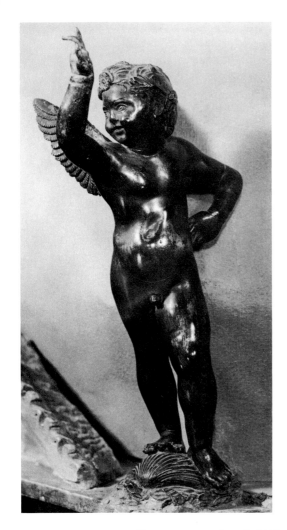

1. DONATELLO. Angel. 1429. Bronze, height 36 cm. On the tabernacle of the Baptismal Font, Baptistery, Siena

2. *Marsyas*, style of Antonio Pollaiuolo. Second half of 15th century. Bronze, height 35 cm. The Frick Collection, New York

every respect the finest of them is in the Frick Collection (fig. 2), and is usually associated with Antonio Pollaiuolo.[6] It is inferred by Middeldorf that if this model were known as early as 1450–55, it must have been evolved by an earlier sculptor than Pollaiuolo. Its origins have therefore to be sought in the circle, probably in the shop, of Donatello.

But how, it may be asked, should we expect a small pre-Paduan bronze by Donatello to look? Probably it would be less highly worked up than the bronze *David* or the *Amor-Atys*. The reason for saying this is that it would have been shown alongside excavated bronzes, and that already in the 1460s, in the work of Pollaiuolo, the practice was current in Florence of leaving bronze statuettes relatively in the rough. Examples are the *Hercules and*

130

Antaeus in the Bargello, where the base has not been chased, the Frick *Hercules*, which is unfinished, and the Berlin *Hercules*, which is more highly worked up than the Bargello group but falls far short of the uniformity of finish imposed in North Italian shops. The bronze, however personally it was inflected, would depend from the antique, and would almost certainly evince the energy and the contained sense of movement of the figures on the doors of the Old Sacristy. If the figure were clothed, the dress might be chiseled like the robes of the saints and Apostles on the doors, and if it were naked, it would be hammered, like the less highly finished passages in the *Amor-Atys*. Its features would be liable to correspond, in characterization and in morphology, with those in larger works by Donatello.

Some years ago I formed the impression that one small bronze, and one only, exactly met all these requirements. This is the statuette known as a *Pugilist* (fig. 3) in the Bargello.[7] By the modest standard of small bronzes, it has an imposing literature. It is recorded in 1825

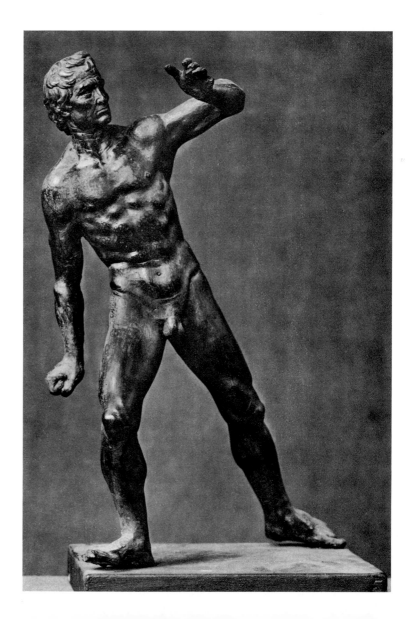

3. DONATELLO. *Pugilist.*
Bronze, height 34.5 cm. Museo
Nazionale del Bargello, Florence

as the work of Pollaiuolo, but was removed by Bode from Florence to North Italy with ascriptions first to Bellano[8] and then to Camelio.[9] The basis of the later attribution was the authenticated Camelio reliefs in the Cà d'Oro, which, Bode argued, "uns den Anhalt geben, um einige unter sich nahe verwandte Statuetten nackter Kämpfer, von denen die eine in Bargello, die andere in der Sammlung Beit in London sich befindet, mit Wahrscheinlichkeit diesem Künstler zuzuschreiben." As a general rule, Bode's errors were misconceptions not mistakes, but on this occasion a mistake was involved, for stylistically the Bargello and Beit bronzes were incompatible. Rightly or wrongly, the postulate of a North Italian origin for the Beit bronze was accepted by later students, and it was in due course shifted by Planiscig from the workshop of Camelio to that of Riccio.[10] The Bargello bronze suffered a more unexpected fate; it was republished in 1930 by Weinberger with an attribution to Sperandio,[11] and is still accepted as a work of Sperandio by Weihrauch.[12] What makes this puzzling is the capricious nature of Weinberger's supporting arguments. They rested on supposed affinities between the bronze and the reverses of certain Sperandio medals, but the plain truth was that the bronze did not resemble the figures on the medals in any way.[13]

Among small bronzes this is an altogether exceptional work. Whereas in the *gnudo della paura* both arms are raised horizontally, here the right arm is shown hanging down. The posture is one of challenge rather than alarm. The movement of the raised left arm and outspread fingers recalls the balance of the *Amor-Atys,* and so does the modeling of the protruding kneecaps, which are there defined with the assistance of the trouser leg and here project from the surrounding flesh. The toes of the right foot are turned slightly up, and the sense of nervous vitality is enhanced by the left foot, of which the ball alone rests on the base. The animation of the pose, though not the detail with which it is worked out, recalls the agitated figures on the bronze doors of the Old Sacristy. One of the remarkable features of the bronze is the strength and continuity of modeling of the torso (fig. 4), which cannot but recall that of the *Crucified Christ* at Padua. For the surface, defined by strong, persistent hammering, a close point of reference occurs in the *Amor-Atys,* where the big toe of the right foot is treated in precisely the same way. Nowhere is the boldness of the working more evident than in the strong horizontal gashes in the neck; these are found again in the figure of a Martyr in the right wing of the right-hand door in the Old Sacristy. Last and most decisively the type (fig. 5), with its wide, compressed lips, its furrowed forehead, its heavily modeled eyebrows and high cheekbones, and strongly marked diagonal depressions down each cheek, is manifestly Donatello's, and recalls what were still in 1440 his best-known works, the Prophets on the Campanile (fig. 6). It may be objected that these analogies, from style and from technique, amount to something less than proof, but the fact is that if the statuette is not by Donatello, it is the only truly Donatellesque independent small bronze that survives.

132

4. Torso of Pugilist, detail of fig. 3

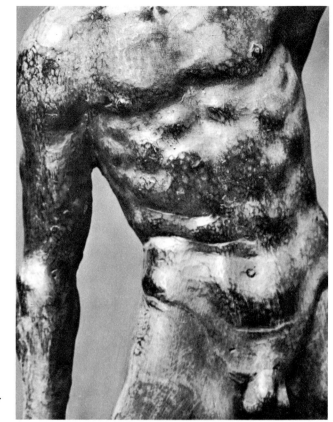

5. Head of Pugilist, detail of fig. 3

6. DONATELLO. *Jeremiah*, detail. 1427–35. Marble.
Museo dell'Opera del Duomo, Florence

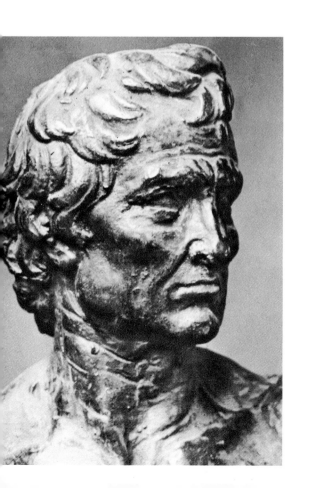

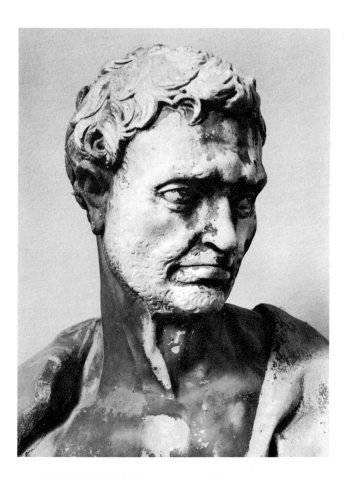

NOTES

1. H. W. Janson, *The Sculpture of Donatello,* 2nd ed. (Princeton, 1963), p. 75.

2. A firm distinction between the style of the Bargello putto and that of the three angels on the font was made for the first time by J. Lányi, "Donatello's Angels for the Siena Font," in *Burlington Magazine,* lxxv (1939), pp. 142–51, who regarded it as the work of a Sienese sculptor of the later fifteenth century.

3. For the Prato grill see particularly R. Nuti, "Pasquino da Montepulciano e le sue sculture nel duomo di Prato," in *Bollettino senese di Storia Patria,* x (1939), pp. 338–41, and G. Marchini, "Di Maso di Bartolommeo e d'altri," in *Commentari,* iii (1952), pp. 108–27, where a generally convincing attempt is made to distinguish the figures of Maso di Bartolommeo (1438–42) from those of Antonio di ser Cola (1447–59) and Pasquino da Montepulciano (1461–66).

4. U. Middeldorf, "Su alcuni bronzetti all'antica del quattrocento," in *Il Mondo antico nel rinascimento* (1958), pp. 170–73.

5. For the history of the example in the Bargello see U. Rossi, "Il Museo Nazionale di Firenze nel Triennio 1889–91," in *Archivo storico dell'arte,* vi (1893), pp. 18–20.

6. J. Pope-Hennessy, *The Frick Collection, iii, Sculpture: Italian* (Princeton, 1970), pp. 30–36.

7. The figure appears as no. 228 in the inventory of 1825.

8. W. von Bode, *Die italienischen Bronzestatuetten der Renaissance,* i (Berlin, 1907), Plate xxviii: "Jedenfalls ist auch diese Figur Paduanisch und grundverschieden von der Art Pollajuolos."

9. Ibid., 2nd ed. (Berlin, 1922), Plate 71, p. 55. In both editions the Beit bronze is described as the "Gegenstück" of that in the Bargello.

10. L. Planiscig, *Andrea Riccio* (Vienna, 1927), pp. 222–24, fig. 25: "Ich nehme diese Statuette, wie ich es bereits vor Jahren getan habe, für Riccio in Anspruch."

11. M. Weinberger, "Sperandio und die Frage der Francia Skulpturen," in *Münchner Jahrbuch der bildenden Kunst,* vii (1930), pp. 309–18.

12. H. Weihrauch, *Europäische Bronzestatuetten* (Braunschweig, 1967), pp. 126–28, 502, interprets it as a North Italian variant of the Pollaiuolo *Marsyas* model.

13. The principal analogies cited by Weinberger are the reverses of the Marino Carracciolo medal of c. 1466 (Hill no. 362) and of the Pietro Albano medal of 1472 (Hill no. 363). It would thus have been produced in Sperandio's second Ferrarese period, a quarter of a century earlier than the statuette of Gianfrancesco Gonzaga in the Louvre (c. 1495).

THE ALTMAN MADONNA
BY ANTONIO ROSSELLINO

ERHAPS THE MOST BEAUTIFUL mid-fifteenth-century Florentine marble relief in the United States is the Altman Madonna of Antonio Rossellino (fig. 1).[1] Not only has it the distinction of being perfectly preserved—in this it differs, for example, from the better-known Foulc Madonna of Desiderio da Settignano at Philadelphia, where the surface has been impaired[2]—but it represents, in its fluent yet sophisticated composition, its superlative technical control, and the restrained emotionalism of its imagery, one of the peaks of quattrocento sculpture.

In paintings the scene that is depicted is generally self-evident, but marble reliefs are more elusive, partly because the differentiation of texture is less precise and partly because they are in monochrome. For this reason we must begin by looking afresh at the content of the Altman carving. In the center is the Virgin turned three-quarters to the left. She sits on a carved seat of which a volute on the corner of the back and the corresponding forward support are shown on the right of the relief. In two places the receding chair arm is covered by her cloak, the folds of which are so disposed that the molded edge beneath them is legible. Her cloak covers her head, and beneath it is a diaphanous veil, whose substance is distinguished both from the heavy material of the cloak and from the dress (fig. 2). The cloak is tied across her throat and the ends of the veil cover her chest. Beneath the breasts her high-waisted dress is bound by a wide girdle twisted in diagonal folds, and on it, as on the edging of the cloak, the sleeve, and the buttoned cuff, are traces of gilt decoration, which is carried through into the halo behind the head. Her hair is dressed with a braid above the forehead and one tress pulled back over the left ear, and her eyes, which are pigmented, look meditatively downwards to the left, directed either to the Child, who sits on the farther arm of the seat, or to the spectator, on whom the Child's gaze is turned.

The posture of the Child is of extraordinary complexity (fig. 3). One leg, his right, is set frontally, while the other is turned almost in profile in opposition to the rest of the design. The lower half of the long torso that is habitual in the children of Antonio Rossellino has the same frontal accent as the right leg and the Virgin's containing hand, but the upper half is twisted to the left, with the right shoulder drawn back and the left advanced, while the right forearm is raised in a gesture midway between benediction and surprise. The

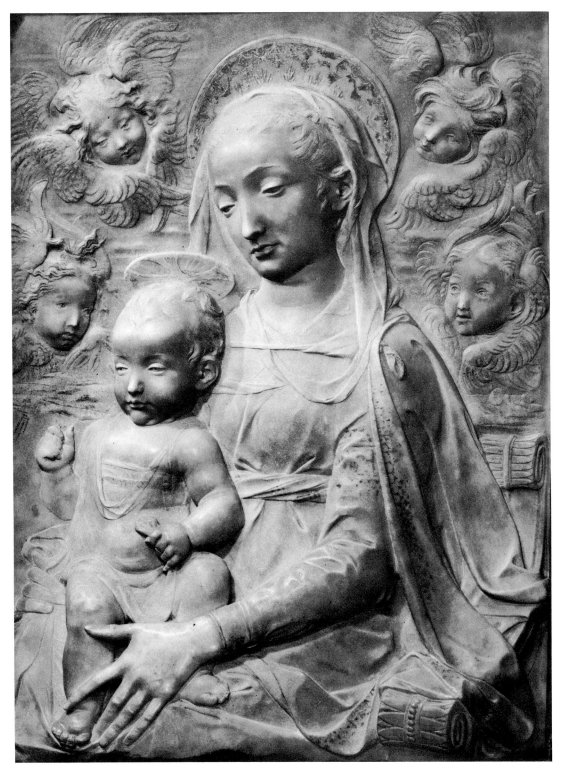

136

1. Antonio Rossellino. *Madonna and Child with Angels.* Marble, 74 x 55 cm.
The Metropolitan Museum of Art, New York. Bequest of Benjamin Altman

2. Virgin, detail of fig. 1

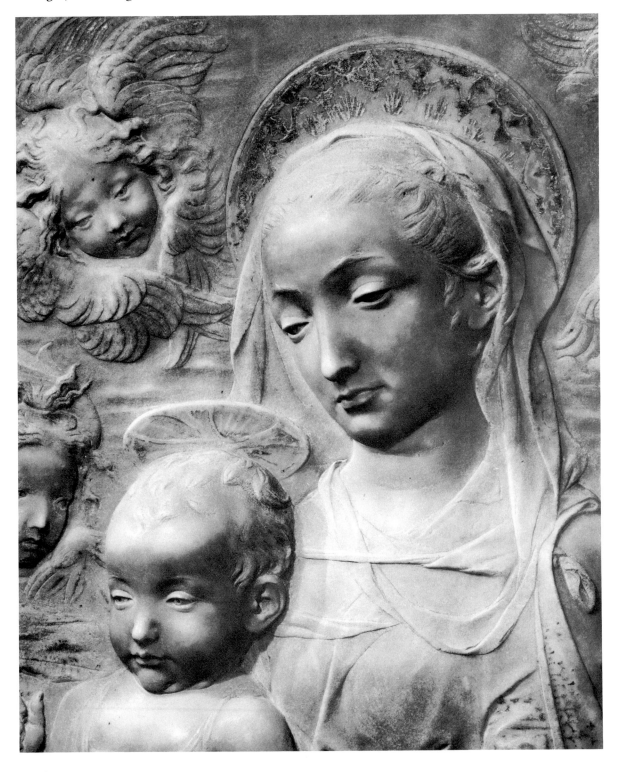

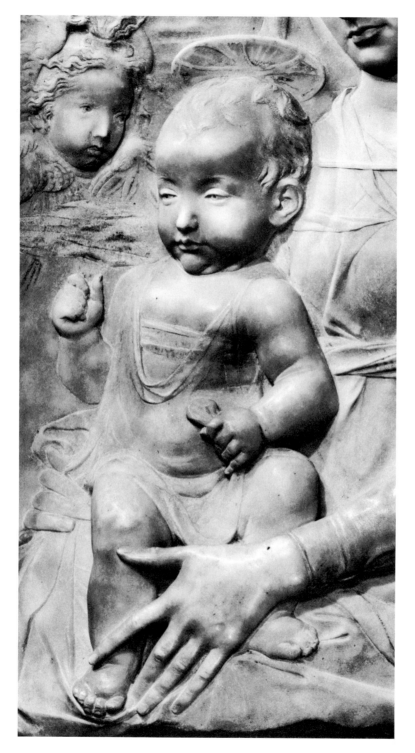

3.
Christ Child,
detail of fig. 1

4.
Left hand of Virgin,
detail of fig. 1

138

head, with chin drawn in, corresponds with the Virgin's in that it is directed three-quarters to the left. The Child has a swaddling band pulled tight across his chest, and over it, suspended from both shoulders, is a transparent smock, through which the surface of the body can be seen.

The depth of the relief is naturally greatest in those parts notionally nearest to the eye, that is, at the base, where the left hand of the Virgin is superimposed on the right leg of the Child, with the thumb and forefinger fully undercut (fig. 4). The front of the seat likewise projects from the main plane of the relief, which is established by a flat rim running along the top and the two sides. Within the rim the background is slightly excavated. Up to the level of the chair back the surface behind the figures is void, but from that point to the top of the relief it is broken by horizontal lines of cloud, from which

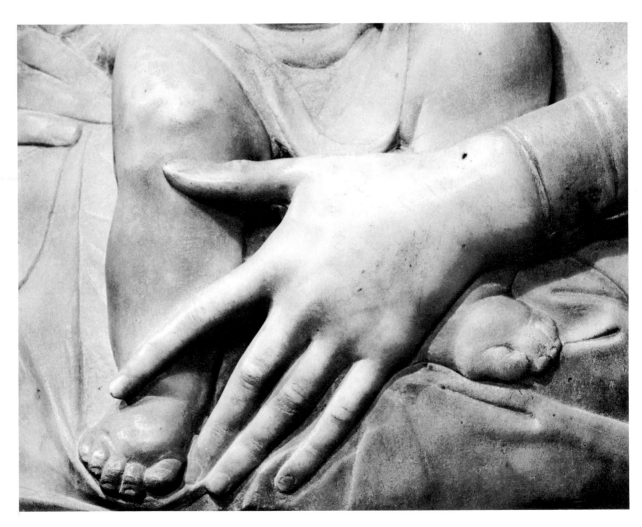

140

emerge four six-winged cherub heads (figs. 5, 6). The two beneath are turned inwards to right and left and posed as though their nonexistent bodies were set on the same vertical axis as the Virgin and the Child. The two above are set on two diagonals protracted from the upper corners of the relief, one of them slightly and the other emphatically foreshortened so that they appear to be on a more distant plane than the heads below them. If the relief is studied in detail in this way, it is impossible not to be impressed by the clarity and confidence with which each visual point is made.

Before we go on to consider the class of carving to which the Altman Madonna belongs, it is necessary to establish, in however approximate a fashion, the date when it was carved. Antonio Rossellino's chronology centers on one major work, the Tomb of the Cardinal of Portugal at San Miniato al Monte, which was begun in 1461, when the sculptor was thirty-three, and was completed in 1466.[3] Thereafter his development can be traced with a fair measure of confidence through dated or datable works, the much damaged bust of Matteo Palmieri in the Bargello (dated 1468), the reliefs of the pulpit in Prato cathedral (payment of 1473), and the figure of the *Young Baptist* from the Opera di San Giovanni, now in the Bargello (payment of 1477). Round them we can assemble a number of undated carvings, which are likely to have been produced in the same term of years. Before the commencement of work at San Miniato al Monte, however, we have only one dated sculpture, the bust of the doctor Giovanni Chellini of 1456 in London (see fig. 17 on page 86).[4] It is carved in a blotchy, brownish marble, and is technically one of the most careful and precocious works Rossellino produced. With it must be grouped a figure that is frequently assigned to a far later time, the statue of *Saint Sebastian* at Empoli (fig. 7),[5] not simply because it is carved from the same type of marble, which does not recur at San Miniato or in any later work before the *Baptist* in the Bargello, but because the handling is so closely similar to that of the Chellini bust. On the plane of style the meticulous treatment of the anatomy has the same relationship to Hellenistic models that the Chellini portrait has to Roman busts, while on that of technique it seems likely that the folds of the loincloth of the statue and the veins on the temple of the bust were carved in close proximity. While the documentary grounds for dating the statue to 1457 are certainly fallacious, the stylistic arguments in favor of a dating about 1460 are very strong. The fact that it was installed, at a much later date, in a painted altarpiece by Botticini, and that two little angels from the complex for which it was originally designed were perched precariously at the top on the corners of the frame, has no relevance to the date when it was carved.

The Altman Madonna must have been produced in close association with these works.

5. Cherub heads on left side of Virgin and Child, detail of fig. 1

6. Cherub heads on right side of Virgin and Child, detail of fig. 1

7. Antonio Rossellino. *Saint Sebastian.* c. 1460. Marble. Museum of the Collegiata, Empoli

142

There are three reasons for making this connection. The first is that the relief is carved from the same marble as the statue and the bust. This is not, of course, a compelling argument, since the sculptor might have returned to a slab from the same vein or quarry at a much later time, but the impact of all three sculptures is bound up with the material from which they are carved, and one might guess that its use was a matter less of expediency than of aesthetic choice. The second reason is that the technique of the relief closely recalls that of the Chellini bust. In both, the living texture of the flesh is rendered with singular success, and the hair of the Child in the relief and that in the portrait are treated in a very similar way. The third reason is the element of ambiguity that is common to the stance of the *Saint Sebastian* and to the pose of the Child in the relief; in both, the frontal position of the leg is contradicted by the movement of the torso above, and the opposition is resolved by the setting of the head. In the absence of documents, therefore, it would seem probable that the relief was carved after the Chellini bust and before the Monument of the Cardinal of Portugal, that is between 1457 and 1461.[6]

There is nothing in the style of the Altman Madonna that directly recalls the work of Donatello, yet thematically Donatello is the source of most of the motifs employed in the relief. It was Donatello who first experimented with the seated Madonna in half-length, notably in a beautiful pigmented terra-cotta relief in the Louvre (see fig. 14 on page 83), where the end of the seat is shown on the relief plane. In the *Virgin and Child with Angels* in the Victoria and Albert Museum, carved in Donatello's workshop probably in the 1450s, the seat is represented endwise in the same way, while in a school work, the so-called Pietra Piana Madonna in Florence, it is set diagonally in a manner which anticipates the practice of Antonio Rossellino. The alignment of the heads of the Virgin and Child is also found in the Louvre Madonna, and the cherub heads in the background are anticipated in another work by Donatello, the ruined terra-cotta Madonna formerly in the Kaiser Friedrich Museum and now in the Bode Museum in Berlin (see figs. 12 and 13 on page 81). Moreover, it was Donatello who first studied the illusionistic potentialities of low relief in marble in the cloud-covered sky of the *Ascension* in the Victoria and Albert Museum and the *Assumption* on the Brancacci monument in Naples (see fig. 8 on page 77) and who later in the Quincy Adams Shaw Madonna in the Boston Museum of Fine Arts transferred the technique he had developed to a Madonna relief. Not for nothing was the Altman Madonna, when it first came to light in Florence in 1877, sold by its owner Conte Cosimo Alessandri to the Berlin collector Oscar Hainauer as a work by Donatello.

Antonio Rossellino's formal training is likely to have taken place in the family workshop under his brothers Bernardo (born 1409) and Giovanni (born 1417), but after 1453, when Donatello returned from Padua, and before 1457, when he left Florence for Siena, Rossellino and the great sculptor must have been in regular contact, and may indeed have frequented the same humanist circle of which Chellini (who was the doctor of Donatello),

Neri Capponi (whose tomb chest was carved before 1457 in the Rossellino studio), and Matteo Palmieri (who was portrayed by Rossellino in a bust) formed part. Still closer contacts must have obtained between Antonio Rossellino and his younger contemporary Desiderio da Settignano, with whom he is bracketed in a document of 1452. Even if we discount the claim that Desiderio was himself trained in the studio of Bernardo Rossellino, the parallelism with Antonio Rossellino is remarkable.[7] Like Rossellino, Desiderio in the Foulc Madonna adapted Donatello's illusionism to a Madonna relief; and like Rossellino, in the Panciatichi Madonna in the Bargello he showed the Virgin on a seat set at an angle to the relief plane. Neither of these reliefs is dated or datable, but the Foulc Madonna may conjecturally have been carved in the late 1450s concurrently with the Madonna relief on the Marsuppini monument in Santa Croce, and the Panciatichi Madonna may have been

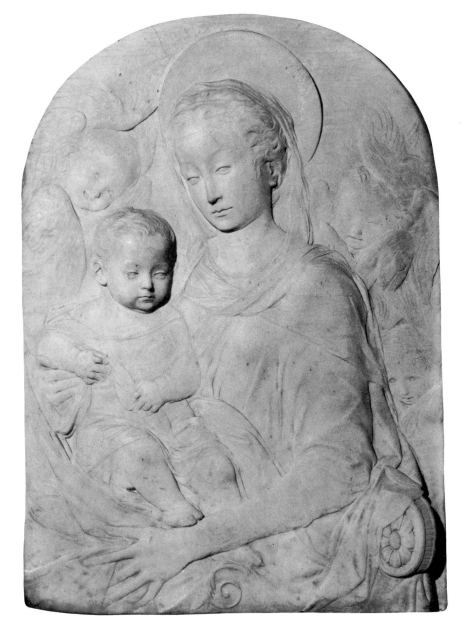

8.
ANTONIO ROSSELLINO.
Virgin and Child. c. 1455.
Marble, 80 x 56.3 cm.
The Pierpont Morgan Library,
New York

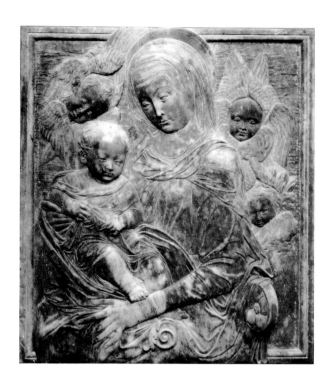

9.
Virgin and Child, after Antonio
Rossellino. Marble, 80.5 x 69.7 cm.
Victoria and Albert Museum,
London

produced between 1461 and 1464. There is no evidence of the influence of one artist on the other, but taken together the reliefs establish very clearly the distinctive features of Desiderio's temperament: the figures are more animated, the designs more linear, and the volumes less pronounced. It is often wrongly claimed that Rossellino was, as an artist, Desiderio's inferior. Though his later works show a progressive decline from the summit of the 1460s, his sculptures before that time are fully commensurate in quality with those of the younger sculptor.

By some odd coincidence the relief by Rossellino that stands closest to the Altman Madonna is also in New York, in the Morgan Library (fig. 8). It is a little taller and far less well preserved, and is likely, in view of its manifest connection with Desiderio, to be rather earlier in date.[8] As in the Foulc Madonna, the whole background is filled with cloud, and the faces of the angels, three in number, are set asymmetrically at the sides. The drapery is more cursive—in this too it resembles the Foulc Madonna—and the factor of recession is less pronounced. If, for example, we compare the exposed hands of the Virgin in the two reliefs, we shall find that the hand in the Morgan relief is the flatter of the two. The felicity of the design is seen as soon as the relief is juxtaposed with a crude marble copy in the Victoria and Albert Museum (fig. 9),[9] probably dating from the fifteenth century and probably copied not from the original, but from a stucco squeeze, in which the figure of the Virgin is extended at the base and superimposed on a molded rectangular frame.

Two other reliefs are patently connected with this work. One, probably contemporary with the Altman Madonna, is the *Madonna of the Candelabra,* known through a number of replicas in stucco and terra-cotta, which seem to depend from a lost marble original (fig. 10).[10] The Virgin faces to the right, and her right arm runs diagonally down the lower part of the relief; in both respects, as well as in the angle of the head, the figure is an inversion of that in the Altman relief. The edge of the seat appears in the lower left corner, and the Child, seated on a cushion on the chair arm opposite, faces inwards and clasps a bird with both hands. At the back are two candelabra with a garland forming two diagonals between them. This last motif, as Marquand observed, recurs on the pilasters flanking the lower part of the Tomb of the Cardinal of Portugal.

The other related work is a marble relief formerly in the Kaiser Friedrich Museum in Berlin (fig. 11).[11] Since it has been destroyed and the only photographs that are available are

10. *Virgin and Child*, after Antonio Rossellino. Terra-cotta, 72.4 x 48.9 cm. Victoria and Albert Museum, London

11. ANTONIO ROSSELLINO. *Virgin and Child*. Marble, 75 x 50.5 cm. Destroyed; formerly in Kaiser Friedrich Museum, Berlin

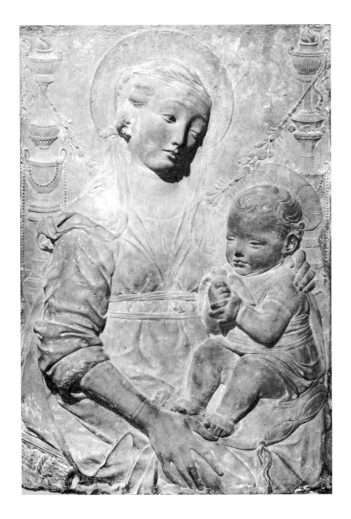

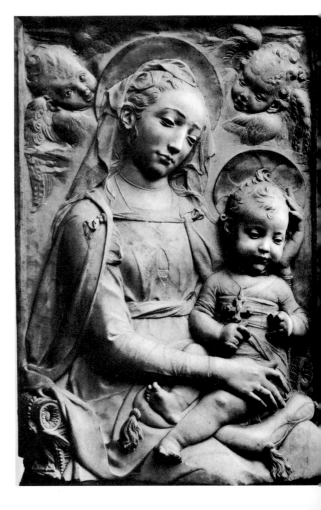

overlit, it is difficult to speak of it with any confidence. It could be judged in reproduction to be rather less sensitive than the Altman Madonna—this seems indeed to have been recognized by Bode—but there is no reason for supposing that it was anything but autograph. The posture of the Virgin is connected with that of the *Madonna of the Candelabra,* though her forearm is held horizontally, almost parallel with the base of the relief, and more of the outer and part of the inner arms of the seat are shown. But the head of the Child is turned outwards to the right, so that the compositional pattern repeats in reverse that of the Altman relief. A feature which has no equivalent in this series of reliefs is the foreshortened left hand of the Child, where the protruding knuckle of the forefinger repeats a similar motif in the Foulc Madonna of Desiderio. The linear properties of the design are less pronounced than in the two New York reliefs, and the recession in the foreground is more abrupt. This and a new insistence on naturalistic detail (in the Child's tunic, for example, as well as in the cross worn round his neck, and in the Lippi-like veil piled up on the Virgin's head) may be among the factors which led Bode to conclude, almost certainly correctly, that it was of somewhat later date.[12] This view seems to be confirmed by the hair of the Child, which no longer adheres to the cranium, but is swept up in animated curls, one of which falls over the forehead. In the Virgin and Child on the Tomb of the Cardinal of Portugal the Virgin's robe is portrayed in the same fashion, and the hair of the Child is, on its larger scale, treated like that in the relief.

In the course of the 1964 analysis based by Clarence Kennedy on stylistic inference and by Frederick Hartt on unpublished documents, it was established that certain parts of the monument at San Miniato commonly given to Antonio Rossellino were in fact executed by his elder brother Bernardo; one of these, in which Bernardo seems to have worked from a model by Antonio, is the angel holding a crown posed on the left above the bier, and another, also from a model by Antonio, is the flying angel in the upper register on the right. It has, moreover, been demonstrated that members of the workshop of Bernardo Rossellino were also involved in the execution of the tomb. The practice of collaborative execution in the Rossellino shop has a long history. As early as 1444, in the *Annunciation* commissioned from Bernardo Rossellino for Empoli, we find two different hands at work, one, responsible for the Virgin, that of Bernardo, and the other, the artist of the Annunciatory Angel, perhaps that of Giovanni Rossellino. In the late 1440s the same phenomenon occurs again in the Bruni monument in Santa Croce, where the two angels beside the Virgin and Child in the lunette are once again by different hands, neither of which is Bernardo Rossellino's. Similarly in the Tomb of the Beata Villana in Santa Maria Novella, of 1451–52, the curtain at the back is supported by two angels so different from one another that the one on the right has mistakenly been given to Desiderio da Settignano. In this case the juxtaposition seems to be that of Bernardo and Antonio Rossellino, as it is once more in the *Annunciation* which crowns the sarcophagus of the Beato Marcolino at Forlì, where the Virgin is a typical work of Bernardo Rossellino, while the head of the

Annunciatory Angel is not far removed from the head of the lower angel on the left-hand side of the Altman Madonna.

Antitheses like these do no more than scratch the surface of a far more intricate problem, that of the models by Bernardo and Antonio Rossellino which were realized by assistants in their shop. This issue is posed by the last of the marble reliefs looked on by Planiscig as early works by Antonio Rossellino, a marble Madonna in the Gulbenkian Foundation at Lisbon (fig. 12).[13] A clue to the date of the carving is provided by the garland and bull's head on the chair end in the lower left corner, which are associable with the classical ornament on the base of the Monument of the Cardinal of Portugal. If proof be needed that the relief was not carved by Antonio Rossellino, it is provided by the clumsy disposition of the cherub heads and by the sky, where the clouds are portrayed as little humps rising from a flat base, and are not treated impressionistically with irregular horizontal strokes, as they are in the Altman and Morgan reliefs. The features of the Virgin are inexpressive, and the front of her dress is treated schematically with no regard to the volume of the forms beneath. The Child likewise reads in a highly artificial way, with awkwardly articulated limbs, and hair which is rendered as a decorative pattern on the surface of the marble slab. At a time when it is fashionable to father on Bernardo Rossellino sculptures for which he cannot possibly have been responsible, it might seem inevitable that he should be credited with this relief. But though there is some morphological resemblance between the head of the Virgin and his genuine works, such an attribution would be unsound, and it is likely that the relief was adapted from a design or model of Antonio Rossellino's by a member of his brother's shop.

The later vicissitudes of Rossellino's style are illustrated by the only other relief by him in the United States, a Madonna in the Kress Collection in the National Gallery of Art (fig. 13).[14] In its own fashion it is a highly accomplished work. The Virgin, almost in full face, is seen in three-quarter length behind a ledge, and the Child stands on a cushion at the right. This formula does not occur in any previous relief by Rossellino but is found regularly in Verrocchio, both in an autograph work, the terra-cotta Madonna from Santa Maria Nuova in the Bargello, where the Child also stands on the right side of the ledge, in the so-called Dibblee Madonna (see fig. 7 on page 226), a stucco squeeze from a lost marble, where the Child stands on the opposite side, and in a related marble Madonna from Verrocchio's workshop in the Bargello. Just as the protruding knuckle of the Child in the Berlin Madonna can be traced back to Desiderio da Settignano, so the clenched right fist, which is one of the least attractive features of the Child in Washington, seems to depend from the Dibblee Madonna and its derivatives. The right hand of the Virgin, as we might expect, continues the tendency towards deeper cutting that is apparent in the Berlin relief, and by comparison with the Altman Madonna her head is rounder, more placid, and more inert. The first step towards this change of type seems to be represented by the Nori tomb

in Santa Croce, where against a marble curtain we see a mandorla containing a Madonna and Child based on the Virgin in the monument at San Miniato. In books on Rossellino the Nori Madonna is usually presented as one of his last works, but it has recently been argued that it dates from before 1461 since "it is hard to believe that an artist of Rossellino's temperament could, after realizing such an accomplished group as the Madonna and Child on the Cardinal's tomb, have returned to this simpler frontal pose and to forms so much more congenial to an earlier stage of the development of Quattrocento sculpture."[15] Hard it may be to believe, but it is nonetheless all but a fact that the Nori Madonna was carved after the tomb, and probably dates from about 1470. Morphologically it marks a median point between the monument and such debased works of the seventies as the Naples *Adoration of the Shepherds* and the large tondo of the *Nativity* in the Bargello. The Wash-

12. *Virgin and Child*, adapted from a design or model by Antonio Rossellino. Marble, 94 x 62 cm. Calouste Gulbenkian Foundation, Lisbon

13. ANTONIO ROSSELLINO. *Virgin and Child*. Before 1461. Marble, 84 x 56 cm. National Gallery of Art, Washington, D.C. Samuel H. Kress Collection

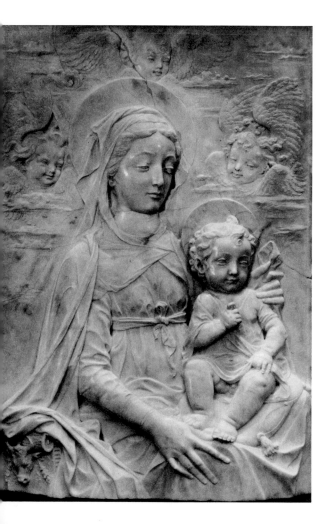

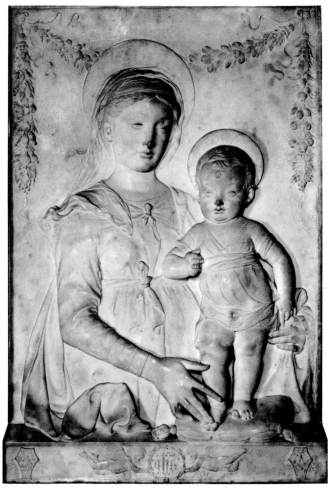

ington relief is closer to the Nori Madonna than to the later works—it has the same rubbery drapery folds—and must have been produced in the same bracket of time.

The epithet commonly applied to Rossellino's relief style is "pictorial," but this term can mean many different things, and a true understanding of the carvings can be obtained only if it is defined. When the Altman Madonna is compared with paintings of the Virgin and Child produced in the 1450s and 1460s, the results are negative. Neither the Berenson and Washington Madonnas of Domenico Veneziano, nor the Louvre and Jacquemart-André Madonnas of Baldovinetti, nor the half-length Madonnas of Filippo Lippi in the Uffizi and the Palazzo Medici, nor the Esztergom Madonna of Pesellino, nor works of secondary artists like Zanobi Machiavelli and Neri di Bicci and the Castello Master, provide satisfactory analogies for the style of this or the cognate reliefs. On the contrary, they serve to confirm that the types and compositions of these early carvings are personal to Rossellino. Yet the idiom of the reliefs, and especially the handling of the drapery, reads unmistakably as though it were a sculptural adaptation from a painted source. And so it is, though the parallel occurs in painting of an earlier time. If we compare the robe and sleeve of the Virgin in the Altman Madonna with those of the standing angels to the right and left in Fra Filippo Lippi's Barbadori altarpiece of 1437 (fig. 14) or with the similar figures beneath the corners of the central platform in the Sant'Ambrogio *Coronation of the Virgin* of the early 1440s, it becomes evident that these great public paintings of fifteen or twenty years before were the source by which Antonio Rossellino was inspired. There is abundant proof of the retarded influence of Fra Filippo Lippi on his later works. Thus, the Naples *Adoration of the Shepherds* of about 1475 undoubtedly sprang from the stimulus of Lippi's altarpieces of the Adoration of the Magi at Annalena (soon after 1453) and Camaldoli (probably 1463), and the circular *Nativity* in the Bargello of about 1470 must have been conceived as a sculptural counterpart for Lippi's great tondo of the Virgin and Child in the Palazzo Pitti of about 1452. Lest it seem tendentious to postulate so close a relationship between two works of different subjects which share no iconographical motif, it may be noted that a group of reliefs of the Virgin and Child made by Rossellino in the late 1460s seems to have been touched off by the pyramidal Virgin in the foreground of the Pitti tondo (fig. 15). The most notable of these reliefs is a composition of which a version in stucco without a background is in the Victoria and Albert Museum (fig. 16).[16]

In Florence in the 1450s and 1460s the personality of Lippi bulked considerably larger than it does in the minds of art historians today, and there are indications of the interest of sculptors other than Rossellino in his work. One of them is Luca della Robbia, one of whose bronze putti in the Musée Jacquemart-André from the Cantoria in the cathedral closely recalls the type of the Child in Lippi's Madonna of 1437 in the Palazzo Barberini, and whose Genoa and Bliss Madonnas reflect two different aspects of the composition of Lippi's half-length Madonna in the Palazzo Medici. Another is Desiderio da Settignano,

14. FRA FILIPPO LIPPI. Angels, detail of
Madonna and Child with Saints and Angels
(Barbadori altarpiece). Commissioned 1437.
Panel. Musée National du Louvre, Paris

15. FRA FILIPPO LIPPI. *Virgin and Child*.
Probably c. 1452. Panel, diameter 134.6 cm.
Palazzo Pitti, Florence

16. *Virgin and Child*, after Antonio Rossellino.
Polychromed stucco, 85 x 56 cm.
Victoria and Albert Museum, London

whose *Saint Jerome* in Washington and whose *Dead Christ with the Virgin and Saint John* in San Lorenzo are both generically Lippesque.

Antonio Rossellino is, however, the only sculptor who made a continuing effort to provide a sculptural equivalent for Lippi's style. The sculptures that resulted are of unequal merit, and the latest of them, carved after the deaths of Desiderio and Bernardo Rossellino, when control of a productive workshop seems to have precluded the close cogitation and technical refinement of the carvings of his earlier years, are little but transcriptions in three dimensions of motifs from Lippi's paintings. But the earlier reliefs, judged by the criteria of invention and expressiveness, are some of the most elegant and resourceful quattrocento sculptures. It was claimed by Leonardo that those reliefs which depend for their effect on the creation of a space illusion should be looked upon as paintings, and though the Altman Madonna was never, so far as we can tell, transformed into a painting, as was the Morgan Madonna—of which derivatives in pigmented stucco exist, one of them in the Metropolitan Museum (fig. 17)—the aspirations revealed in the smooth transitions of its shallow planes and in the illusory mobility of its forms partake of the nature of both arts.

NOTES

1. According to W. von Bode, *Die Sammlung Oscar Hainauer* (Berlin, 1897), no. 6, pp. 9, 61, illustration on p. 8, the relief was bought by Hainauer from Conte Cosimo Alessandri, Palazzo Alessandri, Florence, in 1877. In 1906 it was sold by Frau Julie Hainauer, with other sculptures in the Hainauer Collection, to Duveen Bros., from whom it was purchased in 1909 by Benjamin Altman. The attribution to Antonio Rossellino is due to Bode, and is accepted by all later authorities save A. Venturi, *Storia dell'arte italiana*, vi (Milan, 1908), p. 626, n. 1, who lists it along with the marble relief in the Kunsthistorisches Museum, Vienna, among works wrongly ascribed to Rossellino.

2. The authenticity of the Foulc Madonna is wrongly questioned by A. Markham in a review of I. Cardellini's monograph on Desiderio da Settignano (*Art Bulletin*, xlvi [1964], p. 246): "I should like to eliminate the Foulc Madonna from the oeuvre of Desiderio. The face of the Madonna is as saccharine as that of the Madonna in Turin and the device of the open mouth has been carried to a ludicrous extreme." U. Schlegel, "Zu Donatello und Desiderio da Setti-

gnano. Beobachtungen zur physiognomischen Gestaltung im Quattrocento," in *Jahrbuch der Berliner Museen*, ix (1967), p. 40, tentatively subscribes to the same view. I see no reason to question the conventional view (1) that the Philadelphia relief is an autograph work by Desiderio, (2) that it is the direct source of a version of the composition in pigmented stucco in Berlin, and (3) that the Berlin relief probably corresponds with a gesso Madonna after Desiderio mentioned in the diary of the painter Neri di Bicci in 1464.

3. For the Tomb of the Cardinal of Portugal see particularly F. Hartt, G. Corti, and C. Kennedy, *The Chapel of the Cardinal of Portugal, 1434–1459, at San Miniato in Florence* (Philadelphia, 1964).

4. For the Chellini bust see J. Pope-Hennessy and R. Lightbown, *Catalogue of Italian Sculpture in the Victoria and Albert Museum*, i (London, 1964), no. 103, pp. 124–26.

5. It is stated by G. Gaye, *Carteggio inedito d'artisti dei secoli XIV, XV, XVI*, i (Florence, 1839), p. 188, that a small payment listed in a *Denunzia de'beni* of Bernardo Rossellino of 1457 relates to the Empoli

152

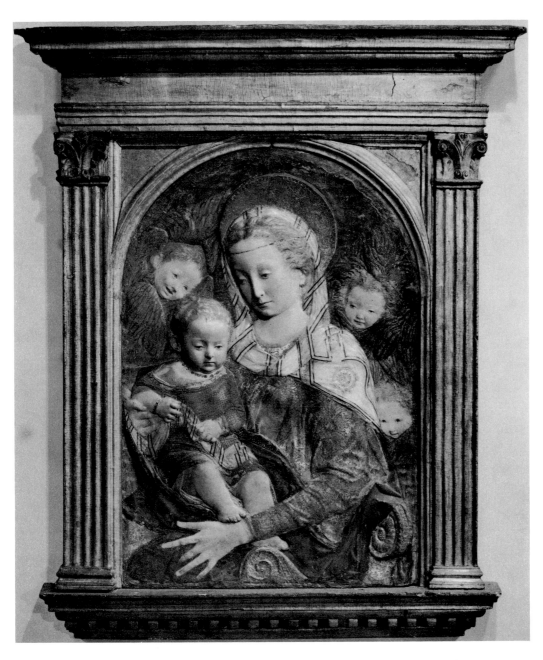

17. *Virgin and Child*, after the Morgan Madonna by Antonio Rossellino. Polychromed stucco,
83.5 x 57.2 cm. The Metropolitan Museum of Art, New York. Bequest of George Blumenthal

statue. For this reason the *Saint Sebastian* was regarded as a work of 1457 by W. von Bode, *Denkmäler der Renaissance-Sculptur Toscanas* (Munich, 1892–1905), p. 100, and P. Schubring, *Die italienische Plastik des Quattrocento* (Berlin, 1919). M. Reymond, *La Sculpture Florentine,* iii (Florence, 1899), pp. 86–87, related the date 1457 to the two angels, not to the Saint Sebastian. O. Giglioli, *Empoli artistica* (Florence, 1906), pp. 46–50, demonstrated that this reference is to the Empoli *Annunciation* of Bernardo Rossellino, and thereafter the *Saint Sebastian* has been commonly assigned to a considerably later date. A dating c. 1470 was proposed by H. Gottschalk, *Antonio Rossellino* (Leignitz, 1930), pp. 67–72, on the grounds (1) of a supposititious connection with the Pollaiuolo *Martyrdom of Saint Sebastian* in the National Gallery, London, and (2) of a conjectural dating in the 1470s advanced by E. Kühnel, *Francesco Botticini* (Strassburg, 1906), p. 40, for the wings by Botticini, and by L. Planiscig, *Bernardo und Antonio Rossellino* (Vienna, 1942), p. 56, "kurz nach 1470." A dating c. 1460 was advanced by M. Weinberger and U. Middeldorf, "Unbeachtete Werke der Brüder Rossellino," in *Münchner Jahrbuch der bildenden Kunst,* n.f. v (1928), p. 99, and is likely to be correct.

6. An early dating for the relief is accepted by Bode, op. cit. (1892–1905), p. 103, who considered it prior to the Madonna in Berlin, by Planiscig, op. cit., pp. 52–53, who adopted the same view, and by Gottschalk, op. cit., p. 42, who regarded the Berlin Madonna as the earlier work.

7. The relationship is wisely defined by Weinberger and Middeldorf, loc. cit., as "eine gewisse Ähnlichkeit mit Desiderio... nur im Sinne einer zeitlichen Parallele." The stylistic affinities between Desiderio and Antonio Rossellino are not such as to compel us to postulate a period of training in a common studio. It is, however, argued by A. Markham, "Desiderio da Settignano and the Workshop of Bernardo Rossellino," in *Art Bulletin,* xlv (1963), pp. 35–45, in my view mistakenly, that Desiderio was trained in the shop of Bernardo Rossellino, and was responsible for the face of the virgin in the Madonna and Child of the Bruni monument in Santa Croce and for the effigy in the Tomb of the Beata Villana in Santa Maria Novella.

8. The relief is generally accepted as an early work

of Antonio Rossellino's but is apparently dated by Gottschalk, loc. cit., and Planiscig, op. cit., p. 54, after the Altman Madonna.

9. Pope-Hennessy and Lightbown, op. cit., i, no. 108, pp. 130–31.

10. See A. Marquand, "Antonio Rossellino's Madonna of the Candelabra," in *Art in America,* vii (1918–19), pp. 198–206, and Pope-Hennessy and Lightbown, op. cit., i, no. 110, pp. 132–33. The relief is ignored by Planiscig.

11. F. Schottmüller, *Die italienischen und spanischen Bildwerke der Renaissance und des Barock, i, die Bildwerke in Stein, Holz, Ton und Wachs* (Berlin, 1933), no. 1709, pp. 46, 47. In contradistinction to Gottschalk, Planiscig, loc. cit., regards the relief as the latest in date of Rossellino's early Madonnas.

12. Bode, loc. cit.

13. It was bought by Gulbenkian from the Palazzo Guicciardini, Florence, through Dr. Jakob Hirsch. The relief is dated by Planiscig, op. cit., p. 53, before 1461.

14. Colls.: Granby; Clarence Mackay, New York; Kress (1939). The attribution to Rossellino is due to W. R. Valentiner, *The Clarence H. Mackay Collection* (New York, 1926), no. 12, and is accepted by Planiscig, op. cit., p. 59, and others, but is questioned in the 1941 *Preliminary Catalogue of Paintings and Sculpture in the National Gallery of Art,* p. 234, where it is stated that "although there are considerable elements of Rossellino's style and technique evident in this relief, the composition is more monumental and less curvilinear than that generally to be found in his work." The relief is variously dated c. 1475 (on account of its relation to the Naples *Adoration of the Shepherds*) and c. 1477 (on account of its relation to the *Young Baptist* in the Bargello).

15. Hartt, Corti, and Kennedy, op. cit., pp. 79–80, where it is correctly argued that the death of Francesco Nori in 1478 has no relevance to the dating of the monument or the relief. The contrary view, that the relief was executed shortly before the death of Nori and is therefore Antonio Rossellino's last work, is adopted by Gottschalk, op. cit, p. 85, and Planiscig, op. cit., p. 60.

16. For the relief see Pope-Hennessy and Lightbown, op. cit., i, no. 112, p. 134.

154

THOUGHTS ON ANDREA DELLA ROBBIA

I N THE CATHOLIC CHURCH you are taught to distinguish between sins of commission—things you should not have done but did—and sins of omission—things that you should have done but failed to do. It is a sin of omission that concerns me in this article. Some years ago I wrote a general book about Italian Renaissance sculpture, which mentions almost every significant artist. Only one well-known sculptor was left out—his name does not appear even in the index—and that was Andrea della Robbia.

Despite the excellent volumes by Allan Marquand devoted to Andrea and what is termed his atelier,[1] he has always had a mixed, indeed a rather unfavorable press. "His view of life is neither very broad nor very strong. . . . Restlessness, emotionalism and a certain triviality lay at the roots of his nature." George Eliot on some delinquent minor character? Not a bit of it; it is Maud Cruttwell on Andrea della Robbia.[2] The reasons for this censure are self-evident. In museums all over the world one sees little Nativities given to Andrea which no one could describe as broad or strong, and where the imagery and the rather artificial gestures are certainly not free of triviality. Marquand gives them to Andrea's studio, and it was indeed in his workshop in Via Guelfa that many of them were produced. The demand for them was inexhaustible, first because they satisfied a need—they were objects to which innocent prayers could be addressed—and second because they reflected, however palely, one of the great religious icons of the later fifteenth century.

The altarpiece by Andrea della Robbia at La Verna from which they depend (fig. 1) is a beautifully architected work. If the pilasters and the base and frieze are translated into terms of gilded wood, one could imagine them housing a painting by Ghirlandaio. The heads of the five seraphs at the top are individualized, and are modeled freely in substantial depth, with their wings depicted in two planes. In the rectangle beneath, the figures are disposed with what might, in less yielding hands, appear too rigorous an insistence on geometry. The left thigh of the Virgin follows the vertical of the pilasters, and her bowed head occupies a median point between them. The diagonal of her neck is reinforced by the figure of the Child Christ, and by the right edge of the grassy mound on which he lies, as well as by the forearms of the angels on the right. Above is God the Father, supported by

155

six seraphs, with hands raised as though surprised at the miraculous occurrence for which He is responsible, and from the sides pairs of angels extend a scroll with the music of the *Gloria,* which is sung by two openmouthed angels on the right. Below, in bold humanist script, is a sentence from the Gospel of Saint John, which informs us, if up to this point we were in any doubt, that the altarpiece represents not the Adoration of the Child, but the Incarnation, the mystery of the word made flesh.

The altarpiece stands in the Brizi Chapel on the right of the Chiesa Maggiore at La Verna, and is not documented, but on the balustrade of the chapel we read the words: "Istam Capellam fecit. fieri Jacobus Britii de Pieve Santi Stephani A.D. MCCCCLXXVIIII." Presumably, therefore, it dates from 1479 or 1480.[3] When it was made, Luca della Robbia was still alive—he died in 1482—and his nephew Andrea was forty-four, and it was Luca della Robbia who first experimented with the production of altarpieces in enameled terra-cotta. Only one integral altarpiece by Luca della Robbia survives;[4] it was made for San Biagio at Pescia, probably about 1470, and is planned as a triptych, with Saints James and Blaise in the wings, and in the center a Virgin and Child with two angels (fig. 2). The three sections are framed in a nonarchitectural decorative border, and the figures are shown on an unincidented dark blue ground. The only intimation of space is provided by the poses of the angels beside the throne. In Andrea's altarpiece, on the other hand, the blue background is conceived pictorially as sky, and though the Virgin hugs the front edge of the relief, as Luca della Robbia's figures also do, the half-length angels beside her are disposed in the limited depth we find in so many contemporary paintings.

With painters in the third quarter of the fifteenth century the scene of the Virgin Adoring the Child was very popular. The only exactly datable example occurs in a sketch for an altarpiece sent by Filippo Lippi to Giovanni di Cosimo de' Medici in 1457, but this seems to have been preceded, soon after 1453, by the Annalena Adoration in the Uffizi and followed, about 1459, by the Medici Adoration in Berlin, and about 1463 by the Adoration for Camaldoli. In a simpler form the motif was the stock-in-trade of the Master of the Castello Nativity. Luca della Robbia had himself treated it in the 1460s in a small relief now at Nynehead,[5] where the Virgin is depicted almost in pure profile, with her cloak pulled forwards so that she and the Child are enclosed in a kind of triangle or pyramid. The figures are strongly modeled and self-contained, and one feels something of an intruder in so much as looking at this wholly private scene. If we return to the La Verna *Incarnation,* we shall find that in both of these respects it differs from Luca's relief. The modeling is drier and less confident, and the scene is a far from private one; it presumes, indeed solicits, the attention of an onlooker.

1. ANDREA DELLA ROBBIA. *Incarnation.* c. 1479–80. Enameled terra-cotta, 240 x 180 cm. Chiesa Maggiore, La Verna

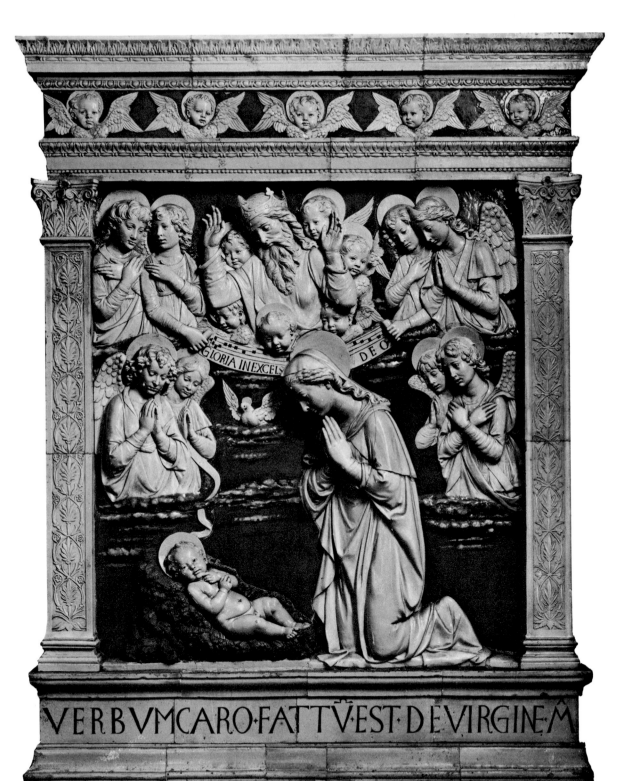

The *Incarnation* is, of course, only one of a number of altarpieces by Andrea della Robbia at La Verna,[6] and it is the circumstances of this commission that explain the way in which Andrea's style evolved. The mountain of La Verna had been ceded to Saint Francis, and it was there, shortly before his death, that the stigmata were conferred on him. After his death, therefore, it was a natural focus of Franciscan pilgrimage, and would have been much frequented but for the fact that it was difficult of access and for that reason ill-maintained. It was run locally from a Franciscan convent at Bibbiena, and the friars were not unnaturally reluctant to leave the relative comfort of the valley to spend the winter months on a holy but inclement mountainside. They were not to be blamed—there were only rudimentary buildings there—but at the beginning of the fifteenth century it was decided that the situation must be rectified. In 1410 the Franciscan convent at Bibbiena was handed over to the Friars Minor at Fiesole. The reason for this step was strictly practical, that a doctor at Bibbiena made a small bequest for the building of new housing for six friars at Fiesole, which could, by this expedient, be diverted to La Verna. Only in 1433, however, did Eugenius IV take the first steps towards establishing La Verna as the great sanctuary it ought always to have been. In the first place he ordered the consuls of the Arte della Lana in Florence to collect offerings and bequests for the restoration of the church and convent, making them, three years later, protectors, governors, and defenders of La Verna and its neighborhood. His second decision was of still greater consequence; it was to enjoin that in the future the Guardiano della Verna should not be an ordinary Friar Minor as hitherto, but a member of the Franciscan Observance. San Bernardino was then at the height of his apostolate, and the effect of the measure was to ensure that for the future the principles of Franciscan reform would preponderate at the sanctuary. In looking at the *Incarnation* and at the other altarpieces made by Andrea della Robbia for La Verna, this point must be borne constantly in mind.

The whole operation was dogged by shortage of funds. Taxes levied locally yielded quite small sums, and in 1451 Nicholas V hopefully granted an indulgence to all those who contributed to the completion and maintenance of the church. There were in fact two churches, a small one, Santa Maria degli Angeli, and a large one, the Chiesa Maggiore. Building of the Chiesa Maggiore started in the 1450s, but it was still unfinished in 1465, when a wooden choir was installed in Santa Maria degli Angeli, so that office could be celebrated there pending the completion of the bigger church, which seems to have been finished in or soon after 1470. In 1472, however, Cardinal Francesco Piccolomini, the future Pius III, paid a formal visit to La Verna, and through the negligence of a member of his retinue the convent buildings caught fire. Providentially the flames suggested to the friars the name of Saint Lawrence, who had been incinerated on a grill, and when they addressed their prayers to him the flames were checked. Nonetheless the buildings were seriously damaged. After the fire the trickle of benefactions that had been flowing in

became a flood. As early as 1470 money bequeathed to the Franciscan church of San Salvatore in Monte in Florence was, with the approval of Paul II, diverted by the Arte della Lana to La Verna and in 1472 indulgences were offered to benefactors who subscribed to the restoration of the buildings and to the supply of chalices, choir books and ornaments for the divine office. In August 1475, Antonio de' Bartoli, a well-to-do farmer from Marciano in the Casentino, made a bequest to the Arte della Lana on behalf of La Verna. Soon after, Jacopo Brizi of the neighboring town of Pieve Santo Stefano paid for a chapel in the Chiesa Maggiore, and the corresponding chapel on the left side of the church was paid for by a member of the Niccolini family, probably Angelo Niccolini, who was *priore* in Florence in 1479. In 1481 Tommaso degli Alessandri contributed to the Cappella delle Stimmate, and in December 1482 Girolamo degli Albizzi made a bequest for the erection of a hospice and a chapel. Four years later, in 1485, at a meeting of the Capitolo Provinciale at Bosco ai Frati, the *juspatronatus* of Santa Maria degli Angeli was granted to Domenico Bartoli and his brothers, Leonardo and Lorenzo, who were inhibited from changing the dimensions of the church but were allowed to decorate its altars and interior.

2. LUCA DELLA ROBBIA. *Madonna and Child with Two Angels Between Saints James and Blaise.* c. 1470. Enameled terra-cotta, 127 x 163 cm. Palazzo Vescovile, Pescia

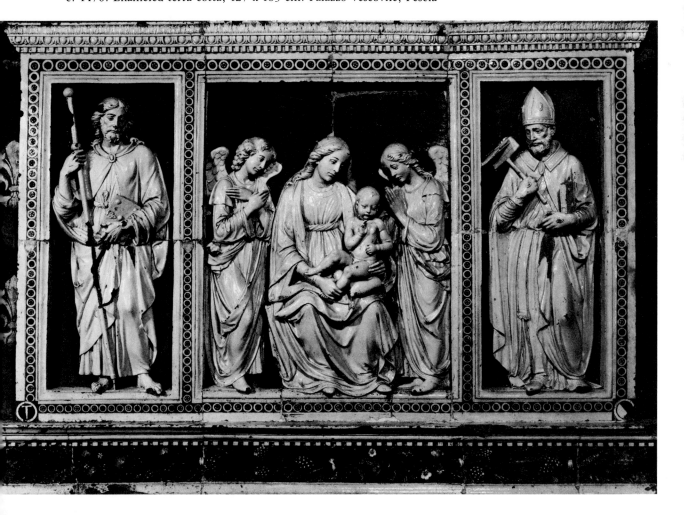

From the early 1470s intensive thought must have been given by the Arte della Lana to the decoration of the churches and the contiguous chapels, and though funds were supplied from a number of sources, their expenditure seems to have been planned centrally. From the first, paintings were ruled out, and preference was given to one art form, the enameled terra-cotta altarpiece, and to one artist, Andrea della Robbia. This may have been due to climatic considerations (though there was an altarpiece by Fra Filippo Lippi at Camaldoli not far away), but it may also have been influenced by the fact that Andrea della Robbia had some pull with the Arte della Lana. For two generations his family had been engaged in the manufacture or sale of textiles; Simone della Robbia, Luca's father, had been a member of the guild, Luca and his two brothers, Marco and the notary Giovanni, were inducted into it in 1428, and Andrea's brother Simone was also a member. A contributory factor in the decision must have been that Andrea della Robbia, from the 1450s, had developed an export trade in enameled terra-cotta complexes which were modeled and glazed in Florence and could then be assembled locally in the center from which the commission came. This rendered the problem of the transport of the altarpieces to La Verna a comparatively simple one; the Niccolini and Brizi altarpieces in the Chiesa Maggiore are composed respectively

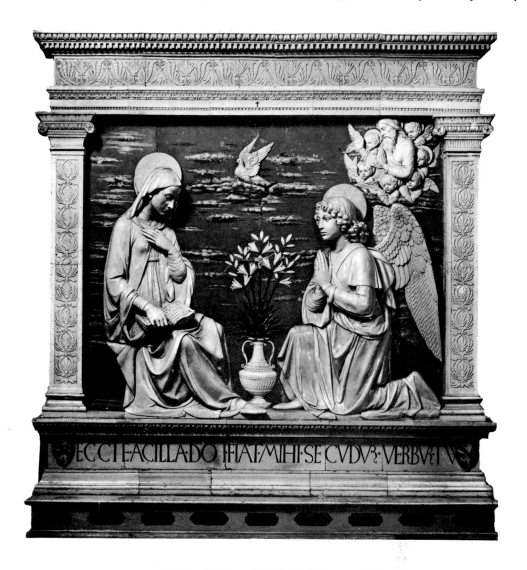

4. Andrea della Robbia. *Annunciation.* c. 1493. Enameled terra-cotta, 154 x 285 cm.
Spedale degli Innocenti, Florence

of 95 and 86 separate pieces of enameled terra-cotta, and the largest of the altarpieces, the *Ascension* in the Chiesa Maggiore, numbers 180.[7]

There is only one reference to Andrea della Robbia in the La Verna documents. It occurs on August 6, 1481, and reads: "Agnolo di Baccio d'Arezzo, per lui Andrea della Robbia lire 12, e lui gli a fatti buoni alla Verna."[8] It may be associated with the *Crucifixion* altarpiece which seems to have been inaugurated on August 16 of that year. The bulk of the terra-cotta altarpieces date from the seventies and eighties of the fifteenth century. Opposite the Brizi Chapel, in the Chiesa Maggiore, is a chapel with the Niccolini *stemma.* The altarpiece shows the *Annuciation* (fig. 3), and it at once transports us to the same symbolic world as the *Incarnation* altarpiece. The Virgin's porphyry seat is set diagonally on a little platform across which her right foot projects, and the right leg and wings of the angel are drawn back. Once more there is in the conventional sense no setting, nothing indeed save a background of sky, the dove, again placed centrally, and a little God the Father on the right. It has been rightly pointed out that the subject as defined by the inscription is not the arrival of the Annunciatory Angel, but the reaction of the Virgin to the message she has received. The implications of this change can be seen very clearly if the altarpiece is compared with the *Annunciation* lunette (fig. 4) made by Andrea della Robbia about 1493 to go over an altar with Piero di Cosimo's *Madonna and Child with Saints* in the church of

3. Andrea della Robbia. *Annunciation.* c. 1476–77. Enameled terra-cotta, 210 x 210 cm.
Chiesa Maggiore, La Verna

161

the Spedale degli Innocenti in Florence, which employs the conventional active Annunciation iconography.[9] The modeling of the figures in the Niccolini *Annunciation* is rather fuller than that in the Brizi *Incarnation,* and is reminiscent of the dated *Madonna of the Architects* in the Bargello of 1475. Probably therefore the Niccolini altar precedes the Brizi altar, and dates from about 1476–77.

Andrea della Robbia was personally responsible for three other altarpieces at La Verna and oversaw the production of two more. The first is in the holiest of the shrines, the Cappella delle Stimmate, and was completed in August 1481.[10] It fills the whole of the back wall of the chapel, which is treated as a kind of stage (fig. 5). Round the proscenium arch runs a white molding and a border of fruit culminating in a roundel with the Holy Ghost. Inside it are angled seraph heads against a background of sky that is continued through the main scene, and inside that again is a knotted rope, an extended Franciscan girdle, surrounding the *Crucifixion* relief. The cross is very high—its height clearly was dictated by the space available—and the livid face and yellowish brown hair of Christ register emphatically even from the chapel door. At each side, behind the cross, are four lamenting angels, and underneath, in the same backward plane, are kneeling figures of Saint Francis and Saint Jerome. The visual interest, however, focuses on the enormous figure of the mourning Virgin beside the cross, and the inscription in the predella, from Jeremiah, explains why this is so.

More delicate is a *Madonna della Cintola* (fig. 6), the scene of the Virgin of the Assumption dropping her girdle to Saint Thomas, in Santa Maria degli Angeli. It carries the *stemmi* of Domenico Bartoli and his wife Maddalena Ruccellai. Bartoli was granted rights over the church in 1486, but the altarpiece may well have been produced before that time. Its architecture conforms to that of the *Incarnation* and *Annunciation,* in that the square central scene is framed by white pilasters and crowned by a frieze of cherub heads, but above it is a lunette, with God the Father and two angels, and, beneath, the inscription is replaced by a deep predella with two elegant angels at each side and a tabernacle in between. In the main scene the mandorla of the Virgin is heavily recessed, so that the angels beside it seem to give it physical support, and illusionistic clouds partly conceal the heads of the cherubs from view. The color is less coarse than in the *Crucifixion,* and the figures of Saints Gregory, Francis, and Bonaventura beside the tomb are modeled with a nervous animation which suggests that they too must be autograph.

The third altarpiece is an *Ascension,* which was made for the high altar of the Chiesa Maggiore (as one entered the church it would have been visible between the *Incarnation* and *Annunciation* altars) and seems to have been a Ridolfi donation (fig. 7). It is a little less large

5. ANDREA DELLA ROBBIA. *Crucifixion.* 1481. Enameled terra-cotta, 600 x 420 cm. Cappella delle Stimmate, La Verna

162

6. Andrea della Robbia. *Madonna della Cintola*. Enameled terra-cotta, 388 x 236 cm. Santa Maria degli Angeli, La Verna

164

7. ANDREA DELLA ROBBIA. *Ascension*. Enameled terra-cotta, 457 x 308 cm.
Chiesa Maggiore, La Verna

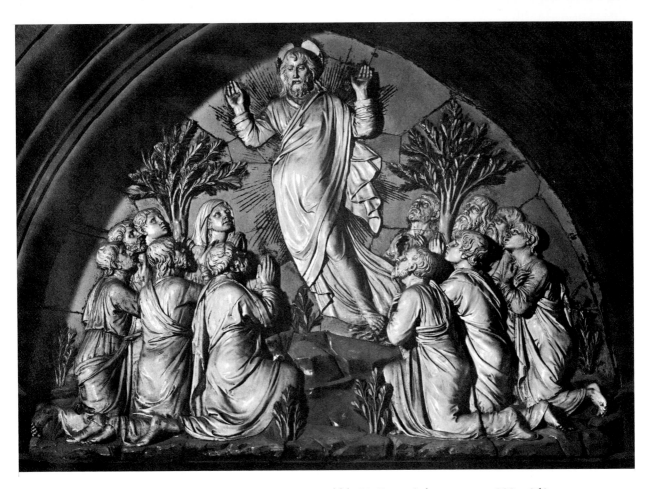

8. Luca della Robbia. *Ascension.* 1446–51. Enameled terra-cotta, 200 x 260 cm. Cathedral, Florence

than the *Crucifixion,* but is framed in the same way. One of the most celebrated works by Luca della Robbia was the *Ascension* over the door of the south sacristy of the Duomo in Florence, which was commissioned in 1446 and completed in 1451 (fig. 8). This is the source from which Andrea's scheme depends. In Andrea's altarpiece, however, Christ is raised high above the heads of the apostles (this is the same rhetorical device as that used in the *Crucifixion* altarpiece) and the two sections of the group beneath are no longer divided, as they are in the lunette in the cathedral, but have been joined up. In some cases the types follow Luca's, but the treatment of the features is more regular and more monotonous. The Virgin is moved from the back of the group on the left to the front—there is some iconographical significance in this, in that the La Verna altarpieces consistently have the Virgin as their protagonist—and Luca's classic drapery is broken up in sharp particularized folds. Nowhere are the differences between the two more striking than in the Christ. Luca's is based on a classical model, whereas Andrea's looks down on the Apostles with a sentiment, indeed a tenderness that recalls the Christ on Verrocchio's Forteguerri monument.

166

The two altarpieces which Andrea della Robbia supervised but did not himself model are at the entrance to Santa Maria degli Angeli, and show the Pietà with the Virgin, Saint John, and eight angels (fig. 9) and a Nativity with Saints Francis and Anthony of Padua. Like the *Madonna della Cintola,* they carry the Bartoli and Ruccellai arms, but their palette is altogether different; it makes use of a range of pastel colors which does not appear in any of the other altarpieces, and finds its closest point of reference in the decoration of the Loggia di San Paolo in Florence, which was begun in 1489. Probably the two altarpieces date from after 1490. They have a close equivalent in an altarpiece of the *Adoration of the Magi* in the Victoria and Albert Museum, which bears the *stemma* of the Albizzi family and may have been made in connection with an Albizzi donation to La Verna.[11]

Looking at these altarpieces as a whole, it is clear that they proceed from common preconceptions about the nature of religious art and about religious iconography. On a lower level the effect they make has something in common with that made by the frescoes

9. WORKSHOP OF ANDREA DELLA ROBBIA. *Pietà with the Virgin and Saint John and Eight Angels.* Probably after 1490. Enameled terra-cotta, 185 x 185 cm. Santa Maria degli Angeli, La Verna

of Fra Angelico and his assistants in the reformed Dominican convent of San Marco. Though they were paid for by different patrons, they have a broad uniformity of style which suggests that they were thought out by a single mind, and were a manifesto of the Franciscan Observant regime at La Verna. San Bernardino's aim was a revivified Franciscanism which would recapture the simpleminded apostolic zeal of the original followers of Saint Francis and would dispel the lassitude in which the order had become submerged. At practically no point (no point at all, indeed, save for his devotion to the Holy Name and his insistence on the doctrine of the Immaculate Conception) did he depart significantly from Saint Francis' teachings. Saint Francis urges that the Virgin be continuously honored because she carried the Son of God in her sacred womb, and San Bernardino, in the sermons on the Virgin which fill so large a part of the eight volumes of his published works, does so too.[12] The Virgin is the consummation and perfection of created nature, and the sole source through which divine grace is dispensed first to the order of seraphim and angels and thence to the Church Militant on earth. Her merit in consenting to conceive the Son of God, he declares in a sermon on the Annunciation, exceeds the merit of all other human creatures (one thinks here of the *Annunciation* at La Verna), and what illuminates the human intellect is the light of faith in the incarnate Word (one thinks here of the La Verna *Incarnation*). Churches (and in this San Bernardino was at one with the reformed Dominicans) must be free from the contagion of lay life. In a sermon on the Stigmatization of Saint Francis, he quotes the great description of La Verna from the bull of Alexander IV, *Si novae militiae militantis Ecclesiae* ("celebrem illum vernantis Alverniae montem, in quo sublimatum corpus a sublimiori animo non dissentit") and the apostrophe of Ubertino da Casale of La Verna as the new Sinai, embodying not the lesson of adequacy but the counsel of supererogation. All this stops some distance short of proof, but it suggests first that the Franciscan Observance would have favored an art that corresponded very closely with the art promulgated at La Verna, and second that La Verna was the place at which a cogitated Franciscan Observant art might be expected to have been introduced.

The Observant Franciscan complexion of Andrea della Robbia's mature style can be confirmed in other ways. In 1476 the prior of the parent church of the Osservanza at Siena, Pier Paolo Ugurgieri, despite widespread opposition, determined to rebuild the church. He was an expansionist and paid no heed to the objectors who pleaded that the size and character of the church founded by San Bernardino should be preserved. When work was complete, the existing altarpieces were transferred from the old church to the new, but it was necessary to supplement them with new commissions and the altarpiece for the Ugurgieri Chapel (fig. 10) was commissioned from Andrea della Robbia.[13] It bears the Ugurgieri *stemma*, and its subject is the Coronation of the Virgin, though the inscription (MARIA VIRGO ASSUMPTA EST AD ETHEREUM THALAMUM) relates to the Assumption, the original dedication planned by San Bernardino for the church. Above is the symbol of the

10. ANDREA DELLA ROBBIA. *Coronation of the Virgin*. Enameled terra-cotta, 265 x 230 cm. Church of the Osservanza, Siena

Holy Name. This was a specially elaborate, heavily gilded altarpiece, but it has been damaged—the upper part of the figure of the Virgin and the back of the head of Saint Francis have been replaced—and scarcely any of its surface gilding survives. More ostentatious than the La Verna altarpieces it may be, but the current of religious thinking from which it emanates is recognizably the same.

At L'Aquila, the scene of Bernardino's death, the construction of a church dedicated to the saint was authorized in 1451, and was prosecuted, through earthquake and adversity, by San Giacomo della Marca. In 1489 its cupola was complete. One of the main altars was financed by a local family, the Vetusti-Oliva, and the altarpiece was again commissioned from Andrea della Robbia.[14] The top of it, with the *Coronation of the Virgin,* refers back to the *Coronation* in the Osservanza at Siena, but beneath it is a *Resurrection* based on Luca della Robbia's *Resurrection* lunette in Florence. Luca's composition is declassicized, the sarcophagus motif of the soldier in the foreground is flattened out, and Christ stands on the front edge of the tomb.

The Church of Santa Maria delle Grazie outside Arezzo was built in 1449 to commemorate one of San Bernardino's most celebrated miracles, and contained a painting of the *Madonna della Misericordia* by Parri Spinelli, which San Bernardino was believed to have commissioned and which was credited with miraculous properties. Late in the fifteenth century the church was modified in two significant respects, a loggia, by Benedetto da Maiano, was built in front of it and an altar was constructed to house Parri Spinelli's painting (fig. 11). Framed by majestic and beautifully carved pilasters, it could well have been designed by Benedetto da Maiano. But in the area inside the lunette and beneath the frieze another mind is palpably at work, and there is every reason to suppose that the sculptor of this part of the altar had the use of models by Andrea della Robbia.[15] The Virgin in the lunette conforms very closely to enameled terra-cotta Virgins by Andrea, and the little figures of Saint Lawrence and San Bernardino correspond with the little figures of the same saints by Andrea della Robbia at Brancoli and Santa Croce. Sculpturally the most impressive feature is the *Pietà* beneath the altar, and here too there is a demonstrable link with Andrea della Robbia in that its three figures reappear in the predella of an enameled terra-cotta altar in Santa Maria in Grado at Arezzo.

The altarpieces at La Verna were some of the most popular images of the whole fifteenth century. The *Crucifixion* was adapted for the Compagnia della Trinità at Arezzo, and a version of the *Ascension* was produced, probably after 1500, for Foiano, where the whole composition is compressed. Another was made for Città di Castello; the bottom of it is in

11. Altarpiece, from models by Andrea della Robbia. Marble and enameled terra-cotta, 720 x 370 cm. Center fresco, *Madonna della Misericordia*, by Parri Spinelli. Santa Maria delle Grazie, Arezzo

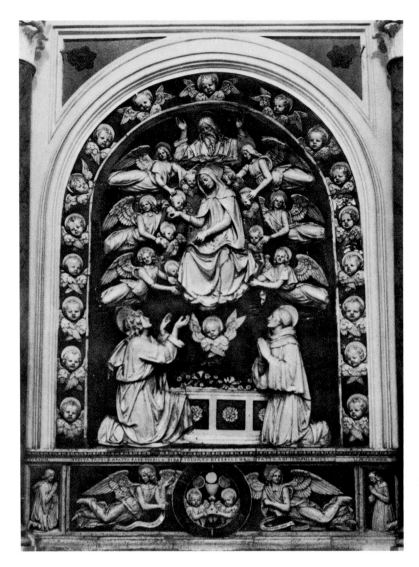

12. *Madonna della Cintola*. 1502.
Enameled terra-cotta, 300 x 225 cm.
Collegiata, Foiano

the Louvre. The main group of the *Incarnation* altarpiece was adapted in small reliefs of two main types, of which literally dozens of examples are known. Also in great demand were versions of the *Madonna della Cintola,* which was reproduced with arched top for the Collegiata at Foiano (fig. 12) in 1502 (where the architectural frame is scrapped in favor of a border of cherub heads, two saints are omitted, and the number of angels is increased from four to six), more coarsely for Santa Fiora near Monte Amiata, where the original rectangular form is preserved, and in the original format in careful, simplified variants in Frankfurt and London. Only the *Annunciation* remained inviolate. There are countless Annunciations from Andrea della Robbia's shop, but never was another altarpiece to this design produced.

The more closely one examines Andrea della Robbia's work, the more evident does it become that after about 1480 he was the victim of a broadly based Franciscan vogue. The

distribution of his altarpieces in Franciscan churches throughout Tuscany speaks for itself. There they are in San Lodovico at Prato, in Fonte Castello outside Montepulciano, in Santa Chiara at Borgo San Sepolcro and Santa Chiara at Monte San Savino, in Santa Maria degli Angeli at Assisi, in San Francesco Grande at La Spezia, in San Francesco at Massa Carrara, in San Lorenzo at Bibbiena, and in San Francesco at Pieve Santo Stefano. The list of Franciscan churches could be protracted almost into infinity. The inescapable result was that Andrea della Robbia was compelled, through sheer pressure of demand, to step up output at the expense of quality. Sometimes the result was acceptable enough, as in the Franciscan altarpiece from Varamista in Berlin, which was commissioned by a member of the Sassetti family. Here the Virgin and the two saints are disposed with a sense of interval that recalls Domenico Ghirlandaio. But less exacting patrons had to content themselves with inferior altarpieces, in which Andrea della Robbia intervened sporadically or did not intervene at all.

At the time of the first datable La Verna commission Andrea was a mature artist of forty-four, who had behind him a quarter of a century of independent or semi-independent activity. When Luca della Robbia made his will in 1471, he left nothing to his nephew, on the grounds that he was *"superlucratus"* and was likely through his industry to become richer still. It was assumed by earlier students that before this time he operated in the main as an assistant of his uncle. But we know from a passage in the Cambini account books published by Hartt that by 1455, when he was twenty, he was already receiving independent commissions.[16] He used the same furnace and the same technical assistants as his uncle, but from that time on he was operating as a partly autonomous artist. The first dated work by him we know, the *Madonna of the Stonemasons* in the Bargello (fig. 13), was made in 1475,[17] about the time that he struck lucky with the Arte della Lana and secured the first of the La Verna commissions. Its only link with Luca is its technique. The Virgin is shown to below the knees, as she is in reliefs by Antonio Rossellino, and the Child recalls Verrocchio. The background is composed of raised naturalistic clouds and is recessed inside a border of seraph heads, shown alternately with open and closed mouths. Whereas Luca's Madonnas employ a multiplicity of receding planes, Andrea disposes the right arm of the Child and the right hand and wrist of the Virgin on the surface of the relief. This difference is so fundamental that whenever we encounter Madonnas in which the arms of the Virgin and Child are shown on one plane, we must weigh up the possibility that they are by Andrea not Luca della Robbia.

One example is a Madonna at Nynehead, which is sensitively modeled, but in a fashion that indicates the presence of Andrea della Robbia not of Luca[18]—it probably dates from about 1465—and another is the Demidoff Madonna at Toledo, where the two arms once more are flat. It appears in recent books as Luca della Robbia, but was recognized by Cruttwell for what it was, a relief by Andrea of about 1470.[19] The Child, like the Child in

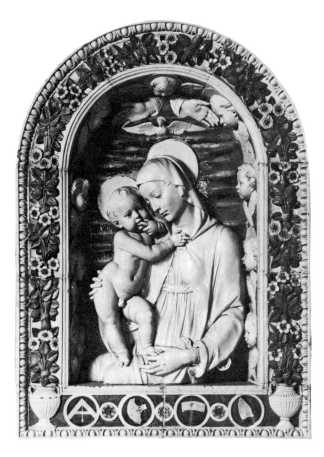

13.
ANDREA DELLA ROBBIA.
Madonna of the Stonemasons. 1475.
Enameled terra-cotta, 134 x 96 cm.
Museo Nazionale del Bargello,
Florence

174

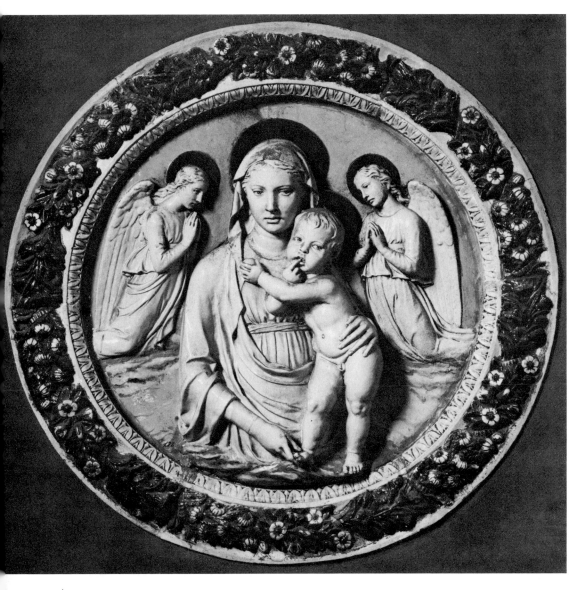

14. ANDREA DELLA ROBBIA. *Madonna delle Cappuccine*. Probably 1460–65. Enameled terra-cotta, diameter 100 cm. Museo Nazionale del Bargello, Florence

OPPOSITE PAGE:

15. ANDREA DELLA ROBBIA. *Stemma* of the Arte della Seta. Enameled terra-cotta, diameter 180 cm. Or San Michele, Florence

the *Madonna of the Stonemasons,* depends from Verrocchio. A third work of the same class is the circular relief known as the *Madonna delle Cappuccine* in the Bargello (fig. 14), where the floreated frame is a typical product of Andrea's shop and the relief of the Virgin and Child with two angels is, as Cruttwell and Reymond recognized, also typical of Andrea della Robbia.[20] The relief is likely to belong to the half-decade 1460–65. From the second half of the same decade comes the full-length Frescobaldi Madonna, formerly in Berlin, where the flaccid forms and the descriptive detail once more offer evidence of Andrea della Robbia's hand.[21] The largest of this group of works is the Via dell'Agnolo lunette in the Bargello. The Della Robbia literature tells us that this is a fairly early work by Luca della Robbia (and so for some time I myself believed it to be), but, as Horne established many years ago, the convent of Lateran nuns for which it was made was founded with the sanction of Sixtus IV only in 1471, and the relief cannot have been made before that time.[22] Is it then a late work by Luca della Robbia? Obviously not; it lacks the linear quality of the roundels in the Chapel of the Cardinal of Portugal and other late works, and the stolid modeling of the figures and the shallow, rather mechanical border are indeed typical of Andrea della Robbia.

In the 1460s Andrea della Robbia seems also to have received official commissions in Florence. One of them was for the *stemma* of the Arte della Seta on Or San Michele (fig. 15), whose emblem was that early symbol of trade unionism, a closed door. In the center of the roundel is a white shield supported by two putti, and the doorway is depicted in white with a violet surround and violet nails, rings, and bolt. Vasari, who describes the three roundels by Luca della Robbia on Or San Michele, does not mention this, presumably because he was aware that it was not by Luca. Its frame, with bunches of fruit widely spaced on a white ground, is typical of Andrea della Robbia, while the two children are conceived quite differently from the Child in Luca's *stemma* of the Arte dei Medici e Speziali nearby. Their limbs are attenuated, their poses are flat, and their lips are parted in the ingratiating half smile that one learns to accept as a hallmark of Andrea della Robbia's work.

At about the time Andrea emerges as an independent artist, we encounter the first record of the export of works in enameled terra-cotta, evidently from the Della Robbia shop. The document dates from May 28, 1454, and lists, as part of a miscellaneous cargo dispatched to Lisbon from Pisa, "sette casse di lavori di terra chotta envetriata, del marchese di Valenza."[23] This work was perhaps a shield of arms. Another case which is more fully documented enables this export trade to be linked firmly to Andrea della Robbia's activity.[24] In 1462 Guillame Fillastre was named bishop of Tournai and a year later he was dispatched by Philip the Good to Rome. His secretary was a Florentine merchant in Bruges, Angelo Tani, and Fillastre seems for this reason to have stopped in Florence. While there, his attention was drawn to the novel technique of enameled terra-cotta, and then or

later he ordered a sepulchral monument from the Della Robbia kiln. When the tomb was completed in 1469–70, the transport of its component parts to Pisa was supervised by Tani and their shipment from Pisa to Ecluse was undertaken by another merchant with connections in the Netherlands, Tommaso Portinari. The tomb was erected at Saint-Omer and the pieces of it that survive were made under the supervision of Andrea della Robbia.

Marquand describes Andrea's studio by the respectable nineteenth-century term "atelier," but it was (in a sense in which most painters' studios in the fifteenth century were not) a shop. One letter written by Andrea della Robbia survives. It was addressed in June 1471 to a contact in Mantua and it refers to a head reserved eight months earlier for the marquess of Mantua by his agent Pier del Tovaglia. A small down payment on it had been made, otherwise it would already have been resold, and Andrea now proposes to market it but can make another if Federigo Gonzaga would still like one.[25] This may have been a little bust of Saint John the Baptist of which a number of variants survive.

Despite the constantly growing demand in Observant churches for altarpieces from Andrea della Robbia's shop, and despite the orders for works in enameled terra-cotta from other centers in Italy and from abroad, the sculptures for which Andrea della Robbia was personally responsible continued to be executed with fastidiousness and taste, and from the mid-1470s on, his development can be followed in some detail. From about 1475 we have a lunette of *Saint Michael* in the Metropolitan Museum, which was made for San Michele Archangelo at Faenza on the commission of the treasurer of the Manfredi,[26] a work of refined, rather self-conscious artistry that looks forward to the *Madonna della Cintola* at La Verna. In or before 1477 it was followed by the great *stemma* of Federico Manfredi, bishop of Faenza, and two other *stemmi* for the cathedral. There follows the public commission in Florence by which Andrea is best known, the reliefs on the Spedale degli Innocenti. In books on him they are generally dated about 1466, but we know now that the "terra-cotta babies," as they are called in the record of payment, were not installed in their roundels till the summer of 1487,[27] and are therefore almost exactly contemporary with Ghirlandaio's great altarpiece for the hospital church of 1488. Their connection with the cherubs in the *Madonna della Cintola* at La Verna is indeed self-evident. Each foundling is set vertically in its circle (fig. 16), with the arms extended at forty-five degrees so that the hands rest on a notional horizontal line drawn through the middle of the relief. In some reliefs the swaddling clothes have fallen to reveal the hips, and very dull the modeling is (fig. 17). But in the remainder the tight swaddling bands are rendered with great care and the heads are differentiated. The children look as though they are appealing for sympathy, and that is precisely what they were meant to do. Founded in 1419, the hospital prospered through the middle of the century, and its church was dedicated by Sant' Antonino in 1450. Within fifteen years, however, the economy of the whole institution seems to have collapsed, and in 1483 it was reported that some of the foundlings had died from lack either of attention

or of food. By 1485, through an energetic fund-raising campaign, money was raised to balance the budget and enlarge the premises.[28] Andrea della Robbia's tondi are really posters which say to us: "Be as generous as you can and do not let this happen again."

The exigencies of an architectural setting continued to inspire Andrea to a higher creative power than the free form of the altarpiece. This can be seen in the beautiful lunette modeled for Prato cathedral in 1489, where eleven unobtrusive cherub heads are used to fill the gothic arch and where the figures of Saint Lawrence and Saint Stephen are modeled with tremulous sensibility. It is evident also in the interior decoration of the two churches in which he was associated with Giuliano da Sangallo, Santa Maria delle Carceri at Prato and Santa Chiara in Florence, as well as in the interior of the Loggia di San Paolo.

When artists live to a great age—Andrea della Robbia was ninety when he died—it is often difficult to judge when their late style begins. But in the present case there is no such difficulty; it is heralded, probably in 1498, by the two massive figures of Saints Francis and Dominic which bulge out of their lunette in the Loggia di San Paolo against a diorama of yellowish blue sky (fig. 18). They anticipate their nearest equivalent in painting, Albertinelli's *Visitation,* by five years. In his relationship to painting, however, Andrea was a dependent, not an innovator. The *Crucifixion* in the Cappella delle Stimmate at La Verna is an imposing but in some respects defective relief; the changes of scale are abrupt and the

178

OPPOSITE PAGE:

16.
ANDREA DELLA ROBBIA.
Foundling. Installed 1487.
Enameled terra-cotta,
diameter 100 cm.
Spedale degli Innocenti,
Florence

17.
ANDREA DELLA ROBBIA.
Foundling. Installed 1487.
Enameled terra-cotta,
diameter 100 cm.
Spedale degli Innocenti,
Florence

18.
ANDREA DELLA ROBBIA.
*Meeting of Saint Francis and
Saint Dominic.* Probably 1498.
Enameled terra-cotta, 140 x
270 cm. Loggia di San Paolo,
Florence

19.
ANDREA DELLA ROBBIA.
Crucifixion. Commissioned
before 1490. Enameled terra-
cotta, 370 x 260 cm.
Cathedral, Arezzo

tenor is expository. When, shortly before 1490, another Crucifixion relief was commissioned from Andrea by the Compagnia della Trinità (now in the Duomo at Arezzo) that was rectified (fig. 19). The cross was moved into a middle plane, the angels were redisposed in space, two kneeling saints gazed up at Christ, and at the top God the Father draped a blue and gold cloth over the cross. There is no precise precedent in painting for this design, but there can be no doubt that Andrea, when he rationalized the composition, applied to it principles evolved in the 1480s by Botticelli and Filippino Lippi. This impression is reinforced by a second altarpiece, also at Arezzo. In 1456, on the commission of Michelangelo di Papi di Maestro Francesco of Arezzo, Parri Spinelli's *Madonna of Mercy* in Santa Maria delle Grazie was adapted as an altarpiece (Pinacoteca, Arezzo) by Neri di Bicci, who added two saints at the sides.[29] Some twenty-five years later a version of Neri di Bicci's composition was commissioned for the Carbonati altar in Santa Maria in Grado from Andrea della Robbia (fig. 20).[30] Once more the redefining of the space, the prevailing linear rhythms, and the attenuated angels holding the cloak and crown, imply an understanding of up-to-date pictorial thought in Florence. On one occasion, in the 1490s, we

20.
ANDREA DELLA ROBBIA.
*Madonna della Misericordia
with Saints Peter and Benedict.*
Commissioned c. 1481.
Enameled terra-cotta,
260 x 233 cm. Santa
Maria in Grado, Arezzo

find Andrea and a major painter working side by side. The scene is the Pugliese altar in the Innocenti, where an altarpiece by Piero di Cosimo was linked with an enameled terra-cotta lunette. If the unity of the two works were still preserved—the lunette is now in the cloister and the altarpiece is in the gallery of the Spedale degli Innocenti—their broad uniformity of style would be self-evident.

Late in life Andrea della Robbia's efforts were concentrated on the production of tactile equivalents for paintings. In the late fifteenth century the iconography of intercession, of Christ as Man of Sorrows pointing to his wounds and of the Virgin as Mother exhibiting her breast to Christ, kneeling before God the Father, assumed new popularity. The archetype painted by Lorenzo di Niccolò about 1400, once in the Duomo in Florence and now at the Cloisters, New York, has been well discussed by Meiss.[31] A variant of it was commissioned from Ghirlandaio in 1481 for San Francesco al Palco at Prato, but was not carried out—a painting by Filippino Lippi in Munich was substituted—and two versions were also made in the Ghirlandaio shop, a panel at Montreal and a fresco in San Giorgio alla Costa. Andrea della Robbia's version, in San Francesco at Foiano (fig. 21) seems to date from about

21.
ANDREA DELLA ROBBIA AND ASSISTANTS. *Christ and the Virgin Interceding with God the Father.* c. 1502. Enameled terra-cotta, 305 x 225 cm. San Francesco, Foiano

1502, and is reasonably faithful to the Duomo painting, but the types of the figures and their heavy vertical drapery recall the variants of the composition from the Ghirlandaio shop. The Foiano altarpiece is relegated by Marquand to the atelier, but there can be very little doubt that it was planned and that the three main figures were modeled by Andrea.

The artist who engaged his attention most strongly in the years immediately after 1500 was, however, Filippino Lippi. We know this from two altarpieces in the Observant friary of San Girolamo at Volterra, the first of which is dated 1501. It shows the *Last Judgment* (fig. 22). In the center is Saint Michael (a placid, Ghirlandaiesque Saint Michael) adjudicating on the fate of Filippino Lippi's son of Theophilus from the Brancacci Chapel, while on the left there kneels a man derived from the Saint Jerome in Filippino Lippi's altarpiece from San Pancrazio in the National Gallery in London. The second of the Volterra altarpieces—it is undated—shows Saint Francis dispensing his rule to Saint Louis

22.
ANDREA DELLA ROBBIA
AND ASSISTANTS.
Last Judgment. 1501. Enameled terra-cotta, 310 x 200 cm.
San Girolamo, Volterra

OPPOSITE PAGE:

23.
ANDREA DELLA ROBBIA
AND ASSISTANTS. *Saint Francis Conferring His Rule on Saint Louis of Toulouse and Saint Elizabeth of Hungary.*
Enameled terra-cotta,
232 x 190 cm.
San Girolamo, Volterra

of Toulouse and Saint Elizabeth of Hungary (fig. 23). It corresponds loosely with a drawing by Filippino Lippi in Rome, which has on its reverse a study for the Genoa Saint Sebastian altarpiece of 1503,[32] and Andrea's relief is likely to date after that time. Presumably he had access either to a drawing by Filippino or to a lost altarpiece for which it was made. In the enameled terra-cotta altarpiece a number of changes are introduced. The head of Saint Francis is turned back in ecstasy, Saint Elizabeth is shown in pure not in lost profile, and Saint Louis is shown in three-quarter face. The heavy drapery forms are those of the lunette in the Loggia di San Paolo.

The two Volterra altarpieces are given by Marquand and by most other scholars to Andrea's son, Giovanni della Robbia.[33] This attribution is based on the assumption that Giovanni, who was born in 1469, must from the nineties on have been operating as an independent sculptor. The evidence is to the contrary. Andrea della Robbia's studio seems

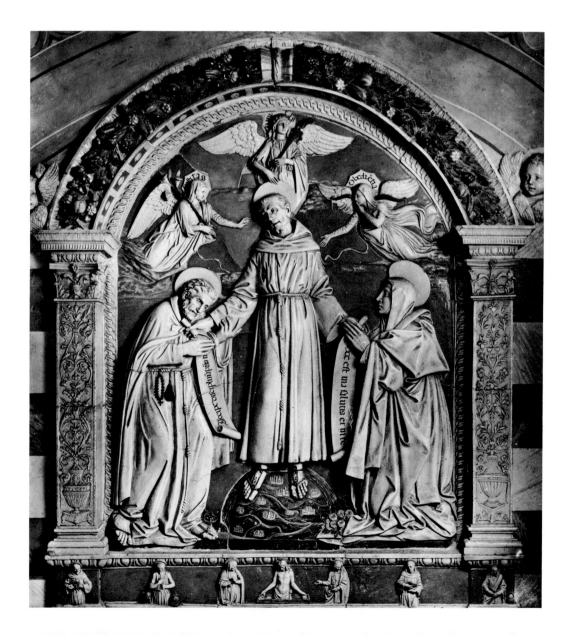

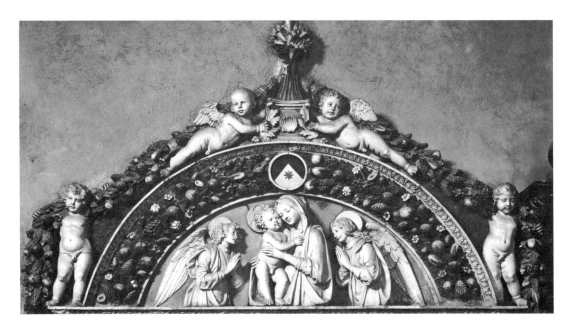

24. ANDREA DELLA ROBBIA AND ASSISTANTS. Lavabo, detail. Enameled terra-cotta. Santa Maria Novella, Florence

26. ANDREA DELLA ROBBIA AND ASSISTANTS. *Madonna and Child with Saints Dominic and Lawrence*. 1507–8. Enameled terra-cotta, 120 x 280 cm. Madonna della Quercia, Viterbo

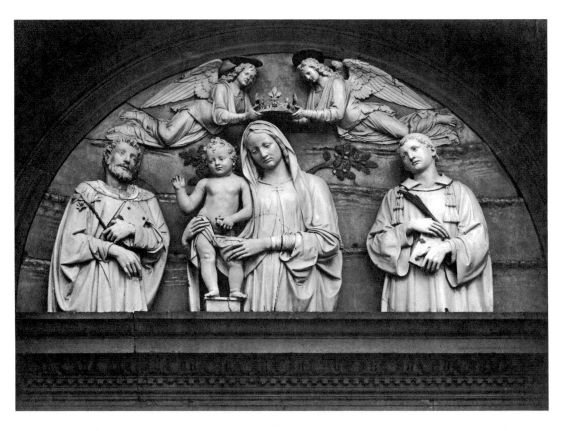

25. ANDREA DELLA ROBBIA AND ASSISTANTS. Altarpiece. Installed 1512. Enameled terra-cotta, 270 x 243 cm. Santi Apostoli, Florence

to have been run in a more doctrinaire, businesslike fashion than Luca's, and Giovanni was a less talented, less precocious sculptor than Andrea. So far as can be judged, Giovanni's emergence did not follow the same pattern as his father's. A hundred years ago Milanesi presented the lavabo in the sacristy of Santa Maria Novella as his first documented work, but the documents (there are two payments of 1498) do not relate to the whole work.[34] They refer to the "residuo del lavatoio delle mani, cioè pel pavimento," and the tiled pavement on which the priests stood when washing their hands is indeed the only part of the structure for which Giovanni della Robbia can be proved to be responsible. Looking at the reclining putti at the top (fig. 24), Marquand concluded that "Giovanni did not share Luca's and Andrea's love of children. His putti were chubby creatures with rings of flesh about their ankles and wrists and deep wrinkles on their legs." But this psychological deduction is hardly justified.

The basis for Marquand's attribution to Giovanni della Robbia of the Volterra altarpieces is the Altar of the Sacrament in Santi Apostoli (fig. 25), which he believed to have been made shortly before 1500.[35] Two documents recently discovered by Dr. Marco Spallanzani show that the supposed date is incorrect—the altar was installed at the expense of Giovanni di Piero Acciaiuoli in 1512.[36] Payment for the altar, moreover, was made to Andrea della Robbia, and it was to Andrea's design that the whole work was produced. When we look back from the putti and garlands and vase at the top to the putti and garlands and vase on the Santa Maria Novella lavabo, it is clear that they and the three-dimensional parts of the lavabo are substantially by one hand. In 1507 we come upon a commission to Giovanni della Robbia *in propria persona*, but it is quite a modest one, for thirty-six casks in enameled terra-cotta for the hospital of Santa Maria Nuova. The order was due to Leonardo Buonafede, who reserved the right to determine how the casks were to be decorated. Not till 1513, when he produced an altarpiece for Arcevia, does Giovanni della Robbia appear as a fully emancipated sculptor, and a year later he started work on the large *Lamentation over the Dead Christ* in the Bargello, which was commissioned by Bernardo Accolti for the garden of the foundling hospital in Via della Scala and depends from an immediately antecedent Granacci altarpiece at Quintole. From this point on until his death in 1529 the graph of Giovanni's development is very clear. No doubt Giovanni della Robbia and other modelers as well were active in the workshop at a much earlier time, but the evidence suggests that until Andrea della Robbia was seventy-eight or eighty he maintained a stranglehold over his studio, and that for this reason none of his assistants emerge as distinct personalities. Looking at Giovanni della Robbia's authenticated works, one doubts whether, even as a young man, he was capable of the tight modeling of the two lunettes at La Quiete, in one of which Verrocchio's group of Christ and Saint Thomas is adapted to a new pictorial context with considerable artistry. I suspect that the large white relief of the *Annunciation* in London, which I once catalogued as a work of Giovanni della Robbia, is also in fact due to Andrea, and is an excellent, in part autograph late work.

When one uses the term "in part autograph" of works made sectionally, what does the expression mean? The outline of the answer is suggested by one of the latest documented works by Andrea that survive, the three lunettes on Santa Maria della Quercia at Viterbo.[37] The prior of the convent was a Dominican from San Marco, Fra Filippo Strozzi, and it is clear from the reliefs themselves that special pains were taken with the commission. The first payment dates from November 1507, and all three were finished by the summer of 1508. They show the Virgin and Child between Saints Dominic and Lawrence (fig. 26), and Saint Peter Martyr and Saint Thomas Aquinas each with two angels. The Virgin and Child and the two flanking saints (all but the head of Saint Dominic, which is a replacement) are by one hand, and so are the central figures in the other two lunettes. But a second, inferior modeler was responsible for the angels flanking the two saints and for the

27. ANDREA DELLA ROBBIA AND WORKSHOP. *Madonna and Child Enthroned with Six Saints.* Enameled terra-cotta, 220 x 210 cm. Santa Croce, Florence

flying angels holding a crown over the Virgin's head. Working back in time, we find that in the altarpiece in the Medici Chapel in Santa Croce (fig. 27) the same pattern presents itself. It was a less important work than its present setting suggests—it was commissioned for another purpose by a comparatively indigent body, the Compagnia di Castel San Giovanni—and here only the Virgin and Child are by Andrea, while the pinched lateral saints were relegated to studio hands.[38] This working method lends an atmosphere of unreality to Marquand's distinction between the works executed by Andrea della Robbia and the works executed in his atelier. Our difficulty is that we know nothing at all about the composition of his shop. Short of some miraculous draft of documents the only way in which that can be rectified is through more rigorous analysis of the reliefs. Laborious? Certainly. Worth undertaking? Beyond all doubt. These were in social terms the only works of art produced in Tuscany in the late quattrocento and the early sixteenth century that enjoyed universal currency, and that affected ordinary people's thoughts and lives. Perhaps a few art-historical nuggets would be disinterred. We might find that the lunette of 1496 in the Certosa di Galluzzo was not the only relief by Benedetto da Maiano glazed by Andrea della Robbia;[39] there are, after all, quite a number of works, like the beautiful *Madonna* at Carda, on which the stamp of Benedetto da Maiano's personality is very marked. We might find that the *Entombment* formerly in Berlin, which is used in the predella of an altarpiece at Camerino, was not the only model by Verrocchio available in the Della Robbia shop. We might find that Rustici's connection with the studio was not restricted to one altarpiece, and that Andrea Sansovino was likewise a more prolific artist in this medium than has been supposed.[40] We might find that the Pescia *Baptist* is not the sole work in enameled terra-cotta by Baccio da Montelupo. We might, for the matter of that, be successful in establishing the authorship of the most powerful of the later Della Robbia works, the *Temptation of Adam and Eve* of 1515 in the Walters Art Gallery, where a Dürer print seems to have been filtered through the mind of Bugiardini. It surely is high time that study of this fascinating, neglected, and in its own terms rewarding subject was begun.

NOTES

1. A. Marquand, *Andrea della Robbia and his Atelier,* 2 vols. (Princeton, 1922).

2. M. Cruttwell, *Luca and Andrea della Robbia and Their Successors* (London, 1902), p. 143.

3. The altarpiece is dated by Marquand, op. cit., i, no. 37, pp. 52–54, to the year 1479.

4. The altarpiece, which is variously assigned to San Pietro at Pescia (L. Burlamacchi, *Luca della Robbia* [London, 1900], p. 71), and to San Rocco (A. Marquand, "An Altarpiece by Luca della Robbia," in *American Journal of Archaeology,* xiii [1909], p. 329), is described in 1772 in the oratory of San Biagio, a dependency of San Jacopo at Altopascio (Innocenzo Ansaldi, *Descrizione delle sculture, pitture et architetture della città, e sobborghi di Pescia nella Toscana* [Bologna, 1772], p. 37).

5. The relief is dated by A. Marquand, *Luca della Robbia* (London, 1914), no. 10, pp. 51–52, before 1440 on the strength of analogies with "Fra Filippo Lippi's adorations of the decade 1430–40." It is considerably later in date, and seems to have been made soon after 1465.

6. For the history of La Verna and its relations with the Arte della Lana and the Florentine Commune see P. Z. Lazzeri, "La Verna, il Commune di Firenze e l'Arte della Lana," in *La Verna: Contribuiti alla storia del Santuario* (Arezzo, 1913), pp. 275–94; Dott. L. Secondo Pugliaro, *Il convento della Verna e il Commune di Firenze* (London, 1931); Arch. A. Lensi, *La Verna* (La Verna, 1934); P. G. Matteuci, *La Verna di Frate Francesco e della sua prima gente poverella, 1213–1263* (La Verna, 1964); idem., *Da Messer Orlando di Chiusi il dono del monte Verna e due edifici sacri sulla scogliera delle Stimate* (La Verna, 1964); Fra. A. Pierotti, "Un libro d'amministrazione del convento della Verna degli anni 1481–1518," in *La Verna; Contribuiti alla storia del Santuario* (1913), pp. 156–74; P. S. Mencherini, *Bibliografia Alvernina* (Città di Castello, 1914).

7. The records of restoration to the altarpieces at La Verna are reasonably complete. Thus we know that the *Crucifixion* in the Cappella delle Stimmate was disassembled and rebuilt, with unsatisfactory results, in 1888, and was again disassembled and reconstructed in 1892, when parts of the base were replaced by Cantagalli. In a letter of June 1892 to the Sindaco of Florence requesting permission to undertake the second restoration, Padre Baldassari names a workman who had, twelve or fifteen years before, supervised the disassembly and reconstruction of all the other altarpieces at La Verna.

8. Pierotti, op. cit., p. 162.

9. For the Pugliese altarpiece and the lunette see W. Paatz, *Die Kirchen von Florenz*, ii (Frankfurt am Main, 1941), pp. 450–55. The altarpiece is datable to the year 1493 (L. Bellosi, *Il Museo dello Spedale degli Innocenti a Firenze*, Florence, 1977), and the lost enameled terra-cotta framing and the surviving lunette are likely to date from the same time.

10. The altarpiece bears the *stemma* of Tommaso degli Alessandri, whose father, as Marquand points out, was one of the first Conservatori del Sacro Monte.

11. The bequest made in 1482 by Girolomo degli Albizzi provides for the erection of a hospice and chapel for the Observant Friars at La Verna (Pierotti, op. cit.). For the London altarpiece, see J. Pope-Hennessy and R. Lightbown, *Catalogue of Italian Sculpture in the Victoria and Albert Museum*, i (London, 1964), no. 206, pp. 216–18.

12. *S. Bernardini Sen. O.F.M., Opera omnia, studio et cura PP. Collegii S. Bonaventurae ad fidem codicum edita*, 8 vols. (Florence, 1950–63), passim.

13. It was inferred by Marquand, op. cit. (1922), i, no. 42, pp. 61–64, probably correctly, that the donor of the altarpiece was Magio Ugurgieri, who occupied a number of official posts after 1482 and in 1490 became Capitano del Popolo. The altarpiece was originally surrounded by "un festone di fiori, frutta e testine d'angeli," which were removed in 1707 to permit the construction of a baroque altar. The altarpiece was seriously damaged in 1943, and was reconstructed in 1948–49 by the Opificio delle Pietre Dure in Florence. For the history of the church see E. Bulletti, *Il Convento dell'Osservanza* (Florence, 1925), and P. M. Bertagna, *L'Osservanza di Siena* (1964).

14. U. Chierici, *La Basilica di San Bernardino a L'Aquila* (1964). The construction of the Observant church was authorized in 1451. Interrupted by an earthquake in 1461, work was resumed in 1464, and in 1472 the body of San Bernardino was installed in the church. The cupola was constructed in 1488–89.

15. The altar is described by G. Vasari, *Vite*, ed. G. Milanesi, ii (Florence, 1906), p. 179. I concur in the view expressed to me verbally by Ulrich Middeldorf that the marble carving is probably due to Leonardi del Tasso.

16. G. Corti and F. Hartt, "New Documents Concerning Donatello, Luca and Andrea della Robbia, Desiderio, Mino, Uccello, Pollaiuolo, Filppo Lippi, Baldovinetti and Others," in *Art Bulletin*, xliv (June, 1962), p. 164.

17. The relevant documents are printed by Marquand, op. cit., i (1922), no. 7, pp. 18–21.

18. The attribution to Luca della Robbia is due to Marquand, op cit. (1914), no. 11, pp. 53–54. The type of the Child is Verrocchiesque.

19. After its appearance in the Demidoff sale in 1880 the whereabouts of this relief were unrecorded until it reappeared in the United States in the 1920s. It was not known to M. Reymond (*Les Della Robbia* [Florence, 1897], pp. 109–10), Marquand (op. cit.,

1914, no. 12, pp. 55–56), or Cruttwell (op. cit., p. 134) in the original.

20. The principal early proponent of an ascription to Luca della Robbia was Bode, "Luca della Robbia e i suoi precursori in Firenze," in *Archivio storico dell'Arte*, ii (1889), pp. 1–9, who regarded the frame as a later product of the Della Robbia shop. There is no reason to suppose that the frame does not belong with the relief.

21. The Frescobaldi Madonna was destroyed in 1945. Accepted by most scholars up to and including L. Planiscig, *Luca della Robbia*, 2nd ed. (Florence, 1948), no. 110, p. 72, as a work of Luca della Robbia, it was dismissed as an "oeuvre d'imitation" by Reymond, op. cit., pp. 120–23.

22. H. P. Horne, "Notes on Luca della Robbia," in *Burlington Magazine*, xxviii (1915), p. 4. The case for removing this work from the *oeuvre* catalogue of Luca is fully argued in J. Pope-Hennessy, *Luca della Robbia* (London, 1980).

23. Florence, Archivio dello Spedale degli Innocenti, Estranei, n. 219, *Francesco e Carlo di Niccolo Cambini a compagni di Firenze, Ricordanze segnate F*, 1453–1455, c. 35. I am indebted for this document to Dr. Marco Spallanzani.

24. J. du Teil, "Notice sur des oeuvres d'Andrea della Robbia en Flandre," in *Miscellanea di studi storici in onore di Antonio Manno*, ii (Turin, 1912), pp. 391–402.

25. The letter is printed by A. Bertolotti, *Figuli, Fonditori e Scultori in relazione con la corte di Mantova nei secoli XV, XVI, XVII* (Milan, 1890), pp. 12–13, and was kindly called to my attention by Professor Middeldorf. The document reads:

A di 28 di Giugnio 1471.

Charissimo mio Elglie più di mesi otto che io ebbi fatta la testa ch io tolsi afare per il Singniore e perche io me sono stato a bada di Pier del Tovaglia che è venuto due volte a Mantova poi che la testa fu fatta, e perchè la prima volta mi disse che ne ragiono chosti e maj non trovò chine sapesse nulla, e di poi scrissi una lettera chostì penso nolla abbiate avuta. Ora a questo dì di nuovo venne Pier del Tovaglia chostà e ramentalgli la detta testa che mi sapesse dire quelle n'avessi a fare: siamo a quello medessimo si che i o detto Piero più volte che io l'arei venduta; ma perche o uto un fiorino però l o tenuta infino a ora: avisatemi quello abbia a fare della testa, che io avevo detto a Pier del Tovaglia,

io la vendero, e lui mi disse vendila e rifanne un altra quando tella chiederanno; non m'è paruto dovere e pero nollo fatto piu presto potete mavissate o pensato infino aora che voi non siate stato nella terra: e avisate el Signor Messer Federigo se io o affare chose piaccia alla sua signoria sono apparecchiato: non mi distendo più. Iddio sia vostra guardia.

Vostro

Andrea di Marcho della Robbia in Firence.

26. For the New York *Saint Michael* and the related works at Faenza see especially O. Raggio, "Andrea della Robbia's St. Michael Lunette," in *Bulletin of The Metropolitan Museum of Art*, n.s., xx (1961–62), pp. 135–44.

27. G. Morozzzi, "Ricerche sull'aspetto originale dello Spedale degli Innocenti di Firenze," in *Commentari*, xv (1964), pp. 186–201.

28. For the history of the Spedale degli Innocenti see particularly L. Passerini, *Notizie storiche dello Spedale degli Innocenti di Firenze* (Florence, 1853).

29. *Neri di Bicci: Le Ricordanze*, B. Santi, ed. (Pisa, 1976), p. 69.

30. Marquand, op. cit. (1922), i, no. 59, pp. 87–89, identifies the donor of the altarpiece as Valerio di Tommaso Carbonati.

31. For the painting in the Cloisters Collection of the Metropolitan Museum and its derivatives see E. Panofsky, "'Imago Pietatis.' Ein Beitrag zur Typengeschichte des 'Schmerzensmanns' und der 'Maria Mediatrix,'" in *Festschrift für Max J. Friedländer zum 60. Geburtstag* (1927), pp. 293f., 350f.; M. Meiss, "An Early Altar-piece from the Cathedral of Florence," in *Bulletin of The Metropolitan Museum of Art*, n.s., xii (1953–54), pp. 302ff.; E. Fahy, "On Lorenzo di Niccolò," in *Apollo*, cviii (1978), pp. 379f. The fifteenth century derivatives are listed by F. Zeri, Metropolitan Museum of Art, *Italian Paintings: Florentine School* (New York, 1971), p. 58.

32. Rome, Galleria Corsini, no. 130452 (A. Scharf, *Filippino Lippi* [Vienna, 1935], no. 90, p. 121; idem., *Filippino Lippi* [Vienna, 1950], p. 58, fig. 140). The assumption that this drawing was made in preparation for an altarpiece from the shop of Filippino Lippi now at Memphis is not necessarily correct. The source of the Volterra altarpiece is the drawing in Rome or a lost painting made from it, not the Memphis painting. Andrea changed Filippino's

Saint Louis of France to Saint Louis of Toulouse, patron with Saint Elizabeth of Hungary of the Franciscan Third Order.

33. A. Marquand, *Giovanni della Robbia* (Princeton, 1920), no. 12, pp. 21–23; no. 16, pp. 26–28.

34. For the documents see Ibid., no. 1, pp. 4–7.

35. Ibid., no. 11, pp. 15–17.

36. Archivio dello Spedale degli Innocenti, Firenze. Estranei, n. 12, *Libro debitori e creditori di monna Alessandra di Ubertino de' Bardi, donna di Raffaello di messer Agnolo Acciaiuoli.* segnato B, 1506(7)–1518(9), c. 165r. ("E deon dare, addi 28 d'aprile (1512), ducati tre larghi d'oro, pagati a 'Ndrea della Robbia per conto di nostra parte d'una tavola facto in Sancto Apostolo, come disse Giovanni di Piero Acciaiuoli, co' l'arme degli Acciaiuoli, e al nostro altare"), c. 167v. (confirmation of this transaction).

37. Marquand, op. cit. (1922), i, no. 100, pp. 164–69.

38. The altarpiece by Fra Filippo Lippi painted for the Cappella Medici in Santa Croce was removed from the chapel shortly before 1823 *(Guida di Firenze,* i [Florence, 1823], p. 171), and was immediately replaced by the enameled terra-cotta altarpiece. The altarpiece is assigned by Marquand, op. cit. (1922), i, no. 79, pp. 118–19, to the bracket 1490–1500, and by Paatz, op. cit., i, p. 560, to the preceding decade. Both datings are conjectural.

39. The Certosa relief is listed by Bode and Fabriczy in J. Burckhardt, *Der Cicerone,* 9th ed., ii (Leipzig, 1904), p. 454, as Benedetto da Maiano, and is discussed with the related documents by A. Marquand, "A Lunette by Benedetto da Majano," in *Burlington Magazine,* xl (1922), p. 128ff.

40. For the work of Andrea Sansovino in enameled terra-cotta, see Vasari, op. cit., iv, p. 510, and U. Middeldorf, "Unknown Drawings by the Two Sansovinos," in *Burlington Magazine,* lx (1932), p. 241.

THE ITALIAN PLAQUETTE

I WAS ASKED as I came into this room, "What are plaquettes?" The answer is that plaquettes are little single-sided bronze reliefs which were part of the fabric of Renaissance life. If you wrote a letter, the box from which you took your pen might have a plaquette on the lid. As likely as not the inkstand would also be decorated with plaquettes, and your pounce box would again be ornamented with reliefs. You might wear one in your cap or round your neck, and there might be another on the pommel of your dagger or your sword. In the room in which you slept there could have been a lamp with a plaquette of a Sacrifice to Cupid or Priapus on the lid, and alongside it might have stood one of those small bronze tabernacles with a plaquette of the Pietà or the Virgin and Child, which are nowadays called paxes though many of them must have been intended for domestic use.

The fact that it was planned for general currency determined the character of the art form. Whereas with medals the emblem or allegory on the back refers to the status or career or character of the person who is represented on the front, the imagery of plaquettes is nonspecific. In those reliefs in which the subject matter is not religious, the artist's aim was to establish visual metaphors of the principles of conduct of his time. There were types of courage. It might be Marcus Curtius Leaping into the Chasm, or Horatius Cocles Defending the Bridge. It might be David Triumphant over Goliath, or it might in Florence be the linked figures of David and Judith, as on a plaquette in Washington which is unaccountably explained by scholars as Judith and Mercury.[1] Courage implied Rectitude, and it is Rectitude that is depicted in a plaquette by the master signing IO. F.F. of two lions attacking a naked youth with the legend ET SI CORPUS NON FIDES MACULABITUR.[2] Further down the spectrum, in a plaquette by the same artist showing a bull barring the path of a lion,[3] Rectitude becomes the oxlike virtue of Constancy. There are allegories of Decency, like the story of the king's son refusing to shoot arrows at his father's corpse, which is shown in a North Italian plaquette generally described as a Martyrdom of Saint Sebastian,[4] allegories of Restraint, like that series of admonitory plaquettes by Riccio, which show the Drunkenness of Silenus, a Bacchanal of drunken children, and a third scene where Virtue, on the right, is veiled.[5] A whole group of plaquettes has as its subject the Allegory of the Virtuous Life, and its end product, Fame.

In the mythology of the plaquette, however, there was one weapon against which Rectitude and Courage were of no avail, and the scene of Vulcan Forging the Arrows of Cupid is depicted on a very large number of reliefs. Sometimes it was worked out with great imagination, as in a beautiful relief by Riccio where Venus holds a smoldering torch,[6]

192

and sometimes it was treated much less delicately, as in a Mantuan cap badge, where Venus brandishes the bow of Cupid and the moral is pointed with the triumphant motto AMOR VINCIT OMNIA.[7] Love, of course, did triumph, in Rome between a double row of figures, of which that behind, to judge from its diagonal accent, was inspired by a spiral columnar relief,[8] in Venice on a shield raised by putti from the Saturn Throne.[9] Only one force indeed could counter this triumphal progress, and that was Chastity, who could confiscate the bow of Cupid and drag Venus by her hair.[10] You may feel all this is rather trite, for we have been conditioned to believe that meaning in Renaissance works of art is invariably arcane. So I repeat once more that these plaquettes fulfilled their function only if they were understood.

Their appeal extended far beyond the boundaries of the locality or country in which they were produced. Once coined, a moral type spread with astonishing rapidity. A plaquette by Francesco di Giorgio is reproduced in marble on the façade of the Certosa at Pavia, plaquettes are copied on the doorway from the Palazzo Stanga at Cremona in the Louvre, and plaquettes appear again at the bottom of the Porta della Rana of Como cathedral. Where the marble copy is datable, it naturally throws some light on the date of the plaquette. Most of the instances of the direct copying of plaquettes in marble occur in the magpie culture of Lombardy, and from Lombardy the practice was transferred to France, to Dijon, and Pagny, and Orleans, and Blois, and Tours, and Chartres. I shall not go into that point in detail here, since it is amply discussed in the great book on plaquettes by Molinier,[11] and most of the French imitations are, in any case, so late as not to affect the dating of the plaquettes. More curious is the response that they evoked in Germany, where replicas were made in lead and where they were adapted by Weiditz and other artists. The most vivid tribute to the vogue of the plaquette north of the Alps is the painting of *Esther Before Ahasuerus* by Burgkmair in Munich (fig. 1), which was painted for William IV of Bavaria in 1528. The setting is an open hall supported by square piers, and at the top of each of them, below the capital, and at the bottom, above the base, there are grisaille reliefs. Classical reliefs we might assume, until we look at them more closely and find that each reproduces a plaquette. Above the doorway on the right is the Moderno *Hercules and the Nemean Lion,* on the central pier are two plaquettes by the master signing IO. F.F., on the piers behind are a Milanese plaquette of a Triumph and the right half of the Pseudo-Fra Antonio da Brescia's popular *Abundance and a Satyr,* and on the three piers on the left are the left half of the *Abundance and a Satyr,* an *Allegory of Virtue* by Riccio, Caradosso's *Hercules and Cacus,* and the *Orpheus* plaquette of the Pseudo-Melioli. In the companion painting by Burgkmair of the *Battle of Cannae* the central group is taken directly from a Moderno plaquette.[12]

When did the making of plaquettes begin, and how was it distributed? If those questions had been asked thirty or forty years ago, the answers would at least have been clear-cut. The plaquette, the reply would have gone, was created by Donatello, and most of the surviving examples were made in Padua, except for some casts from classical gems which

were all made in Florence. Ricci's great catalogue of the plaquettes in the Dreyfus Collection is, for example, based on those three postulates. But I doubt if any of them is quite correct. The supposed Paduan predominance in the field of the plaquette is a matter of assumption, not of fact; Rome was a much more important center than Florence for the casting of plaquettes after the antique; and there is only one plaquette that is firmly associable with Donatello.[13] The Donatello plaquette (fig. 2) shows the Virgin and Child, and the Virgin's profile has been compared, again and again, with the Pazzi Madonna in Berlin (see fig. 3 on page 73). More decisive for Donatello's authorship is the cutting of the huge halo just above the level of the head, which we find again in an authentic work in marble, the *Madonna of the Clouds* (see fig. 7 on page 76). We cannot, of course, be absolutely certain that the relief was designed as a plaquette, and is not a reduction from some lost larger work, but we also know it as a colored cartapesta squeeze in a pigmented tabernacle which cannot have been made much later than the early 1440s or much earlier than 1435,[14] so we are bound to infer that the plaquette was sanctioned, if it was not actually cast, by Donatello.

We know too that after his return to Florence from Padua in the 1450s, Donatello made

1. HANS BURGKMAIR. *Esther Before Ahasuerus*. 1528. Panel, 103 x 156.3 cm. Alte Pinakothek, Munich

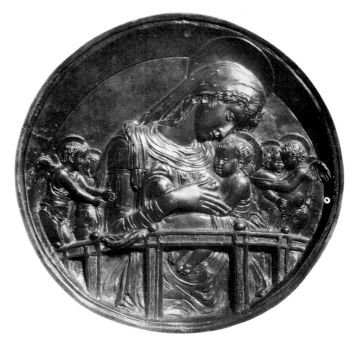

2. *Virgin and Child*, after Donatello. Bronze, 11.6 x 9.4 cm. Victoria and Albert Museum, London

3. *Virgin and Child with Four Angels,* after Donatello. Bronze, diameter 22.2 cm.
 National Gallery of Art, Washington, D.C. Samuel H. Kress Collection

a circular bronze relief (see fig. 21 on page 88).[15] A copy of it is in Washington (fig. 3), where the figures are shown in a circular window in perspective, just as they are in the marble relief outside Siena cathedral, and a bulging balustrade is used as a counterpoise to the circular frame.[16] A circular bronze by Donatello of rather earlier date is in Vienna (see fig. 9 on page 78).[17] But there is no proof at all that Donatello in the last phase of his career was concerned with the casting of plaquettes.

What evidence there is suggests that the commercial manufacture of plaquettes began in Rome, not Florence, and was inspired by the collection of Pope Paul II. In 1457, long before his election to the papacy, he already owned 240 gems,[18] and we know that casts were made from them, because one bronze plaquette reproduces a classical intaglio with the pope's arms as cardinal. After the pope's death in 1471 his gems became the property of Lorenzo de' Medici, and many of them still bear Lorenzo's name. But plaquettes were cast from some of them before Lorenzo's name was added, and those too must have been made in Rome. So these little reliefs really were a product of the same aggressively classicizing

4. PSEUDO-MELIOLI. *Allegorical Scene.*
Bronze, diameter 5.9 cm.
National Gallery of Art, Washington, D.C.
Samuel H. Kress Collection

5. MASTER IO. F.F. *Allegorical Scene.*
Bronze, diameter 3.2 cm.
Victoria and Albert Museum, London

6. *Mars and Venus.* South German (?).
Lead, diameter 5 cm. National Gallery of Art,
Washington, D.C. Samuel H. Kress Collection

taste as Filarete's reduction from the *Marcus Aurelius,* the first datable small bronze.

The meaning of these casts from the antique was frequently in doubt. We know, for example, from the inventory of the collection of Pope Paul II that it contained a gem with a naked man standing before a seated female figure. Nowadays the plaquette based on it is described as Ceres and Triptolemus, but in the only inscribed version the female figure is named as Juno and the scene is identified as *Junonis consilium.*[19] So it is extremely difficult to tell whether the meaning that is attached to these images today is really the same meaning that was attached to them in the fifteenth century. Without these reproductions classical gems would undoubtedly have exercised a more restricted influence. In the Museo Nazionale in Florence there is a bronze bust of about 1460 ascribed to Donatello in which the sitter wears a medallion, with a winged youth driving a biga, round his neck. The medallion has been explained as a Platonic image of the soul,[20] probably correctly since the motif occurs again about 1465 in a funerary context on Rossellino's Tomb of the Cardinal of Portugal in San Miniato al Monte. In both cases the source was a plaquette seemingly made from a gem which was in Rome in the collection of Pope Paul II.[21]

Moreover, the meaning of the symbol was apt to change. I shall take just one example of the sort of problem that is involved. A plaquette (fig. 4), made in Mantua by an artist who was at one time confused with Melioli the medalist, is based on a lost classical gem.[22] It shows a sleeping youth seated on a corselet approached by a naked warrior with a shield in one hand and a trophy in the other; on the right on a column stands a little figure of Eros with a bow and arrow in his hands. Perhaps the artist has conceived the youth as dreaming of military prowess and of love. The same scheme recurs in a second contemporary plaquette by the master signing IO. F.F. (fig. 5),[23] but this time with a difference; a lion's head is substituted for the corselet, and the figure in the center, no longer a soldier, proffers

196

Bacchic sacrificial emblems to the sleeping boy. One sympathizes with Ricci when, in despair, he described the subject as "two hunters." But in this case the youth is manifestly Hercules, and that is confirmed by the appearance of the same design on the back of a medal of Ercole II d'Este later in the sixteenth century. Finally, there is a third variant of the composition (fig. 6)[24] in which the sex of the sleeping figure changes and the figure in the center has a dagger in his hand. In this case the subject is explained by the planetary symbols of Mars and Venus, which appear at the top.

I do not want, however, to throw undue emphasis on plaquettes after the antique or upon iconography. For the claim of the plaquette to be looked on as an aspect of art rests on the fact that it was developed by a number of exceptionally gifted artists. The most prominent and by far the most prolific is the sculptor who is generally referred to by his pseudonym, Moderno. The shortest list of Moderno's works consists of fifty-nine plaquettes, and the longest consists of seventy-two, and even when his work has been scaled down, he seems to have been responsible for an astonishing number of small reliefs. There is one written record of his activity. It occurs in a passage on art in Italy written in or before 1549 by the Portuguese painter Hollanda,[25] which lists the best-known medallic engravers active in Rome in the first half of the sixteenth century. They were Valerio Belli and Caradosso, to both of whom I shall return, Benvenuto Cellini, and Moderno, "who made the seals of the Piombo." Not very informative, you may say, but there is one thing we can deduce from it, that Moderno was not identical with any of the other artists in Hollanda's list. I should not think it worthwhile to make that point had it not been claimed that Moderno was a pseudonym of Caradosso.

For what else we know we are dependent on seven signed works. Four of them show the Labors of Hercules (fig. 7).[26] They are approximately datable—they were copied in fresco at

Cremona and in marble at Como, and must therefore have been made, at latest, in the first half-decade of the sixteenth century—and their classicizing style is North Italian, but not necessarily Paduan. Thanks to Pomponius Gauricus and Scardeone, the records of bronze casting and goldsmiths' work in Padua are so full that Moderno could hardly have escaped attention had he worked there. A parallel for these far from inspired designs is supplied by the early work of the engraver Giovanni Antonio da Brescia.

The making of plaquettes and gem engraving often went hand in hand, and it need come as no surprise that Moderno's fifth signed work is actually a hardstone carving. It shows

7. MODERNO. *Hercules and the Oxen of Geryon.* Bronze, 7.1 x 5.4 cm. Victoria and Albert Museum, London

8. MODERNO. *Flagellation.* Silver, parcel-gilt, 18.3 x 14.8 cm. Kunsthistorisches Museum, Vienna

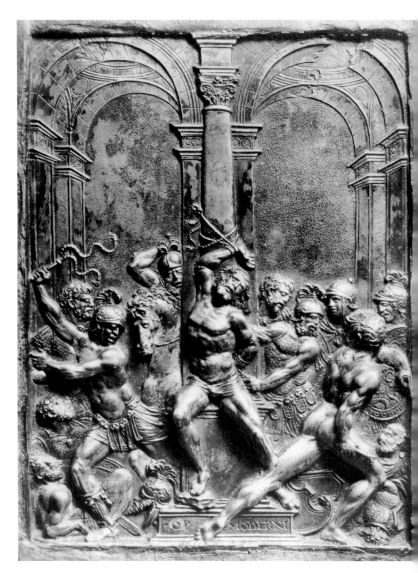

198

Apollo, and is based on the print by Marcantonio after the fictive statue at the back of Raphael's *School of Athens*.[27] The print is undated, but this little carving might have been made between about 1515 and 1525. It does not in itself prove, of course, that Moderno went to Rome, though we know from Hollanda that he did so, but it does show that he became acclimatized to Roman High Renaissance taste. That is confirmed by the sixth signed work, a silver relief of the *Flagellation* in Vienna (fig. 8), where the central figure is based on the Laocoön. The Laocoön was engraved by Giovanni Antonio da Brescia three years after its discovery, but the source of Moderno's plaquette is apparently the somewhat

9. MODERNO. *Virgin and Child with Saints*. Silver, parcel-gilt, 18.5 x 14.7 cm. Kunsthistorisches Museum, Vienna

10. MODERNO. *Virgin and Child with Saints*. Bronze, 6.9 x 5.4 cm. National Gallery of Art, Washington, D.C. Samuel H. Kress Collection

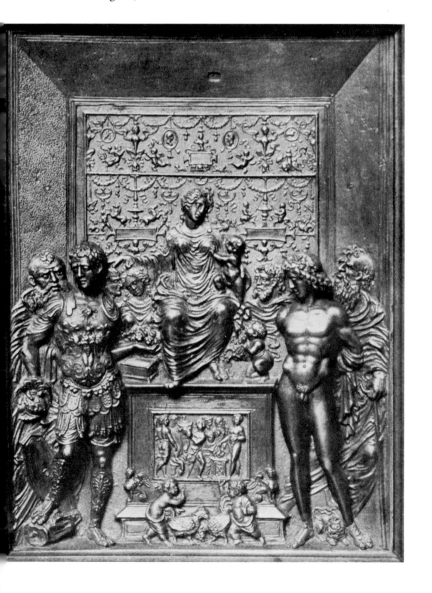

199

later engraving by Marco Dente.[28] What is remarkable in the plaquette is its consistency, in that the style of the central figure is followed through in the two figures at the sides. Its friezelike composition and spacious sense of interval would be inexplicable if Moderno had not also been familiar with the print of the *Massacre of the Innocents* after Raphael and other works in the same style.

The *Flagellation* has a companion piece showing the *Virgin and Child with Saints* (fig. 9).[29] Just as the right-hand executioner in the *Flagellation* is a High Renaissance revision of figures in the earlier Hercules plaquettes, so this scene too is a Roman recension of a North Italian type, an altarpiece of a kind we associate with Costa, where the Virgin and Child are raised on a high throne above a classical relief. But the drapery in the plaquette is classical, the cocks in the foreground depend from a classical gem,[30] and the background is filled with ornament that once more has a parallel in Giovanni Antonio da Brescia's engravings,[31] and includes little figures of the horse tamers on the Quirinal. The analogy with Giovanni Antonio da Brescia the engraver is of some importance, since he too suffered a conversion from the style of Mantegna to that of Marcantonio, and he too was in Rome, probably between 1509 and 1525.

As soon as we look at Moderno's plaquettes sequentially an intelligible pattern can be traced. Quite a number of reliefs, religious reliefs mainly, are manifestly early works, and others are unmistakably connected with the two silver plaquettes. One of the latter is a little relief (fig. 10) which exists only in bronze, but must, to judge from its defective detail, have been molded from a gold or silver original.[32] It is indissociable from the large plaquette by virtue of the poses of the Virgin and the saints and of the classical ornament,

11. MODERNO. *Augustus and the Sibyl.* Bronze, diameter 5.6 cm. Victoria and Albert Museum, London

12. MODERNO. *Prometheus Creating Man.* Bronze, diameter 4.7 cm. National Gallery of Art, Washington, D.C. Samuel H. Kress Collection

13. MODERNO. *Nessus and Deianira.* Bronze, 9.4 x 4.3 cm. National Gallery of Art, Washington, D.C. Samuel H. Kress Collection

and the disk flanked by putti above the throne seems again to have been imitated from an altarpiece by Costa, this time in San Giacomo Maggiore at Bologna. Another is a circular plaquette of *Augustus and the Sibyl* (fig. 11),[33] where the two figures, linked together as a single formal unit, are Raphaelesque, and the relief on the rear wall once more is reminiscent of Giovanni Antonio da Brescia.[34] Another is a charming little circular relief (fig. 12) which is generally described as "a sculptor carving a statue of Cupid."[35] Its real subject is Prometheus, who is described by Pomponius Gauricus in his *De sculptura* as the first sculptor, and is shown on a Hellenistic relief in the Louvre creating man.[36] Yet another is the plaquette of *Nessus and Deianira* (fig. 13),[37] accompanied by two roundels showing a figure of Victory and Hercules and the Stymphalian birds. Perhaps it is worthwhile to turn back for a moment to one of the early Hercules plaquettes to point the transformation that overtook Moderno's style. The change is a double one. Not only does it affect the thinking behind the plaquette, which is no longer restricted by the visual clichés of quattrocento classicism, but also the method by which the image is presented, that is its technique. Since I have used that term "the thinking behind the plaquette," perhaps I should mention here the only case in which it is possible to reconstruct Moderno's thought processes, the only case, that is, in which a trial cast and a finished plaquette survive. The trial cast (fig. 14)[38] shows an armed youth seated among a pile of trophies, and has a parallel in an engraving adapted from a coin of Nero, showing a seated warrior personifying Rome. The final cast (fig. 15)[39] is parcel-gilt and much more highly chased, and a whole series of small changes has been introduced into the scheme. The head is more erect, the right foot is concealed behind the helmet, the left arm is extended with the elbow resting on the quiver,

201

14. MODERNO. *Mars Surrounded by Trophies*. Bronze, diameter 6.4 cm.
National Gallery of Art, Washington, D.C. Samuel H. Kress Collection

15. MODERNO. *Mars Surrounded by Trophies*. Bronze, parcel-gilt, diameter 7 cm.
National Gallery of Art, Washington, D.C. Samuel H. Kress Collection

and the right wrist is slightly raised. As a result the rather loosely composed figure in the trial cast takes on the precision and coherence of the revised relief. All the elaborate plaquettes by Moderno which we take for granted because we only know them in their final state—like the circular relief of the *Death of Hippolytus*[40]—seem to have resulted from the action of this self-critical intelligence.

I suppose I should have said much earlier that we know Moderno's name. It was established by Bode, but in so casual a fashion—five lines in the *Kunstchronik*[41]—that practically no attention has been paid to it. These are the facts. Among the works signed by Moderno is what is nowadays called a pax with the Virgin and Child enthroned and two saints at the sides. The signature on the back of the version in London is in the form HOC HOPVS MODERNI.[42] But sixty-odd years ago there appeared at auction another example of this pax, which was signed on the back with the artist's real name, not his pseudonym. HOC OPVS MONDEL. ADER. AVRIFEX, read the signature, with the date 1490.[43] Unluckily that particular plaquette has disappeared, but the inscription cannot be dismissed on that account. We have records of a Veronese goldsmith and hardstone carver Galeazzo Mondella,[44] and the identification of Moderno with Mondella is favored by the fact that Verona is a far from improbable setting and 1490 a far from improbable date for the origin of this design. The name Moderno must then have been arrived at by an elision of the patronymic ADER and of the first two letters of Mondella's name. Moreover, and this I think is decisive,

there are two inscribed drawings by Mondella in the Louvre. And though their scale is a great deal larger than that of the plaquettes, the repertory of poses is close enough to substantiate Moderno's authorship.

That brings me to what, to my way of thinking, are the most immediately attractive of the plaquettes associated with Moderno, two groups of larger scenes of which Moderno's authorship is probable but cannot be demonstrated in a conclusive way. The first consists of four reliefs of the Labors of Hercules (fig. 16),[45] which have all the appearance of small works by a large-scale sculptor and in three of which the designs depend directly from the antique. The figures fill the whole height of the field, and impress us by their splendidly controlled plasticity. In that they stand in contrast to the small plaquettes, but conform to the drawing in the Louvre. Only in one of them, *Hercules Strangling the Serpents,* does the artist have recourse to a purely decorative device, that of extending the serpents' tails in arabesques over the flat ground of the relief. A fifth plaquette, palpably by the same hand and also rectangular, shows the *Death of Lucretia,*[46] and reveals Moderno, if it be Moderno, as a narrative artist of great sensibility.

The same hand was responsible for what bid fair to be considered the most appealing of

16. MODERNO (attributed). *Hercules and the Nemean Lion.* Bronze, 7.9 x 6.6 cm. Victoria and Albert Museum, London

17. MODERNO (attributed). *Orpheus Redeeming Eurydice.* Bronze, diameter 10.5 cm. Victoria and Albert Museum, London

18. CARADOSSO. *Battle of the Centaurs and Lapiths.*
Bronze, 5.1 x 5 cm. Victoria and Albert Museum,
London

19. CARADOSSO. *A Triumph.* Bronze, 5.4 x 3 cm.
National Gallery of Art, Washington, D.C.
Samuel H. Kress Collection

20. CARADOSSO (attributed). *Augustus and the Sibyl.*
Bronze, 7 x 6.1 cm. Victoria and Albert Museum,
London

all Italian plaquettes (fig. 17). Their subject is the Orpheus legend,[47] and they are enchantingly poetic scenes. In looking at them one recalls the little mythological roundels of Cima da Conegliano. The context is more pictorial and the finish is less fine than in any mature Moderno plaquette, and the system of modeling is more powerful and more abrupt. The groundline, for example, projects to the level of the frame, and the flat surface is broken up by forms that are sometimes modeled and sometimes incised. But one figure, the Eurydice in the Redemption scene, has an exact parallel in Moderno's work.[48] It cannot be ruled out that a painter or engraver was responsible for the designs. Two much less subtle companion plaquettes of scenes from the legend of Arion are reminiscent of the pictures of Michele da Verona.[49]

The doyen of goldsmiths when Moderno was in Rome was Caradosso. He was born in Milan about the middle of the fifteenth century, was employed as a medalist at the Sforza court, left Milan for Rome some years after the expulsion of Lodovico il Moro, and died in 1527. None of his works in precious metals survives, and his reputation is largely due to a passage in Cellini's *Life.* He was one of the few contemporaries whom Cellini did not decry. "He dealt in nothing but little chiseled medals," says Cellini, "made of plates of metal and suchlike things." There are no signed Caradosso plaquettes, but there are some which can be looked on as authenticated, in that they conform in style to the reverses of his medals and correspond in subject with scenes on a silver inkstand which are described in some detail in the *De nobilitate rerum* of Ambrogio Leone.[50] One relief described by Leone showed the *Rape of Ganymede*; the foreground was occupied by horsemen watching Ganymede carried up into the sky. This scene is shown in a rare rectangular plaquette.[51] Another scene mentioned by Leone is a *Battle of the Centaurs and Lapiths,* of which bronze versions in exactly the same format survive (fig. 18).[52] There were two other scenes on the inkstand, *Hercules and Cacus,* and *Hercules and the Nemean Lion,* of which no record has come

204

down to us.[53] So famous was this inkstand and so delicate were its reliefs, that sulphur casts were made from them, and as late as 1586 examples of the reliefs in bronze, or of the molds from which the bronze reliefs were made, were in the studio of Caradosso's grandson in Milan. Figures from two of the plaquettes appear on the doorway from the Palazzo Stanga at Cremona, which was carved shortly before 1500, so they must have been designed by Caradosso at the Sforza court before he left for Rome. The presiding artists in Milan were Bramante and Leonardo, and the influence of both is reflected in these little scenes. The architecture is Bramantesque, and Bode for that reason ascribed the design of the reliefs directly to Bramante.[54] But against that it must be objected that the figure style is quite strikingly unlike Bramante's, as we know it from the Brera frescoes or from the engraving by Prevedari from a Bramante cartoon. Much more significant is the connection with Leonardo, especially with that fascinating sheet at Windsor with studies for a group of Saint George and the Dragon which was made in the late 1490s in Milan.[55] But in an antecedent phase of Caradosso's work his figure style was indeed based on Bramante. The main proof of that is a little plaquette of a *Triumph* (fig. 19),[56] which exists in a single version in Washington, where the figure in the chariot conforms in style to the fresco of the philosopher Chilon from the Palazzo del Pretorio at Bergamo and the precipitous recession of the architecture recalls the intarsia of the *Decollation of the Baptist* from Bramante's design at Bergamo and the roundel beneath the fresco in the Sala del Tesoro of the Castello in Milan. In Rome, in the works to which Cellini refers, the style of Caradosso must have become more classical. That it did so is proved beyond all doubt by the reverse of his portrait medal of Bramante. This is the style with which we might expect plaquettes of later date to correspond. None has been identified, but I rather wonder if one of them is not a beautiful rectangular relief of *Augustus and the Sibyl* (fig. 20) which is sometimes mistakenly ascribed to Riccio.[57] The plaquette seems to have been cast from an original in

205

gold or silver, and the Raphaelesque figures on the right would be less unaccountable in Rome than they appear in Padua.

The only artist whose work can compare in delicacy with Moderno's is the mysterious master signing IO. F.F. So far as we can tell he was not a very prolific relief artist, but the plaquettes that he did make achieved quite extraordinary popularity. Indeed if a census were taken of plaquettes on weapons, his would far outnumber those of any other artist. Artistically his designs are notable not only for their delicacy, but for the compactness of the forms and for an impeccable sense for the relation of the figure to the circular field. Many of them exist in two formats, one shield-shaped and the other circular, and in every case it is the circular version that is the original. As to the date when they were made, we have only one piece of evidence, that a plaquette of *Marcus Curtius Plunging into the Ravine Before the Forum* is reproduced in an engraving by Lucas Cranach.[58] The engraving is not actually dated, but was probably made in 1506, so the plaquette (and others like it) must date from the late fifteenth or very early sixteenth century. In a plaquette of *Phaedra and Hippolytus* which depends from a woodcut made by Jacob von Strassburg after a sarcophagus in Rome, a figure derived from Mantegna is inserted in the center of the scene.[59] The use of allegory, moreover, which is one of the factors that distinguish this master's plaquettes from Moderno's, suggests that they were planned in a humane environment. It is generally assumed that the letters in the exergue are to be read as JOHANNES FRANCISCUS FECIT,[60] and the artist may, therefore, be the bronze caster and medalist Giovanni Francesco Ruberti, who is mentioned in Mantua between 1483 and 1523, provided weapons for the Mantuan court, and was engaged in 1492 in striking coins by a new process at the Mantuan mint. The only signed work by Ruberti that we know is a medal of Gianfrancesco Gonzaga of about 1484, where the handling is a good deal clumsier than that of the plaquettes, but on the analogy of Moderno it is quite possible that Ruberti's style in later works grew smoother and more urbane.

In Venice the principal bronze sculptors of the late fifteenth and early sixteenth centuries were Camelio and Leopardi. Both artists are known as sculptors in relief, Camelio as the author of two signed reliefs in the Ca' d'Oro which were incorporated in his monument, and Leopardi as the author of the circular friezes which run round the flagstaffs outside Saint Mark's. Arguing from these works, we may infer that Camelio was responsible for a small relief of *Vulcan Forging the Wings of Cupid* (fig. 21),[61] which was copied by Carpaccio in the late 1490s in a painting in the Saint Ursula cycle, and that Leopardi was responsible for the beautiful circular relief adapted from Mantegna with a *Combat of Ichthyocentaurs* of which versions are in Paris, Berlin, and Washington.[62] But a signed plaquette by Leopardi, with the unrecorded inscription A.L.V. at the base, also survives (fig. 22).[63] It is conventionally described as the *Instruction of Cupid in Architecture*—the figure on the right is Mercury—and has an unsigned companion piece, known through a stucco cast formerly in the Bardini Collection in Florence, of *Vulcan Forging the Helmet of Mars* (fig. 23).[64] In both works the

206

style is less classical than on the flagstaffs, and it may well be that the reliefs were modeled between 1482, when Leopardi is first mentioned in documents, and 1490, when he assumed control of the concluding stages of the casting of Verrocchio's Colleoni monument.

Among Camelio's and Leopardi's contemporaries in Venice were two much more provincial artists. One of them has been confused with the medalist Fra Antonio da Brescia. By temperament an eclectic, he took his designs from whatever sources were to hand, and did not scruple in his plaquette of *Abundance and a Satyr*[65] to combine a satyr drawn from Dürer's *Satyr Family* with a female figure drawn from an early work by Marcantonio. Less accomplished but more inventive is the artist signing Ulocrino. Eighty-odd years ago it was suggested that the name Ulocrino might be a fusion of the Greek οὖλος and the Latin *crinis,* and was adopted by the Paduan sculptor Riccio, who is also described as Crispus or curly-haired.[66] The suggestion, quite an ingenious one, is embodied in the standard book on Riccio,[67] and there is only one objection to it, that Ulocrino's and Riccio's plaquettes are totally unlike. The case for regarding Ulocrino as Venetian rests on the twin supports of style and iconography. His religious plaquettes—four of them represent Saint Jerome—

21. CAMELIO. *Vulcan Forging the Wings of Cupid.* Bronze, 17.5 x 25 cm. Victoria and Albert Museum, London

22.
ALESSANDRO LEOPARDI.
*The Instruction of Cupid in
Architecture.*
Bronze, diameter 15.2 cm.
Victoria and Albert Museum,
London

23.
Vulcan Forging the Helmet of Mars,
after Alessandro Leopardi. Stucco.
Formerly Bardini Collection,
Florence

24. ULOCRINO. *Alexander of Aphrodisias and Aristotle.*
Bronze, 7.2 x 5.6 cm. National Gallery of Art,
Washington, D.C. Samuel H. Kress Collection

seem to reveal some knowledge of the figure style of Basaiti and Carpaccio, and the Venice of Carpaccio comes to mind again with a plaquette of *Alexander of Aphrodisias and Aristotle* (fig. 24). The closest analogies for this curious scene occur in the woodcut illustrations to Zoppino's *Vite de philosophi moralissimi,* which was published in Venice in 1521. But the plaquette may actually be rather earlier, for the *De anima* of Alexander of Aphrodisias was first published in Venice in translation in 1495; and though the Greek edition of Alexander of Aphrodisias' Aristotelian commentaries appeared also in Venice between 1513 and 1536, it is tempting to link the relief with the earlier book, since its translator was Girolamo Donati, one of the earliest patrons of Riccio.[68] It was for Donati, for example, that Riccio designed his plaquette of two genii stealing the books of wisdom from a sleeping female figure, with beneath it the inscription ΣΕΜΝΗΚΛΟΠΙΑ or Proud Theft.[69] Possibly it was Donati who laid down the terms of reference of Ulocrino's *Death of Meleager,*[70] where the figure of the dying Meleager derives from the antique.

One of the difficulties about dating Ulocrino's works is that despite their rather coarse technique the poses that are employed in them often look surprisingly evolved. An example is the figure of Althaea, placing the brand in the fire at the back of this plaquette, and another is contained in a plaquette of Saint Cecilia seated at her organ, which has as its counterpart the scene of Apollo Triumphant over Marsyas.[71] Both scenes apparently belong to a larger series of plaquettes with allegories of harmony. It must be recognized frankly that these plaquettes by Ulocrino are not of much significance as works of art; their interest resides in the ideas they illustrate, and they are really little culture tokens handed to us by the past.

Once we reach Padua and the work of Riccio, the circumstances change. Riccio's pla-
quettes are culture tokens too, but culture tokens which reflect the mind of a great artist.
His development as an artist in relief can be followed through three major works, the *Scenes
from the Legend of the Cross,* made for the Servi in Venice during the 1490s; the Paschal
Candlestick in the Santo at Padua, which was begun in 1507 and finished in 1515; and the
Della Torre monument at Verona, which seems to date from about 1520. It is in this
framework that we must set Riccio's plaquettes. Luckily enough of them are signed,
generally with an R or an RI or an RIO on the back, to remove almost all doubt about what
Riccio did or did not execute. The poles of his development are best established through
the religious plaquettes. By far the earliest of them is a little relief of the *Entombment.*[72] Its
figure style depends from that of his master Bellano, and it must have been completed
about 1490, and is thus earlier than the earliest of his large reliefs. The emotions are
unruly, and the figurative language is undisciplined. But a means of salvation lay ready to
hand. It was supplied by the engravings of Mantegna. In Riccio's next plaquette of the
Entombment (fig. 25)[73] some of the figures are drawn from a famous engraving by Mantegna,
while others derive from a Mantegna-designed bronze relief.[74] The rather eclectic character
of the whole composition would indicate a dating about 1500, and that is confirmed by the

25. RICCIO. *Entombment*. Bronze, 11.2 x 14.7 cm. Victoria and Albert Museum, London

presence in it of children like those in the foreground in the relief of *The Proving of the Cross* in the Ca' d'Oro. By the standard of the earlier plaquette, this is a noble and moving work, but it is much less noble and less moving than the relief of the *Entombment* on the Paschal Candlestick. The difference between the two is that in the later, the candlestick relief, classicism no longer results from a conscious imitative process but has become a natural mode of speech. Both in the first *Entombment* plaquette and in the second, the sarcophagus is parallel to the relief plane, but on the Paschal Candlestick it recedes slightly to the right, and in the third and latest of the *Entombment* plaquettes (fig. 26) this divergence between the plane of the sarcophagus and the plane of the relief is even more pronounced. This plaquette is often discussed as though it were no more than a free variant of the *Entombment* on the candlestick, but the two scenes differ in imagery and style. In imagery insofar as the plaquette is conceived symbolically—the body is held so that the wounds are exposed to the spectator and on the sarcophagus is an inscription: "He whom the whole world could not contain is enclosed within this tomb"—and in style insofar as the figures are more erect and classical, and relate to the reliefs on the Della Torre monument. So we are bound to assume a dating about 1520–25 for this plaquette.

Sometimes in his secular plaquettes Riccio speaks to us with the voice of an antiquary

26. RICCIO. *Entombment*. Bronze, 11.7 x 16.5 cm. Victoria and Albert Museum, London

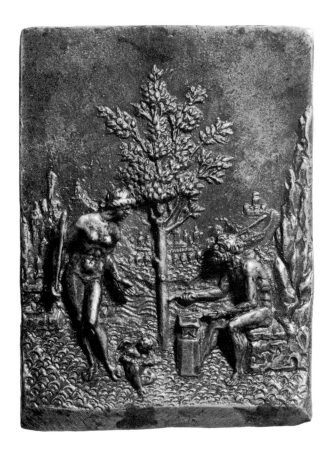

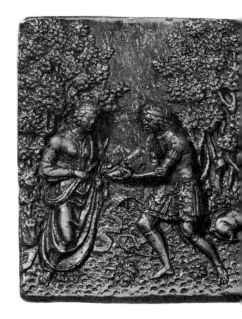

28. RICCIO. *Meleager Proffering the Boar's Head to Atalanta.* Bronze, 7.6 x 6.1 cm. National Gallery of Art, Washington, D.C. Samuel H. Kress Collection

27. RICCIO. *Vulcan Forging the Arrows of Cupid.* Bronze, 10.7 x 7.7 cm. National Gallery of Art, Washington, D.C. Samuel H. Kress Collection

rather than an artist. He does so, for example, in what, to judge from the numbers that survive, must have been his most popular relief, the *Sacrifice of a Swine,*[75] where the central group corresponds with an engraving by Mocetto. But elsewhere he uses classical motifs with wonderful naturalness and sensibility. Who, for example, would guess that the figure of Venus in the enchanting plaquette of *Vulcan Forging the Arrows of Cupid* (fig. 27) was based on a classical torso, if the same torso did not occur again in the much better-known plaquette of *Venus Chastising Cupid?*[76] Obviously these reliefs cannot be divorced from the great paintings which form their background—the *Fête Champêtre* in the Louvre, the Dresden *Venus,* the *Judith* in the Hermitage—but it remains remarkable that so much of the spirit of these works, their richness and their sensuality, should be transferred to bronze reliefs on so diminutive a scale. In its union of figures and landscape Riccio's plaquette of *Meleager Proferring the Boar's Head to Atalanta* (fig. 28) is an equivalent in sculpture for Palma Vecchio's little *Mars and Venus* at Brooklyn or for the small paintings by Previtali in the London National Gallery. In this and in a whole series of related plaquettes Riccio is

212

29. RICCIO. *Allegory of Virtue*. Bronze, diameter 4.9 cm.
National Gallery of Art, Washington, D.C. Samuel H. Kress Collection

30. RICCIO. *Allegory of Virtue*. Bronze, diameter 5.7 cm. Victoria and Albert Museum, London

faithful to Giorgione's pastoral vision of the world, and so direct is the modeling, so skillful the surface working that the landscapes give the illusion of being light-suffused.

I wish that it were possible to linger over them, but if I did so, I should be prevented from discussing another scarcely less attractive aspect of Riccio's small reliefs. This is a whole group of plaquettes which have in the past been looked upon as Riccio's, but of which Riccio's authorship is now mistakenly denied. One of the most characteristic (fig. 29) shows a child standing on a satyr's back.[78] With one hand he waters a laurel bush, and with the other pulls down its topmost branch. Round the trunk is twined a snake and above it is a pair of wings. A withered tree stands on the right. This antithesis between the child and satyr has a parallel in a painting by Lorenzo Lotto in Washington, which formed the cover of a portrait of Bernardo de' Rossi, bishop of Treviso.[79] Lotto's panel represents two figures beside a withered tree from which a new branch springs. One is a satyr surrounded by the symbols of indulgence, and the other is a child armed with the instruments of reason, behind whom a path leads to the summit of a hill. Those emblems which do not occur in Lotto's portrait, the snake and wings and zephyr head, are hieroglyphs drawn from the *Hypnerotomachia Poliphili* of Colonna. If there were any doubt that the winged child represented Virtue, it would be dispelled by a second plaquette, from which the satyr is omitted and which has the word VIRTUS in the exergue at the base.[80] Here the child tugs at a winged vase filled with laurel branches and has a snake in his left hand. This plaquette is double-sided, and on the back is a seated female figure crowning a

213

male mask carried towards her by a running child. Behind (and this is common to one or two other plaquettes in the series) is a palm tree sprouting laurel, and beneath are the letters FA for Fama, Fame. In yet another plaquette (fig. 30)[81] the child Virtue, with a basket on his head, waters the palm tree which sprouts laurel, while Fame sits with her trumpet to her lips. In a fourth variant of the motif[82] the child holds a rudder, and at the back is the emblem of Pegasus. The letters F.V.D. in the exergue have been transcribed "Fortunam virtus ducit," but it is clearly Fame not Fortune that is the subject of the plaquette. The last of the plaquettes that have been denied to Riccio[83] is a summing up or an extension of all these images. The symbol of the Virtuous Life, this time a youth, receives the accolade of Victory while a propitiatory sacrifice is offered on the right.

All these plaquettes are in lower relief than Riccio's religious or mythological plaquettes, and the flattening of the surface brings with it a new linear emphasis in the design. That is no doubt the reason why one of the most typical plaquettes of all has never been ascribed to Riccio. I mentioned that the hieroglyphs used in certain of these little works depended from the *Hypnerotomachia Poliphili,* and this plaquette, which is slightly salacious, like so much of the secular art produced in Padua, is actually based on an illustration to Colonna's text. The woodcut represents a fountain on which is shown a nymph surprised by a satyr who pulls back the curtain beneath which she lies asleep. In the plaquette (fig. 31)—which exists only in a single version[84]—this motif, the satyr drawing back a curtain hanging from a tree, has been preserved, but the nymph now lies on an elaborate couch supported by a sphinx. No longer sleeping, she seeks the protection of a snake symbolizing Prudence coiled round the tree. To all appearances this is a very late plaquette, and it provides impressive proof of the vitality of Riccio's imagination and of his command of form.

I have spent so long discussing the early history of the plaquette that I have left myself less time than I should wish to speak about its end, but end it did within two decades of Riccio's death. Small bronze reliefs were made after that time, of course, but by the middle of the 1550s the Italian plaquette as a continuing organism was dead. The plaquettes we have been looking at till now belong broadly to three types. First, the mid-fifteenth-century plaquettes which were cast from gems. Second, plaquettes like those of Moderno or of Caradosso which are related, expressly or by implication, to goldsmiths' work. Third, plaquettes like those of Riccio or of the *Orpheus* scenes ascribed to Moderno, which are nothing more nor less than little bronze reliefs. In the final phase, the wheel comes full circle and the link with engraved gems is reaffirmed. The revolution was effected by two artists who were best known as engravers of gems or crystals, Vallerio Belli, who died in 1546, and Giovanni Bernardi, who survived him for seven years.

Just as we know no late plaquettes by Caradosso, we know no early works by Belli. He was born at Vicenza about 1468, and moved to Rome, where he seems to have remained until the sack. After a brief period in Venice, he returned to Vicenza where he worked from 1530 till his death. Through the whole of this time his main commissions came from

214

Rome, from the courts of Clement VII and Paul III. Almost all Belli's bronze plaquettes are related to crystal or hardstone carvings, either to actual carvings which have been preserved or to hypothetical carvings which have vanished. For that reason there is a temptation, from which even Molinier was not immune, to dismiss his attitude to the plaquette as reproductive, and to look at the reliefs as inferior copies of expensive and unique originals. I doubt if they were looked at in that way in the sixteenth century. The crystals are the works listed by Vasari, of course, but it was through the bronzes made from them that Belli maintained his contacts with what was evidently a vast public and exercised an influence on taste. Judging from the quality of the best of the bronze casts and the richness with which they were sometimes mounted, it seems that Belli's incredibly subtle mastery of bronze relief was prized as it deserved. Certainly it was thanks to Belli that in

31.
RICCIO. *Nymph and Satyr.*
Bronze, 6 x 7.2 cm.
National Gallery of Art,
Washington, D.C.
Samuel H. Kress Collection

the second quarter of the sixteenth century the endlessly popular religious images that were distilled by Moderno from Mantegna were superseded by the metropolitan idiom of Raphael.

Quite a number of sources testify to the accomplishment of Belli's medals after the antique. Hollanda mentions them in the 1540s, and so does a northern collector, Bonifazius Amerbach. But Vasari, faced with the phenomenon of Belli, seems to have felt some reserve. "If nature had made of Valerio as good a designer as he was skilled in carving," writes Vasari, "he would far have surpassed the ancients instead of equaling them as he did."[85] This reserve was due to the discreditable fact that Belli did not design his own reliefs. The *Passion* scenes in his most famous work, the Casket of Pope Clement VII, were made "from drawings by others," since, says Vasari, "he always availed himself of the drawings of other artists or of antique gems." But the fact remains that Belli's style is

215

32. POLIDORO DA CARAVAGGIO. *Betrayal of Christ.* Brush and gray wash on blue ground heightened with white, 21.2 x 26.3 cm. Royal Library. Windsor Castle. By gracious permission of Her Majesty the Queen

exceptionally homogeneous. The reason for its uniformity is that his models were subjected to an assimilative process that was both rigorous and personal. Perhaps I should take just one example to indicate the way in which he worked. At Windsor there is a drawing (fig. 32)[86] made for Belli, which was from the first designed for transfer to crystal and bronze. The author is Polidoro da Caravaggio, and it was prepared in Rome about 1525. In the drawing the Betrayal takes place above a wall and is visualized from a low viewing point, hence the confused articulation of the figures at the back. In the plaquette (fig. 33),[87] on the other hand, the wall is done away with, and the scene is reconstructed on a raised base line on the level of the eye. The seven figures in the foreground are preserved, with certain changes, but the type of the soldier behind Christ is modified, the pose of Malchus is revised, and a whole series of other changes is introduced in the beautifully individualized figures at the back. Rather significantly the voluminous drapery of Polidoro is abandoned in favor of drapery which defines the forms with classic economy and grace. The

216

33. VALERIO BELLI. *Betrayal of Christ*. Bronze, 8.8 x 9.7 cm. Private collection

unifying factor in Belli's work is that he approaches all his models from the standpoint of an instinctive Hellenist.

The case of Bernardi is rather different. He was almost thirty years younger than Valerio Belli, was first employed by Alfonso d'Este at Ferrara, and then, like Belli, migrated to the court of Clement VII, attracting the notice first of Ippolito de' Medici and then of Alessandro Farnese. In Rome Bernardi came under somewhat the same influences as Belli, and like Belli depended in the main for his designs on artists from the circle of Raphael. In some respects he was a more enterprising crystal carver, but his work is vitiated by the lack of a strong personal stylistic will. In his masterpiece, the Cassetta Farnese, the oval crystals he engraved from designs by Perino del Vaga are conceived as little transparent paintings rather than as reliefs, and when bronze casts were made from them, the artist's deficient command of relief style was doubly evident. Moreover, where Belli impresses his reliefs with a sense of unfaltering seriousness, Bernardi's was a rather trivial mind, from which even great designs emerged debased. Who, for example, would suppose, were it not widely known, that behind Bernardi's *Fall of Phaëton* (fig. 34)[88] lay a presentation drawing by Michelangelo (fig. 35)? The crystal in this case has disappeared, and it was no doubt

217

inescapable, on grounds of size, that Bernardi should omit the splendid figure of Zeus which supplies the formal and literary motivation of the scene. What was not inevitable was that the figure of Phaëton should be moved to the center of the upper group and replaced on the left by a contorted horse, that Eridanus should be shown gazing inquisitively upwards, and that the inspired figures of Phaëton's grief-stricken sisters should be reduced to mannered formulae. Confronted by another of the Cavalieri drawings, the *Rape of Ganymede*,[89] Bernardi's attitude towards it was no less inartistic and impercipient.

These, then, are some of the problems offered by the Italian plaquette. To sum up, there are problems of origin and attribution, problems of date, problems of meaning, problems of style, and finally problems of taste. I doubt if any of them will be definitively solved. Until the time of Giovanni Bernardi and Valerio Belli, the authors of these reliefs either did not sign the works that they produced or signed them in so ambiguous a fashion that their

34. GIOVANNI BERNARDI. *The Fall of Phaëton*. Bronze, 9 x 6.8 cm.
 National Gallery of Art, Washington, D.C. Samuel H. Kress Collection

35. MICHELANGELO. *The Fall of Phaëton*. Black chalk, 41.3 x 23.4 cm.
 Royal Library. Windsor Castle. By gracious permission of Her Majesty the Queen

218

identities remain in doubt. Perhaps time will eventually reveal a fully signed plaquette by the master IO. F.F. or some payment which proves in an utterly conclusive way that Mondella really was Moderno. Perhaps it will bring forward a handful of plaquettes that are exactly dated and are not simply datable by inference. Perhaps our eyes themselves may change, and relationships will become evident which are now invisible. It is disconcerting, for example, that the links between these little works and medals and bronze statuettes remain as slender as they are. How are we to explain the fact that so few medalists applied themselves to the plaquette—that there are no plaquettes, for example, by prolific Roman medalists like Lysippus and Cristoforo di Geremia and none by a Florentine medalist as gifted as Niccolò Spinelli? How are we to explain the fact that there are no plaquettes from the circles of Florentine bronze sculptors like Bertoldo and Pollaiuolo? How are we to explain the fact that only in Padua in the shop of Riccio is there a palpable connection between the language of these reliefs and that of the figure sculpture?

But although the exact place of the plaquette in the complex of Renaissance artifacts remains ambiguous, it offers its own aesthetic compensation, and it presents a body of shared, taken-for-granted images which nobody interested in the Renaissance can justifiably ignore and which are as relevant to historians of culture as they are to historians of art.

NOTES

1. E. Molinier, *Les Plaquettes: Catalogue raisonné* (Paris, 1886), no. 496 (as North Italian). S. de Ricci, *The Gustave Dreyfus Collection: Reliefs and Plaquettes* (Oxford, 1931), no. 295 (as North Italian). W. von Bode, "Neue Erwerbungen an Bildwerken der italienischen Renaissance," in *Amtliche Berichte aus den königlich Kunstsammlungen*, xxxvii (1915–16), col. 258 (as Moderno). E. F. Bange, Staatliche Museen zu Berlin: *Die italienischen Bronzen der Renaissance und des Barock, ii: Reliefs und Plaketten* (Berlin, 1922), no. 499 (as Moderno).

2. Molinier, no. 630. Ricci, no. 312.

3. Molinier, no. 511. Bange, no. 703. Ricci, no. 294.

4. Molinier, no. 477. Ricci, no. 289.

5. Complete versions exist in the National Gallery of Art in Washington, D.C. (A.216.57c) and in Berlin. The third of the three reliefs has also been described (Bange, no. 377) as an Allegory of Fate.

6. Molinier, no. 226. A unique version exists in Washington (A.412.135B).

7. Molinier, no. 482 (as North Italian, end of

the fifteenth century). Bange, no. 544 (as Paduan, c. 1520).

8. A unique version in Washington (A.296.19B) is attributed by Migeon, "La collection de M. Gustave Dreyfus, IV, les médailles," in *Les Arts* (August 1908), p. 16, to Filarete and is classified by Ricci, no. 19, as Florentine.

9. Molinier, no. 78 (as school of Donatello). A North Italian origin for the plaquette is postulated by L. Planiscig, *Die Estensische Kunstsammlung* (Vienna, 1919), no. 378.

10. Ricci, no. 50 (as Florentine, fifteenth century). The correct attribution to the master signing IO. F.F. is advanced by E. Maclagan, Victoria and Albert Museum: *Catalogue of Italian Plaquettes* (London, 1924), p. 55, on the strength of partly effaced inscriptions on examples in the Victoria and Albert Museum and at Modena.

11. Molinier, i, pp. xxi–xxvi.

12. A careful analysis of the plaquettes is given in *Burgkmair-Ausstellung* (Augsburg, 1931), no. 30, pp. 24–25.

13. Molinier, no. 65. For the attribution to Donatello see W. von Bode, "Die italienischen Skulpturen der Renaissance in den königlichen Museen zu Berlin, iii, Bildwerke des Donatello und seiner Schule," in *Jahrbuch der königlich preussischen Kunstsammlungen,* v (1884), pp. 22–23, and H. Kauffmann, *Donatello* (Berlin, 1935), pp. 218–19.

14. Victoria and Albert Museum, A.45–1926. The frame is plausibly dated soon after 1436 by P. Pouncey, "A Painted Frame by Paolo Schiavo," in *Burlington Magazine,* lxxxviii (1946), p. 228.

15. R. Lightbown, in *Bollettino della Accademia degli Euteleti della Città di San Miniato* (1963), no. 35, pp. 19–20.

16. Washington, A.285.8B. The attribution to Donatello was advanced initially by W. von Bode, *Florentiner Bildhauer der Renaissance* (Berlin, 1921), p. 119, who later, *Bertoldo und Lorenzo dei Medici* (Freiburg in Breisgau, 1925), pp. 69–70, reassigned the relief to Bertoldo.

17. The attribution of the frame to Francesco di Simone is advanced by H. J. Hermann, "Aus den Kunstsammlungen des Hauses Este in Wien: Kunstwerke der Renaissance und der Neueren Zeit," in *Zeitschrift für bildende Kunst,* n.f. xvii (1906), p. 91, but is rejected by Planiscig, op. cit., no. 91, in favor of a hypothetical Paduan origin.

18. E. Müntz, "La tapisserie à Rome au xvᵉ siècle," in *Gazette des Beaux-Arts,* xiv (1876), pp. 175–76; idem, "La Renaissance à la cour des Papes, II, Les collections du Cardinal Pierre Barbo (Paul II)," in *Gazette des Beaux-Arts,* xvi (1877), pp. 98–104; idem, "Les monuments antiques de Rome au xvᵉ siècle," in *Revue Archeologique,* xxxii (1876), p. 173; idem, "Inventaire des bronze antiques de la collection du Pape Paul II," in *Revue Archeologique,* xxxvi (1878), pp. 87–92.

19. Molinier, no. 11, with whom the identification as Ceres and Triptolemus originates. An inscribed version of the plaquette in the Rosenheim Collection (no. 651) is recorded by Ricci, no. 30.

20. The iconography of the bust is discussed by R. Wittkower, "A Symbol of Platonic Love in a Portrait Bust by Donatello," in *Journal of the Warburg Institute,* i (1937–38), pp. 260–61.

21. It is assumed by Wittkower that the plaquettes (for which see Molinier, no. 9) depend from the relief on the bust. This theory is not corroborated by their measurements. An attempt of H. W. Janson, *The Sculpture of Donatello,* ii (Princeton, 1957), pp. 141–42, to distinguish between the depiction of the horses on the bust and the plaquettes is fanciful.

22. Molinier, no. 104. Ricci, no. 69.

23. Molinier, no. 133. Ricci, no. 339.

24. Molinier, no. 104. Ricci, no. 70. I am indebted to Professor Edgar Wind for the identification of the two planetary symbols.

25. A. Raczynski, *Les Arts en Portugal* (Paris, 1846), p. 57.

26. Molinier, nos. 194, 195, 201, and 204.

27. A. Ilg, "Werke des 'Moderni' in den kaiserlichen Sammlungen," in *Jahrbuch der kunsthistorischen Sammlungen des allerhöchsten Kaiserhauses,* Vienna, xi (1890), pp. 100–10.

28. L. Planiscig, Kunsthistorisches Museum: *Die Bronzeplastiken* (Vienna, 1924), no. 408. For the architectural scheme compare a dated engraving (1509) by Giovanni Antonio da Brescia (A. M. Hind, *Early Italian Engraving* [London, 1938], Plate 540).

29. Planiscig, op. cit., no. 409.

30. Molinier, i, p. 124.

31. Hind, op. cit., Plates 556, 558, 559.

32. Molinier, no. 164. Ricci, no. 164.

33. Molinier, no. 185. Ricci, no. 181.

34. Hind, op. cit., Plate 559.

35. Molinier, no. 36 (as after the antique). Bange, no. 494. Ricci, no. 211.

36. O. Raggio, "The Myth of Prometheus," in *Journal of the Warburg and Courtauld Institutes,* xxi (1958), pp. 44–62, Plate 6b.

37. Molinier, no. 205. Bange, no. 486. Ricci, no. 198.

38. Molinier, no. 188. Ricci, no. 186. The relationship between this and the following plaquette is inverted by Ricci, who regards the respects in which the earlier differs from the later as "mainly improvements."

39. Molinier, no. 187. Ricci, no. 185.

40. Molinier, no. 191. Ricci, no. 189 (both as *Fall of Phaëton*).

41. W. von Bode, in *Kunstchronik,* xv (1903–4), col. 269.

42. Inscribed versions in London (Victoria and Albert Museum), Paris (Louvre), and Washington (National Gallery of Art). There are small differences between the forms of the signature in the three versions.

43. The relief appeared at auction successively in London (Higgins sale, January 29, 1904, no. 47), and Paris (Garnier sale, December 18–23, 1916, no. 520).

44. For Mondella see G. Vasari, *Vite,* ed. G. Milanesi, v (Florence, 1906), p. 318, and U. Thieme and F. Becker, *Künstlerlexikon,* xxvi (Leipzig, 1931), p. 58. The attribution to Mondella of a hardstone carving in the Louvre (E. Kris, *Meister und Meisterwerke der Steinschneidekunst in der italienischen Renaissance* [Vienna, 1929], no. 280) is unconvincing.

45. Molinier, nos. 193, 196, 197, and 203. Ricci, nos. 190, 193, 194, and 201.

46. Molinier, no. 237. Ricci, no. 214.

47. Molinier, nos. 207, 208, 209, 210. Ricci, nos. 206, 207, 208, 209.

48. Compare the Eurydice on the right of Molinier, no. 208, with the saint on the right of the *Virgin and Child Enthroned with Saints* (Molinier, no. 164). The attribution to Moderno is questioned by U. Middeldorf, *Medals and Plaquettes from the Sigmund Morgenroth Collection* (Chicago, 1944), no. 251.

49. Molinier, no. 206. Ricci, nos. 204, 205.

50. A. Leone, *De nobilitate rerum dialogus* (Venice, 1525), c. xli.

51. Molinier, no. 149. Bange, no. 619.

52. Molinier, no. 150. Ricci, no. 96.

53. A record of the *Hercules and Cacus* is perhaps preserved in an upright plaquette by Caradosso of this subject (Ricci, no. 104), the main figures from which recur in a fictive relief in Burgkmair's *Esther Before Ahasuerus* in Munich.

54. W. von Bode, "Caradossos Plaketten und Bramantes Anteil daran," in *Zeitschrift für Numismatik,* xxxiii (1922), pp. 145–55.

55. Windsor, no. 123331. K. Clark, *A Catalogue of the Drawings of Leonardo da Vinci in the collection of His Majesty the King at Windsor Castle,* i (London, 1935), pp. 24–25, proposes a later dating c. 1507–8.

56. Molinier, no. 155. Ricci, no. 102.

57. Molinier, no. 417 (as Paduan). Bange, no. 629 (as style of Bramante). Ricci, no. 139 (as Riccio).

58. Molinier, no. 139. Ricci, no. 347. For the relationship to Cranach see C. Glaser, *Cranach* (Leipzig, 1921), p. 54.

59. Molinier, no. 127. Ricci, no. 337.

60. For earlier hypotheses as to the identity of this master see Hill, in Thieme and Becker, op. cit., vii, p. 444.

61. J. Pope-Hennessy, "Italian Bronze Statuettes," in *Burlington Magazine,* cv (1963), p. 23.

62. Molinier, no. 411. Ricci, no. 260 (both as Paduan).

63. A. 162–1910. Given by Bode, op. cit. (1925), pp. 51–53 to a follower of Bertoldo.

64. Ibid., pp. 79–80.

65. Molinier, no. 121. Ricci, no. 118.

66. Molinier, i, pp. 176–77.

67. L. Planiscig, *Andrea Riccio* (Vienna, 1927), pp. 462–63.

68. P. O. Kristeller, ed., *Mediaevel and Renaissance Latin Translations and Commentaries,* i (1960), pp. 184 ff.

69. Molinier, no. 238. Ricci, no. 221.

70. Molinier, no. 255. Ricci, no. 159.

71. For the *Apollo and Marsyas* see Molinier, no. 252, and Ricci, no. 157. The *Saint Cecilia* is mistakenly classified by Molinier, no. 392, as an anonymous Paduan plaquette, but is restored to Ulocrino by Bange, no. 423, and all later authorities.

72. Planiscig, op. cit., pp. 452, 492. Four signed examples of the plaquette are known.

73. Ibid., pp. 288–92. Molinier, no. 220. Ricci, no. 126. See also Planiscig, op cit. (1924), pp. 8–9.

74. Molinier, no. 221. Ricci, no. 127.

75. Molinier, no. 235. Ricci, no. 141.

76. The relief of *Vulcan Forging the Arrows of Cupid* exists in a single rectangular version in Washington (A.413.136B), and a single circular version in Berlin (Bange, no. 361). For the *Venus Chastising Cupid,* see Molinier, no. 227, and Ricci, no. 133.

77. Unique version in Washington (A.414.137B), for which see Molinier, no. 228, and Ricci, no. 137.

78. Molinier, no. 244 (as Riccio). Ricci, no. 226 (as Master I.S.A.).

79. National Gallery of Art, Washington. The portrait, in Naples, is dated 1506.

80. Molinier, no. 239. Ricci, no. 228. Unique example in National Gallery of Art, Washington (A.506.228B).

81. Molinier, no. 242. Ricci, no. 224.

82. Molinier, no. 240. Ricci, no. 224.

83. Molinier, no. 233. Ricci, no. 140.

84. National Gallery of Art, Washington (A.396.119B) ascribed by Ricci, no. 119, to the Pseudo-Fra Antonio da Brescia.

85. Vasari, op. cit., v, pp. 379–83.

86. A. E. Popham and J. Wilde, *The Italian Drawings of the Fifteenth and Sixteenth Centuries in the Collection of His Majesty the King at Windsor Castle* (London, 1949), no. 692.

87. Molinier, no. 270. Ricci, no. 354.

88. Molinier, no. 327. For the drawing see Popham and Wilde, op. cit., pp. 253–54.

89. Molinier, no. 328. For the drawing see Popham and Wilde, op. cit., p. 457.

THE FORGING OF ITALIAN RENAISSANCE SCULPTURE

I SHALL BEGIN with definitions. A forgery is something made to deceive—something that deceives intentionally, not by chance. In dealing with this subject, I had hoped to use the term solely in that sense. But the more closely one looks at the question of the forging of Italian sculpture the more unreal does the distinction seem. So I have resorted instead to the definition of a forgery given in the Oxford dictionary, "a spurious thing," and to the related definition of the word "spurious," "not being what it pretends to be." After all there are two parties to deception, the person who deceives and the person who is taken in, and responsibility ought properly to be divided between the two. That point was made by Dr. Johnson when he visited the Western Isles in 1775 to investigate the forged poetry of Ossian. "Credulity on one part," he wrote, "is a strong temptation to deceit on the other, especially to deceit of which no personal injury is the consequence, and which flatters the author with his own ingenuity."[1] With Italian sculpture that is precisely what occurred.

To start with, we have to recognize quite frankly that a great number of Italian sculptures were, and were designed to be, disseminated. In the fifteenth century marble reliefs were often reproduced from molds made in the workshop of the sculptor by whom they had been carved, and painted stucco copies of them were marketed. Typical of these is a stucco relief made in Florence about 1470 in the shop of Antonio Rossellino (fig. 1).[2] Several examples survive today, and they must have been still more common in the fifteenth century. They were portable, and once they were diffused, they could be imitated outside the studio and indeed outside the city in which they had been made. An example of this particular relief seems to have traveled from Florence to the Marches, and it was copied there in marble by a local sculptor (fig. 2).[3] In the copy the rudiments of the design have been preserved, but the definition of the features, the drapery forms, even the placing of the feet, have undergone a change, and the subtlety of the whole image has been impaired.

This was a perfectly normal process. The beautiful *pietra serena* relief of the *Young Baptist* by Desiderio da Settignano in the Bargello (fig. 3) was shut away in the Badia a Settimo outside Florence till the late eighteenth century.[4] But stucco and terra-cotta versions of it were widely known: a very poor example is in the Musée Jacquemart-André in Paris (fig. 4).[5] One of them was reproduced in marble in a technique that has no resemblance to

223

Desiderio's (fig. 5): with its mechanical surface drilling it looks as though it had been through a sewing machine. When I last saw it, this relief was in store in the Los Angeles County Museum.[6] It would be tempting to conclude that it must be a forgery, had it not been bought in Florence about 1740 by Sir Horace Mann and later installed by Horace Walpole at Strawberry Hill.[7] The photograph illustrated here was taken just over 100 years ago. Walpole believed it was by Donatello, and so did a later owner, Sir Charles Dilke. The relief in the Bargello was also looked on as a Donatello. So when it gave rise to a genuine forgery (fig. 6), it naturally bore Donatello's signature. This bronze relief was in existence by 1887, when it was described by Paul Eudel,[8] and was invented,

1. WORKSHOP OF ANTONIO ROSSELLINO. *Virgin and Child*. c. 1460. Pigmented stucco, height 48.6 cm. Victoria and Albert Museum, London

2. MASTER OF THE MARBLE MADONNAS. *Virgin and Child*. Late 15th century. Marble, 77 x 46 cm. Courtauld Institute Galleries, London. Gambier-Parry Bequest

3. DESIDERIO DA SETTIGNANO.
Young Baptist. Pietra serena, 50 x 24 cm.
Museo Nazionale del Bargello,
Florence

4. *Young Baptist*, after Desiderio da Settignano.
Probably 15th century. Pigmented stucco,
height 51 cm. Musée Jacquemart-André,
Paris

5. *Young Baptist*. Florentine. 15th
century. Marble, 54.5 x 28 cm.
Los Angeles County Museum of Art

6. *Young Baptist*. Second half of 19th
century. Bronze, 51.4 x 29.9 cm.
National Gallery of Art,
Washington, D.C.
Samuel H. Kress Collection

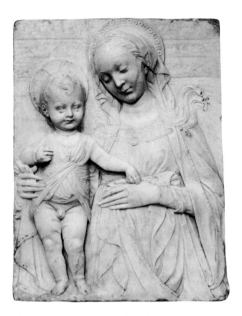

7. *Virgin and Child,* after Andrea del Verrocchio. Late 15th century. Stucco, 84 x 60 cm. Formerly Dibblee Collection, Oxford

8. *Virgin and Child,* after Andrea del Verrocchio. Late 15th century. Marble, 52 x 39.5 cm. Courtauld Institute Galleries, London. Gambier-Parry Bequest

if one can use the term, in Italy, though it was later reproduced in Paris by the firm of Barbedienne.

In the hierarchy of Italian sculptures these are comparatively unimportant works. With sculptures that were more aspiring, the copyright was proportionately harder to preserve. One of the most evocative reliefs of the late fifteenth century is a Madonna by Verrocchio, which is known to us through stucco casts (fig. 7).[9] It was copied at least twice in the fifteenth century in marble, by a sculptor with a defective sense of volume who gives a self-satisfied twist to the Virgin's lips and a pert expression to the Child (fig. 8),[10] and it was also regularly copied in enameled terra-cotta. A version at Arezzo from the shop of Giovanni della Robbia (fig. 9)[11] is a good deal more faithful to Verrocchio's relief than the marble copy, though the types and proportions of the two figures have been slightly modified. Finally, at Birmingham there is still another version of the composition (fig. 10), which was originally described in this article as "almost certainly dating from the nine-teenth century." It has since been cleaned and freed of plaster makeup, and there is no reason to doubt that, though less close to Verrocchio than the Dibblee Madonna, it was made in Verrocchio's shop.[12] Nineteenth-century versions in marble of the great Verrocchio

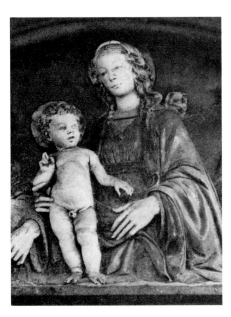

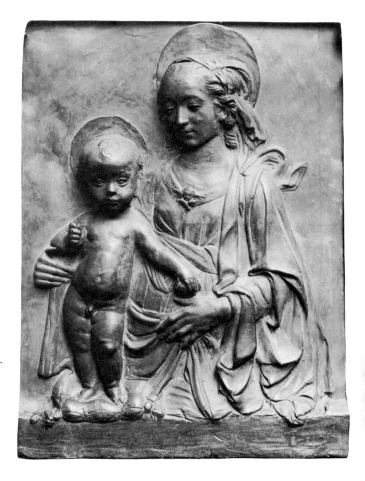

9. WORKSHOP OF GIOVANNI DELLA ROBBIA.
Virgin and Child with Two Saints.
Early 16th century. Enameled terra-cotta,
77 x 175 cm.
Palazzo della Badia, Arezzo

10. *Virgin and Child,* after Andrea del Verrocchio. Late 15th century. Terra-cotta, 76 x 58.4 cm.
 Birmingham Museum and Art Gallery

terra-cotta Madonna from Santa Maria Nuova, now in the Bargello, are also known. The terra-cotta relief was shown in the Bargello only in 1903, but was known at an earlier time.

Once an image has proved its usefulness as a devotional aid, it tends to be retained, even if it is in conflict with later style. In Italy a great deal of fifteenth-century *bondieuserie* continued to be used for the purpose for which it was designed throughout the sixteenth century, and copies of fifteenth-century reliefs continued to be made. A case in point is still another stucco after Antonio Rossellino (fig. 11),[13] from which a relief in marble, now in San Vincenzo at Prato (fig. 12), was carved in the first quarter of the sixteenth century.[14] In this case what differentiates the marble from the stucco is a discrepancy in the rendering of the forms. Whereas in an autograph marble relief by Antonio Rossellino, such as the Altman Madonna in the Metropolitan Museum (see pages 135 to 154), the head of the

227

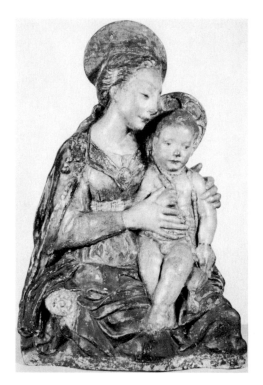
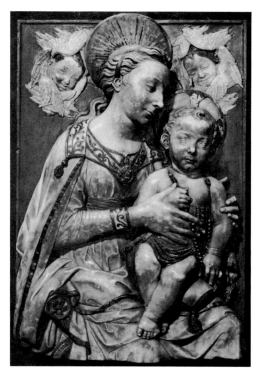

11. *Virgin and Child*, after Antonio Rossellino. 15th century. Pigmented stucco, 85.1 x 55.9 cm. Victoria and Albert Museum, London

12. *Virgin and Child*, after Antonio Rossellino. First quarter of 16th century. Marble. San Vincenzo, Prato

Virgin is distinguished by its etched detail and undulant surface modeling, in the Prato relief the features are coarser and more recessive and the hair is deeply incised.

Lamps burned in front of these reliefs throughout the sixteenth century, and probably, in convents and sacristies and palace bedrooms, they burned on throughout the seventeenth and eighteenth centuries as well. The reliefs were representationally adequate, so the factors that militated against the continued popularity of quattrocento paintings simply did not operate, and their appeal was still very much alive in 1837, when Countess Zamoyska died in Florence. Her husband, Count Stanislaus Zamoyski, and her two sons commissioned a commemorative monument in Santa Croce from Bartolini, the most distinguished Florentine sculptor of the time.[15] It consists of an effigy and epitaph, and above them is a circular relief (fig. 13) copied from Antonio Rossellino. The original, which is now in the Bargello (fig. 14), had been purchased in 1815 from Avvocato Raffaello

Madura, and was presumably on public exhibition at the time.[16] Whether its inclusion was at the wish of Count Zamoyski and his sons, who supervised the progress of the work from Warsaw, or was decided on by Bartolini we do not know, but it effectively fulfills its function of bringing the tomb into harmony with the Marsuppini and Bruni monuments of Desiderio da Settignano and Bernardo Rossellino in the same church. The figures of Saint Joseph and the shepherds in the background of Rossellino's relief are omitted—they are replaced by gold mosaic tesserae—and the proportions of the Virgin's figure are a little changed, so that her halo comes almost to the upper edge of the relief. Otherwise every detail, even the pattern in the border of the Virgin's veil, is reproduced with absolute fidelity. The relief was not carved by Bartolini, who, according to Eliso Schianta, intervened personally only in the head of the effigy,[17] but when the monument was finished in 1844, it must have been apparent that Bartolini's studio contained at least one sculptor whose mastery of fifteenth-century technique was sufficiently precise to enable him, if he so wished, to turn out downright forgeries.

Just round the corner from the Zamoyska monument, in the nave of Santa Croce, is the related Tomb of Raffael Morghen. Morghen died in 1833, but the tomb was not completed till twenty years later, and when it was unveiled in 1854 the *Gazette des Beaux-Arts* protested at the error of adopting quattrocento style as a norm of contemporary art.[18] It is signed by Odoardo Fantacchiotti, and the more closely one looks at the head of Morghen, the more clear does it become that the sculptor devoted months of study to the works of

13. WORKSHOP OF LORENZO BARTOLINI. *Virgin and Child*, after Antonio Rossellino. c. 1837–44. Marble. Santa Croce, Florence

14. ANTONIO ROSSELLINO. *Nativity*. Marble, diameter 100 cm. Museo Nazionale del Bargello, Florence

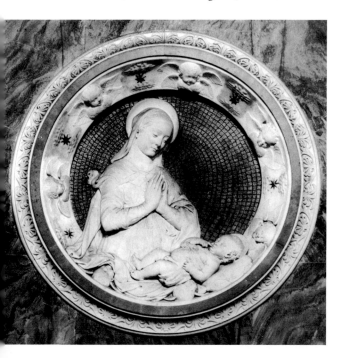

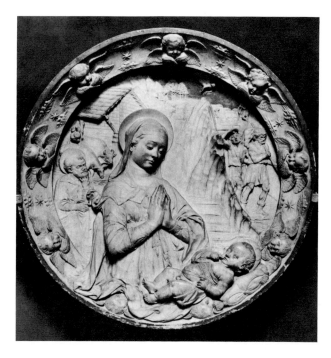

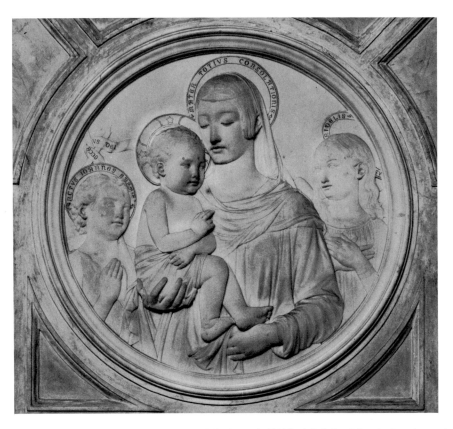

15. ODOARDO FANTACCHIOTTI. *Virgin and Child with Saint John the Baptist and an Angel.*
Completed 1854. Marble. Santa Croce, Florence

Mino da Fiesole in the Badia. The Madonna above (fig. 15) is a work in the quattrocento taste, not an imitation of a specific artist, but squeezes from it painted up to look like authentic quattrocento stuccos were in circulation from quite an early date, and one of them is reproduced in Schubring's book on Donatello.[19] Only when I came across an example in the early 1970s, at a Florentine antique dealer's, did I feel some sympathy with Schubring's mistake.

One other tomb in Florence by Fantacchiotti incorporates a quattrocento-like relief (fig. 16), the Giuntini monument in San Giuseppe, which was finished in the same year as the Morghen monument, 1854.[20] The figures in it are more deeply cut, but the Virgin has the same somnolent eyes as in the Morghen carving, and the treatment of detail, the Child's hair for instance, is in the style of Desiderio. The published information about Fantacchiotti is very sparse. He was born in 1809, was trained in the Florentine Academy, where he was a pupil of Costoli, and lived till 1877. All that is known from the last twenty years of his life are one or two impersonal sepulchral monuments, and there is no telling what he

230

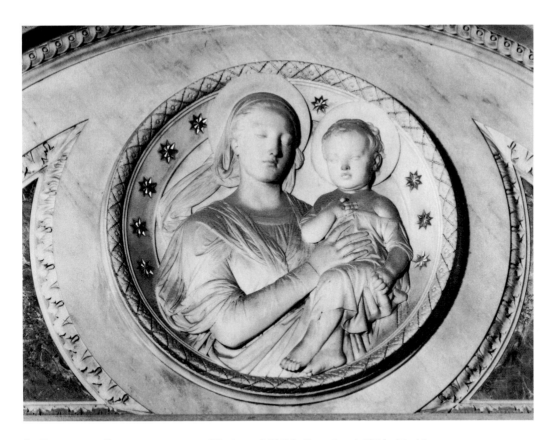

16. ODOARDO FANTACCHIOTTI. *Virgin and Child.* Completed 1854. Marble.
San Giuseppe, Florence

was up to during the crucial years when foreign collectors and museums were engaged in the block buying of Italian sculptures. We do not even know what Fantacchiotti's style in low relief was like, but I suspect he may have been responsible for one of the most appealing of all forged Italian sculptures, a pseudo-Desiderio relief in London (fig. 17).[21] It was bought with the Gigli-Campana Collection in 1861, and in the nineteenth century almost twice as many casts of it were sold as of any other work in the South Kensington Museum.

In Italy there was nothing discreditable in the act of forgery. The forging of Renaissance sculptures was simply an extension of the immemorial trade in forged antiques. Vasari repeatedly alludes to the manufacture of antiques—Tommaso della Porta, for example, is commended for his fabrications on the ground that they did what they were designed to do, took people in.[22] If antiques could be forged without shame and without rancor, so could Renaissance sculptures. As late as 1884 Cavalucci, in his *Manuale di storia della scultura,* applies to the forger Bastianini the same criterion that Vasari applied to Tommaso della

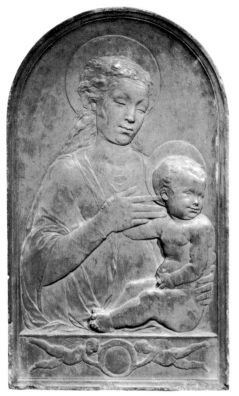

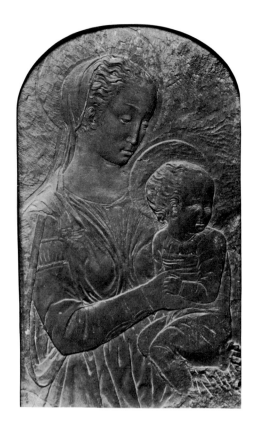

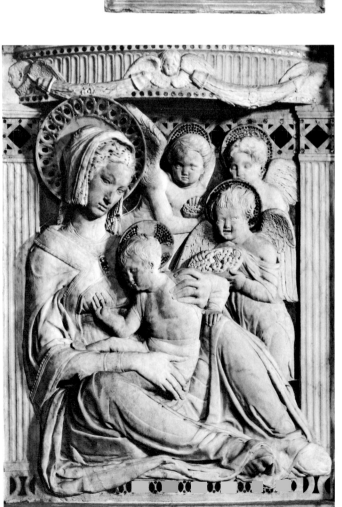

Porta.[23] He executed, says Cavalucci with unfeigned respect, "works which the expert eyes of the most reputable connoisseurs ascribed to the best Tuscan masters of the quattrocento."

The psychological background of comments such as this is established by the *Pensieri sull'arte e ricordi autobiografici* of Giovanni Dupré,[24] who records how, as a young man, he frequented the workshop of the wood-carver Pacetti. The prevailing passion for antiques, he tells us, affected not only foreigners but Italians, too. Modern work, even of uncontested merit, was unsalable or was paid for at a low rate, and he and Pacetti conceived a plan for making a *"cofano o cassetta"* which could be sold as an antique. It had a Medusa mask in front, and at the sides were motifs drawn from the *plutei* in the Biblioteca Laurenziana. When it was completed, it greatly impressed Bartolini, who recommended his patroness Marchesa Poldi to buy it. The *plutei* were ascribed to Battista del Tasso, the associate of Cellini, and it was not for some years that Dupré, then a well-known sculptor, confessed to Marchesa Poldi that he, not Tasso or Cellini, was responsible for the whole work.

The most alarming of the monuments in Santa Croce is in the Medici Chapel. It commemorates Francesco Lombardi, a goldsmith, jeweler, and dealer in works of art, who died in 1864, and it was put up in his lifetime.[25] It must be deemed alarming because it includes Donatellesque reliefs of the *Virgin and Child with Angels* (fig. 18) and of two putti with a garland at the base, which seem to be by a different hand from the remainder of the monument and were sufficiently convincing to deceive Bode and most students of Italian sculpture up to the time of Kauffmann.[26] The sculptor evidently took account of a number of reliefs by Donatello and fifteenth-century Donatello imitators. One of them is a circular bronze relief of the *Madonna of Humility* by Donatello in the Estensische Kunstsammlung in Vienna, where the Virgin's legs are disposed in rather the same way,[27] and another is a Donatellesque marble relief in London, which could have served as model for the technique.[28] The effect of antiquity was enhanced by the fact that the marble, unlike that of the remainder of the monument, was patinated to a yellowish color.

As soon as we know that a debatable relief was made in the nineteenth century, we become conscious of details that ought to have revealed the truth from the very start. The angel heads should have done so in this relief, and so should the absurd posture of the Child. But the fact remains that in this monument we are face to face with a relief which is not simply a copy or close imitation, but a free variation on the style of Donatello, planned with such acumen that three generations of scholars accepted it as genuine.

The part played by Francesco Lombardi in the marketing as well as in the manufacture of forgeries remains to be investigated. On circumstantial grounds there are reasons for suspecting that he was one of the principal instigators and one of the main vendors of forged sculptures. In 1859 he was responsible for selling to Fortnum, the well-known connoisseur of majolica and bronzes, an unfinished *pietra serena* Madonna in the style of Desiderio da Settignano, which is now in the Ashmolean Museum at Oxford (fig. 19),[29] and

20. *Saint Cecelia*, possibly by Odoardo Fantacchiotti. Before 1854. *Pietra serena*, 54.5 x 37.5 cm. The Toledo Museum of Art. Libbey Collection

21. *Portrait of a Lady*, possibly by Odoardo Fantacchiotti. Mid-19th century. *Pietra serena*, 53 x 33 cm. Detroit Institute of Arts

in 1864 Fortnum bought from his executors a nineteenth-century copy of the Turin Madonna by Desiderio, which is also in the Ashmolean Museum.[30] The *pietra serena* relief was said by Lombardi to have come from the Palazzo Brunaccini-Compagna in Florence. Only a few years before the dealer Samuel Woodburn had bought from Lombardi another *pietra serena* relief which allegedly came from the same source. This is the celebrated relief of *Saint Cecilia* in the Toledo Museum of Art (fig. 20), which appeared in 1854 in Samuel Woodburn's sale, was knocked down to a purchaser named Hickman, and was later acquired by Lord Elcho.[31] This work is by the same hand as the Madonna from the Gigli-Campana Collection in London (fig. 17), which was purchased in Florence before 1858.

Three other works in *pietra serena* are inseparable from these reliefs. The first is a *Virgin and Child* which appeared at the Hommel sale in Zurich in 1909.[32] Clearly by the same

hand as the Ashmolean Madonna, it once more shows the Child facing outwards to the right. It differs from the Oxford relief, however, in that it is based on a fragmentary relief which was discovered in the middle of the 1850s and is now at Lyons.[33] The motif of the Virgin's left hand, with fingers turned up over the buttocks of the Child, the Virgin's cloak and the folds of her dress over her right breast are drawn directly from the Lyons relief. The second work in *pietra serena* is a relief in Berlin of a woman facing to the left which was ascribed by Schottmüller in 1913 to the style of Desiderio da Settignano. It reached the Kaiser Friedrich Museum in 1904 with the Simon Collection, and was bought by Simon in Paris from a French collection for which it had been acquired in Florence.[34] A variant of this scheme is contained in a relief in Detroit (fig. 21), also of a woman facing to the left, which can be traced back from the Edsel Ford Collection to Duveen, thence to Baron Arthur de Schickler at Martinvast in Normandy, and from Schickler to that mysterious figure Charles Timbal.[35] There can be no reasonable doubt that all of these six *pietra serena* reliefs belong together, were planned by a single mind, and date from the middle of the nineteenth century. The differences between them are a matter of condition, not of style or of technique.

The name of Charles Timbal occurs so often in catalogues of Italian sculpture that it may be worthwhile to say something about him and his collection here. Born in 1821, he was an academic painter specializing in religious subjects. His first major work, an *Entombment* shown at the Salon of 1848, earned him a prize and the commendation of Ingres, and his last altarpiece, a *Presentation of the Virgin in the Temple,* was completed in 1879, a year before his death. He was an occasional, not very talented critic—Bénézit writes that "ses jugements sur Corot notamment prouvent une absence totale de goût et de sensibilité artistique"[36]—and he was a compulsive collector of Renaissance works of art. He lived, said Edmond Bonaffé in an obituary notice,[37] "en dehors de la mêlée, au milieu de sa chère collection qu'il augmentait dans l'ombrée . . . ouvrant sa porte à quelques amis amoureux comme lui des choses exquises." The vicomte de Laborde, in an introduction to Timbal's posthumous *Notes et causeries sur l'art,*[38] writes that his collection was formed "avec des ressources relativement restreintes," and represented "la victoire du goût et de la clairvoyance." There can be no doubt about it; on painting Timbal had a clairvoyant eye. In 1860, for example, he bought at Bologna the *Crucifixion* by Fra Angelico which is now in the Fogg Art Museum. With sculpture, however, the case was very different. His eye was innocent, and he was taken in. The first work he bought, seemingly about 1860, was a little relief of the *Virgin and Child* which is now in Washington in the National Gallery of Art (fig. 22). It figures in the most recent volume on Mino da Fiesole as an authentic work, but is a palpable forgery, as the throne (which is copied from an authentic relief in the Museo della Collegiata at Empoli), the spastic Child, and the cockeyed halos would alone suffice to prove.[39] A second version of this relief cut in more detail and better patinated but almost certainly from the same studio is in the Detroit Institute of Arts.[40]

235

There is no reason to suppose that Lombardi was necessarily the source of either of these two reliefs. With another Timbal purchase, however, there is a strong presumption that Lombardi was the vendor, since it is a product of the same brain and possibly of the same hand as the *Virgin with Angels* on the Lombardi monument. This is a relief in Washington of a *Virgin and Child with an Angel* (fig. 23), which is commonly given to Desiderio da Settignano.[41] Like the Lombardi relief, it is set between lateral pilasters, which are ornamented with a Bartolini-like neoclassical motif and curve forwards at the top. Where the upper molding of the Lombardi Madonna is convex—it bulges out from the pilasters at the sides—that of the Washington Madonna is concave. There is no authentic Renaissance carving whose form in any way resembles this. The figure carving once more is a pastiche from works that were readily available, the Panciatichi Madonna, whence the forger drew the Virgin's left hand, and the Foulc Madonna, which was accessible for study in Santa Maria Nuova till 1877, whence he derived the angel head beside the Virgin's shoulder on the extreme left and the horizontal lines of cloud. Moreover, the relief includes in the background one eccentric motif that is common also to the Lombardi Madonna, an angel hurrying forward with a superfluous bowl of fruit. A pigmented stucco variant of this strange composition was purchased for the Kaiser Friedrich Museum in 1912 in Venice, as "Style of Mino da Fiesole"; and it also is a forgery.[42] In this the Child is dressed up in a little smock.

In the history of sculpture forgery Timbal is an important figure for the adventitious

22.
Virgin and Child, style of
Mino da Fiesole. Mid-19th century.
Marble, 41.3 x 30 cm.
National Gallery of Art, Washington,
D.C. Andrew W. Mellon Collection

236

reason that in 1872, alarmed at the hazards to which his collection had been exposed in the preceding year, he sold his works of art.[43] The sculptures, the Washington Mino and the Washington Desiderio among them, were bought by Gustave Dreyfus, and, by virtue of Dreyfus's well-earned reputation as a connoisseur of medals and plaquettes, assumed an aura of respectability. The distasteful truth, however, is that with Italian sculptures a provenance from the Timbal Collection is a cause for suspicion, not for complacency.

From the 1850s on we are dealing, therefore, not with sculptors alone, but with an unholy alliance between sculptors and dealers in works of art. The name most frequently mentioned in this connection is that of Giovanni Bastianini.[44] Bastianini was born in Florence in 1830 and was trained at the Florentine Academy, under Pio Fedi. He may also have worked under Fantacchiotti; in any case the two sculptors must have known each other well. At quite an early age—he was eighteen or nineteen—his gifts were perceived by an unscrupulous Florentine dealer, Freppa, who encouraged him to read the few books that were then available about Italian sculpture and to look at the originals. After he met Freppa he carved or modeled a few portraits and some independent reliefs, but effectively he was engaged in making forgeries from about 1850 till 1867, when his pretensions were exposed. He died a year later, in June 1868. At least the books tell us that he did so, though Bode, in his autobiography,[45] claims to have bought two sculptures from him— fifteenth-century sculptures, not forgeries—as late as 1880. He says (and it is something of an understatement) that Bastianini had "eine feine Empfindung für alter Kunst."

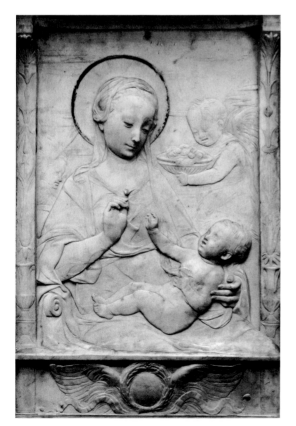

23.
Virgin and Child with an Angel, style of Desiderio da Settignano. Mid-19th century. Marble, 70 x 47 cm. National Gallery of Art, Washington, D.C. Andrew W. Mellon Collection

237

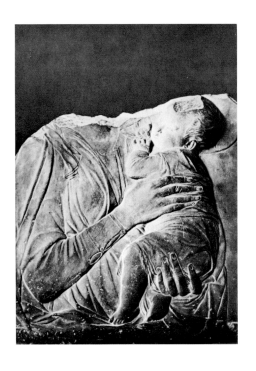

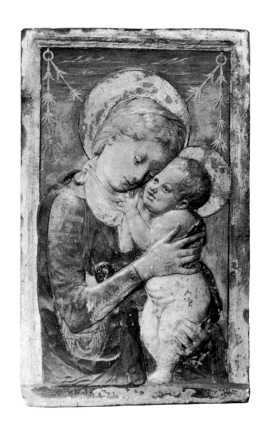

24. *Virgin and Child*, style of Desiderio da Settignano.
Third quarter of 15th century. Marble, 37 x
37.5 cm. Musée de Lyon

25. *Virgin and Child*, after Desiderio da Settignano.
Second half of 15th century. Pigmented stucco,
64.8 x 40.6 cm. Victoria and Albert Museum,
London

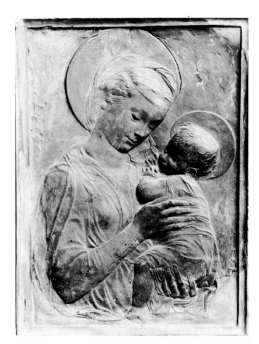

26. GIOVANNI BASTIANINI. *Virgin and Child*.
Third quarter of 19th century. Wax, 57.2 x
41.9 cm. Victoria and Albert Museum, London

Like the sculptor of the Hommel relief, Bastianini profited from the discovery of the fragmentary relief in the style of Desiderio which is now at Lyons (fig. 24). The notion was a simple one, that if the new relief were suppressed (its value since it lacked the Virgin's head must have been minimal) and copies of it were combined with known compositions by Desiderio and Antonio Rossellino, new reliefs attributable to both artists could be produced. The first experiment was with the composition by Desiderio that is called the Turin Madonna. The original was bought by the Galleria Sabauda in Turin in 1850,[46] and it is also known through countless stuccos (fig. 25). With painstaking precision Bastianini grafted the Virgin from the Turin Madonna onto the newly discovered Child and from them produced a new relief (fig. 26). For some reason it was left in the form of a wax model, and no marble from it seems to have been carved.[47]

The second experiment was based on a well-known stucco after Antonio Rossellino of which there was no known original and of which a poor version is in London (fig. 27). Once more a partial copy was made and combined with the fragmentary Child (fig. 28). To our

27. *Virgin and Child,* after Antonio Rossellino. Probably 15th century. Pigmented stucco, 61 x 50.2 cm. Victoria and Albert Museum, London

28. GIOVANNI BASTIANINI. *Virgin and Child.* Before 1857. Marble, 67.3 x 44.8 cm. Victoria and Albert Museum, London

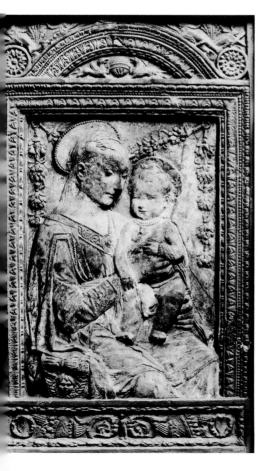

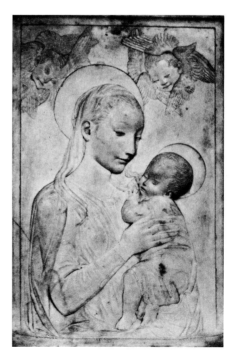

239

style-conscious eyes, in the marble relief that resulted, the two figures, Rossellino's Virgin and Desiderio's Child, seem not to marry up particularly well, but when it was finished in 1857, it was sufficiently convincing to be sold to an extremely experienced buyer as a work by Antonio Rossellino,[48] and through the years it brought in a continuing bonus through the copies and variants of it that were made. In one of them, the putto heads have been left out, and the cutting has become a little more mechanical (fig. 29).[49]

But even for a craftsman as diligent and uninspired as Bastianini, it was intolerable to go on reproducing the same composition without change. In the original the Child is sleeping, in a second version his eyelids have begun to open, and in a third he jumps precipitately to his feet (fig. 30).[50] This last relief looks rather absurd, of course, but I doubt nonetheless whether we have heard the end of Bastianini. It is by no means certain that all the reliefs ascribed to him are really by one hand. If they had been produced in the fifteenth century, not in the nineteenth, one would ascribe them to different hands working in a common studio, and it may well be that they were indeed turned out in that way. Moreover, there is reason to believe that Bastianini, in the ten years that follow the relief in London, himself became a more resourceful, more ambitious sculptor. The justification for saying this is that he was responsible, in the 1860s, for carving a much more deceiving Madonna in the Hermitage (fig. 31).[51] It is quite large, and was based directly on the

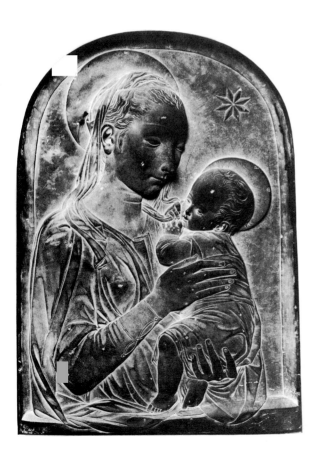

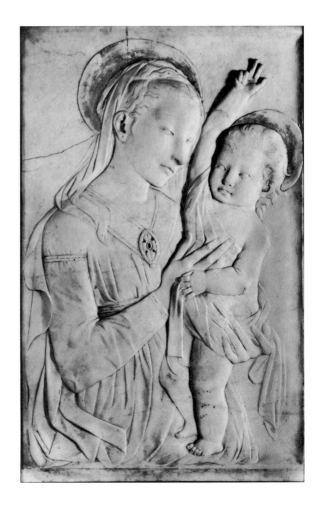

stucco after Antonio Rossellino that he had used for the Virgin of the London relief. What was involved on this occasion was transliteration into marble, and little more. When it was finished, it was sold to a Russian, Mme Bibikow. Mme Bibikow offered it to the Hermitage, but it was turned down as what it was, a forgery, and it was then sold to a collector called Yourawlew. At that time it was patinated, and the new owner made the mistake of washing it. It came out, according to an eyewitness account, "as white as sugar," and in 1915 was again offered to the Hermitage. This time it was accepted, and it is still shown there as a work of Rossellino. The tiresomely demure expression of the Virgin and the ogling cherubs show quite clearly that it is the brainchild not of Rossellino but of Bastianini.

There is a convention by which forgers of sculpture, when they are detected, are praised as though they were artists of all but the first rank. It is a sort of compensation process to reassure the people who were taken in. That happened to Bastianini. But in marble he is not a significant artist, and he was less accomplished and intelligent than Fantacchiotti or than the Master of the Lombardi Monument.

As everyone who has the morbid taste for reading books on forgery will know, the habit is to pass on at this point from Bastianini to Dossena. But Dossena was not born till 1878, so there is quite a long interval between the prime of the two sculptors. In it a

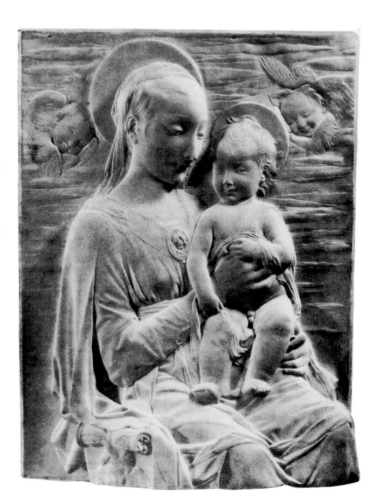

29. GIOVANNI BASTIANINI. *Virgin and Child.*
Third quarter of 19th century. *Pietra serena.*
Formerly Havemeyer Collection, New York

30. GIOVANNI BASTIANINI. *Virgin and Child.*
Mid-19th century. Marble, 68.5 x 44.5 cm.
Private collection, Birmingham, England

31. GIOVANNI BASTIANINI. *Virgin and Child.*
1860s. Marble, 69 x 50 cm. The Hermitage,
Leningrad

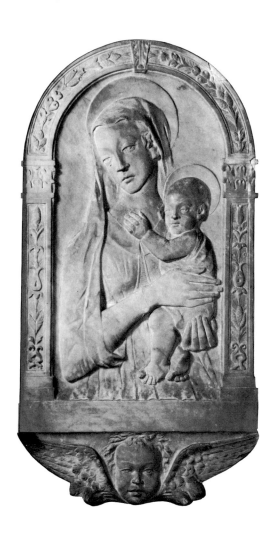

32. *Virgin and Child*. Probably Florentine. 1870s or 1880s. Marble. Formerly art market, London

33. *Virgin and Child*. Probably Florentine. 1870s or 1880s. Marble. Formerly art market, Rome

34. *Virgin and Child*. Probably Florentine. 1870s or 1880s. Marble. Formerly Henry Harris Collection, London

quantity of forged sculptures was undoubtedly produced. Not unnaturally, names are very scarce. Unless he is found out, a forger is almost always condemned to anonymity. So we are forced to tramp along what Beerbohm calls "the great grey beach of the hesitational." We know, for example, that a longer-lived contemporary of Bastianini, Paolo Ricci, was responsible in 1885 for carving three quattrocento-like reliefs of classical figures on the commission of a lawyer, Giuseppe Mantellini, and that one of the three was modeled by a certain Arturo Pellucci,[52] but there was nothing underhanded about these works, and no deception about what they were.

Despite this prevailing anonymity, I want to mention three groups of forgeries that seem to have been made in Florence in the seventies or eighties of the nineteenth century. The first sculptor's starting point was Madonnas in the style of Domenico Rosselli, a Florentine Rossellino imitator active in both Florence and the Marches in the later fifteenth century. In this case no art history was involved. The works supported one another, in the way that all good forgeries should do, and the appearance of each new relief must have made the antecedent carvings seem more plausible. I had a characteristic example (fig. 32) photo-

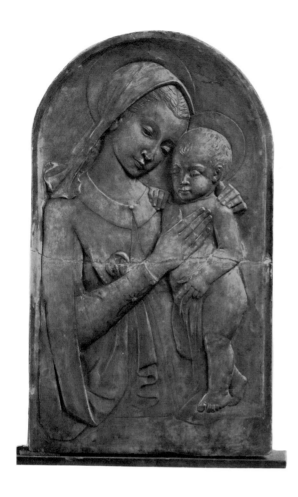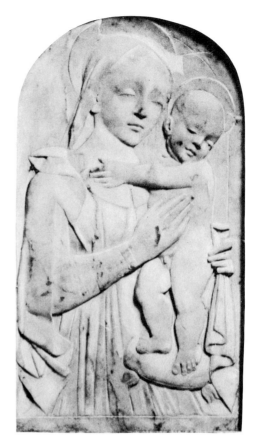

graphed in 1956 when it was on sale in London.[53] The sculptor's sole strength was a sense of line, and looking at the faces of his Virgins I have always called him privately the Modigliani Master. Another of his works was for sale early in this century in Rome (fig. 33)[54]; in it the Child, the same Child, is standing up. Limited as was his repertory, the Modigliani Master was also capable of modifying his Child type, as in another relief, where the head is carved more freely and the hair is curled.[55] A fourth relief by the same hand was in London in the collection of Henry Harris (fig. 34), one of the last great amateur collectors of Italian art.[56]

Obviously these are modest works. When they were marketed in Florence, they can have fetched only quite small sums, and even today, if they were mistakenly supposed to date from the fifteenth century, their value would be very limited. But there were also grander, more ambitious forgeries which took longer to make and were sold at a proportionately higher price. Most of them, or most of those with which I am familiar, pivot round Antonio Rossellino. There were two reasons for that: first that a number of genuine reliefs by Rossellino were known, and second that there existed a host of works by fifteenth-

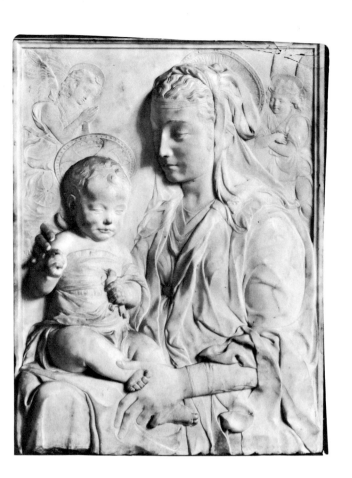 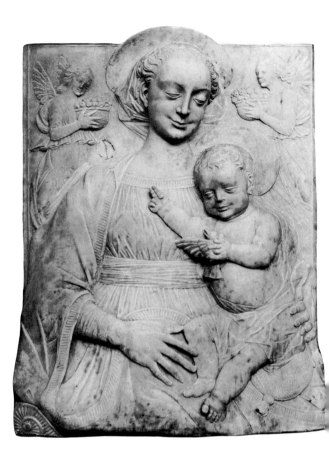

century Rossellino imitators that the forger could in extremity translate back into the style of Rossellino. One of Rossellino's most delicate Madonnas is a beautiful relief in Vienna (fig. 35) which reached the Kunsthistorisches Museum from Schloss Ambras in 1880.[57] It was known through stuccos—one of them, of doubtful antiquity, was bought by Timbal—and in the fifteenth century it seems to have inspired a number of reliefs by the Master of the Marble Madonnas like that in the Louvre (fig. 36), where the forms are stratified and the angels are depicted rather differently.[58] By combining the two compositions a forger (who he was one does not know) produced a third relief (fig. 37).[59] That this dates from the nineteenth century is not open to doubt; the angels which overlap the molding, the cherub head which is inserted on the left, the carving of the Virgin's head, and the throne with a full-length putto on an arm all prove decisively that that is so. One of the hallmarks of this sculptor is the fact that he first dresses up the Child, and then, in a rather muddled fashion, undresses him. In another work, in terra-cotta (fig. 38), which is manifestly by the same hand, a similar process occurred.[60] The full-length putto on the throne appears once more—this time he peeps coyly round the Virgin's drapery—and a putto head looks up from the chair arm. Once more it was the Master of the Marble Madonnas, in a relief in the Palazzo Ducale at Urbino (fig. 39), who inspired the composition.[61]

244

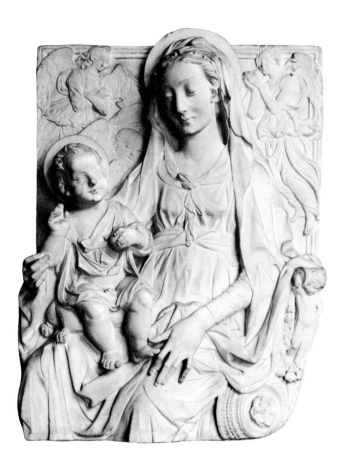

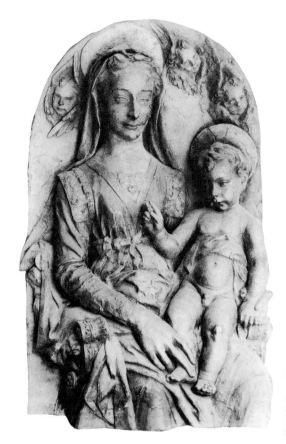

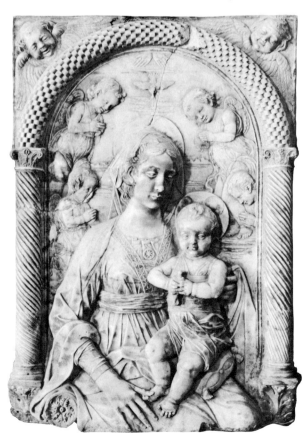

35. ANTONIO ROSSELLINO.
Virgin and Child with Angels. Marble, 69.5 x 51 cm.
Kunsthistorisches Museum, Vienna

36. MASTER OF THE MARBLE MADONNAS.
Virgin and Child with Angels. Second half of
15th century. Marble, 72 x 55 cm.
Musée National du Louvre, Paris

37. *Virgin and Child with Angels*. Florentine.
Second half of 19th century. Marble, 104 x 79 cm.
Hyde Collection, Glens Falls, New York

38. *Virgin and Child with Angels*. Florentine. Second
half of 19th century. Terra-cotta, 98 x 53.5 cm.
The Toledo Museum of Art. Libbey Collection

39. MASTER OF THE MARBLE MADONNAS,
Virgin and Child with Angels. Late 15th century.
Marble, 120 x 83 cm.
Galleria Nazionale della Marche, Palazzo Ducale,
Urbino

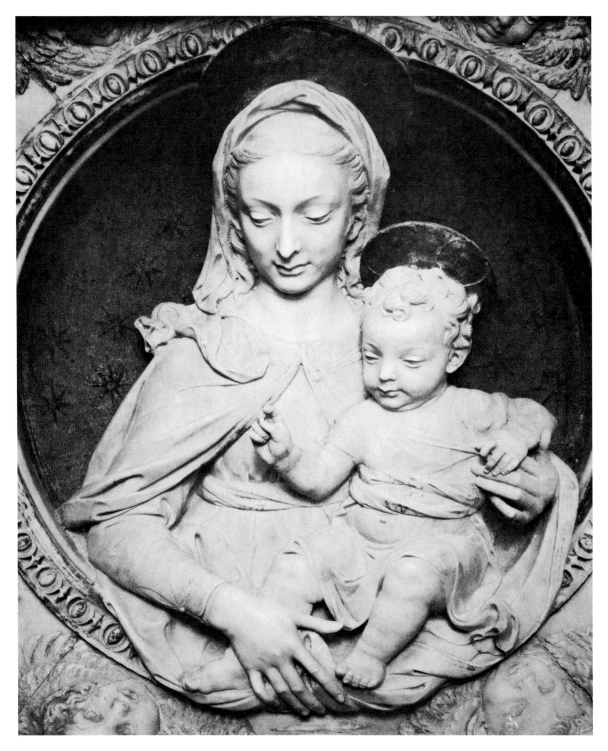

246

40. ANTONIO ROSSELLINO. *Madonna and Child,* from the Chapel of the Cardinal of Portugal. 1460–66. Marble. San Miniato al Monte, Florence

Another group of anonymous forgeries centers on the Madonna by Antonio Rossellino in the Chapel of the Cardinal of Portugal (fig. 40). One of them, in the Isabella Stewart Gardner Museum, was made before 1888, when it was shown by Sir George Donaldson at Burlington House (fig. 41). In the 1935 Fenway Court catalogue it is noted, perfectly correctly, that "the cherubs in the background have been added, and the cross in the halo of the Madonna is an iconographical error."[62] Another much more eccentric adaptation, apparently by the same hand, is in Chester cathedral (fig. 42). In this the composition is extended at the base, but the lower edge of the original drapery is preserved so that the extension reads as a kind of tent.[63] A third forgery, almost certainly by the same sculptor, is at Port Sunlight (fig. 43).[64] It purports to be by Mino da Fiesole, and certain features, the upper part of the main group and the Child with a cross at the bottom, are indeed imitated from a relief by Mino which is recorded in the Badia by Vasari and remained there till after

41. *Virgin and Child*, after Antonio Rossellino. Before 1888. Marble, 95 x 61.5 cm. Isabella Stewart Gardner Museum, Boston

42. *Virgin and Child*, after Antonio Rossellino. Second half of 19th century. Marble, 139.7 x 86.3 cm. Cathedral, Chester

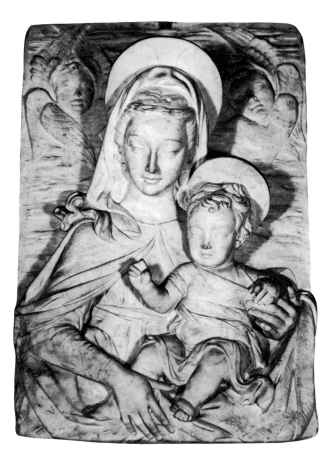

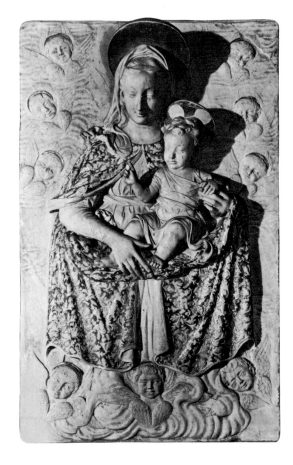

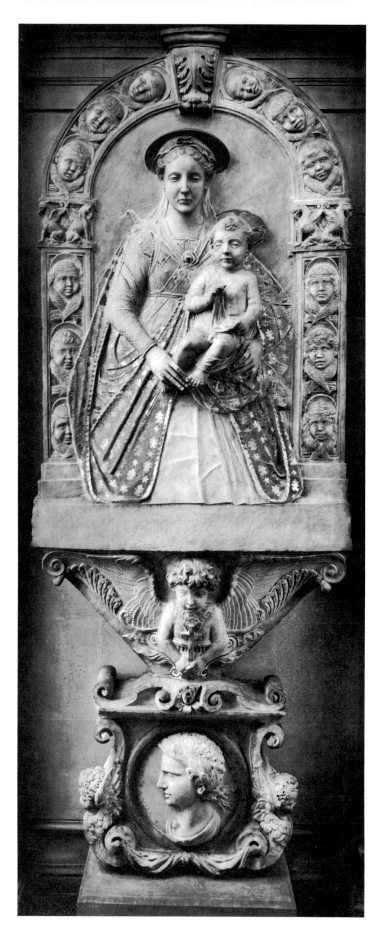

43.
Virgin and Child, after
Mino da Fiesole. Second
half of 19th century.
Marble, 281 x 102 cm.
Lady Lever Art Gallery,
Port Sunlight, England

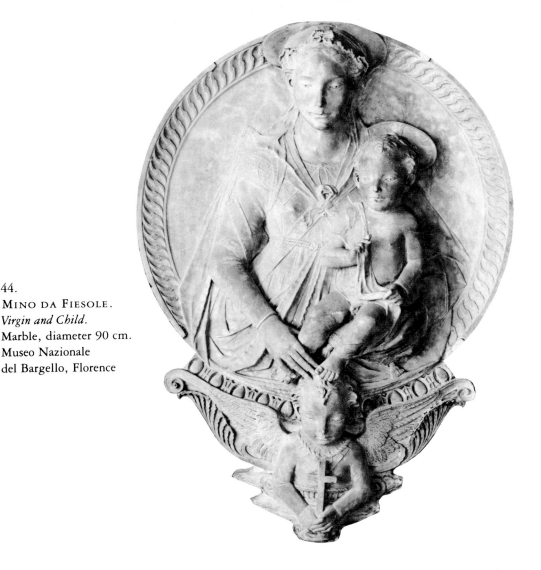

44.
MINO DA FIESOLE.
Virgin and Child.
Marble, diameter 90 cm.
Museo Nazionale
del Bargello, Florence

1858, when it was moved to the Bargello (fig. 44). Once more the figure is lengthened to below the knees. When twelve glum little cherub heads were added in the frame, the whole awful concoction was complete.

The influence that quattrocento sculpture exerted in the nineteenth century is difficult to overestimate. Bartolini was criticized by uncompromising neoclassicists for allowing quattrocento portraits to interpose themselves between his own work and the antique, and the child busts of Desiderio influenced academic sculptors like Niccolini no less profoundly than antiacademic sculptors like Medardo Rosso. When we find one of them adapted as a holy-water stoup, the result is not a forgery, but a touching tribute from the nineteenth century to the magic of Desiderio. The Belgian sculptor Paul de Vigne made careful, perspicacious drawings of works in the Bargello in 1869 and 1870, and accepted "the adorable little busts of the Florentine Renaissance" as an ideal which he hoped one day to attain.[65] Hildebrand consciously based certain sculptures on Mino da Fiesole and other

249

quattrocento artists—how closely we may judge if his well-known relief of Irene Hilde-brand is compared with a portrait ascribed by Bode to the North Italian sculptor, Gian Cristoforo Romano.[66]

In Italy by 1900 this vein of nostalgia was worked out, and the respect that lends so many early forgeries some interest is conspicuously absent from the sculptures produced by Alceo Dossena. How untalented and meretricious Dossena was can be seen very clearly in works that were not made as forgeries, that were, in other words, produced between his exposure in 1928 and his death nine years later. Nor do they differ fundamentally from the works by him that were sold earlier in the century under other artists' names.

Dossena came from quite a different environment from the sculptors I have mentioned hitherto. He was born in Lombardy, and the first sculptures he knew were at Cremona—the Tuscan Gothic figures on the façade of the cathedral and the pulpit reliefs by Amadeo inside the church (fig. 45). From Amadeo he gained a taste for angular drapery and broken planes which he indulged even when later he copied Florentine Renaissance sculptures, and the statuary on the façade inspired him to experiment on a new line of forgery in the area of the Pisani. He was trained by Monti in Milan and had a bolder, less disciplined technique than forgers in Florence. The Renaissance style for which he felt most natural sympathy was that of Lombardy and a signed relief by him in the Fogg Art Museum does indeed represent a decent approximation to the style of Amadeo (fig. 46).[67]

Before the First World War Dossena seems to have set up in Parma—as a forger I need hardly say—and when the war was over his work came to the notice of a Roman dealer, Fasoli, who learned that he was in financial straits and offered to pay him a salary to make forgeries. According to his son's account, Dossena was utterly oblivious of what was happening; he did not even smell a rat when he was given a decorous studio and was told to study chemistry. His sculptures, he believed, were needed for a church in the United States, where the clergy would accept only statues which convincingly pretended to be what they were not.[68] So, in a state of incandescent innocence, he set to work. Unlike the artists we have been discussing, he cast his net extremely wide. He would forge sculptures by Nicola Pisano and Giovanni Pisano and Vecchietta, and Lombard lavabos, and angels by Niccolò dell'Arca. For practical reasons I shall limit myself here to a sculpture that belongs in the same class as those which I have been discussing. The most ambitious of Dossena's forgeries, it is a large relief signed: Donatello (fig.47).[69] It shows the Child on the Virgin's knee with the young Baptist and Saint Elizabeth peering over at the back. One's first reaction is to ask why on earth he troubled to put Donatello's name on it. But the model for the Virgin was indeed a relief by Donatello over the Porta del Perdono of Siena cathedral, from which the veil and folds of drapery over the Virgin's arm were drawn, and the style of carving was based on a work mistakenly ascribed to Donatello, the full-length statue of the Baptist in the Bargello. The types, however, are more saccharine, and the head of Saint Elizabeth is treated in exactly the same fashion as the head of the effigy in another of

250

45. GIOVANNI ANTONIO AMADEO.
Pulpit relief, from the *Arca of the Persian
Martyrs*. 1482. Marble. Cathedral, Cremona

46. ALCEO DOSSENA. *Noli Me Tangere*,
style of Giovanni Antonio Amadeo. c. 1930.
Marble, 75 x 54.5 cm. Fogg Art Museum,
Cambridge, Massachusetts

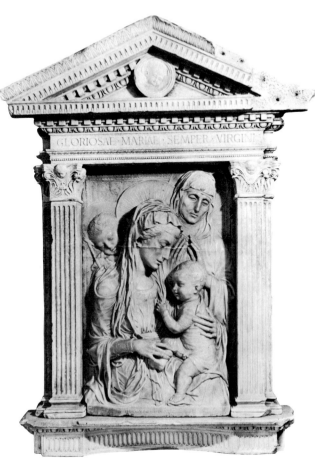

47. ALCEO DOSSENA. *Virgin and Child with
Saints Elizabeth and John the Baptist*, signed:
Donatello. Early 20th century. Marble,
height 150 cm. Private collection, Venice

Dossena's long-acknowledged forgeries, the Savelli monument in the Boston Museum of Fine Arts.[70]

Not unnaturally the story of forged portrait sculptures runs parallel to that of forged reliefs. In the fifteenth and sixteenth centuries stucco replicas were made of portrait busts. They were produced mainly for family reasons, and took the form sometimes of free copies and sometimes of molded casts. Posthumous portraits were also made. One of the most notable is the bust of Boccaccio at Certaldo, which was carved in 1503 by Rustici for Boccaccio's tomb.[71] For historical reasons it was deliberately designed to look more archaic than it was. Another historical portrait is the bust of Andrea del Sarto in the cloister of the Annunziata, which was carved by Caccini in 1606 to commemorate Sarto's connection with the church.[72] This tradition persisted without a break. In 1620 a statue of Michelangelo was ordered from Novelli for the Casa Buonarroti; it combined an authentic portrait bust with a pose drawn from one of Michelangelo's own statues.[73] When in 1674 a bust of Raphael was placed by Maratta on the painter's tomb in the Pantheon, its features were meticulously copied from those in a presumed self-portrait in the Accademia di San Luca.[74] In Rome in the late eighteenth century the practice was still very much alive and by 1820 there were some sixty busts of artists in the Pantheon.[75] They proved rather an encumbrance there, and were moved to the Campidoglio where their number continued to increase. A good deal of trouble was taken to ensure their authenticity; they were based on sculptured originals where possible, and, if there was no sculptured original, on paintings. It might seem axiomatic that unless they looked reasonably like the person represented, commemorative sculptured portraits had no point. But there were exceptions to that view, and one of them is Bartolini's statue of Leon Battista Alberti in Santa Croce in Florence (fig. 48), where the head has no recognizable relationship to Matteo de' Pasti's medal of Alberti or to Alberti's self-portraits.[76]

The Alberti statue was commissioned by a member of the architect's family, a nineteenth-century Leon Battista Alberti, and under it is a frankly chauvinist inscription explaining why it was set up; it was intended to rekindle in the nationally conscious nineteenth century the love for old Italic wisdom that Alberti himself had felt. The project dates from 1838, and the group was installed, after the sculptor's death, in 1851 and is therefore coeval with the most important commission of this class, the commemorative statues in the arcades of the Uffizi, which were carved between 1835 and 1856. Visitors to the Uffizi, when they catch sight of them, tend to look away disdainfully, but they were conceived as components in a civic portrait gallery. The significance of the whole enterprise transpires very clearly from an apostrophe published by Filippo Moisé when the competition was first announced.[77] In this he wrote:

> Now, all the Tuscan artists will decorously lift their chisels. There are twenty-eight statues to be carved. In the execution of them twenty or more artists will be involved, in noble competition inspired by the fire of art. All of them are fellow citizens, all of them know one

48. LORENZO BARTOLINI. Monument to Leon Battista Alberti. Installed 1851. Marble.
Santa Croce, Florence

another, all of them were trained by the same methods and fanned by the same flame, all of them copied the same models and drew their inspiration from the same masterpieces, all of them listened to the same counsels and counselled one another a thousand times. . . . In what respect will the fabric of our Uffizi differ from so many public establishments in Greece and Rome?

Among the best of the statues is that of Michelangelo by Emilio Santarelli, who was regarded in his lifetime as "one of the glories of contemporary art." Nowadays, outside Italy he is known mainly as the man who discovered and certified the so-called Michelangelo Cupid in London,[78] and who also ascribed the terra-cotta bust of Lorenzo il Magnifico in Washington to Michelangelo.[79] As a connoisseur he may have been lacking in a sense of probability, but he was a more than passable sculptor, and the Michelangelo statue (fig. 49) is a lively, viable likeness. The procedure with these statues was broadly the same as that followed with the busts in the Pantheon. If there was a sculptured portrait, the artist followed it. The dividends this practice paid can be seen in the statue of Sant' Antonino carved by Giovanni Dupré in 1852 (fig. 50), which was based on a portrait bust in Santa Maria Novella (fig. 51). The sculptor himself describes the uneasy course he was compelled to steer between realism and ideality in preparing the model for this work.[80]

All this goes some way to explain the portrait busts by Bastianini. To us the credibility gap between these and authentic quattrocento busts seems to be unbridgeable, but they were believed in in the nineteenth century precisely because they represented a type of bust that everyone, historians and connoisseurs and artists, hoped and expected to see. Indeed,

49.
EMILIO SANTARELLI.
Michelangelo. 1835–56. Marble.
Arcade, Uffizi Gallery, Florence

50.
GIOVANNI DUPRÉ.
Sant' Antonino. 1852. Marble.
Uffizi Gallery, Florence

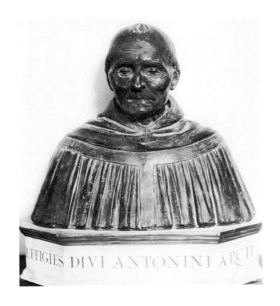
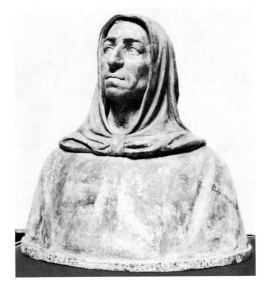

51. *Sant' Antonino*. Probably c. 1460. Terra-cotta. Santa Maria Novella, Florence

52. GIOVANNI BASTIANINI. *Girolamo Savonarola.* Before 1864. Terra-cotta, height 60.3 cm. Victoria and Albert Museum, London

but for one unfortunate slip their authorship might not have been discovered until long after Bastianini's death. The most convincing of the busts—the one that took in more responsible experts than any other—was of Savonarola (fig. 52).[81] It was based on a medal and was inscribed with the sitter's name and the date 1496. After it was finished the lower part was broken and repaired in plaster—this is typical of Bastianini's work in terra-cotta; the practice recurs in the bust known as Saint Cecilia in London and was designed to give the object added authenticity—and it was then pigmented and discreetly distressed by a specialist, Gaiarini. That done, it was planted in an Inghirami villa at Fiesole, and was sole from the villa to a Florentine dealer for 650 francs. Not long afterwards, in 1864, it was resold for a much larger sum. In the interval it had been accepted as authentic by collectors such as Ottley and Spence and by the dealer Foresi, who afterwards, to atone for his mistake, conducted an angry polemic against Bastianini.[82] Eventually it was bought as a fifteenth-century sculpture by two artists, who lent it to an exhibition in Florence. But in 1867, when another bust by Bastianini came under suspicion, with commendable detachment they investigated the credentials of their bust and obtained a letter from Bastianini acknowledging its authorship. Years later, in 1896, it was purchased by the Victoria and Albert Museum from the two artists, as a work by Bastianini, for the then substantial price of £328.

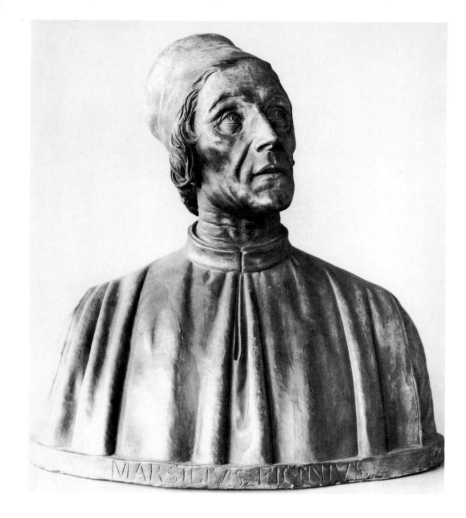

53.
Giovanni Bastianini.
Marsilio Ficino.
Third quarter of 19th century.
Terra-cotta, height 51.2 cm.
Victoria and Albert Museum,
London

This bust was deceiving, and so, when it was still pigmented, was a portrait of Marsilio Ficino (fig. 53).[83] To make it a cast was taken from the bust of Marsilio Ficino in the Duomo by the late fifteenth-century sculptor Andrea Ferrucci.[84] On the dealer Freppa's instructions Bastianini made a number of small changes to the cap and the movement of the head and above all to the face, which as a result took on the look of a person who has not quite understood the question that has been addressed to him. The implication was that this and the Savonarola and other related terra-cotta busts were made in a single Florentine studio in the late fifteenth century, and for that reason they were provided with a rim inscribed with the sitter's name, a stamp of the supposititious artist's handiwork.

What blew the carefully constructed edifice sky-high was a bust that was not based on a fifteenth-century model. It was supposed to represent the poet Girolamo Benivieni,[85] and the only available likeness of Benivieni (or rather the only likeness Freppa could turn up) was an engraving of 1766. So this time the procedure was changed. Armed with the engraving, the dealer and sculptor searched the streets of Florence for a man who resembled the portrait. When one was found, he proved to be an operative in a tobacco factory, but

256

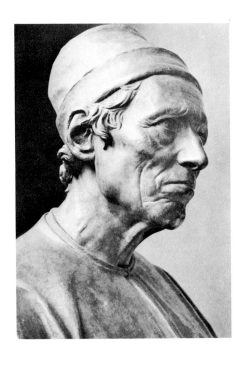

54. Giovanni Bastianini.
Girolamo Benivieni. 1863. Terra-cotta.
Musée National du Louvre, Paris

for a consideration he agreed to sit, and the bust that was produced (fig. 54) appeared so formidably photographic that the imposture was exposed, though not before the Louvre had bought it as a fifteenth-century original for 13,000 francs. A copy of the upper part of it is in London.[86] There are quantities of other sculptured portraits of this type about. I saw one of the sculptor Ghiberti in a private collection near Pistoia not long ago.

These busts and the interest they aroused are explicable only in the light of history. But there is another class of Bastianini portrait-sculptures that are much superior to them, both as forgeries and as works of art. The best documented is the *Lucrezia Donati* in London (fig. 55).[87] Lucrezia Donati was the mistress of Lorenzo il Magnifico, and as usual the bust that Bastianini made of her had her name written underneath lest her identity should be in doubt. It is an extremely pretty work, and it is rather surprising that it found no purchaser before its authorship was recognized. A modern book on forgery says that Bastianini based it on Laurana,[88] but Cavalcaselle, when he was shown it, knew better. He greeted it as the masterpiece of Mino da Fiesole and offered to exhibit it under a glass shade in the Bargello.[89] The features and bored eyes do indeed depend from those of the Virgin in Mino's altar in the Duomo at Fiesole. As with the terra-cottas, so with the marble busts there is a distinction to be drawn between the busts where Bastianini adhered to a known prototype and the busts where he did not. In some respects indeed an animated portrait by Bastianini in the quattrocento style in a collection in the United States (fig. 56) is even prettier than the forgery.[90]

257

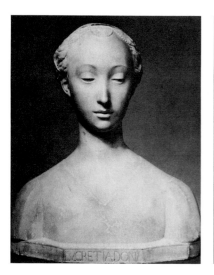 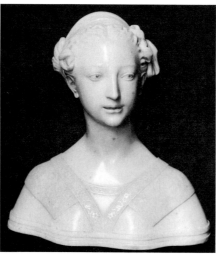 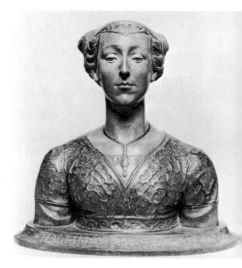

55. GIOVANNI BASTIANINI. *Lucrezia Donati.* Third quarter of 19th century. Marble, height 45.7 cm. Victoria and Albert Museum, London

56. GIOVANNI BASTIANINI. *Portrait of a Lady.* Third quarter of 19th century. Marble. Private collection, U.S.A.

57. GIOVANNI BASTIANINI. *Giovanna degli Albizzi.* Third quarter of 19th century. Pigmented gesso on wood, height 53.5 cm. National Gallery of Art, Washington, D.C. Andrew W. Mellon Collection

OPPOSITE PAGE:

58. GIOVANNI BASTIANINI (attributed). *Portrait of a Lady.* Third quarter of 19th century. Pigmented gesso on wood, height 55 cm. Musée National du Louvre, Paris

59. GIOVANNI BASTIANINI. *Portrait of a Lady.* Third quarter of 19th century. Terra-cotta, height 46.4 cm. Victoria and Albert Museum, London

60. *Portrait of a Lady,* by or after Giovanni Bastianini. 19th century. Enameled terra-cotta, height 57 cm. Isabella Stewart Gardner Museum, Boston

61. GIOVANNI BASTIANINI. *Giulia Astallia.* Third quarter of 19th century. Marble, height 56 cm. Formerly Fitzhenry Collection, London

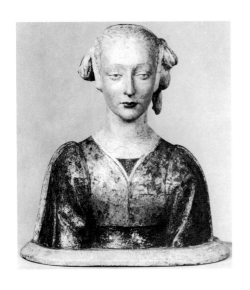

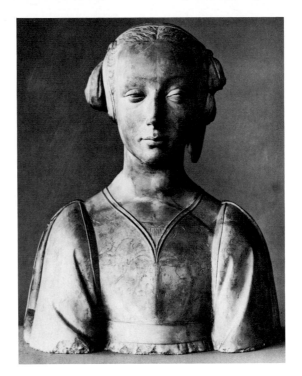

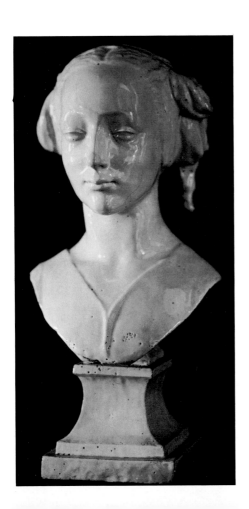

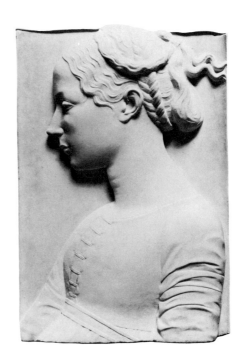

259

Bastianini also made one recorded forgery in painted wood, an alleged portrait of Giovanna degli Albizzi, which was sold to France—it was another of Timbal's unhappy purchases—was accepted by Bode, was bought for the Mellon Collection and is now in the basement of the National Gallery of Art in Washington (fig. 57).[91] We know it to be a forgery because there is an eyewitness description of the way in which it was produced.[92] Another wooden bust of a girl is in the Louvre (fig. 58), as a Desiderio da Settignano[93]—it is illustrated in the most recent volume on that artist—and a terra-cotta version of it by Bastianini exists in London (fig. 59).[94] The terra-cotta is generally explained as a copy of the bust in Paris, but the more often I look at the two works, the more prone am I to wonder whether one is not really a study for the other, and to ask myself if the bust in the Louvre, which has a molded base like that in Washington, is not also by Bastianini. The wooden bust has no history before 1888.[95] By what is surely more than a coincidence a copy of the bust in white enameled terra-cotta (fig. 60) was bought by Mrs. Gardner from Duveen in 1910 on the recommendation of Berenson as "a fifteenth century Della Robbia bust of Marietta Strozzi."[96] The source of the representation is an indubitably genuine marble bust by Antonio Rossellino, which was purchased in Florence for the Kaiser Friedrich Museum in 1842. One last class of Bastianini portraits ought to be mentioned here, portrait reliefs. They are not very common, but early in this century one was

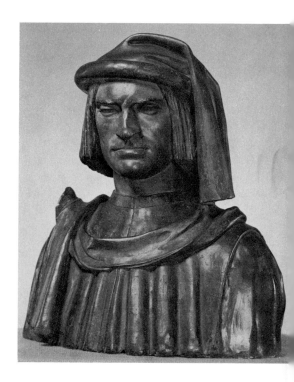

62. *Lorenzo de' Medici*. Late 15th century or early 16th century. Pigmented terra-cotta, height 66 cm. National Gallery of Art, Washington, D.C. Samuel H. Kress Collection

63. ARISTODEMO COSTOLI. *Lorenzo de' Medici*. 1837. Marble. Methuen Collection, Corsham Court, Wiltshire, England

64. *Lorenzo de' Medici*. Mid-19th century (?). Pigmented terra-cotta. Formerly private collection, Florence

recognized as what it was, a forgery by Bastianini after the well-known medal of Giulia Astallia (fig. 61).[97]

Not all the forged Florentine portraits made in the third quarter of the nineteenth century were by Bastianini. Historical busts in particular must have been turned out under other auspices as well. This was certainly the case with those famous terra-cotta busts of Lorenzo il Magnifico. Their history goes back to 1837, when one of them, the example that is now in the National Gallery of Art, Washington (fig. 62),[98] was copied for the collector John Sanford by a Florentine sculptor, Aristodemo Costoli, the master of Fantacchiotti. The marble is at Corsham in the Methuen Collection (fig. 63).[99] There is no reason to doubt that the bust in Washington dates from the late fifteenth or at worst the early sixteenth century; it could well be a sculptural equivalent for the posthumous Medicean portraits commissioned by Alessandro de' Medici as duke of Florence. It seems, however, that in the nineteenth century it was freely copied, and in some impalpable fashion the copies—one of them is in the Bode Museum in Berlin and another was in a private collection in Florence (fig. 64)[100]—change its character. They are more particularized and descriptive and carry with them the aroma of *Romola* and Beerbohm Tree.

Dossena's portraits, like his reliefs, fail as a whole to measure up to the estimate that has been placed on them. One recorded bust,[101] which depends from Lombard models, must

261

have been carved before he left Emilia for Rome; unlike the Roman forgeries, it looks very little salable. But with tuition he improved, and in Rome he turned out busts which would deceive nobody today, but which could, at the time that they were made, have been mistaken for the genuine article.

There is one other aspect of sculpture forgery that deserves more notice than it has received. From time immemorial in Italy it has been acknowledged that there rested on each city an obligation to keep its monuments in fit repair. Workshops were maintained for that purpose alone, and architects and sculptors gave considerable thought to the replacement of decorative carving and architectural sculpture. In Siena, for example, the architect Socini devoted many years to improving the appearance of the baptistery by stripping it of its baroque accretions and forging altars and holy-water stoups with which to replace them,[102] and the sculptor Maccari made a large-scale copy of a small relief by Giovanni di Agostino for the cathedral at Grosseto. In Venice there are records that in 1731 one of the capitals of the Ducal Palace facing the Piazzetta was removed on account of its precarious condition. A new capital was substituted, carved by a certain Bartolommeo Scalfarotto (fig. 65),[103] and so convincing is it that it was published not long ago as a work of the fifteenth-century Lombard sculptor, Matteo Raverti.[104]

Good forgeries of external sculpture were also made during the nineteenth century. The relief of Francesco Foscari kneeling before the Lion of Saint Mark on the Porta della Carta reads convincingly enough from the ground, but the original figure of the doge was in fact destroyed in 1797 (destroyed all but the upper part, that is) and the present figure is by Luigi Ferrari.[105] Were this fact not recorded in guidebooks, some people might well be taken in. In Venice, too, there was a trade in wellheads for use as garden ornaments. Cumbersome and untransportable though they appear to us, the demand for them by foreigners in the nineteenth century far exceeded the supply, with the predictable result that numbers of forged wellheads were produced.

One of them is shown in a photograph of the workshop of the Brescian forger Faitini,[106] whose name first comes to light in 1870, when work started on a necessary but much too thoroughgoing restoration of Santa Maria dei Miracoli at Brescia. It was directed by a local architect, and Faitini was one of two sculptors he employed. No one who was engaged in working there could have failed to become impregnated with the repertory of motifs on its comparatively small façade, but once more it took a dealer to see how they could be put to fruitful use. The dealer was a Cremonese called Molinari, who bought for a modest sum a large undecorated doorway from the palace at Ghedi outside Brescia.[107] It had been offered to other dealers, who rejected it as utterly unsalable, since its only ornament was on the bases of the pilasters. Molinari, however, recognized that if the decoration were extended it could become a marketable asset. The pieces of the doorway, therefore, were handed over to Faitini, who literally covered them with decoration based on the Brescian carvings that he knew. He worked on the doorway on and off for seven years—from 1872 till 1879—and at

65. BARTOLOMMEO SCALFAROTTO. Capital. 1731. Istrian stone. Palazzo Ducale, Venice

the end it was improvidently bought by the South Kensington Museum for just over £600 (fig. 66). It was recognized that the emperor heads Faitini inserted in it must be modern, but the rest of the work was accepted as original. I rather doubt indeed if I should myself have been confident that it was false (false and not simply recut) unless the full documentation of the crime had come to light.

Our knowledge of Italian sculpture is still lamentably incomplete, and we have always to beware of condemning works as forgeries just because they do not fit in. If the relief illustrated as figure 67 were to appear at auction in London or New York, who would trouble to bid for it? The Faith, on the left, grasping an outsize chalice, the Hope, on the right, with her coarse hair blowing across her wing, and above all the Charity, in the center, holding a stiffly contrived child with a cherub blowing a flame behind her, have all the character of a pastiche. Yet the relief is absolutely genuine. It was carved, from

263

66. PIETRO FAITINI. Doorway from the Palazzo Orsini, Ghedi, detail. 1872–79.
Stone and marble. Victoria and Albert Museum, London

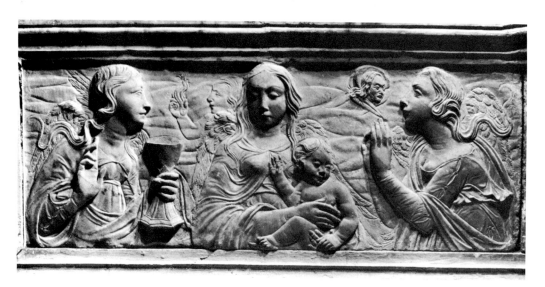

67. WORKSHOP OF AGOSTINO DI DUCCIO. *Faith, Charity, and Hope.* 1476. Stone.
Relief on the Geraldini Monument, San Francesco, Amelia

Agostino di Duccio's design, for one of the Geraldini monuments at Amelia in 1476, and it has never left the church for which it was made. Similarly, if the center of the lunette illustrated in figure 68 were in Kansas City or the Louvre, or indeed in London, we might all be throwing stones at it. But it is in Tuscany, at Grosseto, built into an altar for which it was made in 1474 by Antonio di Ser Ghino.[108] Let us then never make the error of supposing that we know more than we do. "To be ignorant is painful," says Johnson in the book I quoted earlier, "but it is dangerous to quiet our uneasiness by the delusive opiate of hasty persuasion."[109]

The fact nonetheless remains that this whole subject is beset by doubt. There is a story that in 1868, when the Bastianini forgeries came to light, a prospective purchaser was shown Cellini's bust of Bindo Altoviti, the bronze that is now at Fenway court.[110] He refused to buy it because he thought it was by Bastianini. Similarly Bode tells us how in 1887, when he came back in triumph to Berlin with the restored but absolutely genuine bust that is known as a Princess of Urbino and showed it to Empress Frederick, she exclaimed: "Aber wie können Sie eine solche Fälschung kaufen?"[111] She later apologized. Nowadays people who are confronted with genuine works by great Italian sculptors sometimes desist from buying them through doubt. "There are an awful lot of forged Italian sculptures," they say to themselves, "and perhaps somebody will tell me it is wrong."

It is not in the interest of people who buy sculpture to dispel that doubt; the recurrent interrogative is the only thing that keeps the prices of Renaissance sculptures down. But from a broader standpoint dubiety is an unhealthy state, and I believe that it will be dispelled only if we adopt the view that I have advocated here, that the history of forgery is part of the history of Italian sculpture.

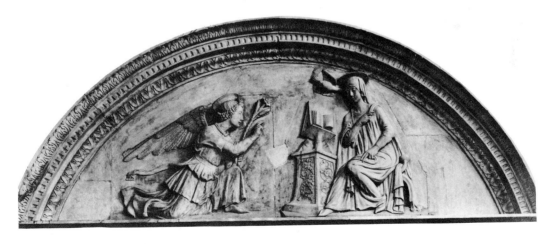

68. ANTONIO DE SER GHINO. *Annunciation.* 1474. Marble. Cathedral, Grosseto

265

NOTES

1. Samuel Johnson, *A Journey to the Western Islands of Scotland* (London, 1775), p. 276.

2. Victoria and Albert Museum, no. A.12–1934. J. Pope-Hennessy and R. Lightbown, *Catalogue of Italian Sculpture in the Victoria and Albert Museum,* i (London, 1964), no. 109, p. 131.

3. J. Pope-Hennessy, "Three Marble Reliefs in the Gambier-Parry Collection," in *Burlington Magazine,* cix (1967), pp. 117–18.

4. According to the 1898 catalogue of the Bargello (*Catalogo del R. Museo Nazionale di Firenze* [Rome, 1898], p. 67), the relief was acquired for nine zecchini from the suppressed convent of the Badia di Settimo on June 5, 1784. For further bibliography see I. Cardellini, *Desiderio da Settignano* (Milan, 1962), p. 150.

5. Musée Jacquemart-André, *Catalogue-itinéraire* (1935), no. 879, p. 124.

6. Los Angeles County Museum of Art, no. A.5933.5110. W. R. Valentiner, *Gothic and Renaissance Sculptures in the Collection of the Los Angeles County Museum* (Los Angeles, 1951), no. 22, p. 70.

7. Presented by Sir Horace Mann to Horace Walpole in November 1772, the relief arrived in London in February 1773 and was installed in the chapel at Strawberry Hill in May 1774. W. Hadley, ed., *Horace Walpole: Selected Letters* (London, 1967), vii, p. 15; Horace Walpole, *A Description of the Villa of Mr. Horace Walpole at Strawberry Hill, Twickenham, Middlesex* (Strawberry Hill, 1784), no. 507. Strawberry Hill sale May 21, 1842, Lot 89, bt. C. Wentworth Dilke. By inheritance to Sir Charles Wentworth Dilke and Mrs. May Tennant. Sold 1916 to Mrs. James Creelman, New York, and later in the collection of Mrs. Benjamin Thaw, New York (sale London, Christie's, June 23, 1932, Lot 97, bt. William Randolph Hearst). Presented to the Los Angeles County Museum by the Hearst Corporation, 1950.

8. P. Eudel, *Le truquage* (Paris, 1887), pp. 327–28. An example of the relief was in the Dreyfus Collection and is now in the National Gallery of Art, Washington, D.C. (Kress Collection, no. A.166.3C). P. Cott, *Renaissance Bronzes...from the Kress Collection* (Washington, 1951), p. 141, repr. p. 53.

9. The best-known version of the composition is variously described as the Signa and the Dibblee Madonna. Purchased at Signa in 1897, it was later deposited on loan at the Ashmolean Museum, Oxford, and was sold at Christie's June 2, 1964, Lot 71.

10. J. Pope-Hennessy, loc. cit.

11. For versions in enameled terra-cotta see T. Cook, *Leonardo da Vinci, Sculptor* (London, 1923), p. 24.

12. Formerly Henry Pfungst Collection, acquired in 1895. After I had expressed the view that the relief "almost certainly dated from the nineteenth century," it was made the subject of a rigorous examination by Stephen Rees-Jones, who has shown in an excellent report ("A Fifteenth-Century Florentine Terracotta Relief," in *Studies in Conservation,* 23 [1978], pp. 95–113) that the surface was covered with a black, waxlike patina under which was a layer of brown pigmented gesso. Thermoluminescence testing demonstrated that the original terra-cotta area dated from between 1416 and 1546 and had been mounted in a clay strip fired in the mid-nineteenth century. Removal of the patinated surface and of the made-up areas has radically changed the character of the two heads and of the drapery. Rees-Jones rightly precludes the possibility that the relief is the terracotta original from which the Dibblee cast was made. This article provides the best available account of the technique of manufacture of fifteenth-century terracotta reliefs.

13. Victoria and Albert Museum, no. A.14–1911. Pope-Hennessy and Lightbown, op. cit., i, no. 112, pp. 134–35.

14. The relief is regarded by Gottschalk, *Antonio Rossellino* (Liegnitz, 1930), pp. 95–96, as by "einem unmittelbaren Nachfolger unseres Künstlers," and by L. Planiscig, *Bernardo und Antonio Rossellino* (Vienna, 1942), pp. 43, 59, as a "Werkstattkopie nach einem verlorenen Original Antonio Rossellinos."

15. For this commission see M. Tinti, *Lorenzo Bartolini* (Rome, 1936), no. lxvii, pp. 64–65.

16. *Catalogo del R. Museo Nazionale di Firenze* (Rome, 1898), no. 190, p. 419. A second full-scale nineteenth-century marble copy, in which the background figures are included, is in the Hermitage, Leningrad (J. Matzoulevitch, in *Annuaire du Musée de l'Ermitage,* i [1936], pp. 71–82, as early sixteenth century).

17. Tinti, loc. cit.

18. *Gazette des Beaux-Arts*, iii (1854), p. 240. For the monument, which was erected by Morghen's pupils and admirers, see W. and E. Paatz, *Die Kirchen von Florenz*, i (Frankfurt am Main, 1941), p. 579.

19. P. Schubring, *Donatello* (Stuttgart-Leipzig, 1907), p. 164.

20. Paatz, op. cit., ii, p. 364.

21. Victoria and Albert Museum, no. 7582–1861. Pope-Hennessy and Lightbown, op. cit., ii, no. 740, pp. 691–92.

22. G. Vasari, *Vite*, ed. G. Milanesi, vii (Florence, 1906), p. 550.

23. C. J. Cavalucci, *Manuale di storia della scultura* (Turin, 1884), p. 404: "E da quei giorni, che paiono tanto vicini a noi, sono mancati a Firenze, Giovanni Bastianini, autore dei busti del Savonarola, del Beniveni, della Cantatrice fiorentina e di altra opera che gli occhi esperti del più reputati conoscitori giudicarono dei migliori maestri toscani del quattrocento."

24. *Pensieri sull'arte e ricordi autobiografici di Giovanni Dupré* (Florence, n.d.), pp. 70–71.

25. Paatz, op. cit., i, p. 561.

26. The antiquity of the relief is accepted by W. von Bode, "Die italienischen Skulpturen der Renaissance in der königlichen Museen zu Berlin, iii, Donatello und seine Schule," in *Jahrbuch der königlich preussischen Kunstsammlungen*, v (1884), pp. 33–34, 40, and in many later publications, and is contested by H. Kauffmann, *Donatello, ein Einführung in sein Bilden und Denken* (Berlin, 1936), p. 241, n. 475, who regards it as "eine Kompilation des 19. Jahrhunderts."

27. L. Planiscig, *Die Estensische Kunstsammlung, i. Skulpturen und Plastiken* (Vienna, 1919), no. 91, pp. 50–51.

28. Victoria and Albert Museum, no. 7624–1861. Pope-Hennessy and Lightbown, op. cit., i, no. 66, pp. 80–81.

29. The authenticity of the relief was accepted by E. Maclagan (in *Burlington Fine Arts Club* [1913], no. 42, p. 50: "the beautiful relief of the Virgin and Child, in a similar dark stone, now in the Ashmolean Museum"), but it is dismissed by A. Venturi (*Storia dell'arte italiana*, vi [Milan, 1908], p. 424, n.5) as "falsissima," and according to a penciled note by C. F. Bell in the margin of Fortnum's manuscript catalogue, was also condemned by Bode.

30. The relief differs from the Turin Madonna in the overall flattening of the forms, e.g., of the drapery beneath the Virgin's right forearm and of the Child's right hand, and in the misunderstanding of certain passages, e.g., the decoration of the Virgin's dress on the right shoulder and the buttoning of her sleeve, represented with a third button and a seam that are not present in the original. The Turin Madonna seems to have come to light in 1850, when it was bought in Florence by Baron Garriod, and it is possible that the Oxford relief was worked up from a stucco, not from the marble at Turin.

31. Purchased by Samuel Woodburn from the Gallerie Lombardi, Florence; Woodburn sale, Christie's, May 19, 1854, Lot 582 ("A noble work of art, and divine impersonation of female purity"). From the time of its first publication by C. Perkins *(Tuscan Sculptors,* i (London, 1864), p. 151, up to the most recent monograph on Desiderio (I. Cardellini, *Desiderio da Settignano* [Milan, 1962], p. 88, n. 17), it has been generally accepted either as by Desiderio or as the work of a somewhat later Desiderio imitator. It is, however, dismissed by P. Schubring, *Donatello,* op. cit., p. 202: "Wir halten das Relief für eine Fälschung," and A. Venturi, op. cit., vi, pp. 424–25, n. 5, as "moderna." Like the Gigli-Campana Madonna in London, the relief enjoyed great popularity in the late nineteenth century. Maclagan, op. cit., no. 42, observes that "although the original is comparatively little known, there is scarcely any piece of Italian sculpture that has been so widely popularized in every conceivable form of reproduction." It is not possible to determine the date at which the first reproductions were made, but it is likely that they preceded the sale of the relief to Woodburn and formed part of a propaganda campaign organized by Lombardi.

32. Hommel sale, Zurich, August 10-18, 1909, Lot 1149, as "in schwarzem Marmor."

33. R. Jullian, *Le Musée de Lyon: sculptures, objets d'art* (Paris, 1954), Plate xxix, pp. 128–30.

34. F. Schottmüller, *Die italienischen und spanischen Bildwerke des Renaissance und des Barocks* (Berlin, 1913), no. 134, p. 58. Omitted by Schottmüller from the 1933 revision of the catalogue.

35. The relief is given by Cardellini, op. cit., p. 280, to a Maestro di Detroit, with the observation that, "solo un esame ravvicinato con questa, quindi—inattuabile per il momento—scoprirà la

vera natura (genuina o no) del profilo ricalcato di Detroit, di uno sconosciuto desideriesco senza scrupoli. (Che ha un imitatore, ancora con minor scrupoli, nel bassorilievo 5005—del Museo di Berlino)."

36. E. Bénézit, *Dictionnaire des peintres, sculpteurs, dessinateurs et graveurs,* viii (Paris, 1955), p. 314.

37. E. Bonaffé, in *Chronique des arts et de la curiosité* (1880), p. 293.

38. Charles Timbal, *Notes et causeries sur l'art et sur les artistes* (Paris, 1881), p. x.

39. G. C. Sciolla, *La scultura di Mino da Fiesole* (Turin, 1970), no. 53, p. 104 ("da collocare intorno al '70 circa").

40. From the Edgar N. Whitcomb Collection. W. R. Valentiner, *Catalogue of a Collection of Italian Gothic and Early Renaissance Sculptures,* no. 46, as Mino da Fiesole. Sciolla, op. cit., no. 6, p. 60, as Mino da Fiesole.

41. Colls.: Timbal, Dreyfus, Duveen, Mellon. The attribution to Desiderio da Settignano is replaced by Cardellini, op. cit., p. 259, with an unfounded ascription to Desiderio's brother Geri ("un autografo di Geri per noi").

42. Schottmüller, op. cit., no. 171, p. 72.

43. Timbal, op. cit., pp. xiii–xiv.

44. For Giovanni Bastianini see A. Foresi, *Tour de Babel* (Paris, 1868), and D. Brunori, *Giovanni Bastianini e Paolo Ricci, scultori fiesolani* (Florence, 1906).

45. W. von Bode, *Mein Leben,* i (Berlin, 1930), p. 181.

46. The relief, for which see Cardellini, op. cit., p. 144, was bought in Florence in 1850 by Baron Garriod.

47. Victoria and Albert Museum, no. 867–1891. Pope-Hennessy and Lightbown, op. cit., ii, no. 729, p. 683.

48. Victoria and Albert Museum, no. 4233–1857. Ibid., ii, no. 728, pp. 682–83.

49. New York, Havemeyer Collection (formerly). Photograph in Victoria and Albert Museum archive.

50. Private collection, Birmingham.

51. The history of the relief is told by G. Frizzoni, "Un'opera inedita di Antonio Rossellino," in *Rassegna d'Arte,* xvi (1916), pp. 54–58. The relief is published as a work by Rossellino by Matzoulevitch, loc. cit., Gottschalk, op. cit., p. 96, adopts a skeptical attitude towards it ("Fur einen unbedeutenden Künstler spricht die schlechte

perspektivische Stellung des Sessels und vor allem die unübersichtliche Anordnung des Kindes, dessen Sitzen völlig unklar ist"). It is ignored in Planiscig, op. cit. (1942).

52. Brunori, op. cit., p. 44.

53. Offered for sale to the Victoria and Albert Museum, December 1956.

54. Photograph by Anderson, Rome (Victoria and Albert Museum).

55. Photograph in Victoria and Albert Museum.

56. Sale, London, Sotheby, October 24–25, 1950, Lot 1472, Plate XI.

57. Planiscig, op. cit., pp. 55–56. The composition is also recorded in stuccos, on which the variants illustrated here are likely to have been based.

58. Musée National du Louvre, *Catalogue des Sculptures,* i (Paris, 1922), no. 597, p. 73. Acquired from the Campana Collection in 1862.

59. Purchased by Stanford White for Charles T. Barney.

60. The relief comes from the Hainauer Collection in Berlin, and is wrongly stated in *Duveen Sculpture in Public Collections of America* (New York, 1944), no. 83, to have been bought by Hainauer from Conte Cosimo Alessandri in Florence in 1877. The catalogue of the Hainauer Collection by W. von Bode (*Die Sammlung Oscar Hainauer* [Berlin, 1897], pp. 9–10) leaves no doubt that the two works purchased from the Palazzo Alessandri were a marble bust of a boy and a marble relief by Antonio Rossellino, which was later in the Altman Collection and is now in the Metropolitan Museum of Art. The present relief appears as no. 12 in the catalogue and has no recorded provenance. The attribution to Antonio Rossellino was doubted by Bode, who notes the uncharacteristic drapery forms and the "naiver Naturalismus" of the conception, and suggests either that the relief is by an unknown contemporary of Rossellino or that it was a naturalistic clay model made in preparation for a marble relief. The "alte Bemalung, wenn auch nur teilweise erhalten" seems in large part to have been removed by Duveen, but is clearly visible in the reproduction in the Hainauer catalogue: illustrated in fig. 36.

61. G. de Nicola, "Tommaso Fiamberti, il Maestro delle Madonne di Marmo," in *Rassegna d'Arte,* xxii (1922), p. 73.

62. Isabella Stewart Gardner Museum: *General Catalogue* (Boston, 1935), p. 234.

63. Formerly in the collection of Sibell, Lady Grosvenor (d. 1928). Presented to the cathedral in her memory in 1930.

64. Bought at Christie's, November 29, 1922, Lot 125. Formerly in the Collection of L. McCormick, London.

65. M. Fransolet, *Le sculpteur Paul de Vigne* (Brussels, 1960), pp. 22–30.

66. For the Hildebrand bust (dated 1876) see B. Sattler, ed., *Adolf von Hildebrand und seine Welt* (Munich, 1962), p. 225, and for the Gian Cristoforo Romano portrait, W. R. Valentiner, *Catalogue of an Exhibition of Italian Gothic and Early Renaissance Sculptures* (Detroit, 1938), no. 91.

67. No. 1929.68.

68. For this see the brief account of Dossena's life by his son, Walter Lusetti, *Alceo Dossena, scultore* (Rome, 1955), pp. 15–16.

69. The relief is discussed in the *Archiv des Verbandes von Museumsbeamten*, no. 1057, and is reproduced by Lusetti, op. cit., fig. 24.

70. E. Hipkiss and G. Edgell, "A Modified Tomb Monument of the Italian Renaissance," in *Bulletin of the Boston Museum of Fine Arts*, xxxv (1937), pp. 83–90.

71. D. Tordi, *Relazione sulla tomba e sulle presunte ossa di Giovanni Boccaccio* (Castelfiorentino, 1932).

72. Paatz, op. cit., i., pp. 93, 153, n. 180, and Baldinucci, *Notizie de professori del disegno*, iii (Florence, 1728), p. 207. See also Vasari, op. cit., p. 59n.

73. E. Steinmann. *Die Porträtdarstellungen des Michelangelo* (Leipzig, 1913), p. 84.

74. P. Cellini, "Il S. Luca di Raffaello," in *Bollettino d'Arte*, xxx (1936–37), pp. 282–88, and idem, "Il restauro del S. Luca di Raffaello," in *Bollettino d'Arte*, xliii (1958), pp. 250–62.

75. C. Pietrangeli, "La Protomoteca Capitolina," in *Capitolium*, xxvii (1952), pp. 183ff. V. Martinelli and C. Pietrangeli, *La Protomoteca Capitolina* (Rome, 1955).

76. Tinti, op. cit., ii, no. lxix, pp. 65–67; Paatz, op. cit., i, p. 549.

77. *Sopra un progetto d'associazione pell' esecuzione di 28 statue in marmo rappresentanti illustri toscani da collocarsi nelle nicchie della fabrica degli Uffizi in Firenze, riflessioni di Filippo Moisé* (Florence, 1836).

78. J. Pope-Hennessy, "Michelangelo's Cupid: the End of a Chapter," in *Essays on Italian Sculpture* (New York, 1968), pp. 111–20.

79. *Catalogue of Works of Ancient and Mediaeval Art Exhibited at the House of the Society of Arts* (London, 1850), no. 617. C. Seymour, *National Gallery of Art: Masterpieces of Sculpture* (Washington, D.C., 1949), no. 36, p. 179.

80. Dupré, op. cit., pp. 202–3.

81. Victoria and Albert Museum, no. 31–1896. Pope-Hennessy and Lightbown, op. cit., ii, no. 725, pp. 680–81.

82. Foresi, op. cit., pp. 33–37, and idem, "Di un valoroso scultore e delle sue opere celebri," in *Rassegna Nazionale*, clxxx (1911), pp. 397–414.

83. Victoria and Albert Museum, no. A.19–1924. Pope-Hennessy and Lightbown, op. cit., ii, no. 726, p. 681.

84. Foresi, op. cit., pp. 23–24.

85. See, in addition to Foresi, Becker, *Die Benivieni-Büste des Giovanni Bastianini* (1889).

86. Victoria and Albert Museum, no. 591–1869. Pope-Hennessy and Lightbown, op. cit., ii, no. 724, pp. 679–80.

87. Victoria and Albert Museum, no. 38–1869. Ibid., ii, no. 727, p. 682.

88. O. Kurz, *Fakes* (London, 1948), p. 136.

89. Foresi, op. cit., pp. 43–47.

90. Photograph by Philip A. Biscuti in the Victoria and Albert museum archive. A more deceiving because unfinished bust of the same type, formerly in the collection of Clarence H. Mackay, was shown at Detroit in 1938 (Valentiner, op. cit., no. 44) as Mino da Fiesole. This is stated to have come "from the collection of Geoffroi Brauer, Rome, who purchased it about 1885 from a princely family in Rome." The bust is accepted by Sciolla, op. cit., p. 82. I do not know it in the original.

91. For this bust see *Duveen Sculpture in Public Collections of America* (New York, 1944), no. 65, where it is reported that G. Swarzenski found the bust "puzzling for the condition of its preservation," whereas Langton Douglas believed that economic considerations "induced Desiderio da Settignano to revive a process for modeling polychrome portrait busts out of wood, canvas and gesso."

92. Foresi, op. cit., pp. 40–42: "Ce fut le menuisier L. Marinari qui fut chargé d'unir ensemble, au moyen de colle forte et de chevilles, les différents morceaux d'un vieux bois vermoulu; puis M. Raphael Cavalenzi, sculpteur en bois, dut faire de ce

tronçon une ébauche grossière de buste de femme que Bastianini, qui n'avait jamais employé les outils de son ami Cavalenzi, perfectionna plus tard; mais, pour achever cette oeuvre, dut-il encore employer une matière composée de stuc, d'étoupe, de chiffons; en outre, les couleurs, et même de l'or, je crois, pour l'imitation de l'étoffe de la robe." The bust was bought by Timbal in Florence for 600 francs from a middleman, Francesco Simonetti.

93. Musée National du Louvre, *Catalogue des sculptures* (Paris, 1892), no. 622. The bust was acquired in 1888 as "école Florentine." For the bibliography of the Louvre bust see Cardellini, op. cit., pp. 248–49, who accepts it as a work by Desiderio, but appears to regard the pigmentation as a later addition. The bust is reproduced by L. Planiscig, *Desiderio da Settignano* (Vienna, 1942), Plate 62, p. 32, with the comment: "Eine bemalte Holzbüste des Louvre kann an diese Arbeiten angeschlossen werden; wir wissen jedoch nich, ob es sich bei ihr um eine eigenhändige Arbeit Desiderios handelt."

94. Victoria and Albert Museum, no. A.9–1916. Pope-Hennessy and Lightbown, op. cit., ii, no. 730, pp. 683–84.

95. In the last resort the date of origin of the Paris bust can be established only by technical examination. It differs in certain respects from the Duveen/Mellon bust, in that use of gesso decoration is more restrained. The style of hairdressing is, however, highly unpersuasive, and the timid profile corresponds exactly with that of the terra-cotta bust.

96. *General Catalogue* (1935), p. 236: "now considered to be of recent execution."

97. A photograph of 1908 is in the Victoria and Albert Museum.

98. C. Seymour, op. cit., no. 36, p. 179.

99. The marble copy, which is signed and dated, is on the staircase at Corsham Court.

100. According to F. Schottmüller, *Kaiser Friedrich Museum, Berlin: Bildhauerei in Stein, Holz, Ton and Wachs* (Berlin-Leipzig, 1933), no. 184, p. 152, the Berlin bust was purchased in Florence in 1839. It is possible therefore that its unfortunate appearance is due to nineteenth-century repainting, not to a nineteenth-century origin.

Since the above passage was written, the Washington bust has been the subject of close examination by Professor Ulrich Middeldorf, *Sculptures from the Samuel H. Kress Collection: European Schools, XIV-*

XX Century (London, 1976), pp. 43–45. Middeldorf, while accepting the antiquity of the Washington bust argues, possibly correctly, for a dating in the second quarter of the sixteenth century, and claims that the bust here illustrated as fig. 64 is an original from which the bust in Washington and other terra-cotta busts of Lorenzo il Magnifico derive. A thermoluminescence test would be required before the date of this bust could be firmly established, but whether or not it is of the period, I find it difficult to credit that it is anything save a derivative of the bust in Washington.

101. Lusetti, op. cit., Plate 25.

102. V. Lusini, *Il San Giovanni di Siena e i suoi restauri diretti dal Cav. Prof. Agenore Socini* (Florence, 1901), pp. 69–89, describes the problems that arise when "si mette mano a liberare qualcuno dei monumenti medievali dalle storpiature ed aggiunte onde amò tormentarli lo sviato gusto de' due secoli antecedenti all'ultimo."

103. P. Paoletti, *L'archittetura e la scultura del rinascimento in Venezia* (Venice, 1893), p. 14.

104. G. Mariacher, "Matteo Raverti nell'arte veneziana del primo Quattrocento," in *Rivista d'Arte*, xxi (1939), pp. 23–40.

105. Ferrari (1810–94), a pupil of Tenerani, became director of the Scuola di Scultura in the Accademia in Venice in 1851. The remade sculpture is described by E. Musatti, *I Monumenti di Venezia* (Venice, 1893), p. 90, as "un'eccellente imitazione (dovuta al magistrale scalpello di Luigi Ferrari) di quello distrutto all caduta della Repubblica."

106. A. Peroni, "Di alcuni falsi della scultura bresciana del Rinascimento," in *Arte Lombarda*, x (1965), figs. 8, 9, 10, pp. 111–18.

107. Victoria and Albert Museum, no. 61–1885. Pope-Hennessy and Lightbown, op. cit., ii, no. 591, pp. 553–55.

108. For the relief by Antonio di Ser Ghino see C. A. Nicolosi, *Il Litorale Maremmano, Grosseto-Orbetello*, Italia Artistica, no. 58 (Bergamo, 1910), pp. 101ff.

109. Johnson, op cit., p. 276.

110. The Altoviti bust is described by E. Plon, *Benvenuto Cellini* (Paris, 1883), pp. 221–23, in the Palazzo Altoviti, Rome, where it remained till 1889. It appears to have been drawn to the attention of Mrs. Gardner in or before 1898 by E. P. Warren, and it was bought by her in that year.

111. Bode, op. cit. (1930), ii, p. 71.

PHOTOGRAPH CREDITS

The publishers would like to thank the museums for permission to reproduce photographs of works of art in their collections. Courtesy is also gratefully acknowledged from the following:

Alinari (including Anderson and Brogi), Florence: Connoisseurship, 1, 9, 10; The Sixth Centenary of Ghiberti, 2, 3, 4, 5, 6, 9, 12, 13, 14, 16, 20, 21, 22, 23; The Madonna Reliefs of Donatello, 14, 15; The Evangelist Roundels in the Pazzi Chapel, 1, 2, 3, 4, 5, 6, 7, 8, 10; The Medici Crucifixion of Donatello, 2, 3, 4; Donatello and the Bronze Statuette, 1, 3, 4, 5, 6; The Altman Madonna by Antonio Rossellino, 7, 15; Thoughts on Andrea della Robbia, 1, 2, 3, 4, 5, 6, 7, 8, 9, 10, 11, 12, 13, 15, 16, 17, 18, 19, 20, 21, 22, 23, 24, 25, 26, 27; The Forging of Italian Renaissance Sculpture, 12, 13, 14, 15, 18, 33, 40, 45, 48, 49, 50, 51, 68. Archives Photographiques, Paris: The Altman Madonna by Antonio Rossellino, 14. James Austin: The Forging of Italian Renaissance Sculpture, 4. Bazzechi, Florence: The Forging of Italian Renaissance Sculpture, 16. Philip A. Biscuti: The Forging of Italian Renaissance Sculpture, 56. Roger D. Easton, Rochester, New York: The Sixth Centenary of Ghiberti, 24. Clarence Kennedy: The Forging of Italian Renaissance Sculpture, 40. Lightfoot & Newman, Chester: The Forging of Italian Renaissance Sculpture, 42.